Courtauld Research Papers

This series makes available original recently-researched material on western art history from classical antiquity to the present day.

Also in the series:

Art, Politics and Civic Religion in Central Italy, 1261–1352

Edited by Joanna Cannon and Beth Williamson

Artists and Patrons in Post-War Britain

Essays by postgraduate students at the Courtauld Institute of Art

Edited by Margaret Garlake

Courtauld Research Papers No. 2
ASHGATE

Published by
Ashgate Publishing Limited
Gower House
Croft Road
Aldershot
Hants GU11 3HR
England

Ashgate Publishing Company
131 Main Street
Burlington, VT 05401–5600 USA

Ashgate website: http://www.ashgate.com

British Library Cataloguing-in-Publication data
Artists and Patrons in post-War Britain : essays. –
 (Courtauld research papers ; no. 2)
 1.Art patronage – Great Britain – History – 20th century
 I.Garlake, Margaret II.Courtauld Institute of Art
 709.4'1'09045

Library of Congress Control Number: 2001088807

ISBN 0 7546 0045 9

This book is printed on acid-free paper

Typeset in Palatino by Manton Typesetters, Louth, Lincolnshire, UK and printed and bound in Great Britain by TJ International Ltd, Padstow, Cornwall

Contents

Figures

3.6 Alan Davie, *Martyrdom of St Catherine*, 1956, oil on canvas, 183 × 244 cm/72 × 96 in, Astrup Fearnley Museet for Moderne Kunst, Oslo

3.7 Hubert Dalwood, *Open Square*, 1959, aluminium, 42 × 34.5 × 13 cm/17¾ × 13 × 5 in, Leeds City Art Galleries

4 'A place for living art': the Whitechapel Art Gallery 1952–1968

4.1 Barbara Hepworth exhibition, Whitechapel Art Gallery 1954

4.2 Bryan Robertson, 'Entertainers in *Vogue*, February 1968. The caption reads: Bryan Robertson, Director of the Whitechapel Art Gallery since 1952; advisor to the Peter Stuyvesant Foundation on their grants scheme to encourage young English artists; author; broadcaster; bachelor, for whom cooking is 'an unwinding process, real self-indulgence. I usually cook two or three times a week for myself and have friends over in the weekend'. His specialities are chilled cucumber, mint and yoghurt soup, followed by roast lamb or veal with a large selection of vegetables, fruit and cheese – 'real simple fare, bachelor stuff, but good', and the ideal adjunct to his entertaining recipe – 'total

informality, very close friends, no business, no more than six, ideally three or four, resulting in more talk, more communication'. Photographed here in the dining-room of his Islington flat: below, through a prism sculpture by Robert Downing; on the left, Lee Krasner's painting *Earth Green*. Beside him, above, Nigel Hall's fibreglass and metal castle sculpture; on the wall, a Brigid [sic] Riley black and white painting.

5 The triumph of 'The New American Painting': MoMA and Cold War cultural diplomacy

5.1 Jackson Pollock exhibition, Whitechapel Art Gallery 1956

6 'Place'

6.1 Ralph Rumney, model for 'Place', 1959

6.2 Installation of 'Place'. Left-right: Ralph Rumney, untitled; Robyn Denny *Place 7* 1959; Robyn Denny, *Place 1*, 1959

6.3 Robyn Denny, *Place 3*, 1959, 213.4 × 182.8 cm/84 × 72 in oil on canvas, artist's collection

6.4 Richard Smith, ground-plan of 'Place', 1959

Acknowledgements

The editor and authors would like to thank Kenneth Armitage, Brian Bell, Denis Bowen, Christopher Butcher, Anthony Caro, the late Prunella Clough, Roger Coleman, Alan Davie, Robyn Denny, Hilary Diaper, Ronnie Duncan, Pamela Edwardes, Jane England, Peter England, Terry Frost, Martin Froy, Peter Garlake, Chris Garlick, Mel Gooding, Chris Green, the late Josef Herman, John Hoyland, Isabelle King, John Jones, Ellen Keeling, Phillip King, Porter McCray, Stephan Munsing, Waldo Rasmussen, Benedict Read, Bryan Robertson, Rona Roob, Robert Rowe, Ralph Rumney, Fiona Russell, Tim Scott, Jack Smith, Richard Smith, Darthea Speyer, Julian Stallabras, John Thorp, Sarah Wilson and an anonymous reader.

Introduction

Margaret Garlake

In 1952 the painter, Felix Topolski wrote to Sir Kenneth Clark, former director of the National Gallery and Chairman-in-waiting of the Arts Council, complaining that despite the Council's promises of support for drama and music theatre, 'when it comes to visual arts, the artist is left to his own (nonexistent) devices'.[1] Topolski's protest, which was far from unique, was addressed to a man who operated at the core of the network of patronage relationships. It indicates that the artist might expect to be supported by the state. This in turn suggests an attitude to patronage specific to the immediate post-war years.

Studies of patronage in this period have focused on state institutions and the nature of their power rather than individuals[2] or art produced in opposition to official funding bodies or events that do not fit into an institutional mould. Concentration on the Arts Council has obscured the diversity and conflicts within state patronage and has resulted in the Council's being adopted as a metonym for the entire system. The publication of several substantial studies suggests that this focus is increasing even as the Council's long-term survival becomes less plausible.[3] Conversely, very little has been published on the British Council, the Institute of Contemporary Arts or the various County Councils, all of which established pioneering connections between artists and the institutional art world.

This book consists of five case-studies, initially written as MA theses, that closely investigate aspects of the mechanisms of patronage outside the state institutions, while indicating structural links with it.[4] The writers have sought to elucidate the relationship between patronage, the production of art and its dissemination. Without seeking to provide an inclusive account of patronage or art production in the early post-war years, their disparate and highly selective papers set up models for the structure of patronage under specific historical conditions. They assume an understanding that works of art are

embedded in their social contexts, are products of the conditions under which they were produced and that these contexts and conditions are complex, fluid and imbricated in one another.

The contentious and intractable issue of quality obtrudes insistently into a study of this kind, if only because it may so easily be sidelined. Neutrality is no more plausible within a patronage system than within any other form of art production, though its terms may be discreetly concealed. Within self-justifying texts produced by the Arts Council, for instance, 'quality' was constructed as autonomous, self-evident and inherent in works of art, whereas in practice it was grounded in 'a multiplicity of individual aesthetic responses and judgements' by the Council's staff and advisers.[5]

Similarly, the individual judgement of maverick patrons is seldom straight-forward; within the field covered by these papers there are consistent preferences for works of art that are stable, durable objects; that are not politically determined or propagandist and that conform to broad critical criteria consistent with progressive or, in some instances, avant-garde art. To suggest that such works are 'better' than the numerous available alternatives would be unsustainable, yet some kind of consensus is evident, within a common artistic nexus, that may be understood as a perception of quality. However contingent the judgements that produced that perception, they more or less uniformly acknowledged contemporary American painting as a datum point for assessment. Critical judgement suffered a crisis of confidence when first faced with Abstract Expressionism; not so artists, however, who recognized it as both challenge and inspiration. This may either be understood as evidence of the pre-eminent quality of Abstract Expressionism over the painting of Europe or as further evidence of the relative and over-determined nature of critical judgement.

Issues in state patronage

Over fifty years after its inception within modern institutions,[6] state patronage in England has changed beyond recognition. A concept of patronage as the idealistic provision of a social benefit to passive recipients has long since dis–solved, as have notions of an homogeneous public or a normative art practice. By the early 1960s the coexistence of Pop Art, late Bloomsbury and Gustav Metzger's hypothecated, metaphorical art of destruction already indicated an urgent need to reformulate the terms of the transaction between the donor state and its potential recipients. Eventually the diversity of both practice and response proved to be a hydra that the state model was unable to combat.

Though this book covers a time-span of only just over twenty years, this was a period in which the relationship between state and private patronage

was radically reformulated; when, despite a gap between theory and practice, a welfare-oriented social democracy demanded that the state acknowledge the burden of cultural provision.[7] It was a period of painful redefinition of national status and wildly shifting centres, in which the notion of Europe as a cultural and political entity was redrawn and reduced in relation to the United States, only to be reasserted by the formation of the European Union in the 1990s. A full study of patronage since 1945 would acknowledge these shifts as fundamental; the acronym 'yBa', for instance, indicates practices, critical contexts and markets constructed as a function of international relationships. Important on a more detailed scale for understanding the nuances of patronage systems was the gradual valorization of local cultures and communities, a complex process in which factors as diverse as a burgeoning tourist industry and new universities played contributory roles.

There persists a perception of the 1950s as an interim period, characterized by a drab austerity and archaic social practices. I suggest that this view is not only simplistic but that the period 1945 to 1960 may be characterized and distinguished as one of flux and unresolved contradiction that produced the conditions in which a post-modern culture might flourish in subsequent decades. Whereas the years since the early 1960s are seen to be richer in theoretically engaged, cross-cultural, multi-disciplinary practices than earlier decades, these practices are unlikely to be fully understood without a consideration of those that immediately preceded them.

Despite a perception of the naturalness of the state's ascendancy as patron after 1945, the new Labour government was slow to address the issue of state support for the arts.[8] In the 1945 policy declaration, *Let Us Face the Future*, five lines were devoted to the desirability of 'concert halls, modern libraries, theatres and suitable civic centres', to ensure an equitable distribution of culture.[9] Counter to the naturalness of state provision ran a current of fear, expressed by the right-wing press, that the foundation of the Arts Council would encourage the dissemination of a uniform, official art. Similar doubts even emerged from within the Council itself, when the visual arts were singled out as particularly vulnerable to charges of succumbing to '*l'Art Officiel*' because they were the only art form directly provided by the Council.[10] This fear was widely seen as the strongest argument for encouraging diversification among providers of the visual arts. Within a few years a realignment of both resources and ideology took place, brought about largely by reductions in the tiny Treasury grant but also by a tacit acknowledgement that the arts were to be understood as the natural preserve of the middle classes; others might safely be deemed to prefer different forms of leisure activity.

After 1951 the principle of universal arts provision as a function of social justice eroded rapidly; the South Bank Exhibition of the Festival of Britain

was the last great exhibition where self-improvement through education was as strong an imperative as pleasure. The tacit abandonment of a primary educational impetus reversed a trend that had been in place since the mid-eighteenth century, when a knowledge of art was to be the means of 'moral and intellectual improvement',[11] particularly for the working classes, deemed to be most in need of wholesome alternatives to gin and debauchery. Yet the shift in priorities that took place after 1951 was also a necessary prelude to any attempt by the Arts Council to realign itself with advanced practices.

The motivations of patronage may involve politics, ideology, propaganda, pleasure, generosity. To move through those words is to move away from the institutional patron, towards the private benefactor. Rather than a condemnation of the state model, those words indicate its complexity and inherent contradictions. The latter certainly include the idealism of the early Arts Council, which sought to perpetuate a nation-wide, Ruskinian practice of grass-roots, hands-on participation in parallel with a long-term programme of education. These admirable intentions ignored not only the divisions of a still sharply class-specific society, but also the low priority accorded to the visual arts – as opposed to the national theatre companies – by the Treasury and the mandarins who ran the Council.[12]

Given its inability to provide artists with more than token support, the prominence that state patronage rapidly aquired is far from self-explanatory. Since private patronage has often been a compensatory response to the deficiencies of the state model, it is unsurprising that the two are less rigorously separated than they appear to be. The distinction between a politically inflected state patronage and a multiplicity of philanthropists is more complex than a simple dichotomy between institution and individual for, as Nicholas Pearson has written, 'the relationships, authorities and powers of the State are of individuals but are more than individuals'.[13] Individuals form the powerful cabal known as the art establishment which, through shared membership of boards and committees, effectively controls the state system[14] while it also determines policy and runs departments.

The structures of patronage

The Arts and British Councils, which offer the most visible faces of state patronage, act as gatekeepers, in a system of checks and balances, committees and advisers set up to ensure the neutrality strenuously publicized by institutions accountable to the taxpayer. Paradoxically, these structures may be mirrored in private initiatives, even when control finally rests with a single individual. Most importantly the gatekeeper mechanism acts as a system of closure through which potentially threatening cultural formations

are absorbed into the dominant culture and diffused.[15] The thrust of the gatekeeper is always towards concealment of its own process, so that any given system appears to work naturally or to be self-regulating.

Nevertheless, despite the plethora of controls, even within the state system crucial areas may be dominated by an individual, as was the case with Lilian Somerville, head of the British Council's Fine Art Department from 1948 to 1970. Well known for her aesthetic perception, she was also a fixer adept at manipulating her advisers, though she too was ultimately subject to constraints that were presented as financial exigencies. Comparably, on a smaller scale, Stewart Mason, Leicestershire's Director of Education, was the controlling force in building up the Education Authority's collection, for which he bought contemporary work with the confidence and eclecticism of a private collector.[16] Institutions without individuals able to bypass or manipulate the gatekeeper mechanisms were apt to become embroiled, like the London County Council's art advisory system, in processes of byzantine complexity and inefficiency.[17]

The art support system that survived from the end of the war until the 1980s originated in 1934, with the emergence of the British Committee for Relations with other Countries, supported by no less than four government departments.[18] Its purpose was to conduct cultural activities in support of 'political and commercial' ends – which were not initially distinguished from one another. In 1936 the organization, by then the recipient of a prophetically inadequate Treasury grant, was renamed the British Council and given a royal charter. By the end of the war the much expanded Council, funded principally by the Foreign Office, was explicitly 'concerned with cultural relations as an arm of the foreign policy' of the government.[19] It was thus comparable to organizations like the Goethe Institute.

With unpredictably long-lasting effects, the British Council set in train a system of advisory committees defined by medium, such as music, drama and visual arts. The system was replicated by Maynard Keynes in re-structuring the Council for the Encouragement of Music and the Arts in 1942, and subsequently adopted by the Arts Council. This structure all too soon became paralysing: premised on easel painting, sculpture and work on paper, it was manifestly unable later to accommodate murals, photography, book art and concrete poetry which, not hitherto acknowledged as 'high' art, presented insoluble problems of categorization. During the 1960s, it became evident that visual art, hitherto manageable and medium-specific, had metamorphosed into practices that engaged with performance, music and text, that incorporated the ephemeral, the self-destructive and – most dangerous of all – the political gesture.[20] No longer content to conceal radicalism, artists were overtly and constantly assimilating, discarding and re-identifying the nature of visual practice.

The quasi-autonomous status of both Councils was inseparable from the much discussed 'arm's length principle': the convention that Treasury money is distributed through an independent, intermediate agency, in order that art not be politically inflected. Though this system is still notionally in operation, its merits are far from clear-cut. First it suggests that the making and dissemination of art are a single process and secondly, that the state actively seeks, or has reason to seek to direct the making of art. In addition and equally contestable, the arm's length principle is based on the premise that the intermediate agency is free from constraints and pressures.

Because the British Council works almost entirely outside this country, it has escaped much of the attention and criticism directed at its domestic counterpart, the Arts Council. Moreover, its increasingly overt political role appears to have saved it from the agonizing reappraisal suffered by the Arts Council in recent years. Although it retains a minor rôle in post-colonial cultural relationships, its work in former colonial territories remains largely concealed even from art specialists. However, its presence in Europe is increasingly visible:[21] it established a European Community Liaison office in Brussels in 1991 and has subsequently opened numerous centres in the former Soviet Union and central Europe, while its presence at events such as the Venice and São Paulo Bienals remains high profile. The Visual Arts Department has been much praised by artists for promoting their careers and assisting them to exhibit abroad. For visual artists at least, the limited patronage offered by the British Council has proved beneficial and efficient.

Diversifying the system: responses to new art forms

The Attlee government's emphasis on social services, partial nationalization and a planned economy[22] were consistent with a skeletal system of state patronage established in the expectation that its shortfalls would be privately compensated. Ben Pimlott has argued that Harold Wilson's 'fascination with planning' 'contained an element of nostalgia for 1940s controls'.[23] It is plausible, then, to discern a dominant strand of patronage that was still understood in the 1960s as normative within a social democracy committed to regulation and planning.

Under the Wilson government of 1964 to 1970 the arts gained an un-precedented prominence. In 1964 Jennie Lee, Secretary to the Ministry of Housing and Public Work, was appointed minister with a special responsibility for the arts; in 1967 she became Minister for the Arts within the Department of Education and Science. The White Paper, *A Policy for the Arts*, published in February 1965,[24] is an exhilarating document and the most significant official statement on the subject since the foundation of the Arts

Council. While the authors noted the importance of the contributions of 'private collectors' in the past and anticipated the patronage to be offered in future by 'progressive industrialists and trade unions', they envisaged 'a fully comprehensive policy for the arts', recognizing arts funding as a social service and fulfilling the distant promise of *Let Us Face the Future*.

With Lee's encouragement, the Council made strenuous efforts to respond to the ways in which art was conceptualized, made and absorbed by a multiplicity of publics. Much research was undertaken, particularly into the various strands of practice subsumed under the heading 'community arts', a heterogeneous movement facilitated by the economic boom of the 1960s and united by varying degrees of allegiance to popular music, recreational drug-use and an egalitarian society. It stands as a metaphor for all kinds of art production operating outside conventional patronage systems. Whereas many community arts activities may simply have appeared intractable to assimi-lation by the Arts Council, the smaller group of artists committed to political action presented a direct threat.[25]

The political potential of the movement was emphasized when, in 1977, *The Arts and the People* tacitly acknowledged links between community arts and the Left, demonstrated in a scheme intended to reform and democratize arts funding. The authors recommended the appointment of a Cabinet Minister for the Arts, Entertainment and Communications and the establish-ment of a 'National Conference for the Arts and Entertainment'.[26] The members, many to be elected by local authorities, Regional Arts Associations and unions, would determine Arts Council policy and elect most of its members. The authors called for increased funding for the arts, a triennial budget for the Arts Council and greater committment by artists to residencies and community projects.[27]

A concealed function of state subsidy has been identified as reducing 'the risk of experimental or avant-garde activities'.[28] This may be achieved by stimulating the process of incorporation. In May 1969, the Council's first reaction to the community arts movement was to establish the New Activities Committee, charged with conducting investigations into new art forms at public meetings, described in period dialect as 'gatherings'.[29] Demonstrably ineffectual, the NAC was soon replaced by the Experimental Projects Committee which in 1972 resulted in the formation of the Association of Community Artists, an umbrella organization empowered to negotiate for grants. During the following decade, as the Arts Council devolved its financial responsibilities to the regions, the dilemma was resolved by passing responsibility for community arts funding to many disparate organizations. While community artists can be accused of naivety in accepting grants, the Arts Council first absorbed then fragmented the movement, betraying its artistic purpose and converting it, as Owen Kelly has argued, from activism to harmless neutrality.[30]

In 1988, after years of acute under-funding, the effects of which had become particularly evident in museums and national theatre companies,[31] the Arts Council published its first three-year plan, a strategy proposed in *The Arts and the People* nearly a decade earlier. The plan emphasized 'business planning and marketing' and the desirability of private subsidy, proposing a management-based organization that would be 'less of a traditional funding body ... and more of an advocate, an adviser and a policy-maker'.[32] The formation of the Regional Arts Boards, a strategy promoted within the rhetoric of political devolution, was consistent with the abolition of the metropolitan authorities in 1986. In practice, however, the RABs had very little autonomy; the result of their formation was to increase the centralization of the Council, rather than to devolve its powers.[33] Unable to reform itself, the Council has not recovered from the redefinition thrust upon it in the late 1980s, which was sufficiently radical to threaten it with 'extinction'.[34]

Commercial patrons

During the 1960s, when contemporary art became a marker of corporate status and prestige, industrial and commercial patronage briefly offered alternatives to the publicly funded model. However, the authors of *The Arts and the People* were sufficiently disillusioned by 1977 to complain that commercial patrons were far more generous to sport than to the arts and that the relatively small sums dispensed were principally for 'prestige events in London'.[35] A spectacular intervention into contemporary art was made by the Peter Stuyvesant Foundation, established in 1962 on Bryan Robertson's initiative. It was to proclaim: 'By spending £60,000 over three years, the Foundation aims to form a collection of modern British painting second only to that of the Tate Gallery'.[36] The New Generation phenomenon, sustained by the Foundation, became synonymous both with the Whitechapel Art Gallery and with highly coloured abstract sculpture. The Foundation was a generous patron, offering bursaries to artists, buying work and supporting exhibitions not only at the Whitechapel but in other cities, though the sculptural enterprise failed to survive the disastrous 'Sculpture in the City' programme of 1972.[37]

Artists were the chief beneficiaries of the Stuyvesant sculpture programme. The most innovatory aspect of their work was complete before the New Generation programme of exhibitions started; indeed, the impetus within St Martin's was such that when the series ended in 1968, New Generation sculpture had already been displaced by various manifestations of body-oriented art. The achievement of the Stuyvesant programme was to identify contemporary art as fashionable and desirable. A less beneficial side-effect of

the immense publicity was that the diversity within the New Generation phenomenon was concealed and the artists' individuality submerged.

As commercial patronage began to flourish in the late 1960s, simultaneously large numbers of artists turned to self-support and thus reduced their dependence on committees. It was evident that they were able to control not only the making of art but the systems for housing and exhibiting it. If the prognosis was disturbing for the Arts Council, the situation for the artists could scarcely have been better, for as practice diversified, so did the range and nature of initiatives established to support it. If not the first instance of an artists' self-regulating support system, one of the most enduring has been the enormously successful SPACE (Space Provision Artistic, Cultural and Educational Ltd) studios venture, started by Bridget Riley and Peter Sedgley in 1968. SPACE was established as a non-profit distributing company to provide studios able to accommodate the large scale of much contemporary art. The GLC made available a warehouse at St Katharine's Dock, pending development, the Arts Council gave a grant for conversion work and by 1985 SPACE was running ten studio sites in London and had a waiting list of over 200 artists.[38]

A very different artist-led enterprise, that sought to modify society, was the Artist Placement Group (APG), established in 1966 by John Latham and Barbara Steveni[39] with a very small grant from the Arts Council. With continuing Arts Council support, the APG was to act as a counter to commodity-based commercial enterprises. Its purpose was to explore possible relationships between artists and industry and to elucidate the mutual mediations that might take place in the confrontation between an industrial context and an artist's work. In so far as the work produced under the auspices of the APG was generally more concerned with relationships than objects, it may be considered performative, though object-based work included a film, documentation and factory machinery brightly painted by Stuart Brisley. In 1972 Brisley was to condemn the APG, which had, he considered, become a vehicle for Latham's ideas rather than an artists' 'self-help' group. Even the initiatives taken by artists to organize their own support networks were only to be seen as a 'series of attempts to resolve aspects of the developing larger crisis in which artists and art are seen to be largely irrelevant given the priorities of capitalist society'.[40]

Since the early 1980s the private model of patronage has flourished. While 'Freeze', organized in 1988 by Damien Hirst, was an astute career move that has spawned many imitations, other ventures, such as private, museum-like spaces, have demonstrated tendencies as hegemonic as any imputed to the state model, while the business sponsorship once perceived to be the panacea of all cash-starved arts bodies has proved to be dominated by an impetus towards a centrist art. Nevertheless corporate sponsorship holds many

attractions, both for donors and receivers, as Chin-tao Wu has demonstrated. While it enables museums to open new spaces and mount exhibitions that would otherwise be financially impossible, it also brings a humanizing aspect to corporations, provides social cachet for managerial staff involved with sponsorship and helps companies that produce socially unacceptable products to modify their images. Primarily, however, corporate sponsorship is a matter of 'sales promotion, however well disguised it may be'.[41]

During the 1990s earlier forms of state provision were largely replaced by the National Lottery and a plethora of local and special interest systems for which the gatekeepers devised application rituals of such complexity that many artists prefer to find alternative, often commercial systems of support that they may control themselves. This situation, as we have seen, had its roots in the 1960s; indeed commercial patronage was perceived as an essential compensation for the deficiencies of the state system as early as 1951.[42] Today it is often seen as the only alternative, since it has eclipsed such initiatives as the detailed studies discussed below.

Case studies

The five papers in this book are arranged roughly chronologically. Fiona Gaskin's study of English Tachisme (written in 1996) stands slightly apart from the rest since it is concerned not with patronage but with the philosophic and physical construction of an imagery that has become a visual shorthand for the 1950s. However, since the other papers reveal that Tachisme informed the work of many of the artists discussed, Gaskin's text acts as an introduction to a number of important themes that run throughout the book. Marian Williams's account of the early Gregory Fellowships at the University of Leeds (1997) provides a model for the interrelationships of a patronage system in a rich regional city. Mary Yule's study of Bryan Robertson's directorship of the Whitechapel Art Gallery (1991) assesses the degree of autonomy that may be claimed by an individual working within a publicly financed system. Stacy Tenenbaum (1992) and Toby Treves (1997) have analysed single exhibitions, respectively 'The New American Painting' and 'Place', both of which took place in 1959.

Gaskin is principally concerned with the construction of meaning within a certain kind of painting. As she demonstrates, English Tachisme represented an ideology, linked with Existentialism and a period of flux, uncertainty and moral dilemma after the war. In her discussion of the way that artists as disparate as Patrick Heron, Roger Hilton, Alan Davie, Ralph Rumney and William Gear may be united through practice, Gaskin isolates the broad field defined as process-dominant art[43] as the field within which artists formulated

responses to Georges Mathieu or, with greater conviction, Nicolas de Staël. His 1952 exhibition at the Matthiesen Gallery took artists by storm in a way that no exhibition had done since 'Picasso and Matisse' in 1945. William Gear kept a framed letter from de Staël in his studio; brief and uninformative – de Staël asked simply whether a meeting would be possible during a forthcoming visit to London – it indicates the reverence in which many English colleagues held him.

What was the potency of the *tache*, which led so many artists to adopt it? Gaskin argues that its appeal, in the trauma left by the war, was precisely its lack of fixed meaning and thus its ability to imply a certain utopian idealism. While the relationship of the *tache* to existential philosophy is securely established at its French source, the relationship was much less clear in this country, where first-hand knowledge of Existentialism was rare. Gaskin however, demonstrates that in its British manifestation, Tachisme might equally be inflected by Zen Buddhism or Jungian philosophy.

Herbert Read, conduit for the popularization of Jung among artists, played many roles in the art world: founder of the ICA, a Leeds man, friend of Eric Gregory and critical theorist among them. He wrote a rare English text on Existentialism[44] three years before he published the brief but well-known essay, 'New aspects of British sculpture' in the catalogue for the sculptors exhibiting at the 1952 Venice Biennale. It famously introduced the phrase 'the geometry of fear' which, while it is no longer understood to define a coherent group of sculptors, does eloquently express the post-war ethos into which it is now common to read a sense of communal, undifferentiated guilt for Hiroshima and the Holocaust. While Marian Williams discusses the work of some of these sculptors, these first two papers incidentally emphasize the separation of the motivations of patronage from the philosophies that inform the production of art.

Eric Gregory was one of a number of private collectors and patrons who contributed substantially to the formalization and growth of an institutional art world after the Second World War. As a founder member and Treasurer of the ICA in its crucial first years, as a member of the Contemporary Art Society eligible to buy for the nation's museums and as the chairman of Lund Humphries, responsible for publishing definitive monographs on British artists, he stood, like Read, at the centre of a network of relationships.

As with the Whitechapel Art Gallery, education was a strong strand in the Gregory Fellowships, with the Fellows teaching at Leeds University and the Art College and thus contributing substantially to the development of Basic Design courses in the north of England. A process-dominant practice was inherent in the notion of Basic Design, with which several of the early Fellows were closely concerned. Almost as strong a thread within the Fellowships – and a declared goal for the Whitechapel Art Gallery – was to

articulate relationships between the visual arts and theatre, music and literature, though this desire was more fully achieved in Leeds than in London. The Fellowships also strengthened links between Leeds and artists in St Ives, some of whom Gaskin discusses in a different context.

While Gaskin and Williams both emphasize the close links formed between British and French artists, Yule's paper acknowledges the shift that took place in the late 1950s from Paris to New York. This adjustment established a new order for western European art, reformulating not only the market but art production, criticism and modes of display, which Yule investigates through exhibitions of contemporary American art in the late 1950s and early 1960s. The Whitechapel Art Gallery's list of exhibitions reveals both linkages and closures, showing that exhibitions of American artists were interwoven with leading European modernists; it is symbolically significant that de Staël's posthumous exhibition took place at the Gallery shortly before the start of the long American series.

'The New American Painting' took place not at the Whitechapel, but at the Tate, the second seminal American survey exhibition in three years. Its impact on English artists was only surpassed by its ideological implications. Stacy Tenenbaum's paper is a study in the demystification of Cold War cultural politics, now arguably a field of greater fascination than it was before the unravelling of the Cold War. 'The New American Painting' was long assumed to have been a manifestation of Cold War politics, a parallel to the sometimes damaging and almost invariably fatuous cultural interventions by the CIA.[45] However, Tenenbaum demonstrates that this exhibition, long supposed to have been devised by the United States Information Services as an act of Cold War cultural diplomacy, was solely the product of New York's Museum of Modern Art. She is concerned less with the production of art than with the structure of patronage, its determinants and the ways in which a single exhibition was misinterpreted for so many years.

The changes that took place between 1946 and 1960 in the external relationships of the English art world are implicit throughout this book. The dependence – or perceived dependence – of English artists on French models so pronounced in the first half of the twentieth century was replaced in the later 1950s by a more commercially oriented relationship with the New York School. While this shift took place gradually, with English artists making sporadic appearances in New York galleries from the late 1940s, its initiation is symbolically located in the survey exhibition, 'Modern Art in the United States', which reached the Tate Gallery early in 1956, at the end of a European tour. Its impact was reinforced three years later by the more tightly focused 'The New American Painting'. Between the two exhibitions, English artists took advantage of unprecedented opportunities to exhibit in New York.

The priority given by artists to New York and the ascendancy of its art market were paralleled in the 1960s by the dominance of American criticism. Yule suggests that Bryan Robertson's richly pluralist pattern of exhibitions at the Whitechapel challenged the modernist orthodoxy propounded by Clement Greenberg and Michael Fried, both of whom made specific reference to Anthony Caro, the doyen of New Generation sculpture which was, of course, first exhibited at the Whitechapel Art Gallery.

Treves's analysis of 'Place' reveals the presence in England of a cultural heterogeneity more common and vigorous in continental Europe – and utterly distinct from the market-led orientation of artists towards the United States in the late 1950s. 'Place', mounted at the ICA in September 1959, was less an exhibition of painting than a demonstration of the rôle of art in situationist social theory. Deeply obscure and highly politicized, the Situationist International had only a single English member, Ralph Rumney, who devised the initial plans for 'Place'. Though his scheme was much amended, the assemblage of paintings in restricted formats and colours that mystified critics was produced and displayed primarily in response to theoretical formulations.

Treves emphasizes that 'Place' can only be understood through a political reading: specifically the politics of the French Left, modified to be acceptable to an English avant-garde institution. In this modification we recognize the agency of Gramsci's theory of hegemony as interpreted by Raymond Williams and filtered through the imperfect understanding of individuals in response to contingent events. Thus Tenenbaum's detailed refutation of a political motivation for 'The New American Painting' does not mean that it may not be situated within the American economic hegemony of the late 1950s; though not politically motivated, our reading of it inevitably remains politically inflected. Conversely it is impossible to understand 'Place' outside its originating context of the European Left, yet examinations of 'Place' have hitherto focused on its aesthetics rather than its ideology.

* * *

It is not coincidental that the flowering of the commercial support system took place at the same time as the expansion of the Arts Council. While this was facilitated by a strong economy, we may also see in the belated flowering of the state system in the 1960s a response to a rival order with dialectically opposed motives. In other words, the only time when central government attempted to make adequate provision for the arts was when the system appeared to be threatened by a rival ideology. To suggest that this attempt was fully successful would be absurd; indeed as this book reveals, one of the strengths of the state system lay, by default, in the *in*adequacies that allowed individuals to develop idiosyncratic parallel initiatives.

Today, though more sources of funding are available to visual artists than ever before, the hierarchy that Topolski deplored is still all too evident, while the patronage system remains unresolved and unsatisfactory. The problems inherent in corporate funding are increasingly evident, even though it may seek to assume the hegemonic status once claimed by the state. Devolution has failed to compensate for the lack of a unified system, though the Arts Council, formerly a locus of centrist authority, is now scarcely more than a conduit for funding. Patronage is not simply a matter of distributing money; to be effective it must be an intellectual system, with a well-formulated creative agenda, inscribed in the larger social and political system. We need to acknowledge that Keynes's Arts Council – with its subsequent ramifications – was an admirable institution that no longer works effectively. Secondly, and more problematic, we neeed to establish an alternative system, adequately funded, authoritative and unified, as a modern successor to Keynes's creation and to Jennie Lee's aspirations.

Notes

Abbreviations

PRO: Public Record Office
TGA: Tate Gallery Archive

1. Kenneth Clark papers 8812.1.2.6501, 30 December 1952, TGA.

2. Exceptions include Veronica Sekules, 'The ship-owner as art patron: Sir Colin Anderson and the Orient Line 1930–1960', *Journal of the Decorative Arts Society*, 10, 1986, pp. 22–33; Jennifer Mundy ed., *Brancusi to Beuys: Works from the Ted Power Collection*, exh. cat., Tate Gallery London, 1996.

3. See Robert Hewison, *Culture and Consensus: England, Art and Politics since 1940*, London: Methuen, 1995; Andrew Sinclair, *Arts and Cultures: the History of the 50 Years of the Arts Council of Great Britain*, London: Sinclair-Stevenson, 1995; Richard Witts, *Artists Unknown: an Alternative History of the Arts Council*, London: Little, Brown & Co., 1998.

4. In the context of this book, 'patronage' excludes museums.

5. Nicholas Pearson, *The State and the Visual Arts: a Discussion of State Intervention in the Visual Arts in Britain, 1760–1981*, Milton Keynes: The Open University, 1982, p. 99.

6. For a recent account of the longevity of state patronage, see Brandon Taylor, *Art for the Nation: Exhibitions and the London Public 1747–2001*, Manchester: Manchester University Press, 1999.

7. Milton. C. Cummings Jr. and Richard S. Katz, *The Patron State: Government & the Arts in Europe, North America & Japan*, New York and Oxford: Oxford University Press, 1987, pp. 7–8.

8. John Harris, *Government Patronage of the Arts in Great Britain*, Chicago & London: University of Chicago Press, 1970, pp. 151–2.

9. Labour Party, *Let Us Face the Future*, April, 1945, p. 9.

10. *The Public and the Arts: Eighth Annual Report of the Arts Council of Great Britain 1952–1953*, p. 8.

11. Taylor, *Art for the Nation*, 1999, p. 51.

12. See Robert Hutchison, *The Politics of the Arts Council*, London: Sinclair Browne, 1982, chapter 4.

13. Pearson, *The State and the Visual Arts*, 1982, p. 45.

14. Hutchison, *Politics*, 1982, pp. 30–3; Margaret Garlake, *New Art, New World: British Art in Postwar Society*, New Haven & London: Yale University Press 1998, pp. 10–15.

15. For a theoretical formulation of incorporation, see Raymond Williams, 'Base and superstructure in Marxist cultural theory' in *Problems in Materialism and Culture*, London: Verso, 1980, pp. 31–49. See also Toby Treves, 'Place', Chapter 6 in this volume.

16. *British Sculpture and Painting from the Collection of the Leicestershire Education Authority*, exh.cat., Whitechapel Art Gallery, London, 1967, p. 33.

17. See Margaret Garlake, '"A war of taste": the LCC as art patron 1948–1965', *The London Journal*, 18:1, 1993, pp. 45–65.

18. See Frances Donaldson, *The British Council: the First Fifty Years*, London: Jonathan Cape, 1984, chapter 1.

19. British Council papers, EC[615]15 Appendix A, PRO/BW 78/4.

20. For later perceptions of continued links between art and politics see Labour Party, *The Arts and the People, Labour's Policy towards the Arts*, NEC paper October, 1977, pp. 6–7; see also Cummings & Katz, *The Patron State*, 1987, p. 12.

21. See *Arts without Frontiers, a Conference on the Effects of the European Single Market*, Arts Council of Great Britain, 1990 Plenary 2, 'Arts practice without frontiers', p. 13.

22. See Jeremy Brookshire, *Clement Attlee*, Manchester & New York: Manchester University Press, 1995, p. 71.

23. Ben Pimlott, *Harold Wilson*, London: HarperCollins, 1992, pp. 128 and 276. On the centrality of planning to Labour thinking, see also Labour Party, *Let Us Face the Future*, 1945.

24. HMSO, *A Policy for the Arts: the First Steps*, Cmnd. 2601,1965.

25. Owen Kelly, *Community Art and the State: Storming the Citadel*, London: Commedia Publishing Group, 1984, pp. 9–11.

26. Labour Party, *The Arts and the People*, 1977, App. II & p. 11.

27. Ibid., p. 37.

28. Cummings and Katz, *The Patron State*, 1987, p. 11.

29. For information on the New Activities Committee I am indebted to Paul Shackleton, 'New activists, new art and the Arts Council 1968–74' unpublished MA thesis, Courtauld Institute of Art, University of London, 1993.

30. Kelly, *Community Art*, 1984, pp. 35–6.

31. Sinclair, *Arts and Cultures*, 1995, p. 320.

32. Arts Council of Great Britain, *Three-Year Plan 1988/89–1990/91*, 1988, p. 2.

33. Sinclair, *Arts and Cultures*, 1995, pp. 331–2.

34. Ibid., p. 314.

35. Labour Party, *The Arts and the People*, 1977, p. 18.

36. Quoted in Alan Osborne ed., *Patron: Industry Supports the Arts*, London: The Connoisseur Ltd, 1966, p. 103.

37. See 'The Peter Stuyvesant Foundation City Sculpture Project' *Studio Int.*, 184:946, July/August, 1972, pp. 16–32 and 'Press reaction to City Sculpture Project' ibid., pp. 33–40.

38. 'A proposal to provide studio workshops for artists', *Studio Int.*, 177; 908, February, 1969, pp. 65–7.

39. For information on the Artist Placement Group I am indebted to Katherine Dodd, 'Artist Placement Group 1966–76' unpublished MA thesis, Courtauld Institute of Art, University of London, 1992.

40. 'No it is not on', *Studio Int.*, 183:942, March, 1972, pp. 95–6.

41. Chin-tao Wu, 'Embracing the enterprise culture: art institutions since the 1980s' *New Left Review*, 230, July/August, 1998, pp. 28–57.

42. Philip James, 'Patronage for painters: 60 paintings for '51', *The Studio*, 142:701, August 1951, pp. 42–7.

43. See David Thistlewood, *Herbert Read, Formlessness and Form: an Introduction to his Aesthetics*, London, Boston, Melbourne, Henley: Routledge & Kegan Paul, 1984, p. 129.

44. Herbert Read, *Existentialism, Marxism and Anarchism*, London: Freedom Press, 1949.

45. See Frances Stonor-Saunders, *Who Paid the Piper? The CIA and the Cultural Cold War*, London: Granta Books, 1999.

British Tachisme in the post-war period, 1946–1957

Fiona Gaskin

Tachisme: a chameleon word

This essay explores æsthetic and intellectual reasons for the appeal of the *tache* to British artists in the post-war period up to the exhibition 'Metavisual, Tachiste, Abstract' at the Redfern Gallery in April–May 1957. That end-point has been chosen because the Redfern Gallery exhibition may be considered a watershed for three reasons. Firstly, the exhibition signalled the arrival of Tachisme as a new force within British abstract art, although tachiste artists were not singled out as a group. (The demarcation lines between the various tendencies represented at the exhibition – which included a range of idioms outside Tachisme's scope, such as figurative art by Cliff Holden, geometric abstraction by Ben Nicholson and a constructionist relief by Victor Pasmore – were left undrawn.) Secondly, as a consequence of this exhibition, it became clear that Tachisme had superseded Constructionism as the *enfant terrible* of British abstract art. And thirdly, by 1957 the European origins of Tachisme had become confused with an enthusiasm for American Action Painting and Abstract Expressionism, which had similarities with Tachisme in terms of process and end-product, so that the original motivations for the adoption of Tachisme as a style were ceasing to apply. As far as possible, I have confined this paper to an appraisal of British Tachisme in its unalloyed state.[1]

Tachisme is a chameleon word, which was used by artists and critics to describe a number of idioms. Arguably, it signified an attitude and a process of fabrication rather than a particular 'look'. However, particular looks did emerge, and it was in response to their appearance that the term was invented. Broadly, two distinctive tendencies can be discerned within British Tachisme which took their cue from the Ecole de Paris: on the one hand were artists whose initial stimulus came from the loosely geometric brushstrokes of

Nicolas de Staël and on the other were artists drawn to the more energetic, calligraphic marks of Georges Mathieu. Although British Tachisme may be criticized for being reductive, the same criticism may be levelled at large swathes of British art in the twentieth century. Furthermore, original contributions to the tachiste œuvre were made in Britain.

I argue that the appeal of Tachisme to British artists was rooted in the historical conditions of the period under discussion, and that the dis-enchantment with geometric abstraction and academic art signified by the rise of Tachisme was merely a reflection of a wider revulsion against the so-called rational systems of thought that had contributed to – or, at least, not resisted – the recent global cataclysms. Into the vacuum left by the war were mobilized new ideas from the realms of philosophy, psychology and anthropology to make sense of the human condition. I briefly consider the relevance of three: French Existentialism, Zen Buddhism and Jungian psychoanalysis. In addition, I consider other reasons, socially-determined and æsthetic, for the appeal of Tachisme.

In the period under discussion, the ideas promulgated by Existentialism, Zen Buddhism and Jung were very much in the air in avant-garde circles in London, which centred on the Institute of Contemporary Arts (ICA), Soho cafés and bars and, from 1956, the New Vision Centre Gallery in Marble Arch. That is not to say that artists fully understood their meanings – generally they did not, having simply a grasp of the key concepts derived from secondary sources – nor that those ideas were the *causa causans* of their art. But frequently those ideas were invoked to provide an intellectual rigour and validity for an art form that was strictly intuitive and subjective, which might otherwise seem self-indulgent and meaningless. All three systems of thought had the added appeal of giving a special status to the artist, who was cast in the role of exemplar or mediator.

Abstract art, being an essentially opaque medium, was particularly well-suited as a vehicle for the expression of Existentialism, whose illogicalities, posturings and other shortcomings soon became apparent in fiction – so much so that by 1958 it could be said that 'Existentialism as a cult is now as dead as last year's fad.'[2] Arguably, it was in the Action Painting of Tachisme that Existentialism found its fullest expression. By contrast, Zen Buddhism and Jungian psychoanalysis provided less negative and individualist world views, which appealed to artists of a less nihilistic outlook searching for imagery with a universal significance. They also satisfied a craving for the mystical and primitive. Perhaps as a result, their legacy has been longer-lasting, with artists like Alan Davie and Denis Bowen still drawing on their ideas as a source of imagery or, more usually, of method, to this day.

Tachisme is only a word ...

The word Tachisme is derived from the formal appearance of the works of the movement it describes, which are composed of *taches*. Literally a *tache* means a stain, spot, blob, blot, blur or patch. René Drouin, an important dealer-critic of the day, provided another definition of a *tache* as a 'splotch',[3] which suggests something uncontrolled or accidental.[4] However, that is not a complete definition. Although accidental effects were often sought or left in tachiste works, they were not necessitated by the use of *taches*, which could be controlled, directional and programmatic. Generally, a *tache* suggested a mark that was ragged and organic rather than hard-edged and geometric, but the possible meaning of a *tache* as a patch incorporated the idea of angular shapes. These varieties of meaning reflected the fact that, although the word Tachisme was not invented until 1951,[5] the *tache* had its roots in both the constructive brushstroke of Cézanne and the more numinous dabs of Impressionism and Pointillisme. As we shall see, this dichotomy was to remain in its English usage.

Although a *tache* can be a stain or blot, it was more usually thought of – at least in its earliest manifestations before the experimental use of thinned-down household emulsions – as a thick daub of paint, frequently applied with a palette knife. Both an insistence on rich painterly texture and an acceptance of the independent behavioural properties of paint as a viscous substance, were hallmarks of the tachiste style. Indeed, as Lawrence Alloway observed,[6] painterliness was a defining difference between the lyrical abstraction of Tachisme and the geometric abstraction of Constructionism, which sought to give up paint in favour of relief sculpture made from wood and synthetic materials. Tachisme's rich texture was easily confused with the contemporaneous developments of dripping and *tubisme*, as well as *matière* painting,[7] and the term became subsumed within the generic headings of *informel* and *art autre*.[8] As a result, all of these descriptions soon lost their potency.

As well as painterliness, implicit in the notion of the *tache* was the idea of the artist's action or gesture in creating it. Although the *tache* was frequently applied rapidly – a reason why the term Tachisme was often used synonymously with Action Painting – and splashes resulted from the speed of application, the process of fabrication of tachiste paintings was not confined to the athleticism of Action Painting but embraced more deliberative methods. The gestural character of the action with which the paint was applied was intrinsic to the meaning of Tachisme: the *tache* carried connotations of the emotive and expressive. These lyrical qualities were recognized in the term 'lyrical abstraction', which was used to describe the tendency before the term Tachisme had been invented.[9]

As we shall see, the attraction of Tachisme as a style for British artists was due in part to its affinities with French Existentialism, which provided a language and context that took the artist's action as a register of authenticity and the *tache* as a marker of identity, an affirmation of essence.[10] Yet the *tache* in British art did not function solely as a marker of being. Tachisme embodied a 'stylistic gamut from expressionistic action painting to a kind of sensual impressionism without things'.[11] In the latter idiom, the *tache* was expressive of the effects and colours of nature rather than the artist's self. Equally, self-expression was anathema to tachiste artists like Alan Davie who sought inspiration for their art from the psychoanalysis of Jung, and from the philosophy of Zen Buddhism which holds that the ego is the first impediment that must be overcome on the path to enlightenment. For such artists, the *tache* was an archetype – a symbol derived intuitively from the collective unconscious.

British Tachisme: origins and idioms

In *Nine Abstract Artists*, Alloway distinguished two tendencies in British abstract art: the rational, 'pure geometric' tendency, exemplified by artists like Victor Pasmore and Kenneth and Mary Martin, which his book served to foreground, and the 'irrational expressionism by *malerisch* means' of the 'painterly abstractionists' who 'melt, bury, or fracture platonic geometry'.[12] In this category, he placed artists like William Scott, Terry Frost, Roger Hilton and Alan Davie and argued that theirs was the dominant tendency in British abstract art. In the catalogue to 'Dimensions, British Abstract Art 1948–1957', which was Alloway's subsequent and rather more convincing attempt to codify British abstract art, he defined the painterly tendency as including allusive abstraction – in which highly abstracted pictures contained allusions to landscape, still life and figure – and painterly non-figuration.[13]

British Tachisme included both strands of painterliness identified by Alloway. However, it also included a further category of painting (which Alloway treated as a sub-category of painterly non-figuration) that might be described as allusive non-figuration. Paintings in this category were allusive in the sense that they were permissive of the presence of imagery, although they had been produced by a process of non-figuration; the artist had not started out with an object (whether before his eyes or in the mind's eye) from which to abstract an image, but, because of the inherent power of paint and colour to imply imagery, allusions could be found in the dabs or strokes of paint. Such allusions were allowed to remain, or might even be elaborated by the artist.[14]

All three strands of painterliness identified above were heavily dependent in origin on the work of artists in the Ecole de Paris, notably Nicolas de Staël

and Georges Mathieu, although painterly non-figuration, of which the most important exponent was Davie, also drew on American sources. The paintings of de Staël and Mathieu represented two different types of influence: the former consisted of internally logical images of impasted *taches*, often with an underlying grid, and the latter of a more gestural, calligraphic tendency. Although there were cross-currents between France and America, so that French and American sources cannot be distinguished entirely from one another, British artists absorbed the influences largely through the medium of French art. With the exception of Alan Davie,[15] their acquaintance at first hand with American Action Painting and Abstract Expressionism was slight before 'Modern Art in the United States' (Tate Gallery, 1956). The most important earlier exposure was Michel Tapié's exhibition 'Opposing Forces' at the ICA in 1953, which contained paintings by Jackson Pollock and Sam Francis, as well as by Mathieu, Michaux, Ossorio, Riopelle and Serpan. By contrast, the Ecole de Paris was accorded several important exhibitions in London after the war, bearing out the fact that Britain still considered Paris rather than New York to be the epicentre of the art world.[16]

Nicolas de Staël's work had been seen at 'In Paris Now' at the Leicester Galleries in 1950 and at the Royal Academy's 'Young Painters of the Ecole de Paris' in 1952.[17] However, it was his one-man exhibition at the Matthiesen Gallery in February 1952, covering the period 1946 to 1952, which provoked the most excitement, stimulating such artists as Hilton, Heron, Scott and Gear to experiment with his impasted brand of Tachisme. During the period 1946 to 1952, de Staël had progressed through three distinct styles. His early abstract work, dating from the period 1946 to 1948, consisted of loose grids interpenetrated by clashing diagonals and planes. *Composition* (1947)[19] is a typical example of this style. By 1949 de Staël was producing mosaic-like works of vertical and horizontal impasted slabs and patches. These were also internally logical images (that is, without external referents) although their starting point was in nature. Again, *Composition* (1950) (Fig. 2.1) is a good example, showing how the *taches* now occupied a shallow space because of the absence of orthogonals and the use of a lighter palette. However, as abstraction is a contingent idea, since the degree to which a work is abstract depends on the viewer's perceptions, allusions in such paintings were immediately perceived[20] and dealers soon accorded figurative titles to these works.[21]

In 1952 de Staël started to paint semi-figurative works in which external referents were included and reduced and simplified to their barest essentials. For example, in *Study: Landscape* (1952), sea and sky are suggested by the presence of a horizon line and realistic colours, which in turn make the square and rectangular *taches* readable as houses and other buildings. De Staël's work became increasingly figurative in the remaining years before

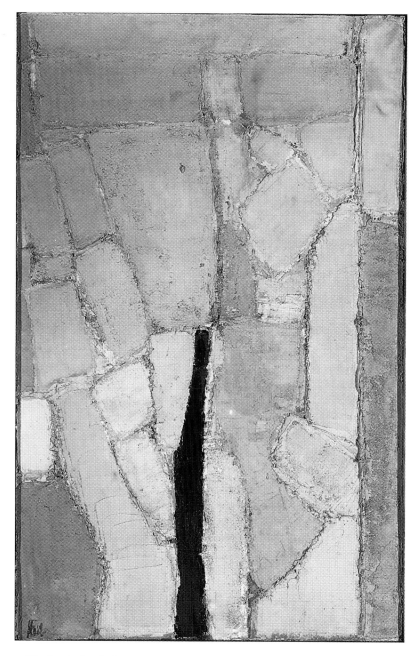

2.1 Nicolas de Staël, *Composition*, 1950, oil on canvas 125 × 80 cm/49 × 31½ in, Tate Gallery

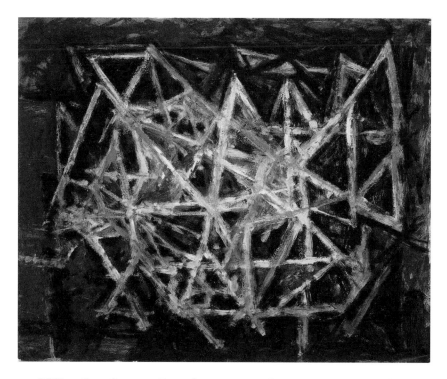

2.2 William Gear, *Structure*, December 1949, gouache on paper 53 × 65 cm / 21 ×
25½ in, private collection

his death and ceased to be strictly tachiste, although it still retained some of
the visual hallmarks of his earlier tachiste style. The range of his styles soon
inflected the work of British artists, who found in him a source of visual
stimulation unencumbered by theory.[22]

De Staël's early work bore similarities to that being produced by William
Gear after he settled in Paris in 1947[23] and by Hilton between 1950 and 1952,
under the influence of Gear and Alfred Manessier.[24] Although Gear's and
Hilton's work was rather more ragged and soft than de Staël's, they all
shared a fundamental idiom consisting of an armature or grid (Fig. 2.2),
initially in black but gradually lightening in palette, with a strong vertical
emphasis. In the interstices of this structural web were painted flickering
patterns of brightly coloured tesseræ which created the illusion – or sensation
– of depth. The works had no focal point or sense of scale, suggesting a
continuous space[25] or 'voluminous spatial reality'.[26] As Heron said, the eye
sinks through it, aided by the juxtaposition of light and dark colours.[27] Space
– the representation of the ether – had itself become the subject of the work,
although the viewer might also be aware of forms in that space without

knowing their actual identity. The space was often penetrated by the forms and colours of landscape – of 'blossom and foliage'[28] in the case of Gear, giving an effect of dappled sunlight.[29] However, despite referential titles, these were non-figurative works, drawn 'in nature' rather than of it.[30]

Gear responded to the de Staël exhibition by experimenting with thick impasted slabs and knife work. His work also became more geometric and subdued in colour. However, Gear had returned to his former idiom by 1956, although the expressive shapes of the earlier works had become more formalized. Hilton's style, on the other hand, gradually changed from ragged, thin brushstrokes to simplified areas of thick, bold colour, such as *August 1953 (Red, Ochre, Black and White)* (Fig. 2.3) or *September 1953*[31] which echoed de Staël's *Composition* (1950) (Fig. 2.1) in its black tongue-like shape penetrating white *taches*.[32] The patches of colour were sawn off at the edge of the canvas and therefore appeared to extend beyond it, bearing out Hilton's claim that the role of the picture had ceased to be a vehicle for images or even for an arrangement of shapes but had become 'an instrument ... for the activization of space'.[33] Although strictly these paintings were non-figurative, the spaces and forms seemed animated – the former work resembling the torso of a woman[34] – and could therefore be considered allusive.

The suggestion of male and female personages was likewise to be found in the tables and kitchen utensils of William Scott's work of the late 1940s and early 1950s. Alloway described Scott and Hilton as being 'devoted to the unknown, the "indefinable"'.[35] During this period, Scott's work became progressively more abstract, with the imagery being flattened and sometimes elongated into thickly-pigmented fields, sometimes divided by thin lines of paint. However, at this stage it was still being abstracted from the human figure or still-life, although that process was being 'pushed to a point of near-concretion'.[36] Patrick Heron compared Scott's work of this period with a 'Mondrian that is melting',[37] saying that whereas Mondrian's work was 'an essay on form and proportion', Scott's was 'a living entity, utterly organic ... a concrete sensuous fact involving paint'.[38] Although such work was not strictly tachiste because of the manner of its production, it anticipated tachiste works in its semi-abstract blocks of impasted colour. After visiting the de Staël exhibition in 1952, Scott executed a number of works that could be described as tachiste; these included a series of gouaches,[39] in which the linear and metamorphic qualities of his earlier work had given way to a de Staël-inspired mosaic of *taches*. However, this change did not constitute a development into mere surface pattern because the works were imbued with a sense of three-dimensional space and form. Alloway said of Scott's new work that it had no 'paraphrasable meaning ... only a meaning dependent on the act of painting'.[40] Again, however, de Staël's influence was short-lived, and Scott abandoned his experiments with abstract art in 1953,[41]

2.3 Roger Hilton, *August 1953 (Red, Ochre, Black and White)*, oil on canvas 61 × 51 cm/24 × 20 in, private collection

although in his subsequent still lifes the utensils often echoed the massed *taches* of an abstract de Staël.[42]

Patrick Heron was also greatly impressed by de Staël's exhibition at the Matthiesen Gallery and became a convert to Tachisme.[43] During the summer of 1952, Heron produced his first entirely abstract works, consisting of flat slabs of gritty pigment in light and dark colours. Although abstract, Heron's canvases were less static than the majority of de Staël's entirely abstract

works, being closer in feel to his early semi-figurative paintings: the *taches* extended right to the edge of the canvas (whereas de Staël often massed them in the centre of his canvases) and, in *Square Leaves (Abstract): July 1952*, (Fig. 2.4) the *taches* seemed to be gyrating round the centre rather than hovering in space. However, de Staël's influence on Heron was also brief and he soon returned to figuration, with which, according to his own account, he remained until January 1956.[44] However, before the end of 1955 Heron had begun to produce works that might be described as semi-figurative, which suggested the influence of Soulages in their black and white vertical bars and patches (see *Winter Harbour*, 1955).[45] In the spring of 1956, Heron's palette lightened again and he started painting entirely abstract canvases in which the thick vertical bars were replaced by a pattern of more nebulous strokes placed evenly over the canvas, sometimes leaving trails of liquid paint. With referential titles like *Autumn Garden: 1956* (Fig. 2.5) and colours evocative of nature, these painterly works were infused with a sense of light, space and air. They suggested the influence of Sam Francis whose work Heron may have seen most recently in the Arts Council's touring exhibition 'New Trends in Painting'.[46] Unlike Impressionist works, they did not represent nature, nor were they abstracted from it.[47] However, they did connote natural effects – of dusk, mist, autumn[48] – 'often seen through a screen of sentiment'.[49] Heron considered their content to be 'mysterious' but argued that this did not make them less real.[50]

A second, more gestural and spontaneous tendency within the Ecole de Paris was also important for the development of British Tachisme. This tendency was exemplified by the art of Georges Mathieu.[51] *Pacte de St Jean d'Amaeli* (1951) is a typical example of his early style: the canvas has wide, sweeping strokes of black oil paint which are overlaid with a complex mesh of lines and scribbles of red oil paint applied straight from the tube. The effect is vaguely calligraphic: like writing one's name in the air with a sparkler, the paint has not stopped flowing, so that the mesh of lines or *ficelles* in each colour is virtually seamless.[52] The work has clearly been made out of a very few staccato gestures – what Mathieu called '*l'esthétique de la vitesse*'. He described this technique as requiring the following: '(1) *primauté de la vitesse*; (2) *aucune pré-existence de forme*; (3) *aucune préméditation du geste* and (4) *état extatique*'.[53]

Mathieu's calligraphic gestures served as an emblem and record of the body's projection into paint. Gear experimented with this style between 1947 and 1950 and it is possible that Davie, the leading exponent of a calligraphic style[54] in Britain in the late 1940s and early 1950s[55] first encountered it through his contact with Gear before meeting it again in the work of Pollock.[56] The tendency became known in Britain through exhibitions[57] and by a live (and televised)[58] demonstration by Mathieu at his one-man exhibition at the

2.4 Patrick Heron, *Square Leaves (Abstract): July 1952*, oil on canvas, 76.2 × 50.8 cm/
30 × 20 in

2.5 Patrick Heron, *Autumn Garden: 1956*, oil on canvas, 76.2 × 50.8 cm/30 × 20 in

ICA in 1956. This type of Tachisme had a strong following amongst artists linked to the New Vision Centre Gallery,[59] a permanent exhibition space in London for tachiste artists, and came to predominate in the second half of the 1950s.[60]

In conclusion, it may be said that what gave tachiste painters coherence as an artistic tendency was not the formal appearance of their works, which as we have seen, was varied, but the relationship of the artists to their materials. That relationship was process-dominant, which could have two possible meanings in this context. First, it meant that the tachiste work was created spontaneously without recourse to preparatory sketches or drawings. This was largely true of tachiste paintings, although not without exception.[61] And, second, it meant – without exception as far as it is possible to tell – that no attempt was made to conceal the process of fabrication by applying standards of finish to the end-product.

The appeal of painterly abstraction

In *Nine Abstract Artists* Alloway posited a dichotomy between geometric abstraction, which was promoted as being objective, conceptual and rational, and painterly abstraction, which was implicitly dismissed for its allusive, subjective, perceptual and irrational qualities.[62] Both tendencies had their supporters and critics.[63] It is not within the scope of this paper to consider any political or chauvinist motives that underlay the critical positions adopted in relation to the cold art of geometric abstraction and the warm art of Tachisme.[64] Furthermore, it will be left to subsequent sections to explore the links between Tachisme and the *Weltanschauungen* of Existentialism and Zen Buddhism that rose to prominence after the war. Here I will simply explore other socially determined and æsthetic reasons for the appeal of the *tache* to artists and, in particular, why the qualities ascribed by Alloway to Tachisme, insofar as they were true, appealed to them. Those reasons, which are complex, varied and sometimes contradictory, mostly have to be inferred because the artists tended to talk more about the creative act than its purpose – leaving their pictures to speak for themselves. For some artists the creative act was the point of their art[65] but for others (one suspects, most) it was a means to an end. When artists did talk about their reasons for painting as they did, they often spoke, somewhat unhelpfully if predictably, in terms of seeking truth[66] and reality.[67] The fact that so many artists inclined towards the process-dominant painterliness of Tachisme to express these concepts suggests a number of conclusions.

It may be argued that a reason for the appeal of Tachisme lay in the spontaneity – and in some cases virtual instantaneity – of the *tache*, which

provided a way of escaping any trace of the past.[68] Tachisme in Britain developed primarily in opposition to the geometric abstraction of the *Circle* group and Unit One rather than to the organic geometry of Constructionism, which developed concurrently with it. The geometric abstraction of the pre-war years was tainted with the cultural values of an epoch that had given rise to Fascism, war, the Holocaust and nuclear destruction. It is not hard to see why artists (many of whom, furthermore, had seen active service)[69] would have felt that an art form associated with those values had been discredited and that a new language of feeling had to be found with which to grasp the essence of their age. By contrast with geometric abstraction, the *tache* seemed value free, offering a *tabula rasa*.[70] Yet the rejection of the past meant more than simply a denial of the events of recent history and its values. It also meant a rejection of academic traditions in art and, in particular, the tendency towards formalism. Herein lay the origin of the term *informel*.[71]

The restoration of links between the art worlds of Paris and London, and the exhibitions of Picasso, Matisse, Braque and Rouault in 1945–6, although welcomed, had the effect of sapping the vitality of artists in Britain who had had to paint in virtual isolation during the war years or whose artistic careers had been curtailed for that period. They asked themselves how they could better the all-encompassing achievements of Picasso or paint in a way that did not identify them immediately with a particular tendency within modernism.[72] The Paris masters had stamped each tendency with so personal a style that it seemed impossible to grow around them, let alone to go beyond them. Part of the appeal of Tachisme therefore lay in the fact that it offered a new departure which could not be labelled.[73] Ralph Rumney summed up this attitude when he said, 'We look forward to the time when artists will no longer be bound by personal style. When, in anonymity, we shall be free to work without being forced perpetually to repeat and "develop" that which has already been achieved.'[74] Tachisme also had the attraction of coming without the confining dogma associated with many other movements,[75] having no manifesto or dominant apologist.[76]

The idea that Tachisme did not imply a particular look but simply a method of painting was, however, undermined by the fact that, although Tachisme embraced a number of idioms, art within those idioms was often highly similar. Moreover, in the first instance, the impetus for that art had come from the Ecole de Paris and later it gathered momentum from exposure to Abstract Expressionism in 'Modern Art in the United States'. However, these judgments have the benefit of hindsight. The artists who contributed to 'Metavisual, Tachiste, Abstract' felt that they were experimenting with a mode of painting that was entirely novel. The dependence on foreign sources, together with the unstated desire of British artists to situate themselves within an international movement, did not detract from the fact that those

artists believed that they could develop the new mode of painting in an original way. The internationalism of Tachisme was a further reason for its appeal: Constructionism, despite its international pedigree, seemed essentially insular – a fact not assisted by its frequent 'Arts and Crafts individualism'.[77]

Whereas the brushstrokes of geometric abstraction were intended to be smooth, imperceptible and inexpressive, the *tache*, as we have seen, was impasted, calligraphic and visceral. It betrayed a human touch. That human quality – an absence of finish – may be seen as another example of the rejection of the past and, in particular, the values of geometric abstraction and academic art. The experiments with unconventional materials, such as Ripolin, sand and gold leaf and the rough, textured effects caused, for example, by dripping, scouring the surface with a palette knife and decalcomania may also be understood in that light.[78] However, as well as being a form of iconoclasm, the painterliness of Tachisme appealed to artists because of its sincerity or ability to convey human values. Alloway described this mood as follows: 'What they [artists] want is something that is real as a painting, in which the physical qualities of paint have not been suppressed by a fixed idea of finish or elaborated to a point of excessive refinement.'[79]

By contrast, geometric abstraction, although it rested on utopian ideals, appeared cold and inscrutable,[80] as well as deceptive in its ideal of meticulous finish. There can be no doubt that truth to materials – or, even more, truth to process – was a significant underlying reason for the appeal of painterly abstraction. However, it should not be allowed to obscure a simpler, but equally important point: the artists' sheer love of paint. Painterly abstraction – more than painterly representational art – permitted a hedonistic enjoyment of paint as paint.[81] Finally, one further reason for the appeal of textured paint which may have weighed in their thinking, was the fact that it made a painting project into space and therefore seem more concrete or real. This was certainly a pre-occupation for Constructionists[82] and, given the cross-overs between the two groups – as personified by Scott, Hilton and Frost[83] – may have informed tachiste artists' thinking too.

If it is accepted that representational art is humanist,[84] then the allusive qualities of the *tache* may also be understood as an expression of human values. In the case of Gear's *Gay Landscape*, the allusions are re-assuring – at least they seem so to the viewer now, although to many they were incomprehensible in 1952.[85] However, the allusions of Scott's *The Harbour* (Fig. 2.6) or Hilton's *August 1953 (Red, Ochre, Black and White)* (Fig. 2.3) are more troubling, touching a chord that is primitive and erotic. The allusiveness of Tachisme may be seen as an attribute that developed in parallel – or in the case of Scott and Hilton intersected – with the widespread interest in metamorphosis found in British art during the post-war decade, especially

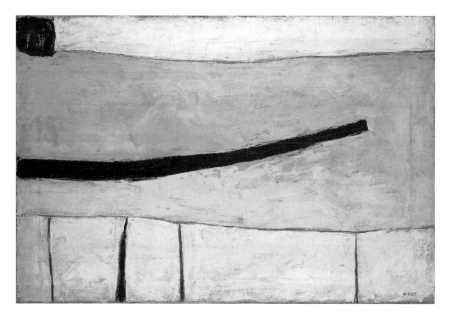

2.6 William Scott, *The Harbour*, 1952, oil on canvas 61 × 91 cm/24 × 36 in, private collection

in the art of Graham Sutherland and Francis Bacon. The roots of this tendency lay in the *objet trouvé* of Surrealism.

By the early 1950s, the personages of Sutherland and Bacon had become metaphors for 'the outer chaos of twentieth-century civilisation':[86] both were painting horrifying personages that were entirely constructs of their imaginations, although they called to mind the human body in robotic torso, snarling mouth or eye. Although it may be argued that Tachisme was also about objectifying a state of mind: whether it be the mood induced by the sight of an autumn landscape or the existentialist *angst* of an artist looking into the void, an important distinction between metamorphic art and Tachisme was that the *tache* was not metaphoric but generative of images.[87] Moreover, although allusions were tolerated and sometimes encouraged, Tachisme was fundamentally a non-representational art form, deliberately eschewing fixed meanings. Unlike the game-playing of Pop Art that followed, the allusiveness of the *tache* was not meant to trick or amuse. Nor was it ever intended to serve as an instrument of terror. Its appeal lay simply in its capacity to deny certainty through a plenitude of meanings. However, with the advantage of hindsight, it may perhaps be argued that those fugitive meanings reflected the insecurity of an age that had seen its certainties shattered by the nihilism of war and nuclear destruction,[88] the establishment of a new global order and, in Britain, by the retreat from the socialist reforms for which many had fought.

2.7 Ralph Rumney, *The Change*, 1957, oil on board, 152 × 198.5 cm/60 × 78 in, Tate Gallery

Although Tachisme developed in opposition to geometric abstraction, this did not mean that tachiste works were formless – merely that they resisted excessive formalism. In fact, many tachiste paintings contained an underlying geometry in an implied grid: the works of Gear and early Hilton often contained an obvious sketchy grid, but grids could also be detected in the work of Scott, Heron, Rumney, Bowen and others. In the early works, the grids often did not extend to the canvas edge, thereby having a centripetal effect on the eye,[89] whereas in later works, such as Rumney's *The Change*, (Fig. 2.7) the grids did extend to the canvas edge and so led the eye outwards, as if into a continuous space, thereby making the paintings seem more real. In both works the *taches* advance and recede amongst the scaffolds of lines. The movement is caused by the contrasting light and dark colours but also by the presence of the grid, which constantly returns the viewer's eye to the canvas surface, thereby denying the illusionistic space of the interstitial *taches*. This tension between flux and stasis may be seen as embodying a dichotomy between matter and spirit, as well as being a further example of the denial of fixed meanings.

Despite the prevalence of an underlying geometry in many tachiste works, Tachisme could not be described as a rational art form, unlike Constructionism, which was derived from mathematical principles such as the Golden Section. Whether it appeared on the canvas in a paroxysm of self-expression or shamanic trance, the *tache* was not arrived at rationally. Nor was it strictly a perceptual art form, although, as we have seen, Tachisme sometimes drew on nature obliquely as a source of inspiration. In these respects Tachisme went against the climate of Logical Positivism then prevailing in intellectual circles in Britain following the re-publication of A. J. Ayer's *Language, Truth and Logic* in 1946.[90] In its highly subjective sources, Tachisme also went against the grain of Patrick Heron's notion of good painting, which he sought to establish by organizing the exhibition 'Space in Colour' at the Hanover Gallery in 1953. In the catalogue Heron argued that good painting required a dualism between illusionistic depth and the physical reality of the picture surface, and that this could be arrived at rationally by following the examples of Cézanne, Braque and Picasso.

As well as being irrational in its sources, Tachisme could very often be considered irrational in its effects and meanings. This was due in part to the fact that tachiste works lacked a focal point, so that no particular area of the canvas was emphasized. Also, as we have seen, the underlying grids in many works were constantly denying a sense of perspectival depth, which might otherwise have imposed a sequential order on the eye.[91] The effects were at best hermetic and at worst meaningless to the uninitiated. The irrationality of Tachisme, both in its sources and appearance, may be seen as a further instance of tachiste artists' abnegation of the past. The events of recent history had revealed new depths of human cruelty with the result that traditional notions of human nature and traditional systems of thought had become unsustainable. As we shall see, powerful new ideas from the realms of philosophy and psychology were being mobilized to rebuild them and make comprehensible the sequence of global cataclysms. The irrationality of Tachisme was an instrument of that process.

Tachisme and Existentialism

The bomb reveals the dreadful and total contingency of human existence.
Existentialism is the philosophy of the atomic age.

William Barrett, 1977[92]

It is impossible to look at the reasons for the appeal of Tachisme to British artists without taking into account the influence of French Existentialism, which swept to prominence in the immediate post-war period. Existentialism had a popular base, being disseminated as much through the novels

and plays of Jean Paul Sartre, Albert Camus, Jean Genet and Simone de Beauvoir as through philosophical treatises. It became the talking point of the café society of St Germain-des-Prés – what Georges Mathieu described disparagingly as the 'cocktail – *littéraire* – Gallimard' set.[93] British artists were part of that scene, although not much is known about whom they met and what they read.[94] A copy of Sartre's essay, 'The search for the absolute' is reputed to have passed between the hands of certain British artists in Paris and David Sylvester, subsequently the art-critic for *The Listener*.[95] Sylvester went on to write 'The auguries of experience' in 1948 – an early application of existentialist thought to art criticism, which linked the fluid space of Paul Klee to the existentialist idea of viscosity.[96] William Gear has acknowledged that Existentialism dominated post-war thought in artistic circles in Paris in the late 1940s, although he claims that he was not interested in such ideas himself.[97] Nevertheless, he had read Sartre even before arriving in Paris, having included an illustration for Sartre's *Huis Clos* in his exhibition in Hamburg in 1947.[98] Hilton, a friend of Gear, would also have imbued this atmosphere while in Paris, and subsequent statements – such as his description of the artist as being 'like a man swinging out into the void' in *Nine Abstract Artists*[99] – suggest that he was influenced by its thinking.

Even less is known about the extent to which existentialist thinking affected artists in Britain. It can be assumed that Herbert Read's *Existentialism, Marxism and Anarchism*, published in 1949 and containing an explanation of the main tenets of Existentialism, would have been known in artistic circles. Similarly, Tapié's *Un art autre*, which was highly redolent of Existentialism, would have circulated amongst the avant-garde.[100] In *Nine Abstract Artists*, a defining work of the period, Alloway spoke in existentialist terms of the work of art as being 'a unique encounter between the artist and his materials', representing the sum of the artist's actions in that encounter; he also spoke of its having the status of an object in its own right by virtue of the 'Existential strategy'.[101] He later equated gestural art with Existentialism.[102]

The fact that Existentialism was primarily a literary movement would mean that even when artists were not acquainted with its ideas through those sources or by going back to the original texts, they could not fail to have known of its key concepts – such as the ideas of the absurd and of engagement – through novels, plays and journalism.[103] The tachiste artist Denis Bowen recalls Existentialism, along with nihilism and Zen Buddhism, as having been discussed frequently in the bohemian ferment of the artists' meeting places of Soho in the early 1950s: in particular, he recalled an evening in 1954 at the ICA on de Sade arranged by Lawrence Alloway which he and other artists attended; much to the annoyance of the jeering audience, nothing happened – the event was a 'non-happening'.[104]

Although the connections between Tachisme and the ideas of Existentialism, as derived mainly from the writings of Sartre seem obvious and strong, the causative nature of Existentialism's influence on Tachisme should not be pushed too far. Arguably both were manifestations of a wider historical mood or *Zeitgeist*.[105]

L'HOMME EST À INVENTER CHAQUE JOUR ...

One of the central planks of Existentialism is that human being is not pre-ordained – its essence lies in its existence. For that existence to acquire meaning or be 'authentic', man must confront and accept the fact that he is entirely free to invent himself, there being no predetermined codes or routines by which he should live. To live authentically an individual must fulfil his real potentiality in the world, instead of merely doing things necessary for living as other members of society live. Reaching this goal involves passing through a number of stages. Initially, it requires an individual to step back from the world and to perceive that his existence is separate from that of other men and the things around him. He must then recognize that the facts unique to him – his 'facticity' – are contingent. The realization that his existence is not in any way necessary engenders a sense of anguish or insecurity. Faced with the prospect of boundless freedom and deprived of an established system of meanings and motives with which to explain the world, he may, like many, fall at the next hurdle and adopt *mauvaise foi* by convincing himself that he is not as free as he actually is. The existentialist hero, however, surmounts this hurdle and confronts the contingent absurdity of his existence through his deliberate acts, which he chooses to take in full consciousness of his absolute liberty and the ultimate absurdity of his condition. By doing so he is able to confer meaning on his existence and create his own essence *a posteriori*. The decision to live by his acts alone reflects commitment – or *engagement*.

The concept of *engagement* had clear parallels with Action Painting, which, in its purest form, gave precedence to process over content. The similarities were accentuated by the fact that Sartre drew on the artist as the paradigm for authentic existence: 'In life, a man commits himself, draws his own portrait and there is nothing but that portrait'.[106] Harold Rosenberg echoed these thoughts: 'A painting that is an act is inseparable from the biography of the artist ... The act of painting is of the same metaphysical substance as the artist's existence'.[107] Thus, in both Action Painting and Existentialism the artist's gesture or action served as an affirmation of essence. To the extent that Tachisme equated with Action Painting, the *tache* can be understood in that light. A good example of the *tache* bearing this meaning in British art is in the *double entendre* of Rumney's *Self-Portrait* of 1957, (Fig. 2.8) which

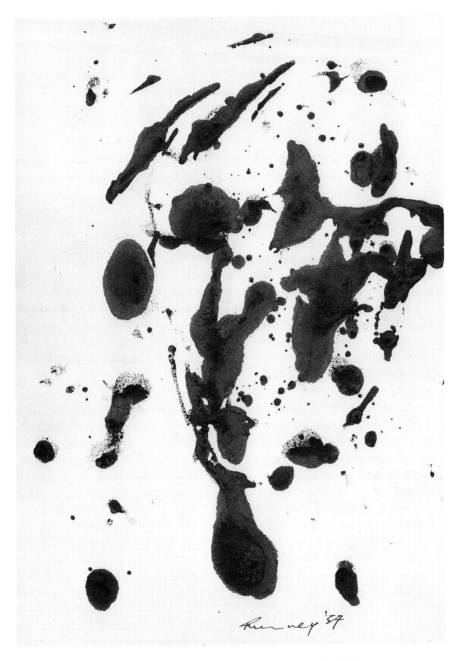

2.8 Ralph Rumney, *Self-Portrait*, 1957, monotype on paper, Tate Gallery

consisted of a swirl of seemingly random blots of ink done at speed. Hilton's work was also loosely existentialist, although for him the *tache* was not so much a marker of his own being as an attempt to make something that was durable and meaningful out of the nothingness that surrounded him. However, although the theoretical resemblances between the language of Existentialism and that of Action Painting seem strong, they should not be allowed to obscure the fact that the interest in Action Painting grew out of other stimuli as well, of which notably Surrealism and a revival of interest in oriental calligraphy both lacked the element of choice associated with Action Painting. Nevertheless, it was likely to be the missionary zeal of Existentialism which intensified and sustained that interest.[108]

The characterization of the canvas as an arena for self-expression lay at the heart of gestural painting and gave it credence as an art form. Arguably, it could be used to justify any end-product, the process being all. This view was supported by Sartre's famous comment in *Existentialism and Humanism*: 'As everybody knows, there is no pre-defined picture for him to make; the artist applies himself to the composition of the picture, and the picture that ought to be made is precisely that which he will have made.'[109] However, that view would be a misreading of Existentialism and the actual practice of Action Painting, which carried with it the notion of possible failure. Action Painting – and especially the variety done at speed in one session – was a high risk strategy, which required an intuitive artistry to pull off. Read recognized this when he wrote: 'Mathieu is a painter with style, and he gambles for the highest stakes in the dangerous game of elegance where one false move can topple his precarious success and turn the vehement calligraphy into a meaningless scrawl of paint.'[110] Responsibility for one's actions was also an underlying theme of Existentialism: freedom was an obligation not only to make choices for oneself but also for the whole of mankind, thereby giving an individual's acts a moral imperative.[111]

In *Opposing Forces* Tapié warned against the *informel* developing the 'traps set by the ubiquitous conformists in defence of false traditions'. In this context, the stranglehold on abstract art exercised over the preceding twenty years by geometric abstract artists who, 'believing that they have found the ultimate, do everything in their power to exclude any other … possibility' was presented as being a type of *mauvaise foi*. He saw the only prophylactic for this as being the 'wider circulation of authentic *individuals*'. Insofar as Tachisme may be seen as reflecting existentialist ideas, it is questionable whether it lived up to these requirements. The resemblances between works within tachiste idioms went beyond what might be expected to arise from the similarities of process. Whilst this was undoubtedly due in part to imitation and influence, it may also be an inescapable fact that artists end up painting in much the same way in any age, especially when linked by a particular *Weltanschauung*. Patrick

Heron put his finger on this flaw in existentialist reasoning when he said: 'No one is really free to paint "as he likes": there is, as it were, a certain prescribed area which has to be explored at a given time.'[112]

LA PÂTE MÊME DES CHOSES ...

According to Sartre, the conscious will of the *homme engagé* marks him off from things or 'beings-in-themselves' (*l'en-soi*) which are inanimate, solid and entirely actual. In the face of inert matter, the individual experiences nausea or a horrified fear that the teeming mass of unmanageable things will engulf him, destroying the elaborate values and purposes of life which he has constructed for himself. Viscosity – the stickiness of things – also engenders this state of fear. However, simultaneously with fear, nausea signifies a paradoxical craving for physical annihilation by things – a desire to obtain the completeness of existence of things, which have essences and are solid, lacking the gaping hole of nothingness within.

Matière painting supported and embodied the existentialist ideas of viscosity and self-abnegation. In addition, the physicality of paint necessitated and reinforced the idea of action – of plunging 'les mains sales ... jusqu'aux coudes ... dans la merde et dans le sang'.[113] By extension it also became a metaphor for the body.[114] To the extent that Tachisme intersected with *matière* painting in its impasted works imitative of de Staël or in its paints mixed with sand or massed drips, it seems reasonable to argue that one of the appeals of thick paint may have been these connotations. In Britain, the existentialist sense of physical disgust and urban alienation also found resonances in *The Wasteland* of T. S. Eliot, which enjoyed unparalleled prestige in the period after the War.[115]

Both a *horror vacui* and the possibility of physical annihilation can be sensed in the lyrical abstract works that were produced by Gear and Hilton in the late 1940s and early 1950s. As we have seen, these works treated the themes of space and matter, the 'frame of space',[116] although they were sometimes also infused with the colours of nature and given referential titles. What David Sylvester said in relation to the late works of Klee could be applied equally to these works: 'With a Klee, the relationship with the picture is reciprocal; you touch a loose rock with your foot, it falls from under you and you are left dangling in space. You are part of it as you are part of the sea when you go swimming; you plough your way through it and, in turn, are buffeted by the waves.'[117] As the eye is drawn inwards into the receding space of these paintings, the viewer has the impression of having 'lost his anchorage in the eternal'.[118]

Finally, Sartre's ideas about *l'en-soi* were relevant to tachiste art in relation to how the work of art was itself perceived. From one aspect it was seen as

a record of the artist's actions and therefore had a quasi-biographical significance.[119] From another aspect – which was equally consistent with Existentialism – it became an object apart from its maker, with the insistent inertia of all matter. Although this line of reasoning was perhaps more relevant to Constructionism, it was found in relation to Tachisme also. Thus, Rumney wrote: 'An act of creation must be autonomous and independent of its creator. That is to say that a work of art, once created, must not rely on the personality of its creator for its impact.'[120]

Tachisme, Zen Buddhism and Jungian archetypes

A painter seats himself before his pupils. He examines his brush and slowly makes it ready for use, carefully rubs ink, straightens the long strip of paper that lies before him on the mat, and finally, after lapsing for a while into profound concentration, in which he sits like one inviolable, he produces with rapid, absolutely sure strokes a picture which, capable of no further correction and needing none, serves the class as a model.

 The hand that guides the brush has already caught and executed what floated before the mind at the same time moment as the mind began to form it.

 If one really wishes to be master of an art, technical knowledge is not enough. One has to transcend technique so that art becomes an 'artless art' growing out of the Unconscious.

Eugen Herrigel, 1953

All three quotations are taken from Eugen Herrigel's *Zen in the Art of Archery*[121] which was published in Britain in 1953. Together with D. T. Suzuki's *Essays in Zen Buddhism*,[122] it was a seminal text for the promulgation of Zen Buddhism in Britain during the 1950s. Unlike Existentialism, which seems to have been ingested by artists from reading novels and seeing plays rather more than from a hard read of the philosophical texts, there is some evidence that these books were actually read by tachiste artists.[123] Although by its very nature, Zen Buddhism is not capable of being described or defined in any manner – since Zen means freedom from logical thought and, in particular, the logical thought brought about by the restriction of language – still these books succeed in giving an understanding of the way of life that Zen signifies. Unlike Hinayanan Buddhism, Zen Buddhism rejects the quest for nirvana. It also rejects the belief in salvation through the use of magical symbols, formulæ and rituals found in Mahayanan Buddhism. Instead, Zen Buddhism is grounded on a belief in a form of enlightenment – known as *Satori* – which is achievable at any time but cannot be desired or grasped. That sense of enlightenment, which is 'the sudden flashing of a new truth hitherto altogether undreamed of',[124] comes from within, rising up from the uncontrollable depths of the subconscious. Because this state of enlightenment

cannot be explained or imprisoned in words, various other means are used to convey or implant the seed of Zen, especially archery, flower arrangement, tea ceremonies, painting and calligraphy. The above quotations give some idea of how that painting and calligraphy are done.

The emergence of Tachisme in France, and of Action Painting in America, may be traced back, *inter alia*, to a revival of interest in Zen calligraphy and brush painting.[125] By the time Zen Buddhism reached Britain in the early 1950s, its importance lay not so much in its role as a source of inspiration of imagery and method, as in its confirmation of the validity of practices in which artists were already engaged.[126] Zen Buddhism provided a theoretical basis for a process-dominant art form, which had already been absorbed from France and America in the form of their partly Zen-inspired Action Painting. It therefore struck a chord with many artists. Unlike American Action Painting – of which the main exponent in Britain in the late 1940s and early 1950s was Alan Davie – which lacked a consistent method, Zen painting and calligraphy provided a discipline, whilst not undermining the vitality of the final work of art. After his discovery of Zen Buddhism, Davie turned to it for that reason.[127] Frank Avray Wilson described the position thus:

A simple blob or line can be seen as vital – provided it is done with vitality. It is a law that a mark can only symbolise the energy that has gone into its making … The elaborate rituals of the Oriental calligraphers were aimed at promoting the right conditions for this vital touch, not by violent and speedy attacks which the Europeans had found necessary, but in more disciplined and verveful ways.[128]

A second reason for the popularity of Zen Buddhism was its reliance on the subconscious for the inspiration of its art. In their search for a language of universal significance, artists had become interested in the possibility of tapping the intuitive symbols – or archetypes – of the collective unconscious. Their ideas were derived from the psychoanalysis of Jung which, like Zen Buddhism, was widely discussed by artists in the pubs, clubs and coffee houses of Soho from the early 1950s.[129] That interest was also reflected in the activities of the ICA.[130] According to Jung, the collective unconscious, unlike the private aspects of the unconscious, was a sphere of unconscious mythology whose symbols formed part of the common heritage of mankind, having a significance that was more than personal. Those symbols or archetypes were not ready-made images; the unconscious merely had a predisposition to fabricate certain types of imagery, there being particular lines of force along which the imagery would automatically arrange itself. Jung believed that the role of the artist was to present those symbols to mankind and thus facilitate a healing understanding of the human psyche. Understandably, the idea of the artist as the mouthpiece of the mytho-poetic character of the unconscious was particularly attractive to artists. However, Jung's ideas also appealed because, unlike the ideas of Freud, they argued

for the existence of subconscious images of universal significance. Jung's ideas received an important endorsement from Read who wrote: 'I think we must all admit, that the self not only has depths of darkness as yet unexplored and unchartered [sic], but even channels of communication with forces that are collective and archaic.'[131]

Zen Buddhism was clearly relevant to these ideas because it provided a method for tapping into the subconscious. Although, in that method, Zen brush painting and calligraphy may have borne superficial resemblances to the automatic writing techniques of Surrealism, there were in fact important differences. In the first place, the aim in Zen was not to be unreflective but rather to gain a level of concentration that succeeded in suppressing all extraneous thoughts. Those extraneous thoughts included thoughts about technique.[132] By contrast, it was the illogicalities and fixations revealed by insuppressible extraneous thoughts that were of interest in Surrealism. A second important area of difference was that the Zen-inspired imagery was derived from a trance-like state and not from dream: dream-induced imagery is revelatory of self – Jung believed that 'one dreams primarily, and even exclusively, about oneself and out of oneself'[133] – whereas Zen imagery consisted of archetypes or 'ideograms' with a more universal origin and significance. Many visual similarities can be found between the work of Zen-inspired tachiste artists, which may be due to its archetypal content. There was no theoretical reason why this should happen in surrealist imagery.

Although the precepts of Zen Buddhism differed in fundamental ways from Existentialism, there were some important parallels, which may explain why they were able to coexist as influences. One such was concerned with the grasping of essences. In the case of Zen, this was achieved, as we have seen, through clearing the mind of extraneous thoughts. That process had resonances in the existentialist idea of the 'phenomenological *epoché*' developed by Merlau-Ponty in his *Phenomenology of Perception*.[134] He argued that to understand man's place in the world, it was necessary first to understand perception, and that this could be achieved only by realizing that there was not an absolute distinction between the perceiving subject and the object perceived; perception was a matter of intention – man is able to project his intentions and his interpretations on what is physically before him and is not committed to any particular projection. As Warnock explains,[135] one can perceive only if there is something to perceive; but *what* one perceives is not identical with, nor limited to, what is there. The goal of the *epoché* was to transcend the given – to rid the mind of preconceptions about the reality or otherwise of objects in the world – in order to experience them directly as 'pure phenomena'. A further important similarity was their shared view of the universe as ultimately meaningless, in the sense of being incapable of rationalization. Barrett expressed this point as follows: 'The Oriental ... has

2.9 Alan Davie, *Blue Triangle Enters*, 1953, oil on masonite, 152.4 × 190.5 cm/60 × 75 in, Scottish National Gallery of Modern Art

accepted his existence within a universe that would appear to be meaningless, to the rational Western mind, and has lived with this meaninglessness. Hence the artistic form that seems natural to the Oriental is one that is just as formless or formal, as irrational, as life itself.'[136]

Alan Davie stood apart both from other Zen-inspired artists and from Tachistes generally in British art because his work often equivocated between spontaneous and unspontaneous motifs. This is demonstrated by his *Blue Triangle Enters* (1953) (Fig. 2.9) in which the triangle and oval were painted in with a different colour from their outline and acquired a symbolic significance from this fact, since it pointed to their being deliberative whereas the other marks appeared to be spontaneous. That significance was accentuated by the fact that they were also recognisable shapes. The basic shapes of geometry, such as the triangle, circle and square, are universal to all societies and symbolize various meanings within them. They therefore have a power – a mysterious potency of their own – which sets them apart in the painting from the other, less coherent imagery. By their inclusion, Davie was seeking

to signify their familiar but indefinable meanings. In later works he often included mandala circles and targets in an obvious and self-conscious reference to Zen as well as diamonds, crucifixes and even words.[137] The use of a recognizable word arguably took Davie outside the scope of painterly non-figuration, the category of Tachisme into which he fitted most easily.[138] It was certainly not a Zen-inspired aspect of his painting, since Zen is concerned with the expression of ideas that cannot be reduced to words. In an article on ideograms,[139] Richard Smith explained this as follows:

In Japan there is a school of progressive calligraphy that is not bound by the ideograms of everyday communication. They create ideograms through which they can express something outside the meanings of the conventional ideograms that have been in use for centuries. They create a language not for direct communication but to communicate by suggestion and inference their *"Weltanschauung"*.

In this context, the interest of tachiste artists in Zen Buddhism may be seen as a further instance of their rejection of the ideas of Logical Positivism, which argued that the propositions of philosophy were wholly linguistic in character.

An artist who was closer to the precepts of Zen painting than Davie in terms of technique was – and is – Denis Bowen (Fig. 2.10). Bowen explained[140] that he was attracted to Zen Buddhism because its painting came out of direct movement. He stated that his practice was to 'empty his mind' of thoughts through meditation, so that he became 'hyperconscious'; using unconventional materials, such as paint mixed with sand and household emulsions, he would build up an image from rapid strokes, splashes and drips; he found that the painting would resolve itself on the canvas and that no further alteration was necessary. Although the painting grew out of unpremeditated acts, nevertheless he believed that he had a predisposition towards certain types of imagery or archetypes.

Working as a radar technician during the war, Bowen had been based in a ship off Portsmouth. He recalls repeatedly having seen the search lights crossing and criss-crossing the dark sky above the horizon line of the harbour in a form of lop-sided grid. This grid or mesh of orthogonals became a recurrent image in his work, sometimes taking the form of a crucifix, as in the 'atomic crucifix' of the work illustrated in the catalogue to 'Metavisual, Tachiste, Abstract'.[141] Also inspired by this experience was the image of light glowing in darkness. It was from this that he developed an interest in atomic imagery which continues to preoccupy him. In the 1950s he created the 'volcanic effects'[142] typical of his work by allowing turpentine and oil to interact on the canvas in an uncontrolled experiment; the process of coming together chemically created evolutions of form relevant to ideas of movement through space. He would then give the works referential titles like *Material-isation* and *Form Through Action*.[143] However, although these paintings now

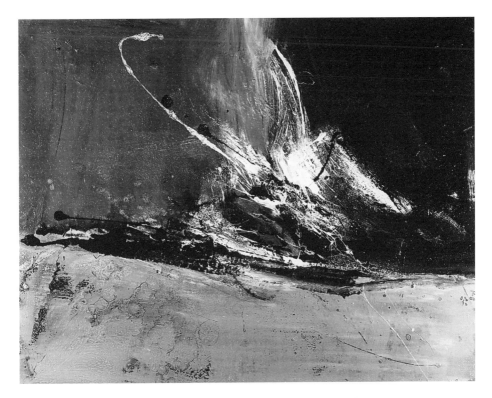

2.10 Denis Bowen, *Exploded Image*, 1959, oil on canvas, 41 × 56 cm / 16 × 22 in

resemble the stellar explosions caught on camera by the Hubble spacecraft, at the time the allusions were intuitive, drawn as much from science fiction[144] as from known images.

As we have seen, the tendency within Tachisme that was influenced by the ideas of Zen and Jung was not concerned with self-expression. The *tache* did not serve as a marker of the artist's being but as a signifier of the unknown or indefinable. The *tache* was an ideogram or ideograph: an image that combined act and idea; a form or shape that carried thoughts in-expressible in words. This meaning of the *tache* was contained within the notion of the 'metavisual' of 'Metavisual, Tachiste, Abstract'[145] – the exhibition chosen as the endpoint of this paper – which literally means 'beyond the visual' or 'visualizing the unknown'. In Zen-inspired art, a further reading of the *tache* was as the smallest particle of life – as the 'macrocosm in microcosm, the world in a grain of sand, the defeat of the anthropocentric'.[146] This reading was enhanced by the absence of scale already noted in tachiste paintings, which often gave the viewer the sensation of having an aerial view of the image on the canvas or of a magnified image.

Because of the ontological nature of art inspired by the ideas of Zen and Jung, it is, and always will be, hard to assess its quality. At one level its success may be judged by its ability to symbolize meanings for the viewer, who must first submit to its imagery as an act of faith. But at another level, it may be judged more objectively – like Action Painting, its more random counterpart – by its ability to create a memorable, and therefore coherent, image through the artist's use of colour, line, texture, form and rhythm. The finer paintings can be distinguished by the artist's æsthetic understanding of the interplay of these elements, as well as by an assurance of execution, that together transcend the chaotic nature of production. Whether British artists were inspired by the precepts of Zen, Jung or Existentialism, or by some of the other socially-determined reasons explored earlier, and despite the fact that many lyrically beautiful paintings were produced as a consequence of these stimuli, Tachisme is likely always to seem abstruse and self-indulgent to the world at large. It remains an art form that is most approachable at its most allusive and that is perhaps more compelling for the ideas underlying the paintings it describes than for the images they contain.

Notes

Abbreviations

AN&R: Art News & Review
NS&N: New Statesman & Nation
TGA: Tate Gallery Archive

1. French Tachisme, American Action Painting and Abstract Expressionism cannot be fully differentiated between because there were cross-currents between France and America and *vice versa*; between America and Britain and France and Britain. British Tachistes could buy *L'Art d'Aujourd'hui* and *Cimaise*, the latter especially containing frequent profiles of tachiste artists, from Tiranti's bookshop in Charlotte Street, London. French tachiste works were exhibited regularly in London from 1949.

2. William Barrett, *Irrational Man*, Connecticut: Greenwood Press, 1977, p. 7.

3. In 'Tachisme is only a word', *Architectural Design*, 26:8, 1956, p. 266.

4. The same is implied by Herbert Read's 'sepiacious ejaculation' in *Mathieu*, exh.cat., ICA, London, 1956, unpaginated.

5. In *De la révolte à la renaissance: au-delà du Tachisme* (Paris: Gallimard, [1963] 1972, p. 88) Mathieu explained that Pierre Guéguen first used the word at a conference on abstract art at Menton in 1951 before reaching a wider audience with 'Le bonimenteur de l'académie tachiste' (*Art d'Aujourd'hui*, 4:7, Oct–Nov 1953, pp. 52–3) which mocked the art critic Charles Estienne.

6. *Dimensions: British Abstract Art 1948–1957*, exh.cat., O'Hana Gallery, London, 1957, unpaginated.

7. See Pierre Guéguen in 'Matières et maîtrise', *Art d'Aujourd'hui*, 5:2 & 3, March–April 1954, p. 52: 'De la tache à la barbouille, au gribouillis, il n'y a qu'un pas, un mauvais pas que seul le talent empêche, car on entre précisément, par la tache, dans le jeu ténébreux de la matière.'

8. Thus René Drouin included the *matière* painters Fautrier, Wols and Dubuffet amongst his exemplars of Tachisme ('Tachisme is only a Word', 1956).

9. In *De la révolte à la renaissance*, 1972, p. 88 Mathieu claimed that he invented the phrase 'lyrical abstraction', to describe the works he selected for *L'Imaginaire* (Galerie du Luxembourg, 1947)

although the first recorded instance of its use was in Jean José Marchand's essay accompanying that exhibition. Too much importance may be attached to putative distinctions between Tachisme, lyrical abstraction and Tapié's *art autre*: the terms must be understood in the context of their creators' bids for supremacy as leading art critic of the day.

10. See Frances Morris, ed., *Paris Post War: Art and Existentialism 1945–55*, exh.cat., Tate Gallery, London, 1993, pp. 15–23.

11. Lawrence Alloway ed., *Nine Abstract Artists*, London: Tiranti, 1954, p. 4.

12. Ibid., pp. 3–4.

13. 'The difference between the process of abstraction and non-figuration is that the former takes nature as its starting point and reduces or distorts it to pictorial form whereas the latter is not seeking to make the paint stand for abstracted natural forms but merely for itself.' See Kenneth Martin, 'Abstract art', *Broadsheet No.1: Devoted to Abstract Art*, 1951 and Lawrence Alloway, 'The limits of abstract painting', *AN&R* 5:16, 5 September 1953, p. 5.

14. Attempts to characterize such art as figurative or non-figurative were increasingly seen as sterile by artists and critics alike. The painter-critic Patrick Heron put the dilemma thus: 'It is as though non-figuration were an ideal impossible of achievement: it is as though all forms become, willy-nilly, invested by the spectator with the property of symbols, or signs, or images which overlap with those of reality.' (*The Changing Forms of Art*, London: Routledge & Kegan Paul, 1955, p. xi). Similarly, Alloway argued that the 'quarrel between realism and non-figurative art is now academic' (*New Trends in Painting*, exh.cat., Arts Council, London, 1956, p. 2).

15. Davie first saw six examples of Jackson Pollock's work (although no drip paintings) in the Greek Pavilion (Peggy Guggenheim collection) at the 1948 Venice Biennale. Later that year he became friendly with Peggy Guggenheim and gained access to her large collection of Pollocks. However, Davie was already familiar with French Tachisme through William Gear.

16. The three flagship exhibitions were: 'London, Paris: New Trends in Painting and Sculpture' (ICA, 1950), 'L'Ecole de Paris 1900–1950' (Royal Academy of Arts, London, 1951), 'Young Painters of the Ecole de Paris' (Arts Council touring exhibition, 1952). The term *Ecole de Paris* was used indiscriminately to describe the work of many artists, whether French or not, resident in Paris. Michel Tapié's 'Opposing Forces' was an important attempt to identify a coherent trend within this school and to compare it with developments in America.

17. The latter exhibition visited Birmingham and Liverpool. De Staël's work was also shown in an eponymous touring exhibition (British Council for the Arts Council's Scottish Committee 1952; Edinburgh, Glasgow and Aberdeen). See also 'Nicolas de Staël (1914–55)', Whitechapel Art Gallery and 'Hommage à Nicolas de Staël', Arthur Tooth & Sons Ltd, both London 1956.

18. Hilton recalled 'the first time I saw de Staël I saw what painting was about' (Adrian Lewis, 'British avant-garde painting 1945–56 Part I', *Artscribe*, No. 34, 1985, p. 34). Heron visited the exhibition with Scott and Peter Lanyon: 'We thought he was a great painter immediately' (*Patrick Heron*, Arts Video Assocs, March 1980 quoted by Lewis, ibid. 'Part II' *Artscribe*, 35, 1985, p. 25). Gear was particularly impressed by the exhibition and urged Sir John Rothenstein, Director of the Tate, to purchase *Les Toits* (now Musée d'Art Moderne) (Richard Tilston, 'Aspects of abstract painting in England 1947–56' unpublished MA thesis, Courtauld Institute of Art, University of London, 1977, p. 7).

19. Reproduced in *Nicolas de Staël*, exh.cat., Galeries Nationales du Grand Palais, Paris, 1981, p. 42.

20. Scott's *The Harbour*, 1952 exhibited São Paulo Bienal 1953–4, closely resembles de Staël's *Composition*, 1950. The image could be read as a figure, still life or landscape (the harbour at Mousehole, Cornwall). Denys Sutton described the allusive qualities of de Staël's work: 'De Staël has established in these works his belief in a tangible world informed by light. He has created "views" that exist in the haze of the half light which occurs when reality and dream intermingle.' (*Nicolas de Staël*, exh.cat., Matthiesen Gallery, London, 1952, p. 4).

21. As in the case of *Les Toits*, which appeared simply as *Composition*, 1952 in ibid.

22. There are many examples of visual plundering of de Staël's work by British artists. Donald Hamilton-Fraser showed several works at Gimpel Fils, London, 1956 that resembled de Staël's later still lifes. Likewise, Gear's *The Footballers* (shown Gimpel Fils 1953) was inspired by eponymous canvases by de Staël (1952). Heron encouraged such practices; see 'At the Mayor Gallery', *NS&N*, 34:866, 11 October 1947, p. 288.

23. Gear knew many Ecole de Paris artists, exhibiting with them at the Salon des Réalités

Nouvelles (1948–50) and the Salon des Surindépendants (1948). He had a one-man show at the Galerie Arc-en-ciel (1948) and exhibited with Cobra in Amsterdam and Copenhagen (1949).

24. Hilton told Heron that 'it was not until 1950 that his first consistently abstract work was done; and that both Manessier and … Gear were at that point influencing him' (Patrick Heron, 'Introducing Roger Hilton', *Arts*, 31:8, NY, May 1957, p. 23 quoted in Adrian Lewis, *Roger Hilton: The Early Years 1911–1955*, exh.cat., Leicester Polytechnic Gallery, 1984, p. 4).

25. The fluid space of lyrical abstraction – as this type of Tachisme was usually called – was heavily indebted to Klee and Kandinsky. After Klee's death in 1940 he was shown at the Leicester Gallery 1941; at the Tate's huge retrospective at the National Gallery 1945 and the Arts Council's touring exhibition 'Klee 1879–1940' in 1946. In Paris Klee was exhibited alongside Kandinsky (d.1944) at the Galerie Berri Raspail 1944; both artists had comprehensive retrospectives in *Cahiers d'Art* 1945–6; Kandinsky had a further retrospective in Paris (Galerie Drouin 1946). *Uber das Geistige in der Kunst (Concerning the Spiritual in Art)* was published in English (New York, 1947) and in French (Paris, 1949).

26. Patrick Heron, *Space in Colour*, exh.cat., Hanover Gallery, London, 1953, unpaginated.

27. Ibid.

28. William Gear quoted in *William Gear: Paintings into Landscape, Paintings & Drawings 1976–82*, exh.cat., Spacex Gallery, Exeter, 1983, p. 3.

29. Hence the name *paysagisme abstrait* given to this type of lyrical abstraction.

30. Gear said: 'I don't want to draw nature, I want to draw in nature' – quoted by David Sylvester, *William Gear*, exh.cat., Gimpel Fils, 1948, unpaginated. Describing his painting in 1950 Gear said, 'It was generally described as "abstraction within landscape"' (conversation, William Gear and Malcolm Davies in *William Gear Paintings 1948–68*, exh.cat., Arts Council of Northern Ireland & Scottish Arts Council, 1969, p. 10).

31. Reproduced in Martin Caiger-Smith (ed.), *Roger Hilton*, exh.cat., South Bank Centre, London, 1994, unpaginated, plate 13.

32. *August 1953 (Red, Ochre, Black and White)* resembles more strikingly the work of Serge Poliakoff. His work was in *L'Ecole de Paris 1900–1950*, 1951.

33. *Nine Abstract Artists*, 1954, p. 30. Hilton may have been referring to the argument of Constant van Nieuwenhuys that modern architecture needed to be humanized by the positive introduction of plastic colour. Art was no longer to be confined to easel-painting but liberated to expand into real space *(For a Spatial Colourism*, 1953). Hilton knew Constant through Cobra (Lewis, *Roger Hilton: The Early Years*, 1984, p. 5).

34. Alloway quoted Hilton as saying of his work that 'ideally there should be a kind of anonymous presence' (*Nine Abstract Artists*, 1954, p. 10).

35. Ibid., p. 11.

36. Ibid.

37. *The Changing Forms of Art*, 1955, p. 199.

38. Ibid., p. 47.

39. Exhibited Hanover Gallery, London, in 1962.

40. *Nine Abstract Artists*, 1954, p. 11. Alloway was probably referring to Scott's work after the summer of 1953. However, the quotation can be applied equally to the gouaches, which contained no residual references to still lifes and tabletops.

41. Scott had been a guest lecturer at the summer school of the University of Alberta's Banff School of Fine Arts. Visiting New York on his return journey, Scott was introduced to Pollock, Rothko, Kline, de Kooning and Brooks. He said of the experience, 'My personal reaction was to discontinue my pursuit of abstract art and to try to put my earlier form of symbolic realism on a scale larger than an easel picture with a new freedom gained from my American visit' (*William Scott: Paintings, Drawings and Gouaches 1938–71*, exh.cat., Tate Gallery, London, 1972, p. 72).

42. Such as *Composition Fond Rouge*, 1951, illus. 50 in *Nicolas de Staël*, exh.cat., Galeries Nationales du Grand Palais, Paris and Tate Gallery, London, 1981.

43. However, Heron had already adopted the decorative qualities of the *tache* in *Boats and Iron Ladder*, 1947, a significant part of which was overlaid with dabs of pink paint, effectively *taches*, perhaps derived from Impressionism or Bonnard rather than recent developments in Paris.

Decorative pointilliste *taches* can also be found in the work of Victor Pasmore (*The Park*, 1947, illus.167, *British Art in the 20th Century*, exh.cat., Royal Academy, London, 1987).

44. Heron in *Statements: a Review of British Abstract Art in 1956*, exh.cat., ICA, London, 1957.

45. Soulages's work was shown at Gimpel Fils in April 1955. *Winter Harbour: 1955* is reproduced in Mel Gooding, *Patrick Heron*, London: Phaidon Press, 1994, p. 91.

46. The exhibition visited Cambridge: Arts Council Gallery, York: City Art Gallery, Liverpool: Walker Art Gallery and Newcastle: Hatton Gallery.

47. See Heron in *Statements*, 1957. Nevertheless, there is a strong link between the content of these paintings and his first impressions of the flowering shrubs of his garden at Eagles Nest, Zennor. He had bought the property in August 1955 but only moved in the following April.

48. Alloway accused Heron of turning Sam Francis into 'weather reports' ('English and international art' *European Art This Month*, 1, 1957, p. 25).

49. Alloway in *Abstract Impressionism*, exh.cat., Arts Council, 1958, unpaginated.

50. See Heron in *Statements*, 1957.

51. Other exemplars were, *inter alios*, Hans Hartung, Pierre Soulages, Henri Michaux, Woh-Ki Zao and Camile Bryen.

52. Alloway objected to the sloppy application of the description 'tachiste' to Mathieu in England and argued that he should be considered a 'linearist' (*AN&R*, 9:26, 8 January 1958, p. 4). Alloway had a point, although Mathieu's works were not all without *taches* strictly defined. However, I describe Mathieu as 'tachiste', since that was how he was generally perceived in England. The confusion indicates that for many artists Tachisme signified an attitude and a *process*, rather than formal appearance.

53. *De la révolte à la renaissance*, 1972, p. 107.

54. Davie's *Blue Triangle Enters*, 1953, is not dissimilar to Mathieu's *Pacte de St Jean d'Amaeli*, 1951, and Gear's *Composition*, 1948, in its broad brushstrokes, scribbles and blotches. The difference lies in the inclusion of outlined and painted-in shapes – the triangle and the oval – which seem to acquire a symbolic meaning by virtue of being so obviously deliberative.

55. It should be noted, however, that 'unpremeditated paroxysms' (Read, *Mathieu*, 1956) and Action Painting only occurred in Davie's early work.

56. Davie disclaims any knowledge of Mathieu's work before the 1970s (unpublished letter to Rose Dawson, 15 May 1996). The origins of both the French and American versions of Action Painting can be traced back to surrealist automatism, an interest in Existentialism and a revival of interest in oriental calligraphy fostered by visits to and from Japan and the reproduction of Zen brush drawings, notably in France in D. T. Suzuki, *Essais sur le Bouddhisme Zen*, 1, (trans. Pierre Sauvageot, Maisonneuve, Paris, 1940–6).

57. Hartung had a one-man exhibition at the Hanover Gallery in 1949; Hartung, Mathieu, Soulages and Woh-Ki Zao were in 'Young Painters of the Ecole de Paris', 1951; Mathieu and Michaux were in 'Opposing Forces', 1953 and Soulages had a one-man exhibition at Gimpel Fils, 1955.

58. Alex Seago, *Burning the Box of Beautiful Things: the Development of a Postmodern Sensibility*, Oxford University Press, 1995, p. 125.

59. For example Ralph Rumney and Denis Bowen. Rumney's *Self-Portrait*, 1957 consisting of blots rather than strokes, harks back to Gear's *Composition*, 1948. Rumney worked in Paris 1951–5 and had links with Cobra and the Italian tachiste Movimento Nucleare founded by Enrico Baj. The New Vision Centre Gallery opened in 1956 under the direction of tachiste artists Denis Bowen, Halima Nalecz and Frank Avray Wilson. It played an important rôle in giving minor and foreign tachiste painters one-man shows (Margaret Garlake, *New Vision 56–66*, exh.cat., Bede Gallery, Jarrow, 1984).

60. The tendency received an important boost from American Action Painting and Abstract Expressionism in 'Modern Art in the United States', (Tate Gallery, London, 1956).

61. Davie developed pictorial ideas successively from small monochromatic drawings, through improvisations in gouache, to large oils (Iain Roy, 'Portrait of the artist: Alan Davie at Gamels studio' in Michael Tucker, ed., *Alan Davie: The Quest for the Miraculous*, exh.cat., University of Brighton Gallery and Barbican Art Gallery, London, 1993, p. 72).

62. By the time he wrote the introduction to *Statements* (1957) and the catalogue to *Dimensions* (1957) Alloway's allegiance was less clear-cut. In the latter the distinction between the

geometric and painterly tendencies was presented as a matter of convenience and not absolute; painterly abstraction was also accorded far greater numerical significance in *Dimensions*.

63. There was little critical support for Tachisme until Modern Art in the United States (1956) when its international significance became obvious (see Margaret Garlake, 'The Relationship between Institutional Patronage and Abstract Art in Britain c.1945–56' unpublished PhD thesis, Courtauld Institute of Art, University of London, 1987, chapter 2).

64. See Margaret Garlake, 'Between Paris and New York: critical constructions of "Englishness" c.1945–60' in Malcolm Gee (ed.), *Art Criticism since 1900*, Manchester: Manchester University Press, 1993, pp. 180–195. Cold and warm abstraction in relation to French Tachisme are discussed by Elena Lledó, 'Post-war Abstractions: the Paradox of Nicolas de Staël' unpublished PhD thesis, Courtauld Institute of Art, University of London, 1995.

65. 'In art, the creative act is the important thing' (Gear, *Statements*, 1957).

66. 'Abstraction is nothing. It is only a step towards a new sort of figuration, that is, one which is more true' (Hilton in *Roger Hilton: Remarks about Painting*, exh.cat. Galerie Charles Lienhard A. G., Zurich, 1961, unpaginated); 'In the last resort a painter is a seeker of truth. Abstract art is the result of an attempt to make pictures more real, an attempt to come nearer to the essence of painting; the truth which makes it an art rather than a craft' (Hilton in *Nine Abstract Artists*, 1954, p. 30).

67. Hilton wished to make his paintings 'activate space' because, by articulating real space, they would be concerned with reality. This thinking was reflected in the Constructionists' preoccupation with the relief and in the vogue for collage. Robyn Denny's strikingly tachiste-looking mosaics (c.1955–6) may also be understood in this light. See also Read in *Mathieu* (1956): 'Each painting is *real*, and its reality is of and in itself without reference to exterior supports ... The reality of ... painting is destroyed by the clumsy insistence upon reference outside the painting.'

68. Tachiste work did have a temporal significance, although different time signatures could be ascribed to different idioms and artists: accretions of paint in richly-textured works functioned like geological strata, recording the duration of the creative process, while the 'quantum of mark' spray gun *taches* of John Latham reduced the gap between mind and matter to a *scintilla temporis*.

69. For example Scott, Gear, Davie. They all came from the Scottish painterly tradition and had never subscribed to the æsthetics of geometric abstraction.

70. Harold Rosenberg's explanation of the appeal of American Action Painting ('The American Action Painters' *Art News* 51:8, December 1952, p. 23) could be applied equally to the emergence of Tachisme: 'The gesture on the canvas was a gesture of liberation, from Value – political, aesthetic, moral.'

71. 'The Informal is not opposed to Form ... but to a sterilised and sterilising formalism' (Michel Tapié, *Opposing Forces*, 1953, unpaginated).

72. See Heron: 'There is still little more than a handful of British painters whose works we could confidently exhibit abroad' ('English and French in 1950' *NS&N*, 39:983, 7 January 1950, p. 9).

73. See Michel Tapié, *Un art autre*, Gabriel-Giraud, Paris, 1952, unpaginated: 'Cependant je crois qu'il y a quelque chose de vraiment nouveau, c'est la conscience qu'ont les gens de l'impossibilité de quelque nouvel <isme> que ce soit ... Nous savons maintenant, et même ceux qui ont la plus mauvaise conscience, qu'il n'est d'aventure qu'individuelle ... Dans la mesure où notre art est autre, s'élabore un nouveau protocole, un nouveau rituel qui n'est pas une amélioration d'anciens critères, mais qui est lui-même totalement autre, dans ses postulats comme dans ses échelles de valeurs.'

74. Exh.cat., New Vision Centre Gallery, London, 1956 (one page).

75. Such as the confining dogma of Charles Biederman's *Art as the Evolution of Visual Knowledge* (Alastair Grieve, 'Charles Biederman and the English Constructionists I & II', *The Burlington Magazine*, 124:954, September 1982, pp. 540–51 & 136:971, February 1984, pp. 67–76).

76. Tapié's *Un art autre*, 1952 was too confused to serve as a manifesto, although it was highly influential (Alloway, 'The Words', *AN&R*, 9:26, 18 January 1958, pp. 3–4).

77. *Nine Abstract Artists*, 1954, p. 9.

78. See Ralph Rumney's *The Change*, 1957, with Ripolin and gold leaf; dripping and decalcomania occur in Rumney's *City Figure*, 1957, (exhibited 'Metavisual, Tachiste, Abstract'). Denis Bowen

liked to mix sand with his paint – until he became aware of the damage it did to his brushes (interview, 27 May 1966).

79. Alloway, *New Trends in Painting*, 1956, p. 2.

80. See Michael Ayrton, 'Ben Nicholson', *The Spectator*, 6120, 12 October 1945, p. 335; Patrick Heron, 'New Sculpture', *New English Weekly*, 30:3, 31 October 1946, p. 28.

81. Although John Bratby's working class scenes painted straight from the tube come close.

82. Alastair Grieve, 'Constructivism after the Second World War' in Sandy Nairne & Nicholas Serota (eds), *British Sculpture in the Twentieth Century*, Whitechapel Art Gallery, London, 1981, p. 156.

83. See *Nine Abstract Artists*, 1954. Terry Frost's *Pink Painting*, 1953, where vestigial shapes like melon slices – a constructionist motif – are combined with thickly impasted *taches*, demonstrates this cross-over and suggests the influence of de Staël.

84. 'People tend to call any artist who distorts and uses geometric shapes "abstract"; or ... any painting which is representational realist' (John Berger, 'Definitions', *NS&N*, 44:1137, 20 December 1952, p. 752). Anthropocentric realism was equated with humanism.

85. Tilston, 'Aspects of Abstract Painting', 1977, appendix.

86. Graham Sutherland, 'Thoughts on Painting', *The Listener*, 46:1175, 6 September 1951, p. 376.

87. 'I think of my painting as a *source* of imagery, something that *generates* imagery rather than contains it' (Bryan Wynter, *Statements*, 1957).

88. Artists and critics were quick to see the visual similarities between the *tache* and nuclear mushrooms: 'This type of painting, which has been given the name of *Tachism* ... is the only face that the atomic age presents to the world – a face of blank despair, of shame and confusion' (Herbert Read, 'A Blot on the Scutcheon', *Encounter*, 6, 1 July 1955, p. 54). See also Denys Sutton in *Denis Bowen 1961 Paintings*, exh.cat., Drian Gallery, London, 1961. Ralph Rumney was associated with the Italian tachiste Movimento Nucleare, (see note 59) which cultivated links between the *tache* and nuclear imagery.

89. See Rosalind Krauss, 'Grids You Say' in *Grids: Format and Image in 20th Century Art*, exh.cat., The Pace Gallery, New York and The Akron Art Institute, Ohio, 1979.

90. First published in 1936. Ayer's treatise dismissed metaphysics because it was based on unverifiable intuitive knowledge and gave primacy instead to the concepts of rationalism, realism and empiricism. See also Robert Hewison, *In Anger: Culture in the Cold War 1945–60*, Weidenfeld & Nicolson, London, 1981, p. 43.

91. 'Modern art has discarded the traditional assumptions of rational form. The modern artist sees man not as a rational animal, in the sense handed down to the West by the Greeks, but as something else. Reality, too, reveals itself to the artist not as the Great Chain of Being, which the tradition of Western rationalism had declared intelligible down to its smallest link and in its totality, but as much more refractory: as opaque, dense, concrete, and in the end inexplicable. At the limits of reason one comes face to face with the meaningless; and the artist today shows us the absurd, the inexplicable, the meaningless in our daily life' (Barrett, *Irrational Man*, 1977, p. 56).

92. Ibid., p. 57.

93. *De la révolte à la renaissance*, 1972, p. 44, note.

94. The seminal philosophical texts were Sartre's *Being and Nothingness*, 1943, published in English 1957, and 'Existentialism and Humanism', lecture at the Club Maintenant, 1945, published in English 1948. His novel *Nausea* was published in English 1949. Merlau-Ponty's *The Structure of Behaviour*, 1938 and *Phenomenology of Perception*, 1945 were published in English 1963 and 1962 respectively.

95. David Mellor, 'Existentialism and post-war British art' in Morris, *Paris Post War*, 1993, p. 53.

96. *The Tiger's Eye*, 1:6, 15 December 1948, pp. 48–51. See below '*La pâte même des choses...*'

97. Tilston, 'Aspects of abstract painting', 1977, p. 15.

98. See Lewis,' British avant garde painting 1945–6 Part I', 1985, note 10.

99. P. 30.

100. See Alloway's bibliography in *New Trends In Painting*, 1956.

101. P. 6. By this he meant the Sartrian idea of *l'en-soi*.

102. *New Trends in Painting*, 1956, p. 4.

103. The ICA archive (TGA) reveals that Existentialism was a popular topic of discussion: the Lectures Sub-committee recommended that 'a rising star of Existentialism' be asked to lecture to the 'Young Group' in April 1952; Roger Nimier spoke on 11 February 1953 on 'Modern French literature', chaired by John Lehmann; a discussion was held in 1955 on *Waiting for Godot*; there were play readings of Sartre's *The Flies*, 25 November 1951 and Genet's *Les Bonnes*, 29–30 October 1952.

104. Interview, 27 May 1996.

105. Clement Greenberg suggested as much: 'What we have to do with here is not an historical mood that has simply seized on Existentialism to formulate or justify itself, but which has been gathering strength long before most of the people concerned had ever read Heidegger or Kierkegaard ... Whatever the affectations and philosophical sketchiness of Existentialism, it is æsthetically appropriate to our age ... What we have to do with here, I repeat, is not so much a philosophy as a mood' ('Art', *The Nation*, 163:2, 13 July 1946, p. 54).

106. Sartre quoted by Morris in *Paris Post War*, 1993, p. 18. I have been unable to trace the source of the quotation. However, Sartre's famous remarks about the nature of art in *Existentialism and Humanism* (1945; 1978, p. 49) post-dated the appearance of Action Painting.

107. 'The American Action Painters', 1952.

108. 'Opposing Forces' perhaps had less impact than 'Modern Art in the United States' because Existentialism was still largely unknown to British artists in 1953. By 1956 artists and critics were more sympathetic to Action Painting – illustrated by the efflorescence of Tachisme in 'Metavisual, Tachiste, Abstract'.

109. London, 1978, p. 49.

110. *Mathieu*, 1956.

111. This view of man's freedom was developed in Sartre's 'Existentialism and Humanism' (1945; 1978), to counteract the charge that Existentialism was essentially negative and irresponsible. However, Sartre subsequently repudiated that essay because he came to see that it was impossible for the true existentialist man to take responsibility for anyone's choices but his own (Mary Warnock, *Existentialism*, Oxford University Press, [1970], 1977, chapter 6).

112. 'At the Mayor Gallery', 1947.

113. Spoken by Hoederer in Sartre's *Les Main Sales*, Paris, 1948, p. 193.

114. Especially in the work of Dubuffet and Fautrier. The metaphor was sometimes supported by handprints and footprints in the paint.

115. Mellor, 'Existentialism and post-war British art', p. 55. He adduces in support of this proposition Read's famous references to Eliot's poetry in 'New aspects of British sculpture' (British Council, 1952) and Bernard Cohen's tachiste painting *The Wasteland*, which won second prize in the 1953 Slade summer competition.

116. See Merlau-Ponty: 'The pattern then must result from the colour, if we wish the world to be rendered in its thickness, for it is a mass without gaps, an arrangement of colours, across which the avoidance of perspective, the contours, the straight lines, the curves are established like lines of force, the frame of space is constituted by the vibrations' ('Cézanne's doubt', *Partisan Review*, 12:4, September-October 1946, p. 470).

117. 'The auguries of experience', 1948.

118. Barrett, *Irrational Man*, 1977, p. 56.

119. Alloway, *New Trends in Painting*, 1956, p. 3.

120. Exh.cat., New Vision Centre Gallery, 1956.

121. London: Routledge & Kegan Paul 1953 (trans. R. F. C. Hull) p. 60. The last quotation is taken from the foreword by D. T. Suzuki (p. 5).

122. London, Rider 1950.

123. Reviewing an exhibition of Yves Klein (*AN&R*, 9:12, 6 July 1957, p. 10), Rumney claimed that Klein, who had been in Japan, had 'brought back a more authentically Zen attitude to painting than anyone in London has been able to work up "reading two books about it".' In *Statements* (1957) Davie wrote: 'My discovery of Zen was quite accidental. I found a book on Archery and

was amazed at how close some of the ideas are to my own.' Davie also read C. Humphrey's *Buddhism* (Harmondsworth: Pelican 1951; see *Alan Davie*, exh.cat., Whitechapel Art Gallery, London, 1958, p. 7).

124. Suzuki, *Essays in Zen Buddhism*, 1950, p. 261.

125. See J. Roberts, 'Japanese influence on the Ecole de Paris, 1947–67' unpublished BA project, Courtauld Institute of Art, University of London, 1986. Pollock was introduced to oriental philosophy at High School (P. Ridley, 'The concept of the gesture in Abstract Expressionism', unpublished MA thesis, Courtauld Institute of Art, University of London, 1974, Section II, n.21). Sam Francis was introduced to oriental art and philosophy in Paris by Georges Duthuit (*Aftermath, France, 1945–54, New Images of Man*, exh.cat., Barbican Art Gallery, London, 1982, p. 132). Mark Tobey had visited Japan and China in 1934 and had worked with a Chinese artist to develop his calligraphic style. He had a one-man show at the ICA, London, in 1955 (*Mark Tobey*, exh.cat., ICA, 1955).

126. For example, Davie was amazed to discover how close Zen ideas were to his own. See note 123 above.

127. Tucker, *Alan Davie* 1993, p. 30. Davie spent a weekend with Pollock on his trip to New York in 1956. Pollock had virtually given up Action Painting, 'realising (as I did) that there was no future in throwing paint around a canvas – and there was so much which one could *NOT* do by working with an "idealess" freedom of this sort' (unpublished letter to Rose Dawson).

128. *Art as Understanding*, Routledge & Kegan Paul, London, 1963, p. 84.

129. Read played an important role in disseminating Jung's ideas in Britain; see 'Jung at mid-century' *The Hudson Review*, 4, 1951, pp. 259–68 and *Icon and Idea: the Function of Art in the Development of Human Consciousness*, Faber & Faber, London, 1955, p. 195.

130. Dr J. P. Hodin lectured on 'C. G. Jung and modern art', 18 February 1954; a lecture series in autumn 1954, 'Image, meaning and metaphor' included 'The analysis of language in modern philosophy' (Prof. A. J. Ayer, 14 October); 'Pre-linguistic communication' (Dr N. Tinberger, 4 November); 'Archetypal images' (Dr M. Fordham, 9 December).

131. *Icon and Idea*, 1955, p. 123.

132. Davie worked at speed to prevent the intrusion of extraneous thoughts – 'to overcome the tedious notions of the EGO' (unpublished letter to Rose Dawson).

133. Quoted in *Icon and Idea*, 1955, p. 120.

134. 1945. Merleau-Ponty's ideas were derived partly from Edmund Husserl, the German philosopher (Warnock, *Existentialism*, 1977, chapters 2 and 4).

135. Ibid., p. 76.

136. *Irrational Man*, 1977, p. 49.

137. As in *Yes* (1955; illus. *Alan Davie: The Quest for the Miraculous*, 1993, p. 28).

138. See also Robyn Denny's tachiste *ManMan* (1957; illus. *Metavisual, Tachiste, Abstract*, 1957) although here the lettering is much less distinct because Denny wished it to lose its autonomy of meaning and appear as a series of abstract strokes or drips.

139. *ARK*, 16, 1956.

140. Conversation, 27 May 1996.

141. The same work, *Image 1957*, was reproduced in his 1957 New Vision Centre Gallery catalogue. Reflecting on the presence of a structural grid in his work, Gear attributed the vertical accent to his unconscious memory of the imagery of the pit head machinery in a Fifeshire mining village (*William Gear: Paintings 1948–68*, p. 6).

142. The resemblances between the 'splotches' of paint and the flow of molten lava, charring, lava spray and white heat of a volcano erupting.

143. Both works were in 'Metavisual, Tachiste, Abstract'.

144. Rumney was also a self-confessed reader of science fiction. He reputedly counted *Astounding Science Fiction* as more essential reading than *Art and Society* ('Portrait of an artist', *AN&R*, 9:11, 22 June 1957, p. 3).

145. In his review of 'Metavisual, Tachiste, Abstract', Alloway referred to 'metavisual' as a 'pretentious coining' ('Westward the Bandwagons … ' *AN&R*, 9:7, 27 April 1957, p. 3). However, the invitation to 'Opposing Forces' (ICA, 1953) indicates that 'meta' was already a

popular prefix. The term 'metavisual' is to be distinguished from a 'meta image', caused by 'gazing in abandonment at some shining, luminous surface' so that 'time is hushed in a penetrative reverie, one's separation from the objective world [being] overcome' (Avray Wilson, *Art as Understanding*, 1963, p. 92).

146. Sylvester, 'The auguries of experience', 1948.

A measure of leaven: the early Gregory Fellowships at the University of Leeds

Marian Williams

Eric Gregory: a grand scheme

Peter Gregory perhaps played a larger part in the English art history of the past 40 years than any other man who was not an artist.

Philip Hendy, 1959[1]

Eric Craven Gregory, known always as Peter to his friends, was born in Scotland on 6 October 1887. He moved to Bradford early in life and was educated at Bradford Grammar School.[2] His friends and acquaintances recall an enlightened, quiet, but genial man who sought the company of writers and artists and went to great lengths to give them his discreet support. He began his long career with Percy Lund Humphries at the Bradford printing works and eventually chaired both the printing and publishing companies.[3] The high quality catalogue-monographs produced regularly by Lund Humphries from the mid-1940s,[4] often as a result of Gregory's friendship with artists like Moore, Hepworth and Nicholson played a valuable role in promoting and furthering understanding of modern British art, affirming his conviction that 'business and art can be combined'.[5] With his colleagues at the Institute of Contemporary Arts (ICA), of which he was a founder member and Honorary Treasurer, he was committed to establishing a centre to stimulate the production of experimental, progressive art in all disciplines and foster a receptive public for contemporary art.[6] As a collector, his patronage was of the most positive kind; he purchased the work of young, avant-garde artists before their reputations were made, not for their investment potential but because he wished to live surrounded by the work of living artists.[7]

In many ways the Gregory Fellowships can be seen as a consummation, or even formalization of Gregory's ideas. The Fellowships, a forerunner of the now familiar artist-in-residence schemes, gave young poets, sculptors, painters

and musicians security at a critical time in their careers and was almost certainly the first scheme of its kind in Britain. His wish that one of the Fellows should always be a poet perhaps indicates that literature was his first love.[8] Whilst not formally stated, it is clear from Gregory's interests and the selection process proposed, that the sculptors and painters would be identified with innovatory practice. He also proposed an architectural Fellowship though no architect was appointed, perhaps because the University did not have a department of architecture.

The Leeds location is fundamental. Like Herbert Read, Henry Moore and Barbara Hepworth, Gregory was one of a number of important Yorkshire expatriates, later dubbed the 'Yorkshire Mafia',[9] and he retained strong links with Leeds and the university nearest to his home town of Bradford. The Fellowships would not only 'drop a little æsthetic leaven into the technological and wholly materialistic dough of a typical university',[10] in Read's words, but enable Leeds to attract its share of talented artists to the north of England. In practice, the early Fellowships stimulated the movement of artists and ideas within and between three points of a notional triangle: firstly Leeds University, the College of Art and the Leeds community; secondly the ICA and London and finally St Ives and the Bath Academy of Art at Corsham Court.

The Committee on Gregory Fellowships in Art at Leeds University approved Gregory's proposals to set up the Fellowships on 30 June 1943.[11] Initially the scheme was to run for nine years starting in 1950, or sooner if Gregory could provide the necessary funds. It is perhaps surprising that such an optimistic scheme was proposed during the war, yet by 1943 the course of the war generated an air of cautious optimism. Education was already a primary constituent of planning for post-war reconstruction.[12] 1943 saw the publication of two contrasting texts: the Norwood Report, which recommended selectively divided secondary education through grammar, modern and technical schools,[13] and Read's *Education through Art*, which argued for education based on the psychological integration of æsthetic and intellectual experiences.[14] Read articulated Ruskin's criticism of an education system weighted towards 'logical activities' such as mathematics and science, at the expense of the creative,[15] a view which can perhaps be traced to his connections with the Leeds Art Club. The book includes a copy of Read's 1931 inaugural lecture at Edinburgh University, 'The Place of Art in a University'[16] in which he argued that

We cannot fully participate in modern consciousness unless we can learn to appreciate the significant art of our own day. Just because people have not learned in their youth the habit of enjoyment, they tend to approach contemporary art with closed minds ... they cannot share the artist's vision ... it seems to me that it is one of the primary functions of a university like this ... to send them out with open eyes and active sensibilities.[17]

Gregory and Read shared many interests and frequently worked together[18] but it is difficult to determine to what extent, if at all, Gregory was influenced by Read's ideas or how far their views overlapped. Read certainly attributed the conception of the Fellowships to Gregory: 'though the idea of this Foundation was entirely his own, he did discuss it with me on many occasions', he wrote after Gregory's death.[19] Gregory, the successful business-man, devised a pragmatic scheme to place young artists at the heart of university life and bring them into regular contact with students. The objectives of the Fellowships were presented with typical modesty:

(i) to bring our younger artists into close touch with the youth of the country so that they may influence it; and (ii) at the same time to keep artists in close touch with the needs of the community. At present there is too great a gap between art and society, and it is hoped that this scheme would constitute a small step towards closing it.[20]

The artists were to work near the University and be readily available to students and staff. Through their creative efforts, the Fellows would, Gregory hoped, 'reach and influence the life of the University, and through it radiate to the outside world, thus creating a response between the artist and the community'.[21]

Leeds before the Fellowships

Gregory, Read wrote, 'would have hesitated to give any formal expression to his ideals'. This reticence tends to steer today's observer towards Read's 'interpretation of his actions'.[22] It is almost certain that Leeds University, where the courses were mainly based on science, technology or sociology, was in need of 'æsthetic leaven'[23] but the degree to which this was so outside the University is less clear. There was a dichotomy in Read's view of Leeds. He applauded the fact that 'so many of our best artists'[24] hailed from Yorkshire but as late as 1964 constructed a bleak image of Leeds in the 1950s (rooted in his early life in the city) as a 'grimy inferno'[25] whose focus on industry and profit impoverished the æsthetic life of its 'unsophisticated industrial community'.[26]

 The context within which the Fellowships should be placed extends back to Michael Sadler's appointment as Vice-Chancellor of Leeds University in 1911. Sadler, a disciple of Ruskin, held views similar to those of Read and worked tirelessly to stimulate the arts within the University and the city. Works from his collection were hung in the University buildings, often with illuminating notes attached, whilst students, Read and Moore amongst them, visited his home to view his paintings.[27] Sadler's unrivalled collection of progressive modern art, which included work by Klee and Kandinsky, was

also readily accessible to members of the Leeds Arts Club which occasionally held meetings at his home.[28]

Read joined the Club in 1912, when Frank Rutter was the newly appointed President and Director of Leeds City Art Gallery.[29] Read and Jacob Kramer conducted a long-running debate about the nature of modernist art[30] while Rutter carried out experiments in non-representational painting 'to represent musical sound … and to correlate words with drawings representing nothing other than emotions' which, David Thistlewood maintained, profoundly influenced Read, who acknowledged Rutter as his mentor.[31] No evidence can be found to suggest that Gregory was a member of the Leeds Arts Club or its sister organization in Bradford,[32] although it is difficult to believe that a young man who, according to Moore, was already collecting art in 1923,[33] albeit not particularly adventurously, and moving within the *milieu* of Charles Rutherston, was unaware of these early critical moves to champion modernism in Leeds. It would seem then that Gregory's thinking in his formative years was not subject to the same influences as Read's. This is not to say they would have disagreed, but that they viewed the Leeds art scene from different perspectives.

The modernist cause waned in the 1920s and 1930s. The Leeds Arts Club closed in 1923. In the same year, Sadler left to take up the post of Master of University College, Oxford (1923–34) and on his departure gave over seventy works from his collection to the University.[34] Rutter was dismissed from his post at Leeds City Art Gallery in 1917,[35] but not before he had brought impressive modernist exhibitions to the city, including the 1913 Post-Impressionist exhibition. He also established the Leeds Art Collection Fund in 1913 in order to bypass obstructive officials and raise funds for the purchase of contemporary art. Moore and Hepworth had attended the Leeds College of Art before moving to London in 1921. Philip Hendy's enthusiasm for modern art revived interest when, as director of the City Art Galleries, he planned a joint exhibition of the work of Moore, Graham Sutherland and John Piper in 1938.[36] The war caused a postponement and change of venue, but the exhibition opened at Temple Newsam House in 1941. This, the largest exhibition of Moore's works to date, included five pieces loaned by Gregory.[37] The wording of Hendy's catalogue introduction[38] suggests that he anticipated a puzzled, even hostile response, such as the comment on the 'horrible Mongolian type of statuary debasing the human form',[39] yet 55,000 people attended the exhibition. Following Hendy's departure for the National Gallery in London in 1946, Ernest Musgrave undertook the reopening of Leeds City Art Gallery after its wartime closure, although in Leeds, as elsewhere, reconstruction naturally had a higher priority than the arts. In 1946, the Dartington Hall Trustees' report, *The Visual Arts*, found the provinces to be 'very badly served', both with arts facilities and collections, although Leeds was regarded as less bereft than some other municipal centres.[40]

A picture emerges of a small number of inspired individuals who promoted advanced practice in Leeds and unwittingly prepared the way for the Gregory Fellowships. It could be argued that the lesser-known contributors, like some Leeds Arts Club members, pursued their creative impulses because of, rather than in spite of, the commercialism that surrounded them. Nevertheless, there were long, barren periods. In 1951, when Martin Froy arrived, feelings about modern art were running high. Moore's *Reclining Figure* (1951) which had been prominently placed opposite the entrance to the South Bank site during the Festival of Britain, had recently been moved to the grounds of Temple Newsam House, engendering a bitter and long-running controversy during which it was daubed with paint.[41]

While the Slade Fine Art Professorships had established a precedent for instilling art into liberal education in the 1870s, no parallel existed in the civic or red-brick universities,[42] although Leeds University had a pioneer in Sadler. In establishing the Fellowships at Leeds, Gregory demonstrated his faith in the Fellows, the University and the region which was the birthplace of his friends Moore and Hepworth. If, as Benedict Read maintains, the Fellowships were 'seed corn',[43] Gregory was quietly confident that the ground was fertile. Gregory is often thought to have established the Fellowships solely to benefit the artists concerned, though if this were so, he could have chosen less troublesome and expensive options. His proposal suggests a wider view, at least at the outset, although to be successful the scheme needed to be couched in terms advantageous to the University community.

Read was highly distrustful of the potentially limiting and levelling influence of state patronage,[44] as was Eliot,[45] who was to be one of the advisors on the appointments to Fellowships, but it is not known whether Gregory shared their view. The Fellowship scheme was a highly selective, élitist form of patronage aimed at young avant-garde artists whose work was of an 'abstract tendency', the 'third group' of artists defined by Read in *Contemporary British Art*.[46] Its exponents had 'close affinities' with continental Europe and were 'possessed by some unconscious cohesive force ... driven to express a reaction against all that is organic and naturalistic'.[47] Most of the early Fellows had some connections with the ICA and/or the Bath Academy of Art and were, ironically, a group very unlikely to bridge the gap between art and the community. In Gregory's mind at least, there was a symbiosis between the ICA and the Fellowships: in 1952 he suggested to the University that an unspent provision in the Fellowship fund be transferred to the ICA, 'especially as it is largely through this organisation that Butler, M. Froy and John Heath-Stubbs have been brought to our notice as they have worked considerably within this body'.[48] Not surprisingly, the University was reluctant to agree and no action was taken.[49]

No applications were sought for the early posts. A formal committee, which included university academics, existed to approve the nominations, although full meetings were rarely held in the early years. In practice, decisions were taken by Gregory and his advisors, Read, Moore, T. S. Eliot and Bonamy Dobrée, Professor of English at Leeds University, since Gregory and his friends knew what they hoped to achieve 'and did not wish to be put in a position where their view of the purposes of the scheme and its standards might be compromised'.[50] In 1949, the Gregory Fellowships Committee rejected the Senate's recommendation that Maurice de Sausmarez, the University's first Lecturer in Fine Art, and the Professor of Music, join the Committee. Whilst de Sausmarez was a consistent supporter of the Fellowships,[51] Dobrée's assertion that he was a 'good Euston Road man' rather than a 'non-representational painter' probably explains why his participation was not sought.[52] The first six Fellows in sculpture and painting were drawn from a relatively small coterie of proven, if not widely known artists. Gregory and his friends identified possible Fellows amongst themselves, then opened discussions with the candidates. The informal discussions continued over a single meeting or series of meetings, often over dinner or lunch at Gregory's London flat.[53]

It is generally agreed that Gregory did not have substantial capital.[54] Nevertheless, he made £1,700 available to the University annually to fund the Fellowships for nine years.[55] The original proposal mentions an 'emolument of £400'[56] but correspondence shows that payments fluctuated between £400 and £600, depending on the status of individual artists. It was necessary to select very carefully if all disciplines were to be represented and quality maintained. Victor Pasmore, Patrick Heron, Bryan Wynter and Robert Adams were early suggestions alongside Reg Butler, although it was thought that Pasmore would command too high a salary and talks were suspended when it appeared that the proposed poet, Peter Russell, editor of the literary magazine *Nine*, might have required the Fellowship fund to support the magazine.[57] The Fellowships were open to women, though Read opposed the appointment of Kathleen Raine as the first poetry Fellow, preferring 'a man of some calibre', a view supported by the rest of the Committee despite Gregory's professed lack of gender bias.[58] Painters and sculptors were usually selected by Gregory, Read and Moore but in keeping with the scheme's wider aims, Dobrée, who was keenly interested in the visual arts, campaigned for Pasmore's appointment.[59]

To succeed, the scheme required the University's full co-operation and Gregory intended that the Fellows should be provided with suitable accommodation such as 'commodious work rooms and rooms for exhibitions'.[60] However, the practicalities of settling the painters and sculptors into the University presented enormous problems. Froy recalls that in 1951,

the newly established Fine Art Department consisted of one room. Another, containing an etching press, was added shortly afterwards.[61] Froy found a house in Headingley, some way from the University, which was adapted to provide a large ground-floor studio. 38, Moor Road subsequently became the home and workplace of a succession of Fellows.

Butler, appointed in 1950, spent little time in Leeds. At the beginning of his Fellowship he was working with forged iron, an extremely noisy practice which made it difficult to situate him near the University. His insistence on living near his workshop compounded the difficulty. Extensive and amusing correspondence records the lengths to which University officials went to resolve matters: the Planning Engineer 'investigated the noise nuisance … by hitting a dustbin lid with an axe in the position where the anvil would be'.[62] By May 1952, however, Butler was suffering from a slipped disc, which prevented him from working in forged iron: 'he will be working in what you call normal materials and for this reason the proposition is much simpler'.[63] The long-running saga perhaps demonstrates a conflict of interests, or even a shift in Gregory's objectives, as the scheme developed. Gregory was highly sensitive to Butler's wishes, writing in 1951, 'I know his psychology very well, as well as the psychology of other sculptors who work in the same way as he does' and he remained convinced that Butler 'would be an enormous influence in the University',[64] but his sympathy for the sculptor possibly outweighed his commitment to the wider objectives of the Fellowship scheme. Butler's Fellowship was extended to 1953, the year he won first prize in the international 'Unknown Political Prisoner' competition organized within the ICA.

The University's records illustrate a series of early practical problems. Some Fellows encountered financial difficulties, which Gregory usually resolved by agreeing to subsidize rent or arrange loans from the Fellowship fund.[65] It is also clear that the University bureaucrats often failed to understand the very different outlooks and needs of the artists.[66] There were, however, some fundamental flaws in the scheme itself. To maintain the independence of the Fellows and avoid excessive demands on their time, they were not officially attached to any department. Nor, it seems, did they have a clear understanding of their role. There were no induction procedures, each Fellow being left to integrate with the University community in his own way. Dobrée ensured that the poets were speedily assimilated into a well-established English Department, but the sculptors and painters fared less well. They were welcomed by de Sausmarez, but staff and students appeared to show little interest in contemporary art, perhaps because there was at the time no University Art Gallery. Consequently, exhibitions of Fellows' work were held in the University's Parkinson Building, which is far from ideal as a gallery space, and were poorly attended.[67] A crisis was

reached in November 1955, when Irene Manton, a Professor in the Botany Department, found Terry Frost in an extremely depressed state following his exhibition. She later recalled, 'He had been used to abuse of various kinds in London, where modern art is not always treated with respect, but he had never before been totally ignored'.[68] Manton immediately urged the Vice-Chancellor to call a Special Senate Meeting to review the scheme.

A briefing memorandum, prepared by de Sausmarez and circulated before the meeting in February 1956, summarized the initial difficulties experienced by the Fellows and recommended improvements.[69] It also acknowledged the same 'general malaise, a consequence partly of the bogey of the "examinable subject"',[70] which tended to dampen students' interest in topics outside their chosen syllabus, a situation which Read had decried in *Education through Art*. The barrier the Fellowships were designed to break down was proving very resistant. Nevertheless, the memorandum contained a comprehensive list of activities undertaken by Frost and Hubert Dalwood, which included addressing meetings, instructing amateur artists, exhibiting their work and welcoming students to their studios.

If progress, albeit slow, was being made internally, the reputations of the individual Fellows and, by association, the profile of the scheme and the University itself were growing rapidly outside, as de Sausmarez reported to the Senate: 'even if the Fellows had had no contact whatever with students, the scheme would have been justified; the very presence in the University of these creative artists indicated to the world the University's concern for the arts of our time.'[71] The Senate judged the Fellowship scheme a success, discussed a number of ways of ensuring that the Fellows were integrated into university life and agreed to recommend that the Fellowships be continued by the University after existing funds were exhausted.

In 1957 the Vice-Chancellor wrote to advise Gregory that the Council of the University was planning to fund one Fellowship, possibly increasing to two, when his funds ran out. Gregory consulted the Fellowships Committee, who were anxious for the scheme to continue but agreed that 'one Fellow would cut very little ice as it is the corporate body of three which is such a strong factor'.[72] Gregory was, however, prepared to fund one Fellowship for a further seven years if the University would finance the other two. His offer was accepted but no formal arrangements were made before his death in 1959. The University undertook the funding of all three Fellowships from 1959 until 1980 when financial constraints brought the wider scheme to an end[73] though one Fellowship, in sculpture, was resumed in 1990 with funding provided by the Henry Moore Foundation.

Both the University and the Fellows benefited greatly when, in the late 1950s, the Fine Art Department, headed by Quentin Bell, introduced a four-year degree course with substantial practical components. John Jones, Senior

Lecturer in Painting recalls that 'the involvement of the Gregory Fellows was a huge bonus on which the department came to rely'.[74] The later Fellows also generated interest in the arts among the wider university community but it is much more difficult to quantify the impact of the early Fellowships. Much depended on the personalities of individuals and their ability to draw on skills over and above those associated with their art. All contributed in some way, perhaps to the Art Club, student magazine or theatre group. Frost and Butler, despite his frequent absence, proved to be charismatic speakers. Dalwood had the advantage of being the first Fellow to work on campus. He welcomed casual visitors to his small studio and is remembered fondly for his commitment and enthusiasm. Jones 'saw being made sculptures that are now national treasures in the Tate Gallery, a public garden in Israel, Liverpool Cathedral, the Museum of Modern Art in New York'.[75] Frost introduced Manton to abstract art and she purchased her first abstract paintings from his exhibition.[76] Ronnie Duncan recalls her hanging abstract paintings 'alongside blown-up microscope photographs of the cells of plants' in the Botany Department, a move echoing Richard Hamilton's 'Growth and Form' exhibition at the ICA in 1951.[77] This coming together of art and science was perhaps a very early indicator that the wider objectives of the Fellowship scheme could be met.[78]

The first six fellows

The Gregory Fellowships provided financial security and stability at a critical point in an artist's career and the adequate but not substantial salary was a powerful incentive, as was the increasing kudos associated with the Fellowships. Nevertheless, Leeds was far from renowned as a centre of advanced practice in the early 1950s, notwithstanding some positive signals in the past, and the move north perhaps took courage.

The security of a Gregory Fellowship (1950–3) enabled Reg Butler, aged 37, to retire from his editorial post at the Architectural Press at a time when contemporary British sculpture, led by Moore, was beginning to be promoted avidly by the Arts Council and the British Council.[79] The prominence of sculpture in the late 1940s and early 1950s was confirmed by student numbers.[80] Butler's work was familiar to ICA members from at least 1950 when *Woman* (1949) was shown in 'London-Paris'.[81] In 1952 *Woman* was exhibited at the Venice Biennale alongside the work of seven other young sculptors, including Kenneth Armitage, an exhibition forever associated with Read's view of the innocent artist expressing a form of collective torment.[82] Of the six early Fellows, Butler spent least time in Leeds, partly because of the difficulties in settling him into suitable accommodation. The most valuable

aspects of his Fellowship were almost certainly the self-discovery, self-criticism and experimental working which followed from being able to concentrate fully on his work. In 'The creative island', one of six lectures given at the Slade in 1961 and based on his experience as a Gregory Fellow, Butler described this period as one of 'supported freedom', 'made possible by Peter Gregory's insight'.[83]

Most notably Butler's Fellowship allowed him to focus intently, over a period of 15 months, on his controversial winning entry for the 'Unknown Political Prisoner' competition in 1953.[84] An extensive series of drawings and a number of maquettes were worked through before Butler arrived at the final entry which brought him immediate international recognition and enhanced the profile of Gregory's scheme. In Britain, neither the competition nor Butler's entry was well received.[85] In 1953 the maquette looked unorthodox to those accustomed to sculpture as mass rather than line, and it was criticized by some for being too abstract and by others for resembling a television aerial or similar device.[86] Today it is difficult to classify the work as abstract. The watching figures ground it in the real world whilst the ambiguous rods, ladder-like structures and rectangular forms which make up the tower structure suggest a variety of oppressive possibilities, particularly given the intended size of the work at three to four hundred feet high.

In 1953, partly due to his back injury, Butler turned from welding to modelling in clay or plaster and casting his sculptures himself in a lightweight, thin shell of bronze. His range of imagery broadened considerably. The two nail-studded bronze objects called *Archaic Head* and *Circe Head* (Fig. 3.1) (both 1952–3) were produced soon after Freud's *Totem and Taboo* was re-published in a new translation. They can be linked to the renewed interest in 'primitive' imagery.[87] The skeletal *Woman* was superseded by closed, recognizably human figures, like *Girl* (1954), often erotically charged, sometimes in the direction of cruelty, the limbs appearing to strain against a rigid, mechanistic, internal framework whilst the feet are rooted to a slender platform of rods. Butler wrote of the advantages of working in privacy, of the 'creative accidents' which led him to discover new images, ways of working and materials.[88] The self-contained practice which he outlined contrasted strongly with the accessible artist envisaged in Gregory's proposal and suggests that Butler could have experienced difficulty in committing himself as fully to the University as Dalwood did.

Armitage is less certain about the benefits associated with his Fellowship (1953–5) and recalls considering carefully before accepting it.[89] He was settled at Corsham, where he had taught since 1946 (and built a small bronze foundry); he had a London gallery – Gimpel Fils – and, since the 1952 Venice Biennale, an international reputation. The move to a minute studio in Leeds, the city of his birth, held no surprises. The decision to break from teaching

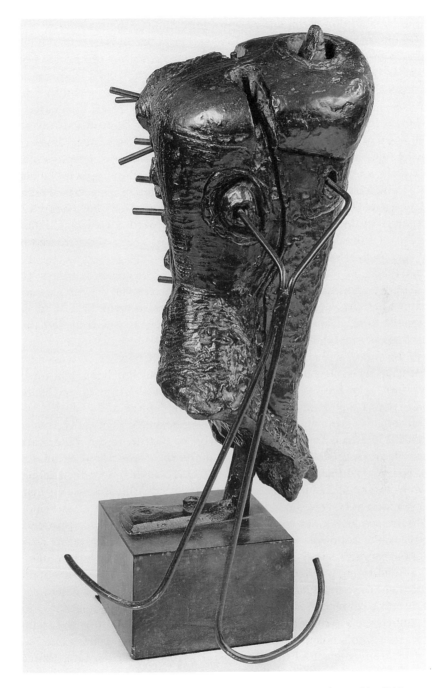

3.1 Reg Butler, *Circe Head*, 1952/3, bronze, 43 × 23.5 × 21.5 cm/17 × 9¼ × 8½ in, Tate Gallery

proved the deciding factor: 'my role would be different there, a known name in the city and people would come to me, and did'.[90] Armitage's assumption proved correct and it is possible that attention was focused on him precisely because there were so few advanced artists in the area.

Two Standing Women (1955) (Fig. 3.2) evinces a shift in his work during his Fellowship years. The two figures are joined at an angle which suggests an association with the often-referred-to folding screen which Armitage owned,[91] but the work is less frontal, more obviously three-dimensional than his earlier figures, such as *People in a Wind* (1950) and invites different viewing perspectives. Armitage and William Scott taught together at the Bath Academy for a number of years and the link between Armitage's square-shaped sculpted figures and such paintings as Scott's *Red Nude* (1956)[92] is inescapable. Haydn Griffiths has identified a source in the work of a French student at the Bath Academy, Marie Christine Treinen, which suggests that a translation of Dubuffet's images reached Corsham as early as 1950 and may have stimulated a parallel development in the work of both artists.[93]

There was a tendency in the 1950s to regard the work of the young British sculptors at the 1952 Venice Biennale as a cohesive force, particularly in terms of Read's 'iconography of despair', which has clouded alternative readings of Armitage's work and underplayed its strong element of wit.[94] With Armitage's own statements in mind, Alan Bowness wrote of the 'sensuality and affection' in his work and a 'warm, endearing quality',[95] a view supported by Norbert Lynton, who found an `affectionate irony' in the image of *Children Playing* (1953) which appeared `unposed' and 'everyday'.[96] He compared Armitage's work with Roger Mayne's photographs which revealed 'the true appearance of life without disturbing it'.[97] Like Butler, Armitage did not play a prominent role in the life of the University but used the time to experiment and consolidate his ideas. He did not regret accepting his Fellowship and recalls working intensely for the subsequent two years, having 'grown up professionally'.[98]

In 1955, Armitage was succeeded by Hubert Dalwood, one of his students from 1946 to 1949, who also sought to break from teaching.[99] Dalwood, the longest serving Fellow (1955–9) arrived in Leeds as the impact of the Fellowships was beginning to be felt within the University and the wider community. From 1955 to 1957 he moved from building clay figures, often with bulky torsos and thin limbs, to an unusually broad range of work including reliefs and non-figurative sculptures (Fig. 3.3). The shift was, Lynton argues, neither sudden nor conclusive and the patterned complexities and organic references within Dalwood's work at this time evolved in part from the richly textured surfaces of the earlier, constantly reworked clay figures.[100]

Lynton, who taught in the Leeds School of Architecture in the 1950s and knew Dalwood well, wrote of his 'altered attitude to sculpture'[101] which led

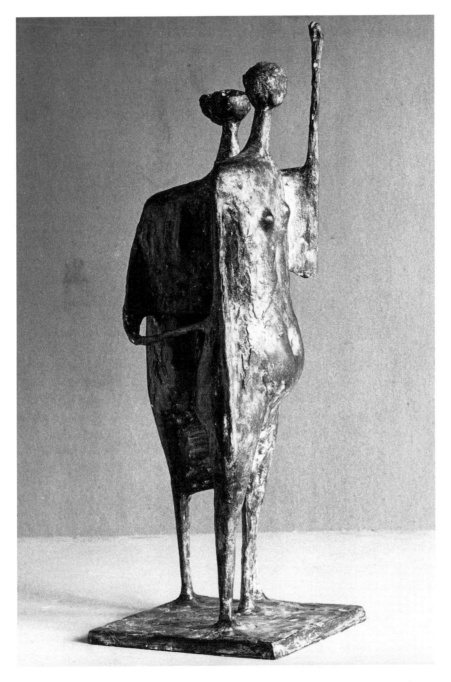

3.2 Kenneth Armitage, *Two Standing Women*, 1955, bronze 49.5 cm / 19½ in high

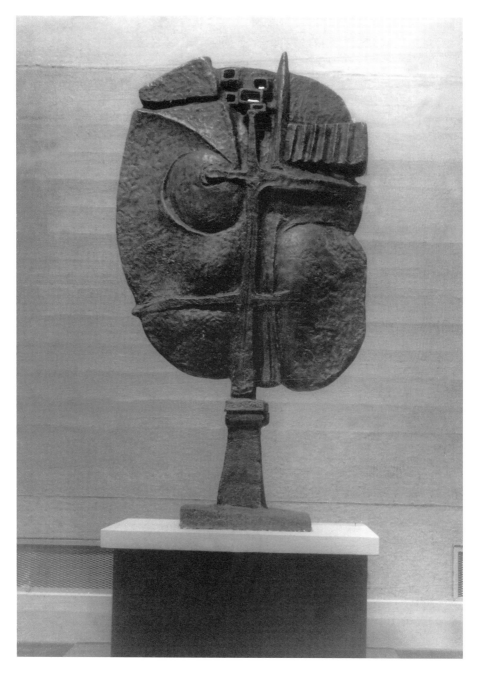

3.3 Hubert Dalwood, *Icon* 1958, aluminium 170.2 cm/67 in high, Leeds City Art Galleries

him to make largely abstract work whilst continuing to draw freely on sources from the visible world. This change came in part from working with Harry Thubron, Frost and Davie at the College of Art in an atmosphere of 'mutuality and a context of warm experimentation',[102] and also from contact with academics, including Tom Blackburn, the Gregory Fellow in Poetry (1956–7).[103] At the same time Dalwood was experimenting with alternative materials and in 1958–9, like Geoffrey Clarke, who worked at Coventry Cathedral, was one of the first sculptors to cast work in aluminium. Basil Spence, Visiting Professor of Architecture at Leeds University (1955–7) may have effected a link between the sculptors. In the spirit of co-operation encouraged by the Fellowships, staff of the Engineering Department built a tank in which Dalwood's casts were treated with acid to achieve their final colours.[104] A mural (1958–9), cast for the University, can be seen at Bodington Hall. As a Fellow, Dalwood's name is overshadowed by those of Butler and Armitage, yet of the six early Fellows, Dalwood's work appears to have flourished most as a result of his Fellowship, commensurate perhaps with his tenacity and commitment to Leeds. Nevertheless, Lynton considered that he breached the conventions of the advanced practice in the 1960s,[105] which may account for his relative neglect since his early death in 1976.

Martin Froy was the youngest of the early Fellows, moving to Leeds on Butler's suggestion immediately after studying at the Slade where Coldstream was one of his tutors. Recognized as a highly gifted and controversial student, his work was shown in the 'International Abstract Artists' exhibition at the Riverside Museum, New York in 1950. Gregory was Froy's first patron and he was anxious to appoint the young man with 'a touch of genius'[106] as the first Gregory Fellow in painting (1951–4). *Brown and White Head* (1950) painted while Froy was still at the Slade, stemmed in part from his interest in Klee and suggested a possible progression towards a form of process-dominant art: constructive abstraction or the current preoccupation with organic processes.[107] However, in Leeds his work moved in an unexpected direction.

Froy recalls the immediate impact made by the blackness of the city on his arrival and his reservations about his ability to fulfil the role of 'prophet in the wilderness'.[108] But a more gradual experience was the feeling of 'the north coming to me' which led him to the view that he should make art that people could understand and enjoy.[109] A similar search for a committed, yet uncompromisingly modern practice, underpinned a section of left-wing, internationally oriented thought in Leeds at the time, particularly that of the Gregory poets.[110] Some years later this thinking led Dalwood to produce his 'ritual objects' which originated in his desire to give sculpture a 'more direct relevance to people's lives'.[111] Dalwood later acknowledged his debt, in this context, to the poetry of Yeats and Tom Blackburn.[112]

The stimulus of the Leeds environment and the sense of isolation that it engendered from other advanced artists perhaps gave a new relevance to those paintings by Froy that can be associated with Coldstream's work. A series of paintings, developed from drawings, shows a girl seated in a room partially lit by a back window, in which the firmly placed figures and grid-like structure of markings can be related to Coldstream's nudes of the 1950s[113] (Fig. 3.4). The interrelated rectangles of colour create spatial ambiguities which contrast sharply with the delineated figure, infusing this most traditional of subjects with an energetic and self-conscious modernity. His Fellowship years were, Froy recalls, incredibly important to him. He left Leeds to teach at the Bath Academy and whilst continuing to paint and exhibit, pursued an academic career.

By 1954 Terry Frost's work had been selected for several group exhibitions, but unlike Armitage his reputation was not well-established, nor did he have a well-paid career to fall back on like Butler. The market for abstract art was limited and the financial security that his Fellowship (1954–7) provided was critical in enabling the break from teaching at the Bath Academy and in London.[114] After his settling-in problems were resolved Frost thrived in Leeds, through contact with his new environment and his connections with the College of Art.

In 1954 Frost was included in Lawrence Alloway's *Nine Abstract Artists*, a book which favoured geometric over expressive or gestural abstraction.[115] Frost's statement, however, which accompanied a reproduction of *Blue Movement* (1953), grounded his geometric shapes in his personal experience of St Ives harbour rather than any mathematical source.[116] By 1957, the year of the ICA's exhibition 'Statements. A Review of British Abstract Art in 1956', Alloway had come to see gestural abstraction as the dominant tendency,[117] whilst Frost's attachment to the external world had been strengthened, largely because the Yorkshire landscape had made such an impression on him.[118]

As David Lewis writes, 'a vocabulary utterly different' from that of St Ives is apparent in the Leeds paintings.[119] The sheer size and scale of features like Gordale Scar profoundly affected Frost.[120] In a draft of an undated letter to Alloway he described how his perspective in Leeds differed from that in St Ives: 'In those days I was a pretty important guy looking at nature. Now I feel space is a bloody big thing looking at titchy me.'[121] The association between Frost's experience of the landscape and his painting in Leeds is well documented.[122] Frost's notebook from around 1975 relates the rudimentary squares and rectangles in *Red, Black and White*, 1956 (Fig. 3.5) to having seen 'the white sun spinning on the top of a copse' on a bright, snowy day when walking with Herbert Read near Stonegrave.[123] The scale of the landscape was also translated in the large canvases Frost increasingly selected, often

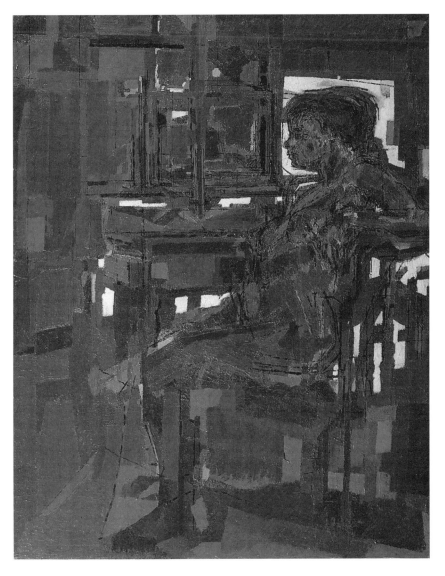

3.4 Martin Froy, *Seated Nude*, 1953, Tate Gallery

painted with near vertical bands, references to the expansive contours, rocks and stone walls of the Yorkshire Dales.

Frost became involved in a variety of activities in Leeds which required him to clarify his thoughts on paper, address various audiences and occasionally defend his work, exercises which enhanced his self-confidence. His increased confidence was perhaps one of the most valuable elements

3.5 Terry Frost, *Red, Black and White*, Leeds, 1956, oil on board 122 × 94 cm/48 × 37 in, private collection

Frost gained from his Fellowship years. In 1957 he returned to St Ives to paint full-time, at the end of a period Ronnie Duncan calls the 'fertile breathing space' that led `to the most productive phase of his whole career'.[124]

Davie's exhibition at the Catherine Viviano Gallery in New York in 1956 prefigured his success, but he too welcomed the financial and practical support of his Fellowship (late 1956–9).[125] He gave a number of lectures about his work in Leeds[126] and found some common ground linking science and art through his discussions with university academics.[127] His career

accelerated after his successful retrospective exhibition in 1958, which was shown first at Wakefield City Art Gallery by Helen Kapp and then by Bryan Robertson at the Whitechapel Art Gallery in London.[128]

Davie was one of the first British artists to encounter Pollock's work when he saw it at the time of the 1948 Venice Biennale. However, whilst the two artists shared some mutual interests and there is an affinity between the imagery of Pollock's pre-drip paintings and Davie's images of the late 1940s, Davie's work was not process-led.[129] The Whitechapel catalogue included a statement, infused with thoughts related to philosophy and Zen Buddhism, taken from a lecture that Davie gave at Leeds and the ICA, in which he sought to correct misconceptions about his work, particularly the application of the term 'Action Painting', which featured prominently in the Wakefield catalogue.[130] It became increasingly apparent from Davie's work of the mid-1950s that the term is a misnomer in his case since images such as the triangle in *Blue Triangle Enters* (1953) (Fig. 2.9) and the wheel in *Martyrdom of St Catherine* (1956) (Fig. 3.6) started to recur in his work. Such enigmatic

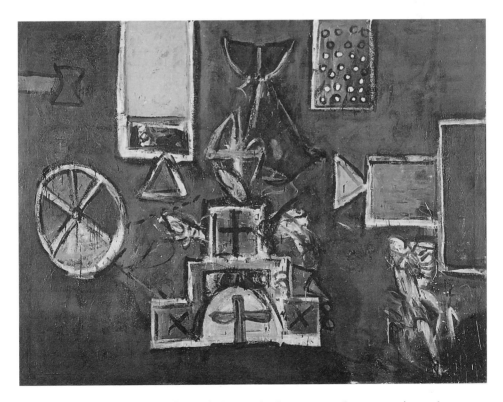

3.6 Alan Davie, *Martyrdom of St Catherine*, 1956, oil on canvas 183 × 244 cm/72 × 96 in, Astrup Fearnley Museet for Moderne Kunst, Oslo

'pointers and symbols' are to be perceived intuitively, not regarded as a form of expressive process or 'drama of the moment of creation'.[131] In parallel with the growing international reputation he gained during his Fellowship years, Davie increasingly asserted his own voice. The extracts from his lectures acted as powerfully corrective statements, critical in locating his work and establishing his individuality.

All the early Fellows clearly benefited substantially from their time in Leeds. All experienced a period of security and their own form of 'creative island', although none sought isolation, certainly not from the gallery system and its markets. The Fellowship years provided a breathing space, an opportunity to consolidate ideas or experiment and were usually followed by a period of intense creativity. Dalwood, Frost and Davie, all appointed after 1956, gained additional advantages through their relations with the College of Art.

'A continuous experience'

The less predictable effects of Gregory's scheme spread like ripples and advanced the promotion and understanding of progressive art practice outside the University. As a result of their Fellowships, Frost, Davie and Dalwood were in Leeds during a dynamic period in the College of Art's history and contributed to the development of the controversial and innovative Basic Course. Thus, as guest lecturers at Leeds College of Art, their sphere of influence greatly increased. All three found their time at the College to be the most stimulating and rewarding aspect of their educational activities in Leeds.[132]

Relations between the Fellows and the College of Art were formalized in 1956[133] when Eric Taylor, previously Head of the College's pioneering Design School,[134] became Principal and requested the University's permission for the Fellows to teach one day a week, for payment, at the College. University officials were understandably wary that such a commitment could compromise Gregory's objectives but gave their consent. The sessions supplemented the Fellows' income without severely impinging on their time and broke their pattern of solitary working.[135]

The Fellows were required to provide teaching support on the College's one-year foundation course, or Basic Course, taken by all students from every discipline within the Fine Art, Design, Architecture and Town Planning Departments with the intention of 'linking all departments … into a unified whole'.[136] Taylor recalls wishing to break down traditional barriers between the disciplines and prepare his students for employment in the modern world, so painting students worked with machine equipment and industrial designers engaged in creative drawing.[137] Taylor's thinking can be associated

with the College's respect for Ruskin's theories and his own interest in the Bauhaus experiment. He had been a visiting tutor at Camberwell School of Art and the Central School of Arts and Crafts and almost certainly had in mind William Johnstone's experiment with a Basic Design course.[138]

Richard Hamilton, who had previously taught at the Central School, brought his own introductory course to the Design School at Durham University, King's College, Newcastle in 1953, but the development of a Basic Course for all disciplines is generally associated with the two-week summer schools held at Scarborough between 1955 and 1957 and initiated by John Wood, an Education Officer in Yorkshire, in which Victor Pasmore, Harry Thubron, Tom Hudson and Wendy Pasmore took part. Two versions of the Basic Course, which ran in parallel, though with little contact between them, emerged from Scarborough: one at Durham University, introduced by Pasmore and Hamilton, and a second at Leeds College of Art, introduced by Thubron and Hudson.[139] Thubron taught briefly at the Joseph Rowntree Secondary School in Yorkshire in 1955 where he experimented with Basic Design derived from Paul Klee, which fed into the Scarborough courses.[140]

It seems that the Leeds course was less structured and placed a higher value on spontaneity and intuition than its counterpart at Newcastle, which focused on rationality and technological imagery.[141] Opinions differ concerning the extent to which a knowledge of Bauhaus principles informed either course: Pasmore believed that only Johnstone, Halliwell and possibly Hamilton had direct knowledge of the Bauhaus course, while John Wood considered that Thubron was also very well informed on it.[142] Nevertheless, evidence suggests that the connection, in theory at least, was strong at Leeds, particularly through Read, whose thinking is said to have influenced activities at the College[143] and who firmly supported Thubron and occasionally visited his classes.[144] Read was well-informed on German educational practices and in 1931 had discussed plans to create a modern art centre, modelled on the Bauhaus, in Edinburgh.[145] The multi-disciplinary nature of the Basic Course was a step towards realizing the ideas expressed in *Education through Art*[146] and an endorsement of process-dominant art. Thus, the Basic Course paralleled the interests of the ICA where Klee was regarded as a key figure.[147]

Those who participated in the Basic Course, including Lynton, Thistlewood and Lewis, recall a vibrant, liberating period of inventive and experimental teaching to which Frost, Davie and Dalwood contributed enthusiastically, at one stage simultaneously when their Fellowships overlapped.[148] John Jones recalls that Thubron's teaching was firstly 'loosely based on what was thought to be the work done at the Bauhaus' and, secondly, 'an approach which freed the artists from insensitive routine methods … which encouraged a sort of spontaneous and intuitive mark-making'.[149] Thubron was unwilling to associate his teaching with either the indirect precedent of Surrealism or the

current awareness of Abstract Expressionism, because his aim in encouraging his students to work in an unrestricted manner was to break with convention rather than to free the unconscious mind. No firmly established programme underpinned the course or even the individual sessions[150] and Thubron was firmly against formulating theories which could compromise the developmental nature of his teaching.[151] For this reason, Lynton argues, he had strong reservations about the ICA's 1959 exhibition, 'The Developing Process', of which only the title represented his views.[152]

With the support of the Fellows, Thubron subverted established teaching methods and undercut the accepted aim of making students concentrate on technical skills. This is not to say that conventional teaching was abandoned. Life drawing was retained, but students were sometimes required to draw the figure in movement as the model walked around the room.[153] Thubron's approach was perhaps most closely complemented by Davie who, Thistlewood recalls, urged students to draw the figure as badly as possible[154] in an attempt to free them from preconceived notions of 'correctness' or 'false concepts of Art based upon knowledge and cleverness'.[155]

Davie also referred to 'simple exercises' which formed an important part of the Basic Course. When the course was in its early stages, students were asked to make a mark from which they developed lines creating plane and volume. Such exercises derived from Klee, whose work and teaching had so deeply informed avant-garde practice. Davie's exercises 'in pure idea-less activity' were devised for a very different purpose. By covering sheets of paper with rapid, gestural marks, in a seemingly purposeless manner, the student's 'magical inner creative force' was encouraged to emerge.[156] The images were then retained or rejected as the students saw fit, an activity which presumably involved intuitive rather than reasoned decisions. Given Davie's declaration that his teaching was 'based on a philosophy of the irrational',[157] Taylor's imaginative request for his assistance on an 'experimental course in colour and form for Town Planning Students' indicates an indirect but resounding success for Gregory's scheme.[158]

Thubron's approach was that of an educationist committed to radically shaking-up art education and broadening the outlook of his students, many of whom were potential teachers. His drive to liberate students from the constraints of accepted practice often involved working methods which were 'just a hair's breadth from a muddle and chaos',[159] and necessitated striking a careful balance if process were not wholly to dominate image. The Fellows, as practising artists, played a valuable role in focusing attention on the work of art. Frost's and Dalwood's emphasis on observation and discovery through analysis perhaps provided a counterweight to Davie's expressive experimentation.

Frost's teaching sessions are something of a legend. His text in *The*

Developing Process fails to convey the excitement and wonder he generated by slowly taking the petals from a flower, laying them on a sheet of sunlit white paper and drawing attention to their colour and structure.[160] Students reproduced the colours, analysed their discords and harmonies and studied the effects of placing them in contrasting contexts.[161] Colour in natural objects was also studied through making constructions. On learning that Rippon Museum was to close, Frost recalls, Thubron brought to the College a large number of objects such as corals, stuffed birds and eggs from which individual colour selections were made.[162] Each student 'then built up on paper all the rhythms and colours, and then built up constructions based on the idea. Then we would have a whole room full of constructions which related to this analysis'.[163] Frost stresses that his own approach was empirical rather than academic. He encouraged students to develop an innate, perceptual and subjective understanding of colour whilst Gavin Stuart, a tutor familiar with colour theory, from whom Frost recalls learning a great deal, provided the technical knowledge.[164] This element of the Basic Course suggests a link with the interest in d'Arcy Wentworth Thompson's *On Growth and Form*, with which Thubron and Frost were familiar. Both were opposed to developing or placing too much emphasis on particular theories however, but broadened their ideas by drawing indiscriminately from such texts.[165]

Thubron's ideas were probably disseminated most speedily and widely at the various short summer and winter schools which were held throughout the country[166] and in which Dalwood and Frost, who normally taught colour elements, sometimes participated.[167] The schools were attended by people of all ages and professions but many were teachers who presumably went on to introduce elements of experimentation to their own practice. Bridget Riley attended one of Thubron's summer schools in Suffolk in 1959 before going on to teach the Basic Course at Loughborough College of Art.

It seems likely that all three Fellows experienced some cross-fertilization of ideas between their work and their teaching. Frost's designs for a canteen screen, for example, which were developed in 1956 whilst working on a project with architectural students, relate to his paintings of that time.[168] But Dalwood's approach seems particularly related to the realizations he reached while working in Leeds. When he came to the College, the Sculpture Department was run on narrowly academic lines[169] and Dalwood swiftly devised new methods which jolted students into seeing that sculpture could be inspired by any source, not only by traditional associations such as the figure or landscape. He recollects introducing students to sculpture by asking them to focus on everyday objects such as electric plugs and connectors, which 'could be the substance of a fantastic thing'.[170] Students were told 'use your imagination, surprise us'.[171] The resulting works were discussed both in terms of their formal properties and imaginative qualities. In a more

advanced exercise for second and third year students, two-dimensional images were translated into three-dimensional objects. Students selected an image from a magazine and, concentrating on the aspects of the image that they found interesting, explored its three-dimensional possibilities in drawings.[172] A clay maquette was then built, from which the final sculpture was developed.

It seems certain that Gregory would have fully supported Taylor's objective of bringing together young creative people who were training for a variety of careers although there is little evidence of Gregory's views on the activities at the College or the Fellows' participation in the development of the Basic Course.[173] Frost recalls that it was necessary for Thubron to persuade Gregory to agree to the extra teaching,[174] but this was probably because he did not wish the Fellows to be overburdened with teaching commitments. However, it is difficult to imagine that the letter to the Vice-Chancellor written in July 1957, which is possibly the closest Gregory ever came to expressing pride, referred only to the Fellows' activities in the University:

I saw Davie here the other day and I have seen Dalwood. They both seem well and flourishing at Leeds. I had a talk with Bryan Robertson the other day who is the head of the Whitechapel Art Gallery who are doing such wonderful work here in London and he tells me he has been up in Leeds and thinks the Fellows are doing … big work there. He rang me up specially to tell me so.[175]

Leeds and the Fellowships: 'an exciting and vibrant place'

Leeds became an exciting and vibrant place for the arts during the best part of a decade and not the least remarkable feature was the cross-fertilisation of activities and interests: academics, businessmen, critics and artists all coming together as a community to share in a ferment of creativity.

Ronnie Duncan, 1994[176]

Gregory's scheme cannot be given all the credit for the revitalization of the æsthetic climate in Leeds in the 1950s, but the presence of the Fellows stimulated some activities and contributed to others.[177] The community to which Duncan referred was a small, élite group whose passion for the arts was not widely shared in Leeds. It included a number of patrons who had mostly derived their capital from commerce and were keen to support contemporary artists. Bernard Gillinson, a local businessman, and his wife Rose were central figures.[178] Their home was the principal gathering point for academics, politicians and business people interested in the arts. The atmosphere was firmly left-wing and Dennis Healey and Hugh Gaitskill were regular visitors. The Fellows were always welcome and Dalwood remembered 'masses of marvellous food and drink, and the whole intellectual life of Leeds … it really was quite extraordinary'.[179]

The Gillinsons and their friends not only purchased from contemporary artists like Frost and Dalwood, but were committed to making their work available to a wider public.[180] In the late 1950s and early 1960s Bernard Gillinson arranged exhibitions in the canteen of his warehouse while Rose Gillinson was the inspiration behind the first Leeds Arts Fair in 1983, organized to put people in touch with local contemporary art. Stanley Burton, another generous benefactor, bought work by most of the Fellows but frequently donated his purchases, including Dalwood's *Open Square*, (Fig. 3.7) to the City Art Gallery.[181] He also assisted the University in the purchase of works by the Fellows, usually anonymously.[182]

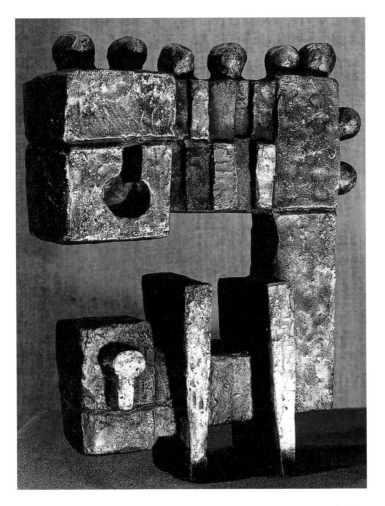

3.7 Hubert Dalwood, *Open Square*, 1959, aluminium 42 × 34.5 × 13 cm / 17¾ × 13 × 5 in, Leeds City Art Galleries

Contact with the Fellows' work awakened the interest of new collectors, sometimes with enduring consequences. Following her introduction to Terry Frost's work, Irene Manton continued to collect abstract art and established her important art and science collection, now housed at the University of Lancaster.[183] Ronnie Duncan, who purchased *Blood Creation* (1952) at Davie's 1958 exhibition in Wakefield, became a firm friend of Frost.[184] Through Frost he was drawn to the work of the St Ives artists, particularly Roger Hilton's, and his collection developed a further dimension.[185] Duncan recalls a 'buzz'[186] which travelled between Leeds and St Ives, where Gregory was a regular visitor – created largely by Frost's and subsequently Trevor Bell's presence.[187] Frost retained his links with Yorkshire, partly through his friendship with Duncan, and as recently as 1996 gave a talk and exhibited with other St Ives artists at the Hebden Bridge Arts Festival. In tandem with the increased interest in progressive art, the mid-1950s and early 1960s saw the advent of a few private, specialist galleries in the region. Peter Stead opened the courageous, but short-lived Symon Quinn Gallery in Huddersfield, which ran for around 18 months. It provided an important platform for innovatory artists at a time when few galleries were prepared to display their work. Hilton and Heath had one-man shows there in 1955 and 1956 respectively[188] and Frost's work was included in Stead's exhibition, 'Romantic Abstraction' in 1954. Sara Gilchrist was another substantial figure in the 1960s Leeds art scene. For a number of years passers-by were attracted to her Park Square Gallery, which provided frequently changing exhibitions of advanced work.[189]

The Fellows were often asked to address meetings or participate in activities which perhaps benefited them as much as the community. Frost and Dalwood were both invited to talk at the City Art Gallery and Frost recalls his extreme nervousness and naiveté in front of his audience, but also recollects the confidence he gained on realizing he 'had to take them on' and counter their scepticism.[190] In 1957 Read and Thubron persuaded Frost to design the curtains for a Molière play at the York Festival, a project which may have influenced the scale of his painting in Leeds. In a letter to Hilton he wrote, 'I've rather enjoyed working on such a big scale and am determined to do a couple of paintings that size.'[191] These valuable learning experiences were not confined to the artists. Jon Silkin, for example, gave readings at the College of Art[192] and wrote the catalogue introduction for the exhibition of Isaac Rosenberg's drawings and paintings at the University Art Gallery in 1959.[193]

Whilst some private individuals quickly appreciated the opportunities opened up by the Fellowships, public bodies were less responsive. An acquisitions fund existed at the University from 1954,[194] but little was done to secure works by the Fellows until Quentin Bell's purchasing policy was implemented in the 1960s.[195] In 1958 de Sausmarez had written to Butler,

Froy, Armitage and Dalwood asking them to consider selling works but his emphasis on the 'small sum' at his disposal and the tone of his letter made it unlikely he would secure favourable responses.[196] The City Art Gallery, under the Directorship of Ernest Musgrave until his death in 1957, acquired works by the Fellows through Stanley Burton's generosity, but many of the Councillors who administered the Gallery were at best apathetic and at worst hostile to advanced art. Similar views were shared by many outside the *milieu* of the Gillinsons.

Articles in *The Leeds Art Calendar*, traditionally edited by the Director of Art Galleries, are valuable indicators of current opinion. Musgrave's frustration is sometimes apparent: 'No-one is forced to look at the works of these young artists, but it is an injustice to oneself to ignore them', he wrote, after Dalwood's *The Swimmer* provoked controversy when exhibited in 1955.[197] In the same editorial Musgrave railed against the failure to decentralize the arts which had, he argued, led to contemporary British art being 'better known in other countries than in the north of England',[198] thus echoing Cumberlege's findings in 1946.[199] Musgrave's argument is clear: the dearth of opportunities to experience contemporary art leads to a lack of interest and understanding.

At least one early observer, Michael Compton, viewed the Fellowships in the light of current dissatisfactions and regarded 'Mr Gregory's desire for decentralisation of the arts' as one of their principal objectives.[200] Gregory's choice of Leeds as the venue for his scheme suggests that the Fellowships were in part intended to redress this imbalance, a view expressed by Moore in the early 1980s. Gregory's thinking was 'that all the good people left the provinces and came to London and so drained the provinces of talent, and he thought there should be a little bit of traffic the other way'.[201] Moore's long and close friendship with Gregory adds weight to his view.[202]

In 1958 de Sausmarez left the University and was replaced by Quentin Bell, who shortly afterwards became Professor of Fine Art. That same year Robert Rowe, the new Director of Galleries, arrived in Leeds inspired by the city's past support for modern art. Four legendary factors drew him to Leeds: the Golden Age of Sadler and his legacy to the city, the war-time exhibitions at Temple Newsam House, *The Leeds Art Calendar* and the Leeds Art Collection Fund. Nevertheless, he perceived that 'Leeds citizens as a whole were more prejudiced against "modern art" than their opposite numbers in Manchester or Birmingham',[203] so that the promotion of con-temporary art became an imperative. Bell, Rowe and Eric Taylor soon formed a powerful and persuasive triumvirate by ensuring that each was co-opted onto the committees and boards of their colleagues' organizations.[204] All recognized the value of the Fellowships to the University, City Gallery, College

and people of Leeds and were determined to derive the maximum benefit from the scheme.

Soon after their appointments, Rowe and Bell discussed proposals for a comprehensive retrospective exhibition of the Fellows' work to be held at the City Art Gallery. Gregory readily consented. Rowe recalls the enthusiastic discussions that he held with him and the long-term plans that they made.[205] They agreed that the retrospective exhibition, to be held in 1960, would be an inaugural event, to be followed by individual or joint exhibitions of every Fellow's work, as a matter of right, during the residency. The objectives were clear. The Gallery's role was to exhibit the work of Fellows chosen by Gregory and the University for 'critical appraisal'.[206] It was, Rowe wrote, 'fair do's for the artists, an advertisement for university prowess and a duty, enthusiastically undertaken, for the gallery.'[207] Rowe believes it was also implicit in the discussions that the exhibitions provided an opportunity for the Gallery to purchase a work by each of the Fellows.[208]

In February 1959 Gregory died suddenly in Lagos at the age of 71. Sadly, plans were readjusted and the retrospective exhibition became the 'Gregory Memorial Exhibition' which opened at Leeds City Art Gallery in March 1960. The two-part exhibition included pieces from Gregory's own collection and a comprehensive selection of work by the early Fellows.[209] Determined to carry out the arrangements made with Gregory, Rowe's 1962 exhibition of Trevor Bell's and Austin Wright's work opened the series of joint shows which ran until 1975. In accordance with Gregory's and Rowe's plans, the Fellows were largely responsible for their own exhibitions. They were given technical assistance but arranged and hung their works themselves. Wright had the additional honour of setting up his exhibition in the newly opened sculpture galleries.[210]

The wording of the 1962 catalogue introduction provides a clue to Rowe's success. The mention of giving 'civic recognition to academic enlightenment' perhaps appealed to those councillors who were reticent about contemporary art. Two of the legendary factors that attracted Rowe to Leeds proved invaluable in furthering the modernist cause. Firstly, the rather tired *Leeds Art Calendar* was rejuvenated and could on occasion 'be seasoned with a little propaganda'.[211] Items and articles about the Fellows were frequently included. Secondly, the perennial problems associated with buying advanced work with public money were largely overcome by making potentially controversial purchases through the Leeds Art Collection Fund. A number of works by the Fellows were acquired in this way. In the 1960s the City Fathers voted to allocate funds to commission one of the Fellows to produce a low-relief sculpture for the south facade of the City Art Gallery, though the scheme was abandoned because of the rebuilding of the Gallery.[212] In Rowe's view, this significant decision demonstrated the acceptance of the Fellows

locally. A further initiative was the introduction of a picture-lending scheme which contained a number of Ganymed prints. This proved extremely popular and continues today.[213]

From the mid-1950s the activities of some dedicated private individuals ensured that the Fellows played an active role in the æsthetic life of the Leeds community. Towards the end of the decade the potential of Gregory's scheme was more fully realized through the support of the Bell, Rowe and Taylor triumvirate. The 'gap between art and society' which Gregory sought to close still existed, but effective steps had been taken to provide opportunities for narrowing it. As a result of the Fellowships, 'one corner of the national society', the University of Leeds, had bridged 'the gap between the artist and the public'.[214] Yet while the situation may well have been positive from the outset in the English Department, the staff of the University did not take full advantage of the early Fellows in sculpture and painting. Few had Irene Manton's vision and willingness to encourage students to develop interests outside their chosen academic disciplines. However, by 1958 the situation had improved and the arrival of Quentin Bell and the expansion of the Fine Art Department in the 1960s drew the Fellows in sculpture and painting further into the life of the University.

The optimism that Taylor felt about the young designers, architects and town planners whose services were so essential in the 1950s and 1960s, echoed the faith that Gregory placed in the young artist's ability to unite society when, in 1943, he looked towards post-war reconstruction and drew up his Fellowship proposal. Taylor's reorganization of the college programme did bring students of different disciplines together and stimulate a cross-fertilization of ideas, principally during their foundation year. Frost worked on practical projects with students from all departments and recalls architectural students bringing him their models to discuss their ideas.[215] The students were receptive and enjoyed the challenge but Thubron's unorthodox approach proved unacceptable to many of the professional designers and architects on the staff. As a result 'we of course, didn't get integrated and became the Enemy', Frost wrote, recalling his time at the College.[216] Taylor's ideals were not fully realized but the Basic Course, which the Fellows helped to develop and disseminate, was to have a profound impact on art education as it spread, in its various forms, throughout the country in the late 1950s. The students certainly benefited from their contact with the Fellows and in this respect Gregory's scheme was instrumental in shaping progressive artists for the future.

The gap between advanced art and its public was disproportionately large in the regions during the post-war period. The Fellowship scheme brought progressive art within reach of the people of Leeds and those who shared Gregory's conviction that business and art could be mutually beneficial

followed his example and supported the Fellows. Their activities were tinged with a philanthropic zeal which can be linked to the strong socialist tradition in Leeds, a tradition which would have been very familiar to Gregory. Equally important, Gregory's focus on the city engendered pride and energy in individuals within the University, College of Art and City Council in the late 1950s, essential factors in ensuring that the Fellows' work was promoted, purchased and displayed. As opportunities opened up for the community to respond to the Fellows' work and their influence did 'radiate to the outside world' beyond the University, the wider objectives of the Gregory Fellowship scheme were achieved.

Notes

Abbreviations

NAEA: The Lawrence Batley Centre for the National Arts Education Archive (Trust) Bretton Hall
TGA: Tate Gallery Archive
ULA: University of Leeds Archive

1. Philip Hendy, obituary, *The Times*, 19 February 1959. The recurrence of the words 'unobtrusively', 'modesty' and 'discretion' in his obituaries emphasizes the difficulty of uncovering many of his actions: 'Much of the good work he has done for the arts is of the kind that leaves no trace of his intervention' (Robert Melville, 'E. C. Gregory', *The Architectural Review*, 125:747, April 1959, p. 229).

2. Dorothy Morland, Director of the ICA in the 1950s knew Gregory for twenty years and recalls that he never mentioned family connections (conversation, 7 April 1997).

3. Lund Humphries Publishers was not set up as a subsidiary company until 1969 and in the 1950s and before that had simply been a department of the printing company' (John Taylor, memo. to Lara Speicher, 24 March 1997).

4. 'Gregory arranged the credit necessary to facilitate the printing of Herbert Read's *Henry Moore Sculptor: An Appreciation* (1934) the first book about his work' (Roger Berthoud, *The Life of Henry Moore*, Faber & Faber, London, 1987, p. 128). Later books included the *catalogue raisonné* of Moore's work; *Ben Nicholson: Paintings, Reliefs, Drawings* (1948), *Paul Nash as Artist* (1948), *Barbara Hepworth, Carvings and Drawings* (1952). The company printed many catalogues for ICA exhibitions, some at reduced rates (minutes of ICA Exhibition Committee, 5 October 1950, TGA). In 1947, the company, with *The New Statesman*, founded Ganymed Press and produced hand-finished collotype prints which were widely disseminated from 1949 (*Ganymed, Printing, Publishing, Design*, exh.cat., Victoria & Albert Museum, London, 1980).

5. Statement in *17 Collectors: an Exhibition of Paintings and Sculpture from the Private Collections of Members of the Executive Committee of the Contemporary Art Society*, exh.cat., Contemporary Art Society, London, 1952, unpaginated.

6. Gregory provided dedicated support to the ICA but did not take a primary role in deciding policy. He regularly sought to raise funds and gave money to the ICA: £1,500 in 1951 towards the refurbishment of the Dover Street premises (minutes of AGM of Advisory Council, 20 June 1951, TGA) and lent at least £500 in 1952 (minutes of Management Committee, 29 October 1952, ibid.). Dorothy Morland recalls Gregory as a very 'benign' treasurer who kept the ICA going through difficult financial times (conversation, 7 April 1997).

7. Initially Gregory collected the work of established artists but [he was] 'at seventy, buying pictures and sculpture which some would call extreme *avant-garde'* (Henry Moore, Introduction, *A Selected Exhibition from the Collection of the Late EC Gregory*, exh.cat., ICA, London, 1959). He often bought in order to support the artist, so the collection had a 'certain unevenness' (ibid.)

8. Much of Gregory's estate was bequeathed to the Society of Authors. The Eric Gregory Trust Fund Awards are still made annually 'for the encouragement of young poets'.

9. 'A conversation between Patrick Heron and Benedict Read' in Benedict Read & David Thistlewood eds, *Herbert Read, A British Vision of World Art*, exh.cat., Leeds City Art Galleries in association with The Henry Moore Foundation & Lund Humphries, 1993, p. 143.

10. Herbert Read, Introduction, *Gregory Memorial Exhibition*, exh.cat., Leeds City Art Galleries, 1960, p. 6.

11. Minutes of Senate, 30 June 1943 (ULA).

12. Paul Addison, *Now the War is Over, A Social History of Britain 1945–51*, London: Pimlico, 1995, pp. 11 & 140.

13. 'The Norwood Report fitted admirably with the preconceptions of the men from the Ministry and was at once adopted as official doctrine. The change of government in 1945 made no difference' (ibid. p. 146).

14. London: Faber & Faber, 1943.

15. Ibid., p. 168.

16. Ibid., Appendix E, chapter 7.

17. Ibid., p. 263.

18. No evidence could be found to show when Gregory and Read first met. Benedict Read suggests they may have met in 1934 when working on *Henry Moore Sculptor* (conversation, 17 April 1997).

19. Read in *Gregory Memorial Exhibition*, 1960, p. 6.

20. Minutes of Senate, 30 June 1943 (ULA).

21. Ibid.

22. Read in *Gregory Memorial Exhibition*, 1960, p. 5.

23. Ibid. p. 6. The new and civic universities, proliferating in industrial and commercial centres, were geared towards serving the demands of an expanding middle class for training (Hilary Diaper, 'The new spirit' in *The New Spirit, Patrons, Artists and the University of Leeds in the Twentieth Century*, exh.cat., University Gallery, University of Leeds, 1986, p. 3).

24. Read in *Gregory Memorial Exhibition*, 1960, p. 7.

25. Introduction, *Gregory Fellows*, exh.cat. University Gallery, University of Leeds, 1964, unpaginated. See also Read, *The Contrary Experience*, London: Secker, 1973, p. 200.

26. Read in *Gregory Memorial Exhibition*, 1960, p. 6.

27. W. T. Oliver, 'Sadler as Art Collector' in *Michael Sadler*, exh.cat., University Gallery, University of Leeds, 1989, p. 17.

28. Sadler's son translated Kandinsky's *Uber das Geistige in der Kunst*. Sadler's collection was frequently used to illustrate talks at the Arts Club (Michael Paraskos, 'Herbert Read and Leeds' in Read & Thistlewood, *Herbert Read, a British Vision*, 1993, p. 31).

29. Founded in 1903, Leeds Arts Club drew its members from the new middle class. Whilst the Club remained firmly left-wing, Rutter and Sadler steered members' interests towards a recognizably modernist discourse (ibid., pp. 27 & 28).

30. See Tom Steele, *Alfred Orage and the Leeds Arts Club*, Aldershot: Scolar Press, 1990, p. 207. This contact gave Read the opportunity to hone his theoretical arguments with a practising artist (Tom Steele, conversation, 17 May 1997).

31. David Thistlewood, 'Expression and design: the Leeds Arts Club debate on the æsthetics of modernism 1911–22' in *Michael Sadler*, 1989, p. 24.

32. Tom Steele, conversation, 17 May 1997. Letter from Janet Axten, 25 May 1997.

33. Henry Moore, Introduction, *The Collection of the Late EC Gregory*, 1959.

34. Sadler's gift 'proved to be the starting point for what has become the main strength of the University's Art Collection: its holding of English modernism' (Hilary Diaper, 'The University of Leeds art collection and gallery: a short history' in *The University of Leeds Art Collection and Gallery: a Short History*, University Gallery, University of Leeds, 1995, p. 1). The collection was enhanced by Gregory's bequest.

35. Ostensibly for purchasing a work by Pissarro, but more likely for his connections with the suffragette Lilian Lenton (Steele, *Alfred Orage*, 1990, p. 196).

36. Under Hendy's direction, Leeds City Art Gallery purchased Moore's *Reclining Figure* (1929) in 1941. When Gregory persuaded Ernest Musgrave to purchase Moore's elmwood *Reclining Figure* (1936) for Wakefield City Art Gallery in 1942, Gregory raised some of the funds.

37. *Seated Girl* (1930), *Figure* (1939), *Drawings for Sculpture* (1938), *Designs for Sculpture* (1938) and *Figures in Setting* (1940).

38. 'All the true artists of the last two or three generations have made drastic simplifications, and the first effort required to understand their work is the effort *not* to expect an exhibition of complicated skill which rivals the camera' (Philip Hendy, *Moore, Piper and Sutherland*, exh.cat., Temple Newsam House, Leeds, 1941, unpaginated).

39. *Harrogate Advertiser*, 24 January 1942, quoted in Berthoud, *Henry Moore*, 1987, p. 179.

40. Geoffrey Cumberlege, *The Arts Enquiry: the Visual Arts, a Report Sponsored by the Dartington Hall Trustees*, London, New York, Toronto: Oxford University Press, 1946, pp. 124 & 128.

41. The Arts Council lent it to Leeds City Art Gallery for five years. A prominent topic of conversation when Froy arrived in Leeds was the 'appalling iniquity' of the siting of the sculpture (conversation, 8 May 1997).

42. Diaper, 'The New Spirit', 1986, p. 3.

43. Conversation, 17 April 1997.

44. See 'The fate of modern painting' in Herbert Read, *The Philosophy of Modern Art*, London: Faber & Faber, 1952.

45. Andrew Sinclair, *Arts and Cultures, the History of the 50 Years of the Arts Council of Great Britain*, London: Sinclair-Stevenson, 1995, p. 71.

46. Harmondsworth, 1951.

47. Ibid., p. 32.

48. Letter, Gregory to the University Registrar, 24 October 1952 (ULA).

49. Letter, Registrar to Bonamy Dobrée, October 1952 (ibid.).

50. Hilary Diaper, 'The Gregory Fellowships' in Read & Thistlewood, *Herbert Read, a British Vision*, 1993, p. 134.

51. Minutes, 9 November 1949 (ULA).

52. Terry Frost recalls that it was only some years later that de Sausmarez took an interest in abstraction (conversation, 27 May 1997). Froy also associated de Sausmarez with the Euston Road School (conversation, 8 May 1997).

53. Froy and Frost recall their 'interviews', held over informal dinners at Gregory's flat (conversation, 8 May 1997 and 27 May 1997).

54. Read, *Gregory Memorial Exhibition*, 1960, p. 5.

55. Minutes of Senate, Committee on Gregory Fellowships in Art, 30 June 1943, minute (iii) 14 (ULA).

56. Ibid.

57. Letters, Gregory to Dobrée, 16 and 30 December 1949 (ULA).

58. Notes of Gregory Fellows Committee 9 November 1949 (ibid.). A letter from Gregory to the University (30 July 1943) states that the Fellows may be 'equally male or female married or unmarried' (ibid.).

59. 'I myself had very much hoped we should have Passmore (sic), or somebody like him, up here, since our crying need is for a non-representational painter' (letter, Dobrée to Gregory, 30 December 1949, ibid.).

60. Minutes of Senate, Committee on Gregory Fellowships in Art, 30 June 1943, minute (iii) 14 (ibid.).

61. Conversation, 8 May 1997.

62. Memo, Planning Engineer to Bursar, 6 July 1951 (ULA).

63. Letter, Gregory to Vice-Chancellor 29 May 1952 (ibid.).

64. Letter, Gregory to Bursar 21 June 1951 (ibid.).

65. Davie had difficulty in financing the framing of his paintings, many very large, for his

exhibition at the Whitechapel Art Gallery in 1958: 'the only possibility that I can see is for the University to purchase one of my pictures in payment. Could this be arranged?' (letter, Davie to the University, 7 October 1957, ibid.). The Bursar sent a cheque for £200 (letter to Davie 25 October 1957, ibid.).

66. The Planning Engineer wrote of a new Fellow: 'In view of the Vice-Chancellor's policy regarding the Gregory Fellows we must try and help him and reconcile ourselves to the fact that he might not be as bad as some of his predecessors' (letter to Mr Lolley, 13 October 1954 ibid.).

67. A small gallery was opened in the late 1950s. Prior to that date works were dispersed throughout the University buildings. In 1970, the collection was placed under the jurisdiction of the University Library and the new gallery, within the Parkinson Building, was opened.

68. Irene Manton, in Elizabeth Knowles ed., *Terry Frost*, Aldershot: Scolar Press, 1994, p. 68.

69. Memo. for Special Senate Meeting on 29 February 1956 (ULA).

70. Ibid.

71. Report of Special Meeting of the Senate, 29 February 1956 (ibid.).

72. Letter, Gregory to the Vice-Chancellor, 20 September 1957 (ibid.).

73. In 1967 the University asked Lund Humphries to supplement the Fellowships (letter Vice-Chancellor to Lund Humphries, 14 December 1967). Lund Humphries was unable to assist (letter, A. W. Bell to the University, 20 December 1967, ibid.).

74. John Jones, 'The Gregory Fellowships in Painting and Sculpture' in Diaper, *The new spirit* 1986, p. 5.

75. Ibid. p. 6.

76. Mary Gavagan, *The Irene Manton Bequest, an Interim Catalogue of Work from the Irene Manton Bequest in Lancaster University's Collection*, Lancaster University, 1993, unpaginated.

77. Ronnie Duncan in Knowles, *Terry Frost*, 1994, p. 64.

78. See statement by Manton in Gavagan, *The Irene Manton Bequest*, 1993.

79. See Read, *Contemporary British Art*, 1951, p. 33. Butler assisted Moore with *Three Standing Figures* in 1948. Moore proposed Butler as the first Fellow in sculpture (Berthoud, *Henry Moore*, 1987, pp. 209 & 249).

80. 'At the Slade School, the percentage of sculptors among the students is double what it was before the war, one out of every four Diploma candidates in 1950 took sculpture as his main subject' (David Sylvester, 'Contemporary sculpture', *The Listener*, 46: 1173, 23 August 1951, p. 295).

81. See Benedict Nicolson introduction, *London-Paris: New Trends in Painting and Sculpture*, exh.cat., ICA, 1950.

82. 'These new images belong to the iconography of despair, or of defiance; and the more innocent the artist, the more effectively he transmits the collective guilt. Here are images of flight, of ragged claws, "scuttling across the floors of silent seas" of excoriated flesh, frustrated sex, the geometry of fear' (Herbert Read, 'New aspects of British sculpture' in British Council, XXVI *Biennale di Venezia*, exh.cat., 1952). See also David Mellor, 'Existentialism and post-war British Art' in Frances Morris ed., *Paris Post War, Art and Existentialism 1945–55*, exh.cat., Tate Gallery, London, 1993, p. 55.

83. Butler recommended that all art students, having finished their training, should be found a private studio space (Reg Butler, *Creative Development*, London: Routledge & Kegan Paul, 1962).

84. Butler worked on his entry from autumn 1951 to January 1953 (Richard Calvocoressi, *Reg Butler*, exh.cat., Tate Gallery, 1983, p. 21).

85. John Berger found the works 'tolerant, uncommitted, remote, anæsthetised, harmless and therefore, in the end, impertinent' and judged the competition a 'total failure'. Butler's entry was 'a compelling emblem – but an emblem of Defeat' ('The Unknown Political Prisoner', *The New Statesman & Nation*, 45: 1150, 21 March 1953, p. 338).

86. Butler's entry had a 'deficiency of invention and grandeur' and was 'devoid of that sense of inevitability which a monument on this scale needs and which can give even a television transmitting aerial a compelling magic' (David Sylvester, 'The Unknown Political Prisoner', *The Listener*, 50: 1255, 19 March 1953, p. 478).

87. *Totem and Taboo* was first published in Vienna in 1913; in English in New York in 1918 and in a new translation by James Strachey in 1950. '[Butler] was fascinated by primitivism and anthropology, Picasso, African Art especially the Benin bronzes, Freud and Havelock Ellis. We have a much fingered copy of Totem and Taboo' (Rosemary Butler letter to Margaret Garlake, 14 December 1994, quoted in Margaret Garlake, *New Art, New World: British Art in Postwar Society*, London & New Haven: Yale University Press, 1998, p. 266 n. 55).

88. Butler, *Creative Development* , 1962, p. 72.

89. Kenneth Armitage, letter to the author, 26 March 1997.

90. Ibid.

91. 'Of...fundamental formal significance ... with its firm stance and its three six-feet high panels with projecting knob-like struts at the corners' (Alan Bowness in *Kenneth Armitage*, exh.cat., Whitechapel Art Gallery, London, 1959, p. 8).

92. Reproduced in *William Scott: Paintings & Drawings*, exh.cat., Irish Museum of Modern Art, Dublin, with Merrell Holberton, 1998, p. 61.

93. Hadyn Griffiths, 'Bath Academy of Art, Corsham Court, Wiltshire 1946–1955' unpublished MA thesis, Courtauld Institute of Art, University of London, 1979. Peter Lanyon mentioned the influence of Treinen on his and Scott's work (letter to Peter Gimpel 1952 in Andrew Lanyon, *Peter Lanyon 1918–1964*, Penzance, 1990, p. 129).

94. Armitage 'refused the invitation to participate in the Unknown Political Prisoner competition of 1953 because he felt so much at odds with the mood suggested by the theme' (John Glaves-Smith, 'Kenneth Armitage', *Artscribe*, No. 16, February 1979, p. 30).

95. *Kenneth Armitage*, 1959, p. 9.

96. *Kenneth Armitage*, London: Methuen, 1962, unpaginated.

97. Ibid.

98. Letter to the author 26 March 1997.

99. Dalwood taught at Newport School of Art from 1951 to 1955. He had studied at the Bath Academy from 1946 to 1949 and had firm connections with St Ives.

100. Norbert Lynton, Introduction, *Hubert Dalwood, Sculptures and Reliefs*, exh. cat., Arts Council, London, 1979, p. 14.

101. Ibid. p. 16.

102. Lynton related Dalwood's *Tree* sculptures to Thubron's 'free-hand grid paintings'; *Screen* to Frost's abstracted landscapes and the dark lines of *Icon* to the 'rough dark lines William Scott and Roger Hilton were putting into their paintings in 1953–54' (ibid., pp. 14 &15).

103. Hubert Dalwood in *Eleven Sculptors, One Decade*, exh.cat., Arts Council, London, 1972, p. 7.

104. John Jones, Senior Lecturer in Painting, conversation, 17 April 1997.

105. Dalwood's imagery was drawn from a variety of sources. Some works had strong associations with the visual world and sometimes political connotations and thus fell well outside the dominant conventions of the 1960s (Lynton, *Hubert Dalwood*, 1979, p. 5).

106. Letter, Gregory to Dobrée, 16 May 1951 (ULA).

107. David Thistlewood used the term 'process dominant' to describe both constructivist and expressive abstraction. By focusing on a process of formation profoundly indebted to Klee's work, through the concept of 'organic formation', explored in ICA discussions and Richard Hamilton's 'Growth and Form' (1951), the ICA established a framework of viewing which accommodated both constructivist and expressive abstraction (David Thistlewood, 'The MOMA and the ICA: a Common Philosophy of Modern Art', *British Journal of Aesthetics*, 29: 4, Autumn 1989, pp. 316–28). Froy helped to make the models for 'Growth and Form' (conversation, 8 May 1997).

108. Conversation 8 May 1997.

109. Ibid.

110. Jon Silkin, Gregory Fellow in Poetry (1958–9) launched his magazine *Stand* in Leeds. '*Stand* drew its considerable energies from the charged Leftist spirit of its industrial, working-class backdrop, as well as from the international perspective that animated the campus and certain modes of revisionist socialist thought and literary criticism' (Romana Hulk & James Acheson

eds, *Contemporary British Poetry, Essays in Theory and Criticism*, State University of New York, 1996, p. 175).

111. *Double Casket* (1962) resembles a cooking pot or household container (Lynton, *Hubert Dalwood*, 1979, p. 19).

112. Dalwood in *Eleven Sculptors, One Decade*, 1972, p. 7.

113. The crosses which register the elbow of the model in *Seated Nude* are redolent of the marks Coldstream used to locate and relate key features. Froy's overall approach is, however, less intense and more expressive.

114. Frost taught at the Bath Academy 1952–4 and Willesden Art School, Dollis Hill, London immediately before taking up his Fellowship.

115. Alloway gave precedence to the constructive abstract artists associated with Pasmore and grouped Scott, Hilton and Frost at 'the other extreme of non-figurative art – irrational expression by *malerisch* means' (*Nine Abstract Artists*, London: Tirani, 1954, pp. 10 & 3).

116. Ibid., p. 23.

117. Introduction, *Statements, a Review of British Abstract Art in 1956*, exh.cat., ICA, 1957, unpaginated.

118. Frost, Statement, ibid.

119. In Knowles, *Terry Frost*, 1994, p. 73.

120. Conversation, 27 May 1997.

121. Undated, but 1957 (TGA).

122. In Knowles, *Terry Frost*, 1994, pp. 64 & 66.

123. Ibid.

124. Ronnie Duncan in ibid., p. 66.

125. Alan Davie, letter to the author, 25 March 1997.

126. Davie 'lectured about [my] work to the University's various departments' and gave 'a talk to the Physics department relating art to scientific experiment', which did not gain the students' interest (ibid.).

127. 'He also benefited from the presence of scientists in the University: seeking some common ground with them he began to read about atomic physics and was surprised to find that the so-called uncertainty principle could be applied equally well to painting like his own in which chance plays a major part' (Alan Bowness, *Alan Davie*, London: Lund Humphries, 1967, p. 172).

128. 'An awful business this, I am inundated with requests for paintings – Lilian Somerville now is shouting for 7 big ones to send to Australia … I suppose a change indeed from only a short time ago when nobody was interested at all' (Davie, letter to the ICA, 31 July 1958, TGA).

129. Lynne Green, 'Listening to the music of heaven and earth, reflections on the art of Alan Davie' in Michael Tucker (ed.), *Alan Davie: The Quest for the Miraculous*, exh.cat., University of Brighton Art Gallery with Lund Humphries & Barbican Art Gallery, London, 1993, p. 30.

130. David Lewis conflated 'action painting', 'tachism' and 'abstract expressionism' but declared 'action painting' to be the best term 'because it does not characterise the end-result … so much as the process' (Introduction, *Alan Davie*, exh.cat., Wakefield City Art Gallery, 1958, unpaginated).

131. Davie, 'Notes by the Artist', *Alan Davie*, exh.cat., Whitechapel Art Gallery, London, 1958. Bryan Robertson made no mention of the term 'action painting' and whilst suggesting links between Davie's work and contemporary American painting, firmly related his work to Europe and his Celtic roots (Introduction, ibid.).

132. 'The most valuable and constructive work I did was at the College of Art where I did a lot of experimental teaching with exciting results. This was a very dynamic period with Harry Thubron and Tom Hudson on the staff' (Davie letter to the author 25 March 1997).

133. Later all three Fellows taught at the College two days each week. Towards the end of his Fellowship Dalwood was teaching three days a week. De Sausmarez disapproved: 'I think it extremely unwise to allow the Gregory Fellows working facilities in the College – the whole idea of the Fellowships was that their studio (*within the University*) would bring the working artists into *closer contact with the university community*' (undated draft of letter by de Sausmarez, NAEA).

134. Taylor was appointed Head of Design in 1949 and immediately changed the way the department was organized. 'I based all teaching in all sections of design on a fine art-orientated course, with drawing as a fundamental component' (Eric Taylor, 'A Lifetime', in *Eric Taylor Retrospective*, exh.cat., University Gallery, Leeds, 1994, p. 30).

135. Froy was willing to work more closely with the College of Art and visited it several times, but recalls that little interest was shown in his presence (conversation, 8 May 1997).

136. Taylor in *Eric Taylor*, 1994, p. 31.

137. Ibid., pp. 30–1. The concept that art should be made more relevant to the modern, scientific age can be associated with the increasingly high profile given to design in the 1950s and 1960s. In 1956 the Design Centre opened in the Haymarket, London. Designers were in considerable demand and fine artists felt they would be more valuable to society and readily employable if they understood industrial processes. However, many students left the Art College unable either to draw or to work effectively in industry (John Jones, conversation, 17 April 1997).

138. 'Most of the subsequent Basic Design courses in British art schools owe something of their character to work done at the Central' (Roger Coleman, Introduction, *The Developing Process*, exh.cat., ICA, 1959). Johnstone initiated the first foundation course derived from ideas associated with the Bauhaus in the Design Department at Camberwell with its Director, A. E. Halliwell. When Johnstone was appointed Principal of the Central School in 1947 the course was extended, but remained confined to the Industrial Design Department. 'Johnstone called on the services of some of the leading post-war abstract painters and sculptors, and took the unprecedented step of dispersing these "fine artists" among the furniture-makers, silversmiths, jewellers and textile designers' (Alan Bowness & Luigi Lambertini, *Victor Pasmore Catalogue Raisonné of the Paintings and Graphics 1926–1979*, London: Thames & Hudson, 1980, p. 281).

139. Thubron and Hamilton did not meet at Scarborough or at any other time (R. R. Yeomans, 'The Foundation Course of Victor Pasmore and Richard Hamilton 1954–1966' unpublished PhD thesis, Institute of Education, University of London, 1987, p. 182). See also transcript of interview, Norbert Lynton and Peter Sinclare, 20 September 1974 (NAEA).

140. Yeomans, 'The Foundation Course', 1987, p. 81.

141. The statements in *The Developing Process* (1959) suggest very different approaches. Richard Hamilton: 'The tasks I set my first year students are designed to allow only a reasoned result. Rarely is a problem presented in terms which permit free expression or æsthetic decision.' Davie: 'My teaching is based on a philosophy of the irrational.' See also transcripts of interviews, Frost and Yeomans, 6 April 1983 and Lynton and Sinclare, 20 September 1974, both NAEA.

142. Pasmore, letter to Yeomans, 2 October 1983; interview with Sinclare, 14 August 1974, cited in Yeomans, 'The Foundation Course', 1987, p. 83.

143. David Thistlewood and Benedict Read associate the ideas underpinning the Basic Course with discussions held at Stonegrave (conversation, 17 April 1997 and 17 May 1997).

144. Knowles, *Terry Frost*, 1994, p. 76.

145. David Thistlewood,'Herbert Read 1893–1968, the turbulent years of "The Pope of Modern Art"' in Read & Thistlewood, *Herbert Read, A British Vision*, 1993, p. 152.

146. See p. 216.

147. Thistlewood, 'The MOMA and the ICA', 1989.

148. Especially Lynton, because of his understanding of art history, particularly in relation to Klee and the Bauhaus (transcript of interview, Frost and Yeomans, 6 April 1983, NAEA).

149. John Jones, 'An attempt to set down what I remember about Harry Thubron with some account of the circumstances in which several films and recordings now being deposited at the Bretton Hall Archive were made', 1992 (NAEA).

150. Yeomans, recorded interview with Frost, 6 April 1983, ibid; transcript of interview with Dalwood by Yeomans, 23 September 1974, ibid.

151. Thubron was opposed to de Saumarez writing about the Basic Course because it was continually developing and experimental (John Jones, conversation, 17 April 1997). Wood supports this view (transcript of interview with John Wood by Sinclare, 14 August 1974, NAEA).

152. Transcript of interview with Lynton by Sinclare, 20 September 1974 (NAEA). The Central School did not take part in *The Developing Process*. As a result of a disagreement about art

education, Johnstone would not allow Turnbull's contribution to be exhibited (letter, Alloway to Pasmore, undated, TGA).

153. See John Jones, *Drawing with the Figure*, 1963, film held at NAEA. At Corsham, Adrian Heath's students similarly drew from moving models, c.1960 (Garlake, *New Art, New World*, 1988, p. 31).

154. Thistlewood, conversation, 6 May 1997.

155. Davie, 'Notes on Teaching' in *The Developing Process*, 1959.

156. Ibid.

157. Ibid.

158. Letter, Eric Taylor to Vice-Chancellor, 22 January 1958 (ULA).

159. John Jones, conversation, 12 June 1997. Jones, who trained under Coldstream at the Slade, had reservations about Thubron's methods. Whilst he accepted some relaxation of conventional teaching, he found Thubron's undervaluing of technical skills sometimes destructive. Whilst Taylor, Wood and many local education officers supported Thubron, the national examining bodies were less enthusiastic (Dalwood, interview with Yeomans, 23 September 1974, NAEA).

160. John Jones, 'The Gregory Fellowships in Painting and Sculpture' in *The New Spirit*, University of Leeds, 1986, p. 4. See also Knowles, *Terry Frost*, 1994, p. 76.

161. Frost's contribution to the Basic Course largely centred on colour studies, based on observation and discovery. Frost also led on colour studies during his term at Newcastle and believes Hamilton was uneasy about this element of the course and therefore invariably brought in a guest lecturer (Frost, conversation with Yeomans, 6 April 1983, NAEA).

162. Ibid. in Yeomans, 'The Foundation Course', 1987, p. 249.

163. Ibid.

164. Ibid.

165. Thubron was apparently interested in H.B. Carpenter's book on colour theory: *Colour* (London, 1923) (Bridget Riley in Maurice de Sausmarez, *Bridget Riley*, London: Studio Vista, p. 87).

166. Fifty or more courses were organized between 1954 and 1956 throughout the country. John Jones made a film at a summer school in 1962 in Bishop Stortford which shows students building constructions with old electrical goods, car parts and other discarded items. A second film (1963) shows Patrick Heron working with students, including some nuns, studying colour relationships (John Jones, films 1962 & 1963, NAEA).

167. Frost did not attend the Scarborough or Bishop Stortford schools but did take part in schools in London and Barry. A draft publicity leaflet for the course at Byam Shaw School, London, December 1962 lists Dalwood, Lynton and de Sausmarez with Thubron (NAEA).

168. *Terry Frost: Paintings, Drawings and Collages*, exh.cat., Arts Council, 1976, p. 15.

169. Dalwood, interview with Yeomans, 23 September 1974 (NAEA).

170. Ibid.

171. Ibid.

172. Ibid.

173. In August 1958 Gregory willingly extended Dalwood's Fellowship (Gregory, letter to Registrar, 5 August 1958, ULA).

174. Frost, conversation 27 May 1997.

175. Gregory, letter to the Vice-Chancellor, 1 July 1957 (ULA).

176. In Knowles, *Terry Frost*, 1994, p. 62.

177. Jon Silkin remembers the cross-fertilization between the business, academic and artistic communities (conversation, May 1997).

178. The Gillinsons were Jewish and their patronage can be seen as a continuation of the strong tradition of support the Jewish community gave to art in Leeds, particularly to Jacob Kramer (see Thubron transcript of interview with Lillian Somerville and Sinclare, 27 July 1974, NAEA). From 1964 Bernard Gillinson served on the Council Committee on Art Treasures at the University and from 1965 on the Sub-Committee on Additions to the Collections (Maurice Kirk, 'An art collection and some art committees' in *The University of Leeds Art Collection*, 1995, pp. 7 & 8).

179. Interview with Yeomans, 23 September 1974 (NAEA).

180. In 1964 a large mosaic, designed by Thubron, was installed on the side of Gillinson's warehouse. Shell had given the College of Art £500 in order to 'experiment with the æsthetic properties of man-made fibres' (M.G. McNay, *The Guardian*, 23 September 1964). Jon Silkin is certain that the business community funded the relaunch of *Stand* (see note 110 *supra*) largely because he was a Gregory Fellow. Lund Humphries supplied paper, free, for the first two editions (conversation, May 1997).

181. Burton also made generous gifts to the University Gallery, including work by Frost and Trevor Bell. Burton served on the Council Committee on Art Treasures at the University from 1964, and from 1965 on the Sub-Committee on Additions to the Collections (Kirk, 'An art collection', 1995, pp. 7 & 8).

182. Jones, conversation, 21 April 1997.

183. It totals over 400 works, mainly Chinese and abstract European art (Gavagan, *The Irene Manton Bequest*, 1993). Manton too served, from 1965, on the Sub-Committee on Additions to the Collections (Kirk, 'An art collection', 1995, pp. 7 & 8).

184. Duncan attributes his interest in contemporary art to the influence of Dobrée, whose support he sought when working on an ephemeral literary magazine. Frost and Duncan knew each other through the Gillinsons (Duncan, conversation, 17 April 1997).

185. Ibid.

186. Ibid.

187. Another Leeds/St Ives connection was maintained through Wilhemina Barns-Graham, who taught at the College of Art whilst her husband, David Lewis, was studying architecture at the College.

188. Hilton's paintings were innovatively hung on a framework of poles which ran from floor to ceiling.

189. She was the wife of Wilfred Gilchrist who, with his brother, ran the printing company which produced colour reproductions for Lund Humphries and colour covers for *The Leeds Art Calendar*.

190. Frost, conversation, 27 May 1997.

191. The curtains measured 12ft by 10ft (Frost, letter to Hilton, undated but probably 1957, TGA).

192. Silkin describes himself as having been 'part of Thubron's network' and recalls giving very well-attended poetry reading sessions at the College (conversation, May 1997).

193. His text also presented the unpublished verse fragments and letters of Isaac Rosenberg (Jon Silkin, *Isaac Rosenberg 1890–1918*, exh.cat., University Gallery, University of Leeds, 1959).

194. In 1954 £100 was allocated for the purchase of original works (Diaper, 'The University of Leeds art collection', 1995, pp. 1 & 2).

195. The first work by a Fellow that the University purchased was by Froy in 1959. Bell's policy recommended that the University continue to collect works by the Fellows (ibid., p. 2).

196. Letter from de Sausmarez, 16 October 1958. It seems that letters were not sent to Frost or Davie, though work by Frost was hung in the dining room of Tetley Hall at the University *c.*1954. (Knowles, *Terry Frost*, 1994, p. 68). De Sausmarez was probably disinclined to write to Davie because his successful show at the Whitechapel Art Gallery had placed his work at a cost beyond the reach of the University.

197. W. T. Oliver wrote of Musgrave's 'courage in defending the original and adventurous' (see 'Ernest Musgrave', *The Leeds Art Calendar*, 11: 38, 1957, p. 3). Musgrave was fighting the intransigence of both councillors and members of the Leeds Arts Collection Fund. 'It is our duty to provide these [new visual experiences] by showing new forms of expression' (Musgrave, ibid., 10: 37, 1957, p. 3).

198. Ibid., 9: 31, 1955, p. 3.

199. *The Visual Arts*, 1946, p. 21.

200. 'The Gregory Fellowships', *The Leeds Art Calendar*, 9: 30, 1955, p. 18.

201. Moore, transcript of interview with John and Vera Russell, 1982(?), TAV 23B, TGA.

202. Gregory and Moore knew each other from 1923; it was 'the closest friendship of my life' (Moore in *Collection of the Late E. C. Gregory*, 1959).

203. 'Artifacts and Figures: the History of Leeds City Art Galleries 1958–83', unpublished ms, 1994, Brotherton Library University of Leeds, p. 177.

204. 'Thus Quentin Bell and I became governors of the College of Art and Eric Taylor and I were put on the Advisory Committee of the Department of Fine Art at the University' (ibid., pp. 448 & 112–3).

205. Ibid., p. 228.

206. Rowe, conversation, 11 April 1997.

207. *Artifacts and Figures*, 1994, p. 228.

208. Ibid., p. 233.

209. The catalogue was subsidized by Lund Humphries and the University (Rowe, conversation, 11 April 1997).

210. Rowe, *Artifacts and Figures*, p. 12. The Fellows were also given a hand in the production of the catalogue, 'a sort of combined operation between artists, printers and staff' (Rowe, Editorial, *The Leeds Art Calendar*, 51, 1963, p. 3).

211. Rowe became increasingly proud of *The Leeds Art Calendar* and recalls the delight he felt when he saw a copy displayed in the Ambassador's residence in Peking (conversation, 11 April 1997).

212. The Fellows in question were Dalwood, Neville Boden and Wright. In 1967, under its Awards to Living Artists Scheme, the Arts Council commissioned drawings and maquettes from the three sculptors to submit to the councillors (Rowe, letter, 15 May 1999).

213. In 1961 the picture lending library had 150 works which increased to 390 by 1967.

214. Dobrée in *The Gregory Fellowships*, 1958.

215. Frost interview with Yeomans, 6 April 1983, NAEA.

216. *Terry Frost Paintings, Drawings and Collages*, 1976, p. 15.

List of Gregory Fellows

Sculpture: Reg Butler 1950–3; Kenneth Armitage 1953–5; Hubert Dalwood 1955–9; Austin Wright 1961–4; Neville Boden 1965–8; William Tucker 1968–70; Rick Oginz 1970–3; Martin Naylor 1973–4; Ainslie Yule 1974–5; Edward Allington 1990–3; Jyrki Siukonen 1994–5; Craig Wood 1997–

Painting: Martin Froy 1951–4; Terry Frost 1954–7; Alan Davie 1956–9; Trevor Bell 1960–3; Dennis Creffield 1964–7; John Walker 1967–70; Keith Milow 1970–2; Oleg Prokofiev 1972–4; Norman Stevens 1974–5; Paul Gopal-Chowdhury 1975–7; John Mitchell 1978–80

Poetry: James Kirkup 1950–2; John Heaths-Stubbs 1952–5; Thomas Blackburn 1956–7; Jon Silkin 1958–9; William Price Turner 1960–2; Peter Redgrove 1962–5; David Wright 1965–7; Martin Bell 1967–9; Kevin Crossley-Holland 1969–71; Pearse Hutchinson 1971–4; Wayne Brown 1974–6; Paul Mills 1978–80

Music: Kenneth Leighton 1953–6; Peter Nash 1976–8

'A place for living art': the Whitechapel Art Gallery 1952–1968

Mary Yule

Bryan Robertson and the Whitechapel Art Gallery

The exhibition programme at the Whitechapel Art Gallery from the early 1950s until the end of the 1960s marked a significant moment in British art, and at the same time exerted a formative influence upon that art. Robert Medley's description of the Whitechapel during that time, the title of this paper, captures the spirit behind that programme: 'there was nothing institutional about it. It did not represent an official or establishment view of things: it was a place for living art'.[1]

By the late 1950s, the Whitechapel Art Gallery had emerged from a marginal position[2] to become one of the very few London galleries to show contemporary art on a truly international scale, thus assisting in the creation of a positive climate for the reception and assimilation of modernism by British artists, critics and public. By then its newly established status as a major venue for international avant-garde art meant that the Whitechapel could be seen to complement, or more often supplement, the exhibitions programmes of the other major public institutions, in particular the Arts Council, the Tate Gallery and the Institute of Contemporary Arts (ICA). Despite a statement in 1963 by the Director of the Tate which seemed intended to create the impression of a degree of formal collaboration between the Whitechapel and the Tate,[3] the Whitechapel's policy was always an independent one, and though Bryan Robertson felt strongly about the lack of any co-ordinated exhibition planning between the major London galleries, competitiveness between galleries and the difficulties inherent in long-term planning seem to have precluded a solution.[4]

From 1952 to 1968, with Bryan Robertson as Director, the Whitechapel played an integral part in repositioning British art. He played a material part in the abandonment of an ideologically inscribed and parochial neo-

Romanticism and the 'very umber grey world' of the 1950s,[5] and saw British art come to a position of strength in the buoyant international art world of the 1960s, with London newly acclaimed as one of the art capitals of that world. This claim was reinforced by such group shows as 'The English Eye', curated by Bryan Robertson and Robert Melville at the Marlborough Gerson Gallery, New York in 1965, 'London: the New Scene' at the Walker Art Centre, Minneapolis in 1967 and 'New British Painting and Sculpture' curated by Herbert Read and Bryan Robertson at UCLA prior to a North American tour in 1968.[6]

Bryan Robertson's appointment to the Whitechapel in April 1952 at the age of 27 coincided with the beginning of that change.[7] The Trustees wanted a young director and one not previously concerned with education. At the time of his appointment Robertson had, since 1949, been Director of the Heffer Gallery, Cambridge. By the late 1950s he exercised considerable influence in the London art establishment, not only through the impact of his Directorship of the Whitechapel, but also through membership of the Art Panel of the Arts Council (1958–61), the Executive Committee of the Contemporary Art Society (CAS)(1958–70) and the Council of the Royal College of Art (1965–7). He was awarded an OBE in 1961. He wrote, broadcast and lectured extensively on the visual arts, was art critic of *The Spectator* from 1965, wrote monographs on Jackson Pollock and Sidney Nolan and appeared regularly on the BBC radio programme *The Critics*, and on television. After his first visit to the USA in 1956, he travelled there regularly and through many informal introductions encouraged an influential dialogue between younger British artists and the painters of the New York School. His resignation in 1968 marked the end of an epoch, coinciding with a move towards greater plurality in the visual arts and political and social revolution.

In this essay I discuss certain aspects of the varied and complex exhibition programme at the Whitechapel during the sixteen years of Robertson's Directorship, and its impact on the production, reception and dissemination of contemporary British art. I consider the strategies he employed to promote that art and thus the status of British artists through a series of one-person exhibitions which created new opportunities to exhibit on a museum scale for a broad range of younger and mid-career British artists, including a significant number of women,[8] thus providing each artist with a level of recognition often otherwise denied; the establishment or consolidation of a critical reputation; new or wider audiences for the work and the opportunity for exhibiting artists to assess their *œuvres*. A series of group shows of British art amplified and increased the impact of the one-person shows.[9] The exhibitions of younger British artists were juxtaposed in the overall programme, with exhibitions of British 'Old Masters' (Turner, Stubbs), senior British artists (Moore, Hepworth), eminent Europeans like Mondrian,

Malevich, de Staël and a highly influential series of shows of contemporary American painters.

A creative and tactical use of counterpoint in the juxtaposition of artists chosen to exhibit operated as a strategic device. One aspect of the success of that counterpoint was to make the whole a great deal more powerful than the sum of its parts. The same device was in evidence in group shows, where the construction of any thesis was avoided. Whilst groups may seem superficially coherent, further examination indicates that they lacked uniformity in theme or style.[10] Through a careful orchestration of juxta-positions, Robertson presented a view of richness and variety in British art, placing it, where he felt it was merited, on equal terms with distinguished foreign art. He sought to show a range of simultaneous discourses and wherever possible tried to make links between the visual and other arts. The stress he placed on illustrating the notion of simultaneity was influenced by his reading of R. H. Wilenski's *Modern French Painters*,[11] in which Wilenski sited the French modern masters within a context which refers to music, dance, opera and poetry.[12]

The Whitechapel Art Gallery: its history and policy

The Whitechapel Art Gallery was founded in 1901 by the wealthy, devout Canon Samuel Barnett and Mrs Henrietta Barnett, prominent East End philanthropists.[13] It was preceded by a twenty-year experiment in social engineering by Canon Barnett, with art exhibitions in St Jude's Church Hall, Whitechapel, intended to improve the moral character of the East Enders. Selections were biased towards works of a moral or religious nature. The pictures were loaned by the rich for the poor and the exhibitions, which were extremely well attended, took place for two or three weeks at Easter. Barnett's ethos was predicated on a belief in the power of art to educate and reform and the aim of the Gallery was to 'open in the people of East London a larger world than that in which they usually work. To draw them to a pleasure recreating their minds, and to stir in them a human curiosity.'[14] Frances Borzello puts forward a convincing case for a direct line of inheritance between that ethos and the 'missionary belief in art's power to educate' which underpins the cultural philanthropy of the Arts Council.[15]

Opened to the public in 1901 and designed, like the Horniman Museum, by the architect Charles Harrison Townsend, the Whitechapel is one of London's very few *art nouveau* buildings. The architect and his patrons rejected the canons of nineteenth-century museum building in favour of what was regarded as an essentially modern design[16] appropriate to its site and function, which employed none of the regulating strategies of the more familiar neo-

classical 'temple of culture'.[17] The street-level entrance brings the visitor into an immediate confrontation with the art, an encounter even more immediate before the rebuilding of the Gallery in 1985. The interior exhibition space consisted of a large and well-proportioned main gallery on the ground floor and a smaller upper gallery. In this discussion, the Whitechapel Art Gallery which is referred to consists of the main gallery only, since the upper gallery was let out to the London County Council and subsequently the Inner London Education Authority, for educational use and only reclaimed in the 1970s. Both galleries had the advantage of natural light, through a carefully devised skylight system. Until the late 1960s, when the Hayward Gallery opened, the Gallery was recognized as one of the best spaces for temporary exhibitions in London, particularly for sculpture[18] and for large-scale work.

The site of the Gallery[19] on Whitechapel High Street adjoining the Public Library underlines its social significance, since it was considered that both buildings provided 'the means for the social advancement of the working classes, and gave them a respectable and sober form of recreation'.[20] In the early 1950s, Whitechapel was a deprived working class area, containing a long-established Jewish community and an emerging immigrant population from the Commonwealth. In the 1960s a community of artists was attracted to the area by its supply of affordable studio space. Throughout the period however, the Whitechapel public was significantly different from that of other London art galleries. This difference could be advantageous for, as Robertson wrote to Barbara Hepworth, 'The Gallery attracts an extremely large public. All the West End people come here, large numbers of East Londoners and people from the City who do not normally visit the galleries ... the exhibition would be seen by the largest number of people.'[21]

There were two distinct Whitechapel publics: one reflected the local population in all its diversity and the other embraced a West End audience, City business people and art world professionals. The Whitechapel could be said to function as 'other' for the West End and art professional public, some of whom regarded their visits to the East End as forays into a sub-culture which confirmed the superiority of their home ground and the values which lay behind the idea of an art establishment. The Whitechapel's potential also to function as 'other' for the East End public and the danger that it might confer an outsider status on the local visitor by presenting an élitist programme, was a constant subject for debate by the Trustees. Serving the needs of the local public was fundamental to the Whitechapel ethos, and the Trustees' minutes record many hours of discussion on this topic, particularly in the 1960s when what was perceived as neglect of those needs seemed to threaten the financial position of the Gallery. However, when he first joined the Gallery, Robertson observed resistance to what had generally been perceived as art with local appeal. The social realism of John Berger's 'Looking Forward'

(1952) was not well received by the local public, who found it colourless and despondent, despite the supposed accessibility of its realist subject matter.[22]

The Whitechapel was a respected public gallery and thus part of the establishment,[23] yet its location and its responsibility to a particular kind of local public gave it another rôle outside that system. Likewise, although Robertson exerted considerable influence within the art establishment of the time, his highly individual way of working also put him slightly outside it. His idiosyncratic policy and very eclectic choices meant he was regarded as a maverick in some quarters because he did not conform to any prevailing critical framework. He felt for instance that whilst he was on the most cordial terms with Lilian Somerville, Director of the Fine Art Department at the British Council, she viewed him with some reserve because of his tendency to show artists outside the critical mainstream, like Robert Colquhoun (1958), whom she saw as a very eccentric choice.[24] His choices reflected his personal preferences and, in many cases, friendship and loyalty to the artist whose work he admired; he took many risks in the process. He has been described as an impresario at the Whitechapel[25] which, combined with a 'social knack of making things happen',[26] placed him in the position of catalyst. He exploited his skill for publicity to the full and the social network he generated had a considerable influence on artists and sometimes made an impact on their practice, as with those, like John Hoyland, whom he introduced to prominent American artists in the 1960s.[27]

The cultural context of the Whitechapel from 1952 was also significant. Immediately the War ended, a major preoccupation for artists was to re-establish links with the Parisian avant-garde and to pick up the threads of continental modernism; artists returning from the War or from reserved occupations to resume art practice took advantage of opportunities to travel after years of enforced isolation. The post-war decade was a time of enormous change in the conditions for the production and dissemination of con-temporary art in London.[28] The dominance of French art continued, but was gradually diminishing. Although the exhibition of work by Picasso and Matisse at the Victoria and Albert Museum in 1945/6 had re-established the hegemony and the work of the Ecole de Paris remained a prime focus,[29] there was for British artists, as Alan Bowness points out, 'a certain feeling of unease ... as if the age of masters was past, and no messiah yet in sight'.[30] Gradually British artists were able to shed that 'inferiority complex' which Michael Ayrton had so eloquently described in 1946.[31] Although this was to a certain extent later replaced by dependence on American art,[32] by the late 1950s British art was experiencing a resurgence in self-confidence in which institutional patronage played a major part.

There were relatively few exhibitions of contemporary art in public galleries in London in the post-war years. Public patronage was a recent phenomenon

and still limited in size and scope. The Arts Council of Great Britain had been founded as recently as 1946 and apart from '60 Paintings for '51' and works of art commissioned for the Festival of Britain, it did not expand from its early patronage of safe, middle-ground art to a more direct engagement with avant-garde practice until the 1960s. The British Council played a different role which had little direct impact on the reception of art in Britain, though it did much to enhance the reputation of British art and artists internationally. The ICA, founded in 1948, was the only institution engaged in providing the *means* of initiating cultural production, rather than merely its reception; it was involved in promoting a British avant-garde with the aim of becoming a national arts centre.[33] It seems to have set a precedent for the Whitechapel by giving shows to younger British artists, and by being the only public gallery to show examples of contemporary art from outside Britain.[34] Although commercial galleries played an important independent rôle in cultivating awareness of both British and international contemporary art in the post-war period,[35] being restricted financially and in terms of space, they were not in a position to mount large exhibitions.

Whilst the major public institutions made use of contemporary art to demonstrate a renewed vitality present in post-war British culture, their choices were strongly affected by critical and public opinion, hence their adherence to a 'middle ground'.[36] A similar thrust to demonstrate 'clear signs of an artistic renaissance in England'[37] can be seen in the Whitechapel exhibitions, though from conviction, rather than cultural patriotism. Like the ICA, the Whitechapel Art Gallery occupied an independent position within the London art world, less impeded by critical or ideological pressures than other institutions like the Arts Council, the British Council or the Royal Academy. This relative freedom came from its independent status as a charity and its roots in the high moral principles of late Victorian cultural philanthropy. The Gallery provided a framework where, perhaps paradoxically in the light of its educational bias, an idiosyncratic, non-didactic policy was more likely to flourish. There was no external pressure to adhere to 'safe' art. Robertson could pursue a policy based upon personal conviction because he was granted a degree of autonomy in his artistic policy by the Board of Trustees[38] which would have been impossible in any other major art institution.[39]

In 1952, when Robertson went to the Whitechapel, the fortunes of the Gallery had entered a more secure phase and he inherited a situation of fairly recent solvency from his predecessor, Hugh Scrutton, though financial problems repeatedly dogged the history of the Whitechapel; in the 1960s they would dominate Trustees' meetings and lead to the closure of the Gallery in the winter of 1966/7. Robertson's appointment to the Whitechapel fell, almost symbolically, between two seminal exhibitions, 'Picasso and

Matisse' show in 1945/6, and 'Modern Art in the United States' at the Tate in 1956. He had had a formative first-hand experience of European art in Paris in 1947 when he attended a course at the Sorbonne and became acquainted with many artists and writers, among whom Brancusi, Picasso, Cocteau and Bérard were particularly important. Other factors consolidated and enlarged upon that experience, especially visits to the Museé de l'Homme, where the African sculpture in particular heightened his awareness of the influences on Picasso's pre-Cubist work.[40] The ICA exhibition '40,000 Years of Modern Art, a Comparison of Primitive and Modern' (1948) alerted him to the importance of historical continuity in art, a concern he felt it particularly important to highlight in the future, after radical changes in art education in the late 1950s and early 1960s diminished the value placed by artists on the art of the past. In his many dealings with artists, he constantly promoted a sense of openness towards the visual art of the past, as well as towards performing arts.

He brought to the Whitechapel a conviction about the supremacy of French art, with the sense of 'something in the air' from America.[41] He took a very broad view of European modernism, seeing in his appointment an opportunity to educate and reform the British public, and British artists, by showing them the best of European art, in particular abstract art. He saw abstraction as 'the dominant invention of the 20th century' and the significant European artists at that time like de Staël, Wols, Tàpies, and Poliakoff as significant in abstract ways. English abstraction was generally far behind Europe and parochial in comparison, and was being exhibited as 'second best'.[42] He faced the challenge of educating the British public with equanimity: 'The English are not more backward than their European neighbours. It is simply that the encounter between the public at large and the art of their own time is still quite a new experience, and cannot be hurried.'[43]

Yet his reforming zeal towards British art was also motivated by a concern about its underlying parochialism and nationalism. In 1946 in his first major article as a very young writer he eloquently summarized his convictions about British art:

It is time some statement was made on behalf of younger British artists ... Nowadays as a whole, British artists are very conscious of their national heritage; and the younger painters, cut off for so long from European influences, are maintaining this tradition in a healthy and virile way. This prevalence on a nationally conscious school of painting is sometimes rather worrying; the results have been magnificent, but sometimes it suggests that British painters are erecting artificial barriers against outside influence – a dangerous practice. The famous School of Paris was great only because it was truly international in feeling and outlook.[44]

The article set out two of the principles which were to underlie his policy at the Whitechapel: the needs of younger British artists and the importance of

encouraging greater openness amongst British artists to a range of inter-national influences in order to create a receptive climate for the production of significant art.

The canon of 'great modern masters' was not challenged at the Whitechapel, but incorporated into a broader field of art. The Whitechapel public was offered a plurality of narratives: old master, modern master (British, European and American); new developments within British art, embracing the significant groupings of the time such as emergent talents from the Royal College of Art and St Martin's and a considerable number of artists like Thelma Hulbert and Gertrude Hermes, who could not be classified within any critical framework, but who, by being given equivalent prominence, received recognition and status. The inclusion of straightforward, if un-fashionable, art also had a strategic function. The encouragement of patronage was to be a consistent theme. This plurality of narratives was carefully orchestrated to create a counterpoint which enhanced the richness and variety of the overall programme and gave status to British art and new opportunities to British artists. Enthusiasm for art as a dynamic process and avoidance of conformity were dominant themes. Although the programme was not revisionist, its pluralism in the 1960s could be seen as presenting an alternative to the prevailing rigid modernist orthodoxy of Clement Greenberg and Michael Fried. From the mid-1960s an emergent pluralism challenged that orthodoxy and the Whitechapel can be seen as playing a part in its eventual demise.

It became standard practice to use Whitechapel catalogue prefaces to make statements of intent, and Robertson's first 'manifesto' was in the catalogue of the first exhibition by a young British artist, Michael Ayrton, in 1955.[45] His intention from the outset, however, was for a series of exhibitions by younger British artists and those in mid-career, with less frequent shows of more senior artists. To intersperse them within the overall exhibitions programme with group shows, important foreign art and 'historical' exhibitions of the 'great archetypal figures in modern art'[46] was the underlying strategy whereby British art would be validated; his first task was to ensure a spectacular beginning.

'An East End gallery with a European reputation'

The first five years of Robertson's Directorship were crucial in creating a memorable initial impact and in setting up a framework for his future ambitions for the Gallery and for British art. His first report to the Trustees after his appointment outlined an exhibition programme which laid down the model for all future programmes during his Directorship.[47] A great deal

of strategic thinking lay behind it and it very soon achieved its aim of putting the Whitechapel in the forefront of London galleries, for whilst the new Director was attentive to the needs of the local people, he also saw the Gallery as catering to a wider public.[48]

Five years later, in 1957, an article in *The Times* signalled establishment approval for the success of the strategy. The article describes the history, aims and principles of the Whitechapel, its 'admirably eclectic' exhibitions policy, and concludes with a statement by Robertson: 'What one may hope for is that the architecture and the situation of the gallery are such that classical and contemporary art are made as accessible as they can be to anyone who may wish to look, and also that at Whitechapel we may be able to extend the living artist's public to a wider world.'[49] The article marked a shift in the Whitechapel's status, was a declaration of intent and highlighted Robertson's passionate commitment to the needs of the living artist which was central to his policy.[50] It marked the success of the plan for the first five years.

The early exhibitions were marked by grandeur in concept, ambition and style. His commitment to improving visual standards in Britain ran like a thread through his selection of artists, the standard of installation and the setting of a consistently high standard of catalogue production. The initial programme set out a blueprint for all future strategy. The importance of a grand beginning, with a Picasso retrospective planned for the autumn of 1953, was borne out by the energy Robertson devoted to this project in his first few months at the Whitechapel. It was conceived as a 'vast, comprehensive and really magnificent retrospective show'[51] which would have brought enormous prestige to the Gallery and to the other artists who exhibited there. The declared aim was to 'show the English public once and for all Picasso's immense achievement in the past fifty years'.[52] A great deal of support was forthcoming from major figures in the British art establishment, including the Directors of the National Gallery and the Tate Gallery. Sir John Rothenstein, Director of the Tate, wrote: 'It is most interesting news that you are organising a retrospective exhibition of Picasso. From all that I hear, you are going to find it difficult to get any co-operation from the artist himself. Good luck, at all events, to your project.'[53]

A letter to Picasso in June 1952 went unanswered and when the support of Alice B. Toklas was enlisted she replied 'Picasso does not answer letters, but a direct appeal might be effective on account of your audience.'[54] It was hoped that the centrepiece of the exhibition would be *Guernica*, (already shown at the Whitechapel in 1939) but Picasso emphatically refused to allow it to travel.[55] Robertson also enlisted the support of Douglas Cooper, the leading British Picasso expert, collector and friend of the artist.[56] He bombarded Robertson with advice and suggestions, offering alternatives to

the original idea of a large retrospective.[57] However, in spite of a great deal of support and goodwill, Robertson's unflagging efforts were not rewarded and the plan was abandoned in December 1952. The reasons for this are complex. Robertson recalls that Kahnweiler, Picasso's dealer, made any further progress on a major retrospective impossible,[58] insisting that the show should be restricted largely to works from English collections.[59] The Trustees also objected to the expense involved in bringing so many works from abroad and feared that 'a communistic focus would be put on it, especially in view of the neighbourhood in which it would be held'.[60]

The publicized reason for the abandonment of the project was political rather than financial, pragmatic or related to dealer displeasure,[61] perhaps a telling indicator of the power of prevailing Cold War attitudes. Any sensitivity about 'modern art as communistic'[62] was compounded by Picasso's member-ship of the Communist Party and the residue of disapproval in some quarters of the press and public at his visit to the Peace Congress in Sheffield in 1950.[63] Though Robertson's plan to start his exhibition programme with a major international show by the leading European modern master was frustrated,[64] the support it received must have stood him in good stead for future ambitious projects, and it underlined the ambition of the Director and his determination to make an impact on British art.

The series of historical shows in 1953 set a standard of grandeur and *gravitas* and provided a context for the contemporary British shows which were to follow, similar to the device employed by the British Council in juxtaposing Moore and Turner at the Venice Biennale in 1948. The first exhibition curated by Robertson was 'J. M. W. Turner' and was very grand indeed, with 224 works. It was a huge success; the Queen Mother paid an unofficial visit and Patrick Heron described it as looking 'like a luminous cave, whose off-white, pale blue and grey-mauve ceiling re-echo with perfect acoustics the blue and gold chords emitted by these Turners'.[65] The selection of work concentrated on rarely exhibited paintings such as *Dort Packet Boat from Rotterdam, Becalmed* (1818) on loan from a private collection. An exhibition of Rowlandson and Gillray followed Turner, illustrating another aspect of the English artistic inheritance, that of satire. The John Martin exhibition in 1953 was the first since the artist's death in 1854. The heroic scale of his apocalyptic canvases was well suited to the gallery space and, like the Stubbs show in 1957, the exhibition resulted in a re-evaluation of the artist's work.

In 1954 Robertson began his programme of exhibitions of contemporary British artists with a 'senior' artist, Barbara Hepworth. This exhibition was of great importance to Robertson as a landmark to launch his series of solo shows of British artists, and also to Hepworth who was at a very low ebb, both professionally and emotionally.[66] It was significant also as 'the first exhibition to be held in East London of the work in its entirety of a

contemporary and advanced artist'.[67] Also important was the hope that the expenses of the show would largely be met by sales.[68] Selling work was a new departure for the Gallery, one which concerned the Trustees. The hoped-for sales were realized but when plans for the next one-person British show were discussed, the implications of selling work for the Gallery's relationship with dealers were debated.[69]

The correspondence on the 1954 Hepworth show deserves more consideration than can be given here because it confirms her rigorous professionalism and illuminates her views on the nature of sculpture. Having welcomed the opportunity to show at the Whitechapel, she threw herself into making work and the arrangements for the exhibition.[70] Her letters to Bryan Robertson touch on her views on various aspects of sculpture, its form, meaning, scale and the conditions necessary for its production; at a time when she was on the brink of a move into much larger, more monolithic work it is interesting to note her commitment to the importance of small works.[71] She revealed her feelings about the frequent comparisons made between her work and that of Moore. 'I feel that Moore is always referred to in reference to my sculpture (and presumably anyone else's) but it is apt to act as a <u>red herring</u> as people then look at the work to find a similarity and then are disappointed and think the work isn't very good.'[72]

The Hepworth exhibition was a great success and repaid all the extremely hard work which went into it, in critical terms for the artist and in prestige for the Gallery.[73] It demonstrated the museum scale and impressive quality of installation which the Whitechapel could offer the living artist, especially for showing sculpture (Fig. 4.1). Another reason for its landmark status was the catalogue, the prototype of all future Whitechapel catalogues under Robertson's Directorship. They were to serve as important historical documents, acknowledging the magnitude of the *œuvre* and acting as a framework for the critical coverage of the show (along with the press release, which was also to become an important shaper of public response in the 1950s and 1960s).

The Whitechapel catalogue as a genre of art publishing was central to Robertson's strategy and set the tone for a new attitude towards contemporary art. Through its presentation of that art in an attractive and readable format,[74] it fulfilled one of his key aims, the raising of visual standards. It also provided the artist with essential documentation, contributed to art historical scholarship and provided a lasting record of the occasion consistent with the 'major museum' standard of installation accorded to the work. Its format was distinctive; its text and illustrations were of an incomparably high standard for the time. Another of its functions was strategic; as well as fulfilling a public relations function for the Gallery, a great many of the catalogue prefaces, which were almost always written by Robertson, serve if not as

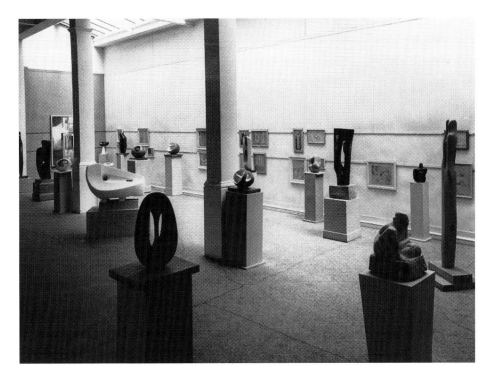

4.1 Barbara Hepworth exhibition, Whitechapel Art Gallery 1954

manifestos, certainly as declarations of intent. Much of his policy and the underlying philosophy behind it was made explicit and thus the public felt drawn into the project. These powerful, highly idiosyncratic essays offer a discourse on the conditions for the production and reception of British art and are informed by a breadth of knowledge and by illuminating parallels and correspondences.

The one-person shows which followed Hepworth: Michael Ayrton in 1955, Josef Herman, Charles Howard and Merlyn Evans in 1956 and S. W. Hayter in 1957, were juxtaposed with European 'greats', Mondrian and de Staël in particular, which although perhaps not as ambitious as the abandoned Picasso retrospective, had a significant impact on British artists. A different kind of impact was provided by the group shows. '20th Century Form' (1953) was a 'plain man's guide' to modern art with the aim of linking painting, sculpture and architecture.[75] 'British Painting and Sculpture' (1954) made explicit its agenda of encouraging patronage, especially with the inclusion of Ivon Hitchens's cartoon for his mural at Cecil Sharp House and Bernard Meadows's bronze cockerel, commissioned by Hertfordshire Education Committee. Although the seminal exhibition 'This Is Tomorrow' (1956)[76] was not

organized by the Whitechapel, Robertson made suggestions on its composition,[77] while the Whitechapel venue is firmly inscribed in its iconography through the much-reproduced ground plan. The exhibition reflected the Gallery's position as a newly established avant-garde exhibiting centre, although the publicity surrounding the show concerned the Trustees.[78]

In his first five years at the Whitechapel, Robertson achieved what he had hoped for, an elevation of visual standards and the creation of a context of great distinction for British and European art. By 1957 the Gallery had 'a European reputation' and was set to embark upon the next stage in placing British art on an equal footing with the best of foreign art.

'An international centre'

By the time that Robertson showed Jackson Pollock in 1958, the Gallery was already a focus for avant-garde artistic activity. Prunella Clough recalled the Whitechapel at that time as 'setting the tone for a whole different kind of avant-garde art', with excellently hung exhibitions and impressive catalogues that made it a 'place everybody went to, a great source of energy'.[79] Reviews of exhibitions from the mid-1950s onwards frequently refer to the status of the Gallery, a shift from the recent tendency to see it as 'lightening the darkness of the East End'.[80] Denys Sutton, writing in 1957, even thought it worthy of comparison with the Museum of Modern Art or the Whitney Museum, New York.[81]

The middle period of Robertson's Directorship was marked by the consolidation of earlier successes and yet more 'admirable eclecticism'.[82] After 1956, British single-artist exhibitions increased in number and variety, reaching a peak in 1960 with consecutive shows by Ida Kar, Roy de Maistre, Ceri Richards, Prunella Clough and Henry Moore. Devoted to work in progress, both solo and group shows also served to chronicle a prevailing shift in artistic interest from Paris to New York. The Nicolas de Staël exhibition in 1956, which was to have been opened by the French ambassador[83] marked the close of a specifically French-oriented period in British art,[84] while the Jackson Pollock show, opened by the American ambassador in November 1958, signalled the beginning of an American hegemony.[85] The Pollock exhibition was the first in the highly influential series of 11 exhibitions of contemporary American art at the Whitechapel over the next 11 years. Most came from the Museum of Modern Art, New York, under its International Exchange Program, and were offered directly to the Whitechapel in preference to any other London gallery.[86]

Pollock's name was common currency amongst the British avant garde by 1958. The retrospective offered a first-hand, large-scale experience of his

work and was significant in attaining wider public acceptance for American painting. One of the most important aspects of that painting was the immediate impact on the viewer of its vitality and sheer magnitude of scale, which were to have a catalytic effect on British art[87] and were exploited to the full by Robertson in the hanging of the show. The idea of the Pollock exhibition was taken up with enthusiasm by the Whitechapel Trustees, who rightly saw it as a compliment to the Gallery.[88] However, Robertson's ambition to make the show 'as handsome as possible'[89] involved seeking the Trustees' approval to commission the architect, Trevor Dannatt, to advise on installation (Fig. 5.1). The reasons given, the size of the paintings and their need for isolation, required some explanation even to William Coldstream, who queried 'what could be done except hang the pictures?'[90]

A great deal was done. Robertson and Dannatt flew to Berlin to see the exhibition there and Dannatt devised a system of moveable breezeblock walls – which were used until 1967 in many flexible combinations – to break up the space and isolate the paintings, and a tent-like false ceiling which unified and intensified the overall effect. The high cost of the installation (over £1200)[91] was balanced against the outstanding success of the exhibition,[92] which resulted in a two-week extension. The enormous importance attached to the installation of the show greatly enhanced its impact.

Robertson's flair for installation contributed greatly to the success of Whitechapel exhibitions and by 1958 it was apparent that they were all hung for the maximum visual impact. Robertson installed almost all the shows and the collaboration of the artist was less usual. Critics frequently mentioned the high standard of installation and artists greatly appreciated it. Jack Smith recalls that his show in 1959 was hung 'incredibly well';[93] Josef Herman was struck by Robertson's 'really wonderful gift of impeccable display', and the way in which the hang of his exhibition was designed around the largest canvas, in an entirely unified way.[94] Perhaps the most telling compliment was an indirect one from Mark Rothko, who worked successfully with Robertson on the installation of his exhibition in 1962 and whose fastidiousness over the installation of his work is legendary. Rothko later asked Robertson to provide the measurement of each painting from the floor, so that he could instruct other galleries taking the show.[95]

Robertson's meticulous, time-consuming working method was based upon a determined logic, disregarding chronology or art historical considerations in favour of the exhibition as a total *ensemble*; one former collaborator described it as 'a joy to behold'.[96] Robertson employed a highly individual play of correspondences and juxtapositions to create a very powerful visual whole. The importance of seeing each exhibition as a totality meant that works in the catalogue could often be excluded from the show in the interest of the overall hang.[97] He never labelled work, disliking anything on the

walls which might detract from the first impact of the exhibition, preferring instead a discreet number.[98] His instinctive flair was applied to the task of giving the quality and scale normally only accorded to grand museum shows to the display of all art, including British art, thus enhancing the professional status of British artists. In some instances it enabled artists to reassess aspects of their work.

The shows of British artists in the late 1950s and early 1960s were extremely varied which is partly the result of Robertson's desire to avoid uniformity, although they projected a collective vigour and certain distinct patterns emerge. One was an increase in younger as well as mid-career artists (which was to escalate in the 1960s); another was the inclusion of artists, who although distinguished, defy classification in any critical framework. Cecil Collins is one such example of a painter who 'swims alone',[99] and there are many others, like Roy de Maistre, Merlyn Evans, Prunella Clough, who defy rigid classification. More than a tendency, it was a strategy to increase the exposure of work by artists who stood outside the fashionable mainstream, informed by awareness that both lesser known and more established artists often worked in isolation or had difficulty showing their work; for many, the result of their exhibition was to be 'injected with a new spirit'.[100] One example was the exhibition of Robert Colquhoun in 1958. Colquhoun and his partner Robert McBryde had been living in considerable hardship and the White-chapel Archive shows that Robertson took an exceptional amount of trouble to make this show a success. He asked Samuel Beckett in Paris to write a catalogue essay about 'the artist in general – the painter – as a kind of archetype (the painter in modern society if you like) and particularly the kind of painter, of whom Colquhoun is one, who is concerned with human beings, the human plight at this moment, and has a tragic as well as a slightly satirical vision'.[101]

Every artist appreciates the opportunity to take stock, and the recognition given to the totality of the *œuvre* was central to the regeneration experienced by the artists.[102] In addition, some artists found that their work was given far wider exposure by being subsequently toured by the Arts Council.[103] Each exhibition was celebrated for its unique qualities; for example, during Ceri Richards's retrospective in 1960 a piano recital was given which included Debussy's 'La cathédrale engloutie', a source of great inspiration to the artist.

Robertson often employed the description 'straightforward' to allay Trustees' fears about 'advanced' exhibitions. Shows of 'straightforward' artists like Derek Hill (1961), Thelma Hulbert (1962) or Mary Potter (1964) were intended to counterbalance the more progressive artists. As early as 1956 Lord Bearsted voiced concern at the 'emphasis on advanced exhibitions lately at the Gallery', and the Director was to be consulted as to how the

exhibitions might be varied.[104] Much rhetoric is recorded in the minutes to inform, educate and persuade the Trustees of the strategy behind the exhibition programme.

A system of checks and balances seemed to operate. The number of safe choices was far less than the number which might present some element of risk. Jack Smith is one instance; having been fêted as a 'Kitchen Sink' realist, his work changed direction in 1956 as he explored a new visual language. Only 31 years old at the time of his exhibition, his work was described in the catalogue preface as interesting because it was at a moment of 'breakthrough'. However, the work was unknown. Smith sees Robertson's offer of a show at that point in his career as a daring gesture, as he had recently been dismissed from the Beaux Arts Gallery by Helen Lessore for no longer painting realist work. None of his new work had been seen, and it was very much part of an exploratory process.[105]

An interest in showing work at a point of transition and change seemed to be a significant factor in determining Robertson's choices, in part no doubt to support the artist at a difficult time but also because he was principally enthused by art practice as a dynamic process. The exhibition of sculpture by Anthony Caro in 1963 was an opportunity for his new work to be seen; otherwise, Caro thought, it would 'probably not have been seen in London for a long time'.[106] The importance of the timing of this show in terms of current developments in British sculpture is crucial. Again the term 'breakthrough' was applied – 'a much abused word in contemporary art writing'[107] – this time by Clement Greenberg, who said of Caro that 'it is possible at long last to talk of a generation in sculpture that comes after Smith's';[108] in Britain that also meant after Moore.

The idea of a British sculptural tradition grew in strength during this period and from an official or public viewpoint sculpture was flourishing, not least in the British Council's exhibitions. The achievements of Moore and Hepworth seemed to have been consolidated by the next generation, Armitage, Chadwick and Butler in particular. An *impasse* had been reached however,[109] and inter-generational conflict was an issue. Moore was viewed with ambivalence; he appeared to have stopped searching for new means of sculptural expression and was now seen as the master-sculptor of the twentieth century. His international standing, rigorous professionalism and concern for the integrity of sculpture were inspirational to younger sculptors, but they looked elsewhere for stimulus. American painting was particularly significant for sculptors at this point, not only for its form and its ex-pressiveness, but because it helped them break away from the recent past in European sculpture.[110]

The exhibitions of sculpture at the Whitechapel during this period, in particular Kenneth Armitage, from the Venice Biennale (1959), Moore (1960),

Hepworth for the second time (1962) and Caro (1963) are the most telling examples of the extent to which the Gallery marked a significant moment of 'breakthrough' in British sculpture, as well as in individual careers. The Moore exhibition gave the public the chance to assess ten years' work and see the larger work in an appropriate space.[111] Reviews were mixed[112] but were perceived by Moore as largely favourable,[113] attendance figures were high and a significant number of sales were made from the Gallery.[114]

The result of this period of consolidation was to establish the Whitechapel even more firmly as a site for the dissemination of advanced art, with an emphasis on late modernism. The American exhibitions were embraced with enthusiasm by the public for their freshness and optimism; attendances at the Rauschenberg exhibition (1964) were 52,000, the highest ever. There were also early signs of those more fashionable aspects of the Gallery's activities which were to characterize the New Generation era from 1964 to 1968, when wide press coverage was given to the regular presence of Princess Margaret and Lord Snowdon at the Gallery. Robertson was by now in a position of considerable influence in the art world[115] and had a formidable international network of friendships and contacts. There was indeed the sense that 'anything was possible'.

'The grandest gallery in London'

The Whitechapel exhibition programme was somewhat less varied during the latter part of Robertson's Directorship and there was a greater emphasis on group exhibitions, with a more pro-active approach to the promotion of younger British artists linked to the ethos which lay behind the four 'New Generation' shows.[116] The patronage of the Peter Stuyvesant Tobacco Company was an essential factor. In 1962–3, Robertson's initiative led to the creation of the Peter Stuyvesant Foundation, a new vehicle for the company's subsequent arts patronage, which extended from music to the visual arts. In addition to the sponsorship programme centred on the Whitechapel, the Peter Stuyvesant collection of recent British painting was started.[117] Robertson argued that the poverty of commercial patronage in England compared with America was due to the 'indisputable fact that the English nation as a whole is not at home with the visual language of the twentieth century',[118] a theme which he addressed throughout his Whitechapel exhibitions programme and in particular through the 'New Generation' series.

At this time there was also a significant increase in exhibitions by younger artists and of those whose work reflected prevailing aspects of late modernist abstraction, like Richard Smith, Harold Cohen, John Hoyland, Tim Scott and Phillip King. Patronage in a broad sense was the dominant theme, linked to

the concept underlying the 'New Generation' series, with its emphasis on youth, on a historical continuum, on creative patronage and, in particular, the attendant media hype. Other group exhibitions also provided models of enlightened patronage: the Peter Stuyvesant Collection was shown in 1965, the Leicestershire Education Authority collection in 1967–8 and the Contemporary Art Society's recent acquisitions in 1968.

Robertson's rôle in establishing the commercial patronage which made the 'New Generation' series possible is well documented. He was approached by the public relations consultants for the Peter Stuyvesant tobacco company in May 1963[119] and immediately responded with an eloquent eleven-point document setting out a sponsorship programme which embraced both the needs of young artists and the public relations requirements of a multinational company.[120] His proposals offered 'all the ingredients: art, youth (but not too young) and internationalism'.[121] The series constituted a phenomenon[122] which is now written into the cultural history of the 'Swinging Sixties' as a signifier of many of the themes of that time.[123]

'New Generation: 1964' reflected the diversity of contemporary British painting between the polarities of abstraction and Pop. Critics seemed confused about whether it represented a break with the past,[124] but saw a similarity of mood between the different styles,[125] in part a reflection of the prevailing cultural image-making of the mid-1960s, with its intermingling of high seriousness and classless informality. Much serious criticism was presented in the language of popular culture[126] with illustrations selected to reinforce this. The excitement generated by 'New Generation: 1964' was less at the newness of the painters, several of whom had already shown in West End galleries or won major art prizes, than at the feel of the show, and a 'highly consistent professionalism, which has not always been so strongly present in British art'.[127] The painters selected in 1966 were more genuinely new, but were hailed as less original, having been overshadowed by their predecessors in the first two shows.[128]

In contrast, the sculpture show 'New Generation: 1965' occupies a crucial position historically as a breakthrough. Evident links between some of the painting in the 1964 show and the sculpture in 1965 highlighted the sculptors' debt to American painters like Kenneth Noland and Morris Louis; in turn, their assimilation and re-invention of American painting were, as John Hoyland suggests, reflected back onto British painting.[129] The group of sculptors chosen by Robertson for 'New Generation: 1965' was a nucleus of five from St Martin's: David Annesley, Michael Bolus, Phillip King, William Tucker and Isaac Witkin, with three others who were perceived as outsiders: Christopher Sanderson from the Slade and Roland Piché and Derrick Woodham from the Royal College of Art, who were perceived as outsiders. The tight knit group from St Martin's saw themselves less as a loose collective

around Caro, than as a 'School',[130] an idea that Robertson loathed,[131] sharing an æsthetic which conformed to the tenets of Greenbergian high modernism. Greenberg's meetings with the St Martin's sculptors when he visited them in 1963 at Caro's invitation and his advice to Phillip King that they should 'stick together as a School'[132] further reinforced the collective bond. King later commented:

> ... whatever feeling of individualistic push I wanted to make for myself, I tended to draw back into the 'School' thing. What I think was wrong with it was that he meant it in terms of aesthetics, of pushing forward in terms of new ideas. Somehow it was linked in one's mind, and he did not make the distinction very clear, to a kind of public image, a 'hype' if you like, a package. That is where one was being deliberately manipulated maybe, without consciously realising it.[133]

Robertson's choice of three outsiders can be seen therefore as not only avoiding a blockbuster show but also one aligned to a rigid theoretical framework. The group shared a rejection of past values, especially of Moore's example, but no consensus on how sculpture might be regenerated. Though King recalls a desire to make sculpture 'that was private',[134] their shared sculptural concerns, in particular colour, abstraction, the absence of the base and the use of new materials, which emerged from a consensus about questioning the very nature of sculpture, gave the work a strong collective impact.

Robertson simultaneously wrote New Generation sculpture into the emergent notion of a British sculptural tradition, placing the younger sculptors in direct linear progression from the British modern masters.[135] Central to this history-making was the timing of 'New Generation: 1965' to coincide with the exhibition at the Tate Gallery, 'British Sculpture in the Sixties', organized by the CAS and sponsored by the Peter Stuyvesant Foundation. Because of concern about funding the CAS exhibition, Robertson agreed to approach the Peter Stuyvesant Foundation about sponsoring it, incorporating the young sculptors at the Whitechapel with those at the Tate. The Tate show was to be described as a 'CAS exhibition in association with the Peter Stuyvesant Foundation' whereas the New Generation show was to be 'an exhibition organised by the Peter Stuyvesant Foundation, in association with the CAS'.[136]

Following a review of both exhibitions in *The Times*,[137] the New Generation group of sculptors was swiftly propelled into an international arena through touring shows such as 'London, the New Scene' and 'The English Eye' (1965).[138] However, the appropriation of their work as a fashionable commodity was irreconcilable with the sculptors' seriousness and professionalism.[139] Although it contributed to the successful marketing of the sculpture it shortened its life as an artistic phenomenon.

The last of the series, 'New Generation: Interim' (1968) was a summary and, with one work by all the artists shown previously in the series, a

conclusion. The New Generation phenomenon had coincided with un-precedented expansion of the art market and its by-products[140] and many of the artists shown were brought to the attention of public institutions and commercial dealers.[141] However, the success of the series was qualified. Although the exhibitions, purchases, dealer and critical interest and the opportunities for travel afforded by the bursaries were of undoubted benefit to the artists, while the sponsors received the publicity and prestige that they sought and British art received an enormous boost, unfortunately the series did not achieve one of Robertson's primary aims, that of setting an example of patronage which other companies might follow. Nevertheless, the series assisted in creating a new status internationally for British art and for London as an art capital.

Robertson also simultaneously helped to shape the notion of London as an 'art capital' through his co-authorship of *Private View*,[142] published in 1965 when the recent expansion of mechanisms for the publicity and promotion of art was just being acknowledged. Reviewed dismissively at the time of publication as a coffee-table lightweight, it now serves as a primary document on the conditions for the production and reception of art in London in the 1960s. Its opening sentence, 'Just what is it that has turned London into one of the world's three capitals of art?' reveals its agenda. Whitechapel artists were heavily represented and the dominant position of the Gallery reinforced in the text.

The possibility of a conflation of *Private View's* image-making and the thrust of the Whitechapel's policy in the mid-1960s may have exacerbated existing tensions between the Director and the Trustees. By 1965 the Gallery and its Director had a high media profile; a double portrait in *Vogue* of Robertson in his home exemplified his flair for using the mechanisms of fashionable publicity to promote a serious intent (Fig. 4.2). It is unclear however, how much the Whitechapel's formative role within 'one of the world's three capitals of art' was appreciated by a number of the Trustees. Local boroughs that gave grants to the Gallery were reported to feel that the exhibitions were too much concerned with experimental art and not enough with catering to the tastes of the local public. In 1966 it was decided to postpone all further exhibitions until additional grants were received.[143] Consequently the Gallery closed from October 1966 until January 1967.

Minutes and correspondence indicate a gradual distancing by the Director between 1966 and 1968. The concentration on high æsthetic standards for exhibitions had been detrimental to efficient administration and financial planning, with overspending and the funding of catalogues a particular concern to the Trustees. An increasingly complex funding situation demanded accountability to organizations as disparate as the Arts Council, the Greater London Council and the Drapers Company, and created an urgent need for

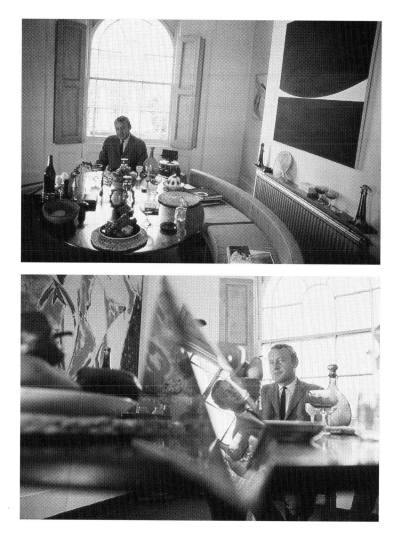

4.2 Bryan Robertson, 'Entertainers in Vogue', *Vogue*, February 1968. The caption
reads: 'Bryan Robertson, Director of the Whitechapel Art Gallery since 1952; advisor
to the Peter Stuyvesant Foundation on their grants scheme to encourage young
English artists; author; broadcaster; bachelor, for whom cooking is "an unwinding
process, real self-indulgence. I usually cook two or three times a week for myself
and have friends over in the weekend". His specialities are chilled cucumber, mint
and yoghurt soup, followed by roast lamb or veal with a large selection of
vegetables, fruit and cheese – "real simple fare, bachelor stuff, but good", and the
ideal adjunct to his entertaining recipe – "total informality, very close friends, no
business, no more than six, ideally three or four, resulting in more talk, more
communication". Photographed here in the dining-room of his Islington flat: below,
through a prism sculpture by Robert Downing; on the left, Lee Krasner's painting
Earth Green. Beside him, above, Nigel Hall's fibreglass and metal castle sculpture; on
the wall, a Brigid [sic] Riley black and white painting'.

strategic administrative and financial planning. Although catalogue prefaces frequently made public much of the strategy underlying the exhibitions policy, this was never documented in any comprehensive policy statement by the Trustees, which was a major deficiency. The funding situation improved but the problems posed by the absence of a policy statement were not resolved until Nicholas Serota was appointed Director in 1976 and a three-year strategy for the Gallery was instituted, to be reviewed annually.

The Gallery was re-opened in 1967 by Jennie Lee, Minister with responsibility for the Arts,[144] with a John Craxton retrospective, an appropriate choice strategically, as his work had broad appeal.[145] Although not well received critically, the show was welcomed with relief as a sign of the Gallery's revival.[146] However, a sense of exhaustion was creeping into the exhibition programme, with a decline in momentum and less variety. John Hoyland's and Tim Scott's two-part shows followed the Craxton exhibition in rapid succession, both delayed because of the Gallery closure, while both exhibitions were subject to dealer pressure to expedite them for psychological and financial reasons.[147] Scott feels that he did not benefit from his exhibition as he had expected; he was disappointed by the muted and puzzled reaction of his peers and, having installed the work himself, considers it was over-crowded.[148] 'Painters from East London' which followed was a 'token'[149] gesture of conciliation fitted in at short notice to address local interests, particularly those of Tower Hamlets Council, as local funding had been reduced because of a perception that the Gallery had 'become a national institution'. Robertson had been asked to consider how the Gallery might be of 'greater interest to the people of East London'.[150] The apparently oppor-tunistic 'Painters from East London' was to become the forerunner of the Whitechapel Open exhibition.[151]

An epoch in the history of the Whitechapel, and British art, was about to end when Robertson's resignation was announced in November 1968.[152] It was of particular significance that his last exhibition of a British artist was Phillip King's sculpture from the disrupted Venice Biennale of 1968. That it was intended to be a finale is clear from the catalogue preface, which offered a résumé of the Whitechapel exhibition policy since 1952. Robertson ended as he had begun, by emphasizing the centrality of British art in the Whitechapel programme, where 'the only criterion has been merit, and this has sometimes cut across fashion'.[153]

Phillip King's exhibition had come from the Biennale, but to the artist the Whitechapel show was a more important event.[154] King, who saw himself as standing somewhat outside the dominant Greenbergian æsthetic at St Martin's, thought that the relationship with the Whitechapel space offered a greater understanding of the relationship between light and colour,[155] and new possibilities for the spectator to experience multi-part sculpture, like

Call and *Span*. The interaction between the Gallery space and the artist's practice vividly illustrates the validity of Robert Medley's description of the Gallery as 'a place for living art'.

The postscript to the Whitechapel exhibition programme was an exhibition not seen in London, an event unique in the Gallery's record. 'New British Painting and Sculpture' was organized by the Gallery for the UCLA Art Galleries in California, with an extensive North American tour in 1968–9.[156] The artists were selected by Robertson and Sir Herbert Read, who made his participation conditional on Robertson's collaboration.[157] A highly prestigious exhibition, it formed part of an extensive promotional programme to reinforce London's status as a new art capital. It demonstrated once again Robertson's avoidance of a fixed position or critical orthodoxy, through the creation of a dynamic group of eight painters and nine sculptors, which included mid-career artists like Caro and Clough and very young artists like Nigel Hall. The artists were selected for their diversity within a predominantly late modernist framework, and part of the agenda for the exhibition was to counteract the stereotype of Swinging London. American public response was mixed.[158] The catalogue dialogue encapsulates Robertson's beliefs about English art[159] and offers a discourse on national artistic identity summarizing some of the dominant issues of the time.

The exhibition travelled throughout North America under the ægis of the Whitechapel, yet remarkably it was not seen by the London public which the Gallery existed to serve. Whilst it demonstrated the international status of the Whitechapel, it also revealed just how distanced the exhibitions pro-gramme had become from the needs of the Gallery's East End public. The previous 16 years had witnessed Robertson's outstanding achievement in repositioning the Whitechapel and British artists within an international framework by means of a highly idiosyncratic programme, but it had been at some cost. It was now time to refocus that programme back onto the needs of the local community, whilst maintaining the Gallery's position of importance in the international art world.

Meanwhile, a somewhat weary Robertson left for the United States in 1968 to set up a new museum at the State University of New York. On his return to London, a series of successful exhibitions followed in the early 1980s at the Warwick Arts Trust. A long and distinguished career as writer, broadcaster, curator and *éminence grise* of modernity was celebrated in characteristic style in November–December 1999 in an exhibition at Kettle's Yard, Cambridge. '45–99: a Personal View of British Painting and Sculpture by Bryan Robertson' was a personal anthology selected and installed by Robertson. It spanned five decades of British art, included many Whitechapel artists and manifested very vividly 40 years later the same expression of individuality and the same spirit which had flourished at the Whitechapel

Art Gallery in the 1950s and 1960s, which exerted such a profound and lasting influence on contemporary British art.

Notes

Any source not otherwise attributed is the Whitechapel Art Gallery Archive.

1. Robert Medley, *Drawn from the Life: a Memoir*, London: Faber & Faber, 1983, p. 212.

2. The position of the Whitechapel in 1952 was one of newly established security in its financial position and in the quality of its exhibitions, after a long period of severe difficulty compounded by war. Hugh Scrutton, Director (1947–52) had managed to regenerate the Gallery as a highly regarded venue, with exhibitions of the Pre-Raphaelites, Eighteenth-Century Venice, W.P. Frith and, for the Festival of Britain, 'Black Eyes and Lemonade.'

3. *The Tate Gallery Review 1953–63*, p. 5.

4. Conversation, 14 February 1991. See also minutes of the CAS Executive Committee, 14 February 1967.

5. A term used by Prunella Clough to describe this period (conversation, 10 March 1991).

6. A comprehensive account of the reasons for the change in the orientation of British painting from Paris to New York by the late 1950s is Alan Bowness, 'The American Invasion and the British Response', *Studio Int.*, 173:890, June 1967, pp. 285–93. The notion of London as pre-eminent art capital was also shaped by *Private View* (Robertson, Russell & Snowdon, London: Thames and Hudson, 1965) which sought to erase Paris and set up a London–New York axis.

7. The post was not advertised; suitable candidates were canvassed and a vote taken on the two final candidates; the other was Peter de Francia (Trustees minutes, 12 March 1952). Robertson recalls that the other candidates included Lawrence Alloway, Quentin Bell, Lawrence Gowing and David Sylvester (telephone conversation, 6 December 1999).

8. Of 32 British one-person shows, seven were by women (Hepworth twice).

9. Robertson is unwilling to claim responsibility for 'This Is Tomorrow' as he did not organize it. However correspondence (letter to Theo Crosby, 23 May 1955) makes it clear that he supported the project.

10. See Robertson's selection of the three sculptors in 'New Generation: 1965' who did *not* come from St Martin's: Sanderson, Piché and Woodham.

11. Faber & Faber, London, 1940.

12. Conversation, 17 January 1991.

13. Canon Barnett also founded Toynbee Hall, the first university social work settlement, which retained close links with the Gallery.

14. First Report of the Trustees 1901, quoted by Juliet Steyn in 'The complexities of assimilation in the 1906 Whitechapel Art Gallery exhibition "Jewish Art and Antiquities"', *The Oxford Art Journal*, 13:2, 1990, p. 44.

15. *Civilising Caliban: The Misuse of Art 1875–1980*, London: Routledge & Kegan Paul, 1987, p. 119.

16. See *The Studio*, 19, 1896, quoted by Steyn, 'The complexities of assimilation', 1990, p. 44.

17. See Carol Duncan & Alan Wallach, 'The Universal Survey Museum', *Art History*, 3:4, December 1980, pp. 448–69.

18. Henry Moore considered the Whitechapel the best space for sculpture in London (Roger Berthoud, *The Life of Henry Moore*, London, Faber & Faber, 1987, p. 324).

19. A change of the name of the Gallery to the less site-specific East London Art Gallery was a recurring topic at Trustees' meetings after the four local councils began to grant-aid the Gallery in the 1940s.

20. See Steyn, 'The complexities of assimilation', 1990, p. 44.

21. Letter, 28 May 1953. See also Robertson's letter to Toklas, 26 June 1952.

22. Conversation, 17 January 1991.

23. See Robert Hewison, *In Anger: Culture in the Cold War 1945–60*, London: Methuen, 1981, pp. 203–6.

24. Telephone conversation with Bryan Robertson, 11 May 1991.

25. Conversation with Tim Scott, 12 March 1991.

26. Conversation with Prunella Clough, 10 March 1991.

27. Conversation with John Hoyland, 22 March 1991.

28. London was then as now, centre of the art world in Britain, and the focus for publishing, critics, major exhibitions and in particular, site of the national collections. See Margaret Garlake, *New Art, New World: British Art in Postwar Society*, Yale University Press, New Haven & London, 1998, chapter 2.

29. The importance of certain major artists, like de Staël, Giacometti and Dubuffet cannot be over-stressed, whilst it seems to have been felt that the younger French artists could offer much less. The older Surrealists were a continuing and significant influence. A number of exhibitions, in particular 'London-Paris', ICA (1950), 'L'Ecole de Paris', Royal Academy (1951) and the Arts Council's 'Young Painters of l' Ecole de Paris' (1952) were important in clarifying the distinctions between the older and younger generations.

30. Bowness, 'The American Invasion', 1967, p. 288.

31. Michael Ayrton, 'The Heritage of British Painting' Parts I–IV, *The Studio* 132:641–4, August–November 1946.

32. This situation was contradicted by Patrick Heron, who claimed that 'the centre of gravity of mainstream development shifted from New York to London around 1960' (letter in *Studio Int.*, 173:889, May 1967, p. 227). Brandon Taylor argues against this claim ('Abstract Colour Painting in England: the Case of Patrick Heron', *Art History*, 3:1, March 1980, pp. 115–28).

33. See Garlake, *New Art, New World*, 1998, pp. 20–2.

34. Most of the exhibitions of contemporary art at the Tate Gallery were organized by the Arts Council. Less frequent organizers were the Contemporary Art Society and the Edinburgh Festival.

35. Predominant were the Leicester Galleries, the Redfern, the Hanover, Arthur Tooth & Sons, Lefevre, Gimpel Fils and smaller galleries such as Helen Lessore's Beaux Arts. See Marcy Leavitt Bourne, 'Some aspects of commercial patronage 1950–1959: four London galleries', unpublished MA thesis, Courtauld Institute of Art, University of London, 1990, for a fuller account of commercial patronage at this time. Restrictions on the import of works of art imposed great constraints upon their activities. Import restrictions from America were lifted in 1953 and all restrictions from December 1954 (*The Times*, 1 December 1954).

36. See Margaret Garlake, 'The Relationship between Institutional Patronage and Abstract Art in Britain, c.1945–1956', unpublished PhD thesis, Courtauld Institute of Art, University of London, 1987, chapter 2, for a full account of the relationship between critical attitudes and institutional patronage.

37. Bryan Robertson, Preface, *20th Century Form: Painting, Sculpture and Architecture*, exh.cat., Whitechapel Art Gallery, London, 1953, p. 3.

38. During Robertson's Directorship, the mix of Trustees was extremely broad. Trustees' minutes show that some, usually those representing local political interests, had very little understanding of contemporary art, while others made a significant and often very creative contribution, notably Francis Watson, director of the Wallace Collection, Professor Sir William Coldstream (who supported many of Robertson's plans with reasoned and persuasive arguments), Lady (Rose) Henriques and Mrs Patricia Strauss, Chair of the LCC Parks Committee in the late 1940s and 1950s.

39. This may also have been because of the approach of the generous and enlightened Chairman of Trustees, the (3rd) Viscount Bearsted, who took a supportive rather than an interventionist role, believing that the Director should have full artistic control of the Gallery (telephone conversation with Mark Glazebrook, 13 March 1991).

40. Conversation, 9 April 1991.

41. 'American Painting' at the Tate Gallery in 1946 set a historic context for Abstract Expressionism; paintings by Pollock were first shown in London in 'Opposing Forces' (ICA,

1953). Clement Greenberg's 'The present prospects for American painting and sculpture' *Horizon*, 16, October 1947 was also a powerful indicator of 'something in the air'.

42. Conversation, 14 February 1991.

43. *Piet Mondrian*, exh.cat., Whitechapel Art Gallery, 1956, p. 3.

44. Bryan Robertson, 'The Younger British Artists', *The Studio*, 131:636, March 1946, pp. 65–76.

45. *Michael Ayrton*, exh.cat., Whitechapel Art Gallery, 1955. The choice of a remarkably diverse artist working in several media, with a broad humanist appeal was significant as a start to the series of younger British artists.

46. Ibid.

47. The next exhibition, 'The Proper Study', later changed to 'Looking Forward', had been arranged by his predecessor and curated by John Berger. After 'East End Academy', Robertson's first show at the Gallery would be '20th Century Form', an exhibition of British and French architecture, painting and sculpture, followed by a Turner retrospective (minutes of Trustees' meeting, 11 June 1952).

48. See *Whitechapel Art Gallery: 52nd Annual Report 1952–53*, p. 6.

49. 'An East End Gallery with a European Reputation', *The Times*, 24 August 1957.

50. Robertson has written and broadcast on numerous occasions on the conditions necessary for artistic production. See 'Against the rimless men: reflections on the young artist', *The London Magazine*, 3:3, June 1963, pp. 48–62.

51. Robertson, letter to Douglas Cooper, 15 October 1952. 'I am starting … a special Appeal fund in the Gallery for the show, to which visitors may contribute … the idea of a somewhat exotic exhibition in this part of London may appeal to them. We shall see' (ibid).

52. Robertson, letter to Alice B.Toklas, 26 June 1952. 'It has never been done in England before and should be a most exciting and wonderful event' (ibid).

53. Sir John Rothenstein, letter to Robertson, 20 September 1952.

54. Whatever intervention Miss Toklas may have made with Picasso, it was unsuccessful. Two letters, one undated but probably July 1952, another 21 August 1952, indicate her willingness to support the project: 'anything I can do to help – short of lending you pictures from Gertrude Stein's collection (they definitely do not leave Paris) – your plans for a comprehensive exhibition of Picasso's work will be done' (July 1952).

55. Alfred Barr, letter to Robertson, 14 July 1952.

56. This was when the 'Tate affair', in which Cooper and John Rothenstein were leading protagonists, was at its height (John Rothenstein, *Brave Day, Hideous Night, Autobiography 1939–65*, Hamish Hamilton, London, 1966, pp. 232–368). Robertson was aware of the problems this raised (letter to Peter Gregory, 31 October 1952).

57. Cooper, letter to Robertson, 24 November 1952: 'select say 30 pictures … big, and by *quality* only … Try and secure the Cubist exhibition planned for 1953 … take a subject or period from Picasso's work to cover … Get the Partisans for Peace to ask Picasso to do a show with them … "They" tell me Penrose is a Communist. If it were a show for Peace (Eisenhower's atom and hydrogen bombs will be well on their way by that time), Whitechapel might be delighted and you would get from Picasso all you want.'

58. Conversation, 9 April 1991.

59. Robertson, hand-written postscript to letter to Cooper, 15 October 1952: 'Gustav K. [Gustav Kahnweiler, brother of Daniel Henry Kahnweiler] suggests that we have the "English collections" show and a handful of great pictures from abroad. He will then lend things, but he implied quite strongly that he would *not* lend if we persisted in calling the show a retrospective, as he agrees with K … that we cannot do this kind of show.'

60. Minutes, 10 December 1952. As the consensus was against holding this exhibition, 'it was decided to abandon the project'.

61. Robertson, letter to Richard P. Taylor, Cultural Attaché at the US Embassy, 30 December 1952 described the reason as a 'rather subtle and difficult political question – we are a public gallery, dependent on various bodies and institutions for our income, and even if, at the lowest and most trivial level, the *Daily Worker* is sold outside our doors, our motives might be misinterpreted by these bodies. The Communist Party is active in this part of London, and it is possible that they might try to make capital out of the Picasso exhibition.'

62. Alfred Barr's 'Is modern art Communistic?' *The New York Times Magazine*, 14 December 1952, pp. 22–30, examined this prevailing fear in the West.

63. Roland Penrose, *Picasso: his Life and Work*, Harmondsworth: Pelican, 1971, pp. 377–9.

64. The most representative exhibition of Picasso's paintings yet assembled took place at the Tate Gallery in 1960 (ibid., pp. 444–5). The overwhelming public response to the exhibition, with almost half a million visitors, indicates the kind of impact Robertson could have expected had a retrospective taken place at the Whitechapel in 1953.

65. 'Turner Resurgent', *The New Statesman & Nation*, 45:1146, 21 February 1953.

66. Conversation with Robertson, 14 February 1991.

67. Trustees minutes, 24 March 1954.

68. The correspondence in the Whitechapel Archive relating to the 1954 Hepworth show demonstrates the enormous effort expended by Robertson on sales and publicity. All major museums and galleries and a range of distinguished collectors, including the Queen Mother, were approached.

69. Trustees minutes, 15 September 1954.

70. 'Yours is the only good gallery for sculpture in London, and I should love to show under your Directorship' (letter to Robertson, 3 June 1953). She involved herself in every aspect of the exhibition, and a relationship of trust and mutual affection grew up between her and Robertson, who consulted her on everything and received lengthy and detailed letters revealing an enormous personal investment in the exhibition; she worked on every detail of the installation, the catalogue and the transport.

71. Hepworth, letter to Robertson, 28 November 1954. He had asked her to 'ruthlessly eliminate as much small scale sculpture as possible … For me the *real* sculpture is large sculpture. I feel the exhibition will be far more dramatic and make its point more tellingly if we concentrate on the fair-size and large items' (letter to Hepworth, 27 November 1954). He acknowledges how much he learnt from Hepworth about sculpture as well as about the struggle women artists had to undergo to succeed.

72. Letter to Robertson, 10 March 1954.

73. For example, Dr Hammacher, Director of the Kröller-Müller museum at Otterloo, wrote to Robertson, 27 August 1954, to propose a Mondrian exhibition at the Whitechapel: 'from every point of view I feel certain it would be the ideal gallery for a Mondrian exhibition'.

74. MoMA had pioneered the scholarly catalogue in the USA but in Britain there were no precedents for Robertson's uniformly excellent catalogues (resisted by some Trustees because of costs).

75. The exhibition contained 70 architectural exhibits, including three of Le Corbusier's Unité d'Habitation in Marseilles. See John Summerson, 'Sense Out of Nonsense', *The Observer*, 19 April 1953.

76. See David Robbins (ed.), *The Independent Group: Post War Britain and the Aesthetics of Plenty* Cambridge, Mass. & London: MIT Press 1990.

77. In a letter to Theo Crosby, 23 May 1955, he suggests the exclusion of Sarah Jackson and the inclusion of Bernard Meadows, Nicholson, Hepworth and either Martin Fry [sic] or Jane Drew and, as a postscript, suggested John Forrester, and 'Have you thought of having furniture? It would probably ruin – and clutter up – everything, but it is a point if you want to [sic] show to have a practical aspect.'

78. See letter from Theo Crosby to Ann Forsdyke, Assistant Director, 10 August 1956: 'It is true that the exhibition is confusing, but it is a confusing subject and cannot easily be described. It was our intention to submit people – and ourselves – to a series of impressions, which vary from group to group. The question of numbering the "stands" is unimportant, as people with catalogues can find their way around, and without catalogues the numbers would be meaningless … In any case it is not to be expected that a completely unsophisticated layman will thoroughly understand the exhibition at once – one needs a certain background to begin from.'

79. Conversation, 10 March 1991.

80. A unnamed reviewer in *The Times Educational Supplement* writing on '20th Century Form', 17 April 1954; a not untypical reflection of the view of an 'other' public in the East End.

81. *The Financial Times*, 23 October 1957. See also 'What the Whitechapel looks at today, the nation will look at twice tomorrow' (*The Times Educational Supplement*, 17 April 1959).

82. 'An East End Gallery with a European reputation', *The Times*, 24 August 1957.

83. At the last moment the French ambassador was unable to come and had no deputy to send; the catalogues had not arrived, and a furore had been caused by resignations from the Committee of Honour, so the de Staël show had an unfortunate start. The resignations, of Douglas Cooper and Graham Sutherland, were over Sir John Rothenstein's membership of the Committee, as Cooper felt he had not done enough to bring de Staël to the Tate in his lifetime.

84. See Bowness, 'The American Invasion', 1967.

85. See ibid. for exhibitions that had already introduced the School of New York to Britain. Lawrence Alloway also advocated and promoted American painting.

86. The importance of MoMA in the 'American invasion' and the politics of American cultural imperialism were important factors in the æsthetic debate. Porter McCray, Director of Circulating Exhibitions at MoMA, had told Robertson in 1956 that if a Pollock retrospective ever happened, he would like it to come to the Whitechapel. Pollock died shortly afterwards, and the show became a memorial, travelled to the São Paulo Bienal in 1957 and toured Europe 1958–9.

87. See Adrian Lewis, 'American art and its influence on British painting', unpublished MA thesis, Courtauld Institute of Art, University of London, 1975.

88. Trustees minutes, 11 December 1957; 19 March 1958.

89. Ibid. September 1958.

90. Ibid.

91. An Arts Council grant of £250 was received towards this but there is no record of MoMA's contribution.

92. Robertson lectured at the Arts Council on Pollock, showed Hans Namuth's film there and at the ICA and was commissioned by Thames and Hudson to write a monograph on Pollock.

93. Conversation with Jack Smith, 11 March 1991. See also *The Critics*, BBC, transcript n/d but probably May 1959.

94. Conversation with Josef Herman, 12 March 1991.

95. Rothko, letter to Robertson, n/d but probably December 1962. See also Robert Motherwell, letter to Robertson, 1 June 1966.

96. Conversation with Mel Gooding, 17 March 1991.

97. Lawrence Alloway's 'The Art of Jackson Pollock 1912–1956', *The Listener*, 60:1548, 27 November 1958, presented none of the compliments to the installation contained in almost every other review and devoted a paragraph to complaining about the omission of drawings listed in the catalogue.

98. Conversation with Robertson, 9 April 1991.

99. See Nevile Wallis, *The Observer*, 25 September 1960.

100. Conversation with Jack Smith, 11 March 1991.

101. Robertson, letter to Samuel Beckett, 19 December 1957.

102. See Medley, *Drawn from the Life*, 1983, p. 224.

103. Colquhoun 1958; Hayter 1958; Clough, Vaughan 1962; Medley 1964 (information from *Bibliography of Arts Council Exhibition Catalogues, 1942–1980*).

104. Trustees minutes, 27 June 1956. It may be no coincidence that this meeting fell between the de Staël show, with its attendant publicity and 'This Is Tomorrow' in August 1956, to be opened by Robbie the Robot.

105. Conversation with Jack Smith, 11 March 1991.

106. Telephone conversation with Anthony Caro, 18 March 1991.

107. Clement Greenberg, 'Anthony Caro', *Studio Int.*, 174:892, September 1967, p. 116.

108. Ibid.

109. See Alan Bowness, 'Some recent history' in *London: The New Scene*, exh.cat., Walker Art Gallery, Minneapolis, 1967.

110. See Charles Harrison, 'Some recent sculpture in Britain', *Studio Int.*, 177:907, January 1969, pp. 26–33.

111. 'Henry Moore should have had this exhibition four or five years ago but the artist was very much hampered by travelling exhibitions which made it difficult to assemble his work' (Trustees minutes, June 24 1959).

112. *The Times*, 28 November 1991; Lawrence Alloway, 'Hollow rolling sculpture', *Weekly Post*, 17 December 1960; Anthony Caro in *The Observer*, 27 November 1960.

113. Berthoud, *Henry Moore*, 1987, p. 289.

114. Moore later offered to donate to the Gallery 'for an indefinite period until our needs have been met, the third commission from all sales of sculpture or drawings *from his studio'*. The offer was refused, possibly because the income would be taxable and would therefore affect the Gallery's charitable status (Trustees minutes, 19 September 1962).

115. The minutes of the CAS 1957–70 show that he used his influence continually to promote the interests of younger artists, and to advocate the commissioning of new work and the occasional purchase of larger works rather than the usual less expensive work (24 March 1961).

116. 'New Generation: 1964' showed painting; 'New Generation: 1965' sculpture and painting; 'New Generation: 1966' sculpture; there was a reprise of all participating painters and sculptors in 'New Generation 1968: Interim'.

117. Curated by Alan Bowness, Sir Norman Reid and Lilian Somerville and exhibited as 'Recent British Painting' (Tate Gallery, 1967).

118. Robertson 'Recent British Painting' in H. Scheepmaker (ed.), *Adventures in Art: an International Group of Art Collections in Industrial Environments*, New York: Harry N. Abrams, 1970, pp. 165–70.

119. Letter to Robertson from Alan Kimber of Frank O'Shaughnessy Associates, 7 May 1963.

120. See memo, 'Rothmans of Pall Mall Call Report', 13 May 1964, from Alan Kimber, PR consultant, to M. M. Kaye, Peter Stuyvesant Company.

121. Ibid.

122. See Tim Marlow, 'The marketing and impact of New Generation sculpture', unpublished MA thesis, Courtauld Institute of Art, University of London, 1988.

123. David Mellor's unpublished lecture 'Rethinking British art in the Sixties' (Courtauld Institute of Art, 5 March 1991) analysed the New Generation phenomenon in terms of the dramatic expansion in the mechanisms for publicity and promotion of art in the 1960s and highlighted aspects of image-making in the depiction of the artists and emphasis on youth and provincialism.

124. See Mario Amaya, 'British Mods and Rockers', *The Financial Times*, 22 April 1964; John Russell, *The Sunday Times*, 27 March 1964.

125. See Edward Lucie-Smith, *The Critics*, BBC, 12 April 1964 (transcript in Whitechapel Art Gallery Archive).

126. See Amaya, 'British Mods and Rockers', 1964; Jonathan Miller, 'à la Mod', *The New Statesman & Nation*, 29 May 1964.

127. Amaya, 'British Mods and Rockers', 1964.

128. Indicated by titles like 'Whitechapel Gallery's good idea gone stale' (*The Times*, 20 July 1966) and 'Living on the Past' (*The Financial Times*, 26 July 1966).

129. 'The way that [the sculptors] were approaching the basics, colour, form, scale, and non-figuration head on was something that seemed to give more clues to a way forward than what anyone was doing in painting' (conversation, 22 March 1991).

130. This term was used by Greenberg to King. Caro recalls the group's relationship in similar terms (telephone conversation with Caro, 18 March 1991).

131. Conversation with Robertson, 9 April 1991.

132. Conversation with King, 23 November 1990.

133. Ibid.

134. Ibid.

135. Although King heard obliquely that Moore initially described his work 'and maybe that of the other sculptors as window-dressing stuff' (ibid.).

136. CAS minutes, 24 April 1964.

137. 'A Revolution in British Sculpture', *The Times*, 9 March 1965.

138. Marlow, 'The marketing and impact', 1988, pp. 32–6.

139. The conflation of art and fashion was a dominant issue, but the economic reality for the artists was quite different. The film director Antonioni was introduced to a number of artists in order to experience the London artistic milieu, but was very disappointed to find that the artists 'were not swinging enough' (conversation with King, 23 November 1990).

140. There was a great expansion in the dealer system, with a powerful group of new commercial galleries: Kasmin, Rowan, Robert Fraser and Marlborough. Much more money was available to promote the reception of art in the newer dealer galleries. There was a great increase in the number of international exhibitions with a much higher standard of catalogue production, new audiences for art through TV programmes like *Monitor*, the new Sunday colour supplements and the re-launch of *Studio* as *Studio International*.

141. The British Council's selection of Phillip King and Bridget Riley for the 1968 Venice Biennale followed their successes in the New Generation shows.

142. With John Russell, art critic of *The Sunday Times*, and photographs by Lord Snowdon.

143. Trustees minutes, 7 September 1966.

144. With a widely reported speech on the importance of increased spending on the arts by Government and private sponsors (BBC External Services Broadcast, 10 January 1967; transcript in Whitechapel Archive).

145. It pleased the Trustees, as a safe choice, while Hugh Farmar, Secretary to the Draper's Company (the sponsor) had a particular interest in saving Cretan wild goats from extinction so Craxton's imagery had a special appeal for him.

146. David Thompson (*The Spectator*, 27 January 1967), John Russell (*The Sunday Times*, 22 January 1967) and others acknowledged the value of variety in art and Robertson's policy of cutting across fashion in Whitechapel exhibitions.

147. Letter to Robertson from Leslie Waddington, 12 January 1967. This is the only instance found of direct intervention by a dealer in Gallery affairs, although there were a number of collaborations, such as Kasmin's financial assistance towards the Caro exhibition.

148. Conversation with Scott, 12 March 1991.

149. Trustees minutes, 5 July 1967.

150. Letter to Robertson from Walter Birmingham for the Finance Committee, 29 April 1968. Robertson's first response (n/d), 'An Exhibition Scheme for East London', was greeted as 'an exciting project' by the Trustees.

151. See Dennis Barker, *The Guardian*, 11 August 1967.

152. Press release, 1 November 1968.

153. See Preface, *Phillip King 1960–68*, exh.cat., Whitechapel Art Gallery, 1968, unpaginated.

154. Conversation with King, 20 March 1991.

155. Ibid.

156. It was funded entirely by UCLA. Letter from Robertson to Alec Gregory-Hood and Diana Kingsmill, 25 July 1967.

157. See Preface, *New British Painting and Sculpture*, exh.cat., Berkeley: UCLA Art Galleries, 1968, unpaginated.

158. Telephone conversation with Nigel Hall, 11 May 1991.

159. Read and Robertson shared a dislike of 'British' as a descriptive term for national cultural identity, preferring 'English every time, unless one is writing for the British Council etc.' (letter, Read to Robertson, 10 September 1967).

Whitechapel Art Gallery exhibitions 1952–69

1952 Looking Forward (curated by John Berger); East End Academy **1953** J. M. W. Turner; 20th Century Form; Thomas Rowlandson; John Martin; East End Academy **1954** Pictures for Schools; Barbara Hepworth; George Catlin; British Painting and Sculpture 1954 **1955** Pictures for Schools; The Bearsted Collection; American Primitive Art; Piet Mondrian; Michael Ayrton; London Group members' exhibition; East End Academy **1956** Pictures for Schools; Josef Herman; Nicolas de Staël; Charles Howard; This is Tomorrow; Merlyn Evans; Jewish Artists in England 1656–1956; East End Academy **1957** George Stubbs; Bernardo Bellotto; Sidney Nolan; Women's International Art Club; S. W. Hayter; East End Academy **1958** Pictures for Schools; Robert Colquhoun; Guggenheim Painting Award; Alan Davie; Seven British Artists; Women's International Art Club; Jackson Pollock **1959** Pictures for Schools; East End Academy; The Graven Image; Jack Smith; Kenneth Armitage; Kasimir Malevich; Cecil Collins **1960** Pictures for Schools; East End Academy; Ida Kar; Roy de Maistre; Ceri Richards; Prunella Clough; Henry Moore **1961** Pictures for Schools; Vanishing Stepney (paintings by Rose Henriques); Edmond Kapp; Recent Australian Painting; Contemporary Art Society Recent Acquisitions; Mark Rothko; Derek Hill **1962** Mark Tobey; Keith Vaughan; Barbara Hepworth; Arthur Boyd; The Hallmark Collection; Thelma Hulbert; East End Academy; Pictures for Schools **1963** Philip Guston; Serge Poliakoff; British Painting in the Sixties; Antony Caro; Robert Medley **1964** Robert Rauschenberg; The New Generation 1964; Franz Kline; Young Commonwealth Artists; Mary Potter; Jasper Johns **1965** The New Generation 1965; Harold Cohen; Morris Louis; Lee Krasner; Peter Stuyvesant Foundation **1966** Bryan Kneale; Robert Motherwell; Richard Smith; The New Generation 1966; Women's International Art Club **1967** John Craxton; John Hoyland; Tim Scott; Painters from East London; Gertrude Hermes; British Sculpture and Painting from the Leicestershire Education Authority Collection Part 1 **1968** British Sculpture and Painting from the Leicestershire Education Authority Collection Part 2; Contemporary Art Society Recent Acquisitions; The New Generation 1968: Interim; Ghika; Phillip King; (subsequent exhibitions organized by Bryan Robertson before he left the Gallery) Betty Parsons; New British Painting and Sculpture (organized by the Whitechapel to tour the USA and Canada) **1969** Helio Oititica; Helen Frankenthaler; Robert Downing.

The triumph of 'The New American Painting': MoMA and Cold War cultural diplomacy

Stacy Tenenbaum

Writing the cultural Cold War

This paper is concerned with a single exhibition, 'The New American Painting' (1958–9), organized by the Museum of Modern Art, New York. The Cold War mythology surrounding it has become its principal discourse, even though it is falsely constructed. An episode replete with paradox, involving a confrontation between international Communism and abstract painting, US government agencies and artists, museum directors in New York and Europe, as well as a vociferous and respected clutch of historians, its detailed history reveals much about the politicization of contemporary art during the Cold War.

The 1950s was not a successful decade for American cultural diplomacy, with specific regard to officially organized art exhibitions. This was not for any failure to recognize the potential of modern art as a form of cultural exchange. The US State Department fully realized that showcasing American art was a means to show the rest of the world that, in the words of George Kennon, America was not 'a Nation of vulgar, materialistic nouveaux riches, lacking in manners and in sensitivity, and … contemptuous of every refinement of æsthetic feeling'.[1] In spite of this pragmatic point of view, right-wing politicians and government cultural agencies often blocked the export of officially organized art shows, as certain artists were suspected of being politically subversive – solely because their art was abstract. Several government-sponsored exhibitions intended to be sent abroad were cancelled at the last minute for fear of exporting 'communistic', and therefore un-American, art. So paralysed was the government by its fear of the communist threat in modern art, that it was unable to take responsibility for organizing US representation at the numerous international art fairs throughout the 1940s and 1950s.

With the government unable to consummate cultural exchange pro-
grammes, the successful export of contemporary American art to Europe
during the Cold War was left to private institutions. The International Program
of the Museum of Modern Art (MoMA) in New York played a key role – by
default – as cultural ambassador throughout the 1950s. Sponsored by the
Museum's International Council, the International Program's mission was to
organize and circulate exhibitions abroad in order to educate the world
about American art, unintentionally filling the cultural void left by the
government. Ironically, MoMA has suffered criticism instead of praise for its
cultural exchange activities during these years.

'The New American Painting' was 'the first comprehensive exhibition to
be sent to Europe of advanced tendencies in American painting'.[2] It marked
the first time American Abstract Expressionism was exhibited by an institution
as a coherent style, a significant event in the history of post-war art. The
exhibition featured 17 artists: William Baziotes, James Brooks, Sam Francis,
Arshile Gorky, Adolph Gottlieb, Philip Guston, Grace Hartigan, Franz Kline,
Willem de Kooning, Barnett Newman, Robert Motherwell, Jackson Pollock,
Mark Rothko, Theodoros Stamos, Clyfford Still, Bradley Walker Tomlin and
Jack Tworkov, with four to five works by each artist and a total of 81
paintings.[3] The paintings represented major examples of each artist's work
between 1945 and 1958.

Organized at the request of European museums, 'The New American
Painting' was intended as an educational, cultural exchange between the
United States and European countries. The exhibition travelled to Basel,
Milan, Madrid, Berlin, Amsterdam, Brussels, Paris and London under the
auspices of the Museum's International Council. To inform foreigners about
the International Program, a mural-sized map at the exhibition's entrance
illustrated the many accomplishments of its seven-year history, which at that
point totalled 461 showings of 60 exhibitions, in many media, in over 50
countries. At the end of the tour, 'The New American Painting' was shown
at MoMA; it was the first travelling exhibition organized by the International
Program to be shown at the Museum.

In 1958 *Time* magazine called 'The New American Painting' 'one of the
most explosive and controversial art shows in decades'; its impact was
compared with the 1913 Armory show and accordingly, it received an
enormous amount of attention.[4] Decades later, the exhibition continued to
receive attention, as it was embroiled in a conspiracy theory linking MoMA
to the CIA. This notion was conceivable to some, as the CIA is now known to
have funded a variety of cultural activities during the Cold War intended to
promote democracy at home and abroad.[5] The commonly held belief is that
a key government cultural agency, the United States Information Agency
(USIA), not MoMA, sponsored 'The New American Painting'. It has also

been suggested that the Museum carried out the government's cultural offensive of promoting democracy abroad by exhibiting American Abstract Expressionism in foreign countries. Some scholars have even proposed that MoMA was a CIA operative and conceived 'The New American Painting' solely as a propaganda tool to help the CIA wage its cultural Cold War.

This conspiracy theory was promulgated in the 1970s and 1980s by revisionist art historians, who attempted to resituate modern art history in a more socio-political context.[6] They challenged the modernist idiom espoused by Alfred Barr, Clement Greenberg and Irving Sandler who, in their individual ways, had all championed Abstract Expressionism. The revisionists fundamentally disagreed with æsthetic, formalist interpretations of post-war art such as Sandler's *Triumph of American Painting* (1970), which ignored political ideology. They dismissed such readings as American 'cultural swaggering'.[7] Instead, the revisionists interpreted the success of Abstract Expressionism and the concurrent shift in artistic hegemony from Paris to New York in relation to the political climate in the post-war era.

They argued that Abstract Expressionism's facile triumph over Ecole de Paris abstraction was a result of American Cold War cultural imperialism, and not artistic merit. They credited the US government with enlisting Abstract Expressionism, which was avant-garde and startling in the 1950s for its large-scale, exuberant brushwork and lack of concrete subject matter, as a propaganda tool, a cultural manifestation of American liberalism and free-world values. They argued that – in the minds of 'enlightened' American government officials – exhibiting abstract art abroad demonstrated that a democratic, free nation like the United States not only *permitted* but also *encouraged* artistic initiatives as extreme as Abstract Expressionism (initiatives still incomprehensible to the American public) in order to promote democracy abroad.

Much revisionist scholarship erroneously proposed that 'The New American Painting' was commissioned and sponsored by the USIA as a weapon of the government's 'cultural Cold War'. Hence, MoMA became a target of criticism for having promoted this 'triumph' of American avant-garde art in the 1950s. Serge Guilbaut, Max Kozloff, Eva Cockroft and several of their followers criticized the Museum on the grounds that the USIA's direct sponsorship of 'The New American Painting' placed both the exhibition and the Museum in a problematic political light. They argued that MoMA had a political agenda and was actively engaged in fighting the government's 'cultural Cold War', using Abstract Expressionism as a propaganda weapon. However, 'The New American Painting' was sponsored by MoMA's International Council, not by the USIA or any other government agency. It was organized at the request of curators from major European museums, not the US government. Moreover, it circulated at a time when the US government was actively censoring any art thought to be 'communistic' in officially organized or

sponsored exhibitions, so government sponsorship of Abstract Expressionism would have been virtually impossible.

As a result of the wide publication of revisionist criticism, a false history of MoMA and its CIA, 'cultural Cold War' affiliations persists to this day. The predominant source for MoMA's purported Cold War activities is Cockroft's brief 'Abstract Expressionism: weapon of the Cold War' (1974). Full of revelations about art and patronage during the Cold War era, this article contains little bibliographical support and several errors regarding the Museum and 'The New American Painting'. Cockroft suggested that MoMA's directors had political motives in promoting Abstract Expressionism. She posited that 'links between cultural cold war politics and the success of Abstract Expressionism are by no means coincidental, or unnoticeable. They were consciously forged at the time by some of the most influential figures controlling museum policies and advocating enlightened cold war tactics designed to woo European intellectuals'.[8] In addition, Cockroft maintained that MoMA promoted Abstract Expressionism to the exclusion of other art movements during these years. These and other allegations in Cockroft's article were false, but they were nevertheless accepted as fact. The influence of this article on subsequent scholarship was substantial. Following its publication, critics and historians looked not to MoMA's archives, but to Cockroft's article for a history of 'The New American Painting' and MoMA during the 1950s. As a result, the damaging perception of MoMA as a cultural cold warrior gained momentum.

This essay discusses the organization of 'The New American Painting' in the context of 1950s American cultural diplomacy and clarifies MoMA's role in that diplomacy. It is not intended as an exoneration of MoMA, but rather as a defence: an attempt to survey MoMA's international activities during the years 1952 to 1959 and the motivation for organizing an exhibition like 'The New American Painting'. Additionally, the government's role in cultural exchange during these years will be examined.

At the beginning of my research, an administrator in MoMA's International Program remarked that 'The New American Painting' is a veritable cottage industry of research. Indeed, many historians capitalized on the exhibition as the quintessential example of American cultural imperialism. Yet a common thread that binds all the published material on this subject is that MoMA's staff and archives were never consulted for information. Many key museum officials and curators involved with the organization of 'The New American Painting', including Porter McCray, director of the International Program from 1952 to 1961; Dorothy Miller, Senior Curator of Painting and Sculpture until 1969 and Waldo Rasmussen, director of the International Program from 1964 to 1993, all obvious primary sources for researchers of this period and subject, were never contacted by the revisionists.

The lack of understanding of the historical record of this era has resulted in historians accusing MoMA of complicity in the US government's cultural Cold War, perhaps to further their own political agenda. Expressing his frustration, Waldo Rasmussen wrote in an unpublished letter to former Whitney Museum director David Ross: 'Had [Eva Cockroft or the others that followed her] talked with Dorothy Miller who directed the exhibition, Porter McCray who then was Director of the International Program, or myself, the myth of government sponsorship could quickly have been dispelled.'[9] All of the documentary evidence presented here derives from interviews with senior MoMA staff members, past and present, conversations with former USIA officers and from the extensive papers of Alfred Barr, Dorothy Miller and the International Program, all in the Museum's archives. Dispelling this myth is the chief objective of this essay.

Modern art amidst Cold War *angst* and congressional hysteria

The inescapable subtext of exhibiting modern art in 1950s America was the radical Right's paranoid fear of communist treachery, which included its perception of a threat posed by artists suspected of having communist or Popular Front affiliations. From congressmen in Washington to war veterans in Dallas – none of whom professed to know anything about modern art – much of America was engaged in rooting out and banning the artwork of suspected communist artists. Such witch-hunting caused the embarrassing cancellation of several government-sponsored art exhibitions, at home and abroad.

Senator Joseph McCarthy's anti-communist dogma set the tone for the post-war decade.[10] Although McCarthy never directed his vigilantism at art, George Dondero, a Republican Congressman from Michigan and ally of McCarthy, did. Dondero was possibly the most alarming of the self-styled crusaders against modern art and used every available opportunity to link abstract art with Communism. From 1949 until 1956 his congressional speeches, with titles such as 'Modern Art shackled to Communism', filled page after page of the *Congressional Record*.[11] Anything modern, progressive or non-conformist was anathema and therefore 'communistic' to Dondero, who readily admitted he knew nothing about the very art that he so vehemently condemned. To create abstract art was not just un-American, but an act of deviance, of cultural heresy against the United States of America.[12] He accused dozens of American abstract artists of being subversive and denounced their art as communistic.[13] 'Modern art', he told critic Emily Genauer in 1949, 'is communistic because it is distorted and ugly, because it does not glorify our beautiful country, our cheerful and smiling people, and

our great material progress. Art which does not portray our beautiful country in plain, simple terms that everyone can understand breeds dissatisfaction. It is therefore opposed to our government, and those who create and promote it are our enemies.'[14]

Dondero's attacks on modern art seem ridiculous to present-day readers. In the context of the 1950s, though, when the American government was seriously engaged in fighting the Cold War, he had many supporters who agreed that modern art was nothing more than a communist propaganda weapon. He also believed that MoMA, the Metropolitan Museum of Art and several other art institutions had been used in 'the Communist conspiracy of art to help make this government over into the image of the USSR'.[15] Not just artists, but prominent social figures were under suspicion by Congressman Dondero, including Nelson Rockefeller, John Hay Whitney, Henry Luce and William S. Paley, all modern art collectors and MoMA trustees.[16] The irony of Dondero denouncing abstraction as 'communistic' is that it was simultaneously equated with American cultural imperialism by the Soviet government. Official art in the Soviet Union after 1932 was Socialist Realism, which was figurative, narrative – and therefore easily understood by a mass public. Abstraction was anathematized with such terms as 'formalism, Western decadence, Leftist estheticism' and 'petty bourgeois degeneracy'.[17] Moreover, Dondero's proclamations sounded disturbingly similar to those of Hitler or Lenin, who stated, 'I cannot praise the works of expressionism, futurism, cubism, and other isms ... Art must unite and uplift the people in their feelings, thoughts, and aspirations ... '.[18]

Alfred Barr who, in his role as director of MoMA from 1929 to 1943 had long been fighting the censorship of modern art, was infuriated by Dondero's assertions. His 1952 article, 'Is modern art communistic?' was read by a wide public. Here Barr defended abstract art, explaining its 'degenerate' status in Soviet Russia and Nazi Germany. Barr also paralleled Dondero's ignorance with that of Hitler and the Soviet leaders: 'Because [conservative politicians] don't like and don't understand modern art they call it communistic. They couldn't be more mistaken. It is obvious that those who equate modern art with totalitarianism are ignorant of the facts.'[19]

The birth of American cultural diplomacy

Compared with other countries, the United States was relatively late in establishing an official programme of cultural exchange. It was initiated in the 1930s to combat Nazi Germany's cultural offensive in Latin America. It was resurrected during the Cold War, partly to prove America's cultural competence but mostly to counter-attack the Soviet Union, which was busily

assaulting Western Europe with a battery of cultural propaganda. The US government hoped that '[exchanges would] help to educate other people about the freedom of expression found in an open, pluralist society' and that an influx of American culture would outshine communist propaganda.[20]

Prompted by this fear of Soviet propaganda abroad, much American Cold War posturing ensued, cultural, legislative and otherwise. The Fulbright Act (1946) promoted 'international understanding through a bi-nationally administered program of academic exchange'.[21] The Truman Doctrine (1947) declared the United States' commitment to defending and protecting any country threatened by Soviet takeover. American anti-Soviet foreign policy was further entrenched by the Marshall Plan (1948), which granted economic aid to European countries rebuilding their devastated continent. The Smith-Mundt Act (1948) was the first peace-time commitment 'to conduct international information, education, and cultural exchange activities on a worldwide, long-term scale' in order 'to promote a better understanding of the United States in other countries, and to increase mutual understanding between people of the United States and people of other countries'.[22]

All such foreign policy led to the exportation of the American way of life through politically motivated cultural programmes, in an effort to ensure that America's free world democratic values would prevail in Europe over the closed Soviet system.[23] One manifestation of these efforts was government-organized exhibitions of contemporary American art. Many of these official art exchange efforts were serious failures, probably causing more harm than good to America's foreign image. In 1946 the State Department allotted $49,000 to purchase 79 contemporary American paintings. The art was organized into two travelling exhibitions, both called 'Advancing American Art', which toured Europe and South America. Many right-wing organizations and conservative newpapers, William Randolph Hearst's in particular, attacked the State Department for including the work of artists with supposed communist affiliations. The State Department terminated the exhibition in mid-tour in Prague, which no doubt caused a certain embarrassment to the United States. Eventually, the paintings were sold by the government at one-tenth of their original purchase price.[24]

In 1953 the USIA was formed.[25] Operationally independent of the State Department, the USIA was and is 'an independent foreign affairs agency within the executive branch [that] supports US foreign policy and promotes US national interests abroad through a wide range of information and cultural programs'.[26] Its stated missions included countering attempts to distort the objectives and policies of the United States, and bringing about greater understanding between the people of the United States and the rest of the world.[27] While cultural programmes were essentially non-political and

concerned with the promotion of mutual understanding among nations, they were inevitably viewed as instrumental to a country's international political objectives.[28] Porter McCray was more blunt: '[The] USIA was decidedly political,' he recalled. 'The USIA was meant to be a public relations agency for the American government in dealing with foreign nations.'[29]

One realizes how impossible government sponsorship of 'The New American Painting' would have been when one considers that the USIA's preoccupation with communist infiltration in its own art exhibitions throughout the 1950s was even worse than the State Department's had been in the 1940s. The USIA was extremely concerned about the communist threat supposedly rampant in abstract art and made no attempt to conceal its very political position. In October 1953, the USIA's chief spokesman, A. H. Berding, stated in a speech at a meeting of the American Federation of Arts (AFA) that '[The US] government should not sponsor examples of our creative energy which are non-representational', including 'works of avowed Communists, persons convicted of crimes involving a threat to the security of the United States or persons who publicly refuse to answer questions of Congressional committees regarding connection with the Communist movement'.[30]

This totalitarian-sounding policy was probably the impetus for the AFA's 'Statement on Artistic Freedom', adopted on 22 October 1954. It read in part: 'Artistic expression must be judged solely on its merits as a work of art and not by the political or social views of the artist, any more than by his personal character or conformity to other standards.'[31] Barr, who had collaborated on the 'Statement', was enraged by Berding's decree and wrote: 'In word and deed the USIA made clear it did not want abstract art ... included in its exhibitions, in spite of the fact that abstract art was the most vigorous current movement in this country, and indeed throughout most of the Western world.' He concluded, 'let us not underestimate the anxieties and difficulties of the USIA staff. Often the very works of art most likely to enhance American prestige abroad are also most likely to offend congressmen and thereby arouse the fears of superior officers in the Administration.'[32]

In 1956, 'Sport in Art' and '100 American Artists', both USIA-sponsored exhibitions, were cancelled after certain artists in the shows were accused of communist subversion.[33] Already shown at the Boston Museum of Fine Arts and the Corcoran Gallery in Washington in late 1955, 'Sport in Art', organized by the AFA for *Sports Illustrated*, was to represent the US at the 1956 Olympic Games in Australia. The Dallas County Patriotic Council, an organization composed of leaders from the American Legion, Veterans of Foreign Wars and other conservative groups, as well as Congressman Dondero, protested, labelling four of the artists – Ben Shahn, Leon Kroll, William Zorach and Yasuo Kuniyoshi – politically subversive. Ironically, Shahn's work had already

represented the United States at the 1954 Venice Biennale, an exhibition organized by MoMA. Fearing criticism from Congress, the USIA cancelled the exhibition. Less than one month later, it cancelled '100 American Artists', another AFA-organized show scheduled to travel abroad, because ten of the artists were politically 'unacceptable'.

The USIA's director Theodore Streibert defended the USIA's anti-abstract art, anti-communist policy in a letter of 23 May 1956 to the Whitney Museum's director Lloyd Goodrich, after cancelling an exhibition organized by the College Art Association because it included work by Picasso.[34] 'The matter has nothing to do with the freedom of the arts', Streibert wrote. 'The question actually boils down to whether the Agency may decide for itself which artists are to be represented and which works of art are displayed in overseas exhibits sponsored and financed by the Agency.' He continued:

This policy is required as a matter of public and congressional relations, we feel, if the Agency is to be of maximum value in promoting and assisting the exhibition of works of art abroad. Furthermore, the policy is necessary in order to prevent the exploitation by Communist elements overseas of controversies aroused in the United States if the works of artists who are Communists or Communist sympathizers were to be used.[35]

Streibert concluded: 'It is ... indefensible for a Government agency to be responsible for the exhibition abroad of works by the artist who is responsible for the Communist dove.' This of course referred to Picasso's illustration of a dove which appeared in the leftist French newspaper, *Lettres Françaises*, and became the international symbol of the Communist Party. Interestingly, the Soviet Union developed a bipartite policy towards modern art. Socialist Realism was promoted in the USSR and its satellite countries, but Picasso's kind of abstraction was supported by Soviet-funded communist groups in France.[36]

Increasingly, the American government did not attempt to disguise the political intent of its cultural programmes. A report of the Bureau of the Budget openly stated:

Culture for culture's sake has no place in the United States Information Exchange Program. The value of cultural interchange is to win respect for the cultural achievements of our free society, *when that respect is necessary to inspire cooperation with the United States in world affairs. In such a situation, cultural activities are an indispensable tool of propaganda* [author's italics].[37]

In July 1956, Streibert told the Senate Foreign Relations Sub-Committee that the USIA's policy was to 'include no works by politically suspect artists in exhibitions overseas'. Moreover, in a move to avoid controversy that hardly sounded emblematic of a 'free society', the Agency indicated that there would be no more government-sponsored exhibitions abroad of 'American oil paintings dated after 1917' – the year of the Russian revolution.[38]

The USIA became increasingly unpopular as the decade progressed. Darthea Speyer, who worked for the United States Information Service (or USIS, the foreign branch of the USIA) in France, where she was the equivalent of an overseas cultural affairs officer for the United States, recalled having been given specific orders that the USIA was forbidden to have anything to do with The Museum of Modern Art.[39] 'No, we never identified at any time with the USIA', confirmed Porter McCray, ' ... because the USIA was *extremely* unpopular. [However] I was mistakenly identified time and again as being an operator of the USIA for the Museum of Modern Art.'[40] The USIA's exhibitions continued to be extremely conservative well into the 1960s. Too wrapped up in the crusade against Communism to be able effectively to export and educate the foreign public about contemporary American art during the 1950s, the job was inevitably left to private institutions. Hence, a closer examination of the role of MoMA's International Program in American cultural exchange is necessary.

MoMA: the latent patriot and its so-called political machinations

The Museum of Modern Art was founded by a small group of wealthy New Yorkers, including Mrs John D. Rockefeller, mother of former US Vice-President and New York State Governor Nelson Rockefeller, who would himself become a key figure at the Museum. From its inception in 1929 one of the Museum's primary goals was to educate the public about modern art. During its first two decades though, it was hardly a staunch supporter of American art, let alone Abstract Expressionism. In 1936 Alfred Barr curated two seminal survey exhibitions, 'Cubism and Abstract Art' and 'Fantastic Art, Dada and Surrealism', with the intention of proselytizing a sceptical public about modern European art.

As it matured into a substantial, influential force in modern art, MoMA continued to focus on exhibiting and collecting European – not American – modernist art. In the 1930s and again in the 1940s it faced criticism from American artists who claimed that the Museum did not collect enough American art. In January 1944, the politically conservative Federation of Modern Painters and Sculptors released a letter to the press attacking the 'increasingly reactionary policies of [MoMA] towards the work of American artists'.[41] Discontented with what they believed were MoMA's unfair policies of acquiring Ecole de Paris paintings instead of American paintings, several artists picketed the Museum in 1948.

During the Second World War, MoMA finally displayed patriotism by acquiring more American art.[42] Curator Dorothy Miller began her prestigious 'Americans' exhibition series in 1942.[43] The Museum also executed govern-

ment contracts for cultural programmes, such as exhibitions, posters and films relating to the problems and suffering experienced during the War; the film department analysed enemy propaganda films. Overall, 38 contracts were executed for various governmental agencies, including the Office of War Information, the Library of Congress and the Office of the Coordinator of Inter-American Affairs, Nelson Rockefeller's department, for which it created nineteen exhibitions of American painting for Latin America. Nineteen shows travelled abroad and 29 were shown at the Museum, all of which were war-related. [44] MoMA's wartime commissions were never intended to be, nor were they ever, kept secret; one can find published documentation of their existence without difficulty. Despite the Museum's openness on the matter, some historians have tried to 'reveal' these activities. Cockroft, for example, presented this information in the manner of an *exposé*, without acknowledging her source.[45]

The Rockefeller family played a crucial role in the development of MoMA, but Nelson Rockefeller's role in the genesis of 'The New American Painting' is perhaps not as instrumental as Cockroft implies.[46] Following in his mother's footsteps, Rockefeller was extremely active at MoMA. In 1931, he was appointed chairman of the Junior Advisory Committee and in 1939 he was named president of the Museum. Rockefeller resigned as president in 1941 to pursue a political career, but remained on the Board of Trustees.[47] He would become president of MoMA again in the 1950s. Cockcroft's thesis is that Rockefeller's personal investments in Latin American oil and his rôle in US foreign policy indirectly influenced MoMA's promotion of the Abstract Expressionists through the International Program. Refuting her insinuation that Rockefeller's political and economic ambitions coloured his actions at the Museum, Porter McCray said, 'Nelson did not confuse the Museum and the government ... They resembled one another because they were the same period.' He continued, 'It has always been very confusing, although not intentionally so'.[48]

Rockefeller supported abstract American art at a time when most Americans still found it suspect. He actively collected avant-garde art and because of this was himself under suspicion of communist subversion. He persuaded his influential friend Henry Luce, owner of *Time* and *Life* magazines, that Abstract Expressionism was not politically subversive, but was instead a 'tribute to American freedom of ideas and expression'.[49] In 1949 *Life* published a feature article heralding Jackson Pollock as the quintessential American artist.[50] Pollock was unquestionably the most influential – and most popular – of the American artists in Europe, and the article was as widely read in Europe as it was in America.[51] It is here that one perhaps sees an early instance of Abstract Expressionism, with its huge scale and lack of subject matter, being embraced by more liberal, open-minded and influential Americans, not as a symbol of degeneracy, but of freedom and liberalism.

Despite Rockefeller's enthusiasm for Abstract Expressionism, and contrary to revisionist lore, MoMA was not yet fully committed to supporting and showing avant-garde American art in the mid-1950s. Waldo Rasmussen was adamant on this point:

The other disagreement I have with the Cockroft article ['Abstract Expressionism, Weapon of the Cold War'] is that it states that the Museum had a particular bias for Abstract Expressionism. And though that may be true for individual staff members, it certainly wasn't true for the Museum as a whole ... 'The New American Painting' was the first Abstract Expressionism show the Museum ever presented. And that's not exactly early in the years of Abstract Expressionism. And though the museum acquired Abstract Expressionism, it was not at the exclusion of other art. If you look at the series of exhibitions that Dorothy Miller did during that period, those were always exhibitions that represented groups of individual artists rather than movements.[52]

Indeed, Miller's 'Americans' shows, mounted between 1942 and 1963 had presented a range of artistic tendencies.[53] Even Alfred Barr was not a partisan for Abstract Expressionism, although he was still an early supporter of organizing a major exhibition around it.[54]

The International Program: unofficial cultural diplomat

In the early 1950s MoMA's curatorial efforts broadened to global proportions. The International Circulating Exhibitions Program, with its sponsoring organization, the International Council, were founded in 1952 and 1953 to create and circulate exhibitions of American art around the world, as well as to import exhibitions of foreign art to the United States. Its mission was to make American art better known in the world. Unintentionally, the creation of the International Program was a significant development for American cultural diplomacy as it was the most extensive cultural exchange effort – private or public – yet undertaken in the United States. Although formed the same year as the USIA, the creation of the International Program long preceded adequate government sponsorship of American art abroad.

MoMA had circulated its exhibitions to other institutions as early as 1932. In June 1952 a 'Five-Year Plan of International Exhibitions' was proposed, outlining the creation of the International Program. This document pointed out that while other governments had recognized the necessity of cultural exchange, the United States 'so far has been unable to carry out such enterprise. It is not impossible that a convincing demonstration of this activity by a private institution *whose sole concern is one of quality* will lead ultimately to government support of a comparable program' [author's italics].[55] MoMA officials astutely realized that:

The lack of a permanent, responsible government agency charged with the function of encouraging and coordinating cultural activities has occasioned embarrassment to other countries in their attempts to invite [US] participation in international art events, request exhibitions of American art for individual institutions, or send exhibitions of their own for circulation in the United States. Even more seriously for our prestige, it has resulted in inadequate representation or none at all in important international art manifestations abroad.[56]

As a result, in 1952 the International Program was established, substantially increasing the Museum's financial potential to export and import exhibitions.[57] In 1953 the International Council was formed as a membership organization of 'art patrons and civic leaders throughout the United States who are vitally interested in furthering international good will through exchanges in the visual arts' to help fund the International Program's endeavours.[58] Because of the similarity in names and dates, there is often confusion about the roles of the International Program and the International Council.[59] Cockroft did not even realize there was an entity called the International Program; she also stated that the International Council was launched in 1956.

The International Program organized and sent many major exhibitions of all kinds of American art abroad, not just Abstract Expressionism. Two major exhibitions were '12 Modern American Painters and Sculptors' (1953–4)[60] and 'Modern Art in the United States: Selections from the Collections of The Museum of Modern Art, New York' (1955–6), the show which sparked intense European interest in the Abstract Expressionists.[61] This exhibition showcased 50 years of American painting, sculpture, printmaking, design and architecture, representing all areas of MoMA's collection.[62] 'Modern Art in the United States' received mixed reviews, but most attention – both positive and negative – focused on the one room of Abstract Expressionist paintings.[63]

One of the most important functions of the International Program was organizing American representation at the increasing number of international art exhibitions – a function that typically should have been administrated by a government cultural body like the USIA. However, the USIA was still busily barring 'works of avowed Communists' from official exhibitions and left the task to the private sector. In addition to the second and fourth São Paolo Bienals (1953 and 1957) and the underwriting of the third (1955), MoMA's International Program arranged US representation at the second and fourth Mainichi Art Exhibitions of Japan (1953 and 1957) and the third International Contemporary Art Exhibition of India (1957). The International Program was also responsible for US representation at several Venice Biennales.[64] Although the government approved participation in the Biennale it did nothing to support, fund or organize representation.[65] A press release written by Alfred Frankfurter, editor of *Art News* and chairman of the US pavilion, chastised the government for its failure to arrange official

representation: 'This is an example of what typically American goodwill and private initiative can do toward proving our country's cultural maturity on the international scene, hampered though we are by the absence of any government art program or assistance. Every other nation in the big Venice show is participating under official sponsorship of its government.'[66]

While MoMA was indeed responsible for the US representation at several international art exhibitions in the 1950s, it is often wrongly singled out as the only American museum to have organized such exhibitions.[67] The Art Institute of Chicago and the Baltimore Museum assumed responsibility for organizing exhibitions at the 1956 and 1960 Biennales, respectively. For São Paolo, MoMA only arranged three shows between 1953 and 1965; in other years selections were made by the San Francisco Museum of Art, the Minneapolis Art Institute, the Walker Art Center and the Pasadena Art Museum. After 1962 the USIA finally took responsibility for some of the international shows, such as Venice. Eventually, in 1965, responsibility for international exhibitions was assumed by the Smithsonian Institution.[68]

As we have seen, the revisionists argued that MoMA promoted Abstract Expressionism to the exclusion of all other art, particularly at the international art shows. This was not true of the 'Americans' exhibitions at MoMA, nor was it true of the exhibitions organized by the International Program. Abstract Expressionism was included in the American exhibitions at the Venice Biennale but hardly dominated them, as Cockroft implied. In 1948, out of 79 artists, just one Abstract Expressionist work, by de Kooning, was exhibited. American representation at the 1950 Biennale featured a large John Marin retrospective, along with a few pieces each by Pollock, Gorky and de Kooning.[69] In her account of the exhibition, Cockroft omits any mention of Marin, who was *not* an Abstract Expressionist, and the fact that most of the exhibition was devoted to his work. Neither of these shows was organized by MoMA, but rather by a selection committee representing several American museums. For the 1954 Biennale, the Social Realist painter Ben Shahn represented the United States with Willem de Kooning. In 1958 the Museum sent Rothko, Tobey, Lipton and Smith.[70]

Like Alfred Barr, Porter McCray should be seen as a proselytist for modern art, not as a cold warrior. Cockroft accused him of being 'a particularly powerful and effective man in the history of cultural imperialism'.[71] McCray was hired by Nelson Rockefeller to direct the circulating exhibitions department at MoMA in 1946.[72] In 1952 he was appointed Director of the International Program. By 1956, McCray's department had sent 31 exhibitions of American art, in many media, to 22 countries. The popularity of these exhibitions generated requests for many more.[73] The success and autonomy of McCray and the International Program, which with few exceptions never exhibited at MoMA the shows that it developed, did turn the heads of other

MoMA officials, but not for political reasons. McCray explained in an interview that the Museum did not want the International Program to take on a political identity, despite its role. He recalled the 'healthy sort of respect' in which it was held by European officials in the absence of a US government initiative. At worst McCray was perhaps guilty of running his own museum within the Museum.

In response to the confusion surrounding the objectives of the International Program in the 1950s, Rasmussen wrote in July 1991:

I would like to emphasize that the Museum's International Program affirms a basic tenet of the Museum – that modern art transcends national barriers. Exhibitions sent abroad by the International Program have never been restricted to the work of American artists but have sought to reflect the interest and needs of our museum colleagues and audiences in other countries. Thus the implication that 'The New American Painting' and other exhibitions were organized for purposes of political propaganda is absolutely contrary to the internationalist objectives of this Museum.[74]

Perhaps the International Program's expertise and success in organizing and exporting American art, its somewhat portentous sense of duty and its self-induced need to stand in for the government, were what led so many to assume that it was an official, government-affiliated body. As a result of the criticism it suffered, the International Program became the unwitting victim of its own success.

Genesis and critical reception of 'The New American Painting'

As a concept, 'The New American Painting' originated simultaneously from European museums and MoMA's International Program. Recognizing that it was a few years overdue, Porter McCray and Dorothy Miller had already been trying to gain support for an exhibition of avant-garde American art when the Museum was approached by European curators.[75] A confidential memo proposed sending such an exhibition abroad:

A number of recent discussions with European visitors … have made more evident than ever before the desirability of sending abroad an exhibition of … our most avant-garde American painters and sculptors. In addition *we have also had a number of specific requests for an exhibition of this sort from Berlin … Amsterdam … Brussels, and … Milan …* Especially in view of the USIA's present orientation and the probability that exhibitions assembled under its auspices may become increasingly conservative, *it seems that The Museum of Modern Art is the only institution likely to organize this kind of representation for showing abroad and our obligation to do so is thereby all the greater* [author's italics].[76]

The European museum officials who wanted to organize an exhibition of American Abstract Expressionism were Arnold Rüdlinger of the Kunsthalle

in Basel, Wilhelm Sandberg of the Stedelijk in Amsterdam and Robert Giron of the Palais des Beaux-Arts in Brussels.[77] Initially they had addressed the request to the US government but when negotiations faltered, the trio asked MoMA. In an interview, Rasmussen explained the chain of events as follows:

[Rüdlinger, Sandberg and Giron] formed a team, and were trying to organize the show. However, they encountered problems ... they asked The Museum of Modern Art to take over the organization of the show ... [which] shifts the argument to aesthetics rather than politics. They weren't interested in using this as an instrument of American cultural propaganda. They were interested in the art.[78]

Rüdlinger provided a wish-list from which the final roster of artists was selected.[79] The exhibition was curated and organized by Dorothy Miller.

The European genesis of 'The New American Painting' is not a secret, but a fact that the revisionists ignored. Correspondence in MoMA's archives documents the European interest in an exhibition of American avant-garde art. Rüdlinger, long a supporter of American abstract art, wrote to McCray, 'I do hope that the exhibition of "American Avant-Garde Art" which you prepare will fulfill mine and my friend's [Giron's] expectations' as 'everyone here is eager to get in contact with the younger American art'.[80] Rüdlinger later met Porter McCray in Zurich during the summer of 1957 to discuss the organization of the show. MoMA's archives also contain correspondence from Giron, who sent an official request for the exhibition to MoMA, dated 2 April 1957. Sandberg too wrote to McCray in July 1958 to request formally 'The New American Painting'.[81]

Other archival documentation indicates the European origins of 'The New American Painting'.[82] MoMA's standard art loan request letter for the exhibition began 'in response to urgent requests from major institutions in leading European cities'. In addition, many early, internal Museum memos and documents emphasized the necessity for a curatorial survey of Abstract Expressionism, which had yet to be undertaken on a large scale.[83] In addition to confidential Museum documents, more accessible sources support the European desire for an exhibition of American avant-garde painting. The preface and essay in the exhibition catalogue plainly state: '"The New American Painting" was organized at the request of European institutions for a show devoted specifically to Abstract Expressionism in America.'[84] The Basel edition reads: 'This event is the outcome of discussions between the Kunsthalle and our museum in New York extending back for more than 6 years.'[85] All documentation points to an educational, academic motive for organizing 'The New American Painting', not to a political one. 'The New American Painting' was a purely cultural exchange and was in no way a manifestation of government propaganda. Countries had to request the exhibition formally; it was not forced upon them.[86] Moreover, the exhibition only stayed in each country for one month, a relatively short period of time for a major exhibition.[87]

'The New American Painting' catalogue was published in seven foreign language editions, but it is the New York edition that is especially important for historians of Abstract Expressionism, for the documentary information it contains on the exhibition's critical reception in Europe. In wanting to show the American public that 'The New American Painting, as Shown in Eight European Countries, 1958–1959'[88] was a historical moment for American avant-garde art, MoMA's director René d'Harnoncourt lobbied to add a summary of European exhibition reviews and headlines to the New York edition.[89] He thus enlarged it by eight pages to include 'an account and photographs of the reception of the exhibition abroad, with press quotations both favorable and unfavorable'.[90] It contained 16 colour plates, which was lavish in the 1950s; its cover derived from the intense red ground of Barnet Newman's *Adam*, which was in the exhibition.[91] Similar in format to Dorothy Miller's 'Americans' catalogues, it included personal statements by all the artists alongside reproductions of their work.

The mixed critical reception throughout Europe, as much political as it was æsthetic, indicates that 'The New American Painting' did not confirm an immediate triumph of American painting. In London, for example, the paintings were called everything from 'rubbish' or 'brush wipings' to 'a joke in bad taste', although attendance was a record high for the Tate.[92] In certain countries, some of the press hostility was based on general antipathy toward America.[93] Since an international exhibition of the new American art was likely to be seen as a threat to French artistic hegemony, the French critics were negative and prone to make politically determined, anti-American statements. In Paris the exhibition was shown concurrently with 'Jackson Pollock, 1912–56', the first monographic exhibition to be circulated in Europe by the International Program.[94] Most reviews focused on the Pollock retrospective (Fig. 5.1).[95]

It is noteworthy that it was not a French initiative to import American avant-garde art. The Musée d'Art Moderne did not request 'The New American Painting' until the summer of 1958, when the exhibition was already under way. The three countries that initially asked for the show, Switzerland, Belgium and Holland – smaller and politically weaker than France – were the most critically receptive to the art. This may indirectly have reflected their resentment of France's cultural hegemony which, despite the war, appeared to be as vital as ever. Rüdlinger tactfully alluded to this in his speech at the Basel opening of 'The New American Painting' and 'Jackson Pollock': 'Swiss neutrality forces us to be rather reserved on foreign political questions. But this neutrality gives us also the possibility to be open for all cultural problems and to act in a sense of freedom which is untouched by any nationalism'.[96] Moreover, Sandberg was involved with the Cobra group, founded in 1948, whose artists consciously distinguished themselves from

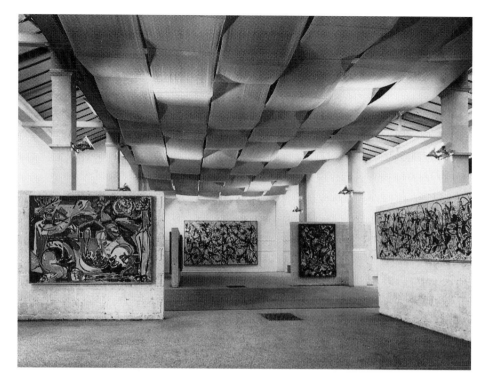

5.1 Jackson Pollock exhibition, Whitechapel Art Gallery 1956

the Ecole de Paris. Thus, one could argue that it was an anti-Parisian collusion of Swiss, Belgian and Dutch museum curators who requested the exhibition. To Rüdlinger, 'The New American Painting' was not American cultural propaganda in the same way that the French might have perceived it.[97]

An oft-quoted excerpt from Barr's introduction to *The New American Painting* comments on the appropriation of Abstract Expressionism into the ideology of American liberalism:

Indeed one hears Existentialist echoes in [the artists'] words, but their 'anxiety', their 'commitment', their 'dreadful freedom', concern their work primarily. They defiantly reject the conventional values of the society which surrounds them, but they are not politically *engagés* even though their paintings have been praised and condemned as symbolic demonstrations of freedom in a world in which freedom connotes a political attitude.[98]

Amusingly, given the US government's position on such art, one Swiss critic suggested that Abstract Expressionism was politically *safe*: 'It is only under McCarthyism that [the Americans] got frightened and renounced their own politically committed past to hide among the esthetics of abstract art which,

because it has no ideological content, can shelter the artist from all political inquisitions.'[99]

The revisionists also overlooked the fact that the so-called triumph of the new American painting did not go unquestioned even on American soil; most American critics did not immediately support Abstract Expressionism, even in the late 1950s. John Canaday and Emily Genauer, the leading critics for *The New York Times* and *The Herald Tribune*, were opponents as late as 1961 – at which point others already viewed Abstract Expressionism as no longer avant-garde but almost academic.[100] Reviewing 'The New American Painting' in New York in 1959, Genauer wrote, 'Nor will I speculate on the effect the show, more extreme than any [MoMA] has presented in New York, may have on the many Europeans seeing this kind of thing for the first time. Besides, I am informed that European museums specifically asked to see "advanced" art.'[101]

Revisionism revised

Max Kozloff's wide-ranging 'American painting during the Cold War' (1973) was the first article to question the relationship between post-war American painting and American political ideology. He argued that not only had Abstract Expressionism's success gone unquestioned, but that its 'natural superiority' had been taken for granted, and that its critics had 'not yet asked sufficiently well what past interests have made [its success] so official'.[102] He also observed that 'The most concerted accomplishments of American art occurred during precisely the same period as the burgeoning claims of American world hegemony.'[103] Kozloff rightly credited MoMA with making American painting accessible overseas, but wondered whether the ideology of Abstract Expressionism as a movement was compromised by its institutional success. 'The New American Painting', he believed, 'furnished out-of-date and over-simplified metaphors of the actual complexity of American experience'.[104] He also stated that as a result, by 1960 'the USIA had already capitulated to furious reaction from right-wing groups when attempting exhibitions of non-representational art or work by "communist tinged" painters, [and] it was now able to mount, without interference, a number of successful programs abetted and amplified by the International Council of The Museum of Modern Art', thereby intimating an unofficial relationship between the MoMA and the USIA.[105] Kozloff concluded by dismissing formalism as a realistic tool for interpreting post-war art.

Kozloff's article was the first of a spate of articles and books linking Abstract Expressionism to the Cold War and political ideology. While he questioned why Abstract Expressionism's triumph was taken for granted,

Cockroft went one step further, stating that its success was absolutely a result of cultural Cold War politics and was consciously used for 'political ends'. Her 'Abstract Expressionism, weapon of the Cold War', a 'dense re-writing of history'[106] published in *Artforum* in 1974, caused a fair amount of damage to the Museum's reputation. Cockroft's version of MoMA's activities during the 1950s was validated and accepted as fact as a result of its wide dissemination: first by its publication in a reputable journal of art history, subsequently by its publication in an anthology of post-war art criticism and its frequent use by other historians as a source. Waldo Rasmussen drafted a letter to *Artforum* in 1974 defending the museum and correcting the article's numerous errors but the letter was never sent.[107] Perhaps this was bad judgement: the act of not responding intimated that the Museum was actually guilty of Cockroft's allegations and opened the floodgates for more damaging criticism.

Cockroft suggestively paralleled MoMA's activities and those of the CIA, but never directly accused the Museum of CIA involvement. Others picked up where she left off. John Perreault wrote in July 1974, one month after the publication of Cockroft's piece, '[Her] informative article … revealed some of the CIA involvement with MOMA [sic]' which, he believed, 'Most people with any insight into the mysteries of propaganda had always suspected'.[108] In 1976, John Tagg also connected MoMA with the CIA and footnoted Cockroft:

But the more subtle policy of the CIA, which aimed to use the new American art as a means of winning acclaim for the U.S. and influencing foreign intellectuals with an image of the 'free' world, was gaining ground all the time. Even while there was still opposition to modern art in Congress, the CIA cultural operations began to attack, through apparently independent organizations and institutions, the idea that America was an artistic backwater. The Museum of Modern Art in New York was one such 'independent' institution.[109]

Additionally, many essays in the revisionist anthology *Pollock and After* (1985), cite Cockroft as the source for MoMA's alleged political engagement and acts of cultural imperialism. Ironically, these texts are grouped under the heading 'History: representation and mis-representation – the Case of Abstract Expressionism'. They are, the editor Francis Frascina wrote, 'a response to the art-historical myth-making of institutions such as the Museum of Modern Art'.[110]

The self-perpetuating, MoMA-as-CIA-operative myth resurfaced in July 1991 in the form of a Whitney Museum exhibition entitled 'Constructing American Identity'. This 'nasty little exhibition' as Hilton Kramer called it took place at the Whitney satellite museum in downtown New York at Federal Reserve Plaza in 1991. The curators stated that their exhibition arose 'from recent discussions of American identity in art and cultural theory'

which 'questioned the conventional monolithic notions of national identity and obscure the heterogeneity and fluidity of American cultural production'.[111] The catalogue contained an introduction and three unannotated essays, which alternately state that 'The New American Painting' was 'sent abroad under the auspices of the USIA', was 'co-sponsored by the USIA' and even sponsored by the CIA.[112] The introduction claimed that '"The New American Painting" was part of a larger effort to promote culture abroad. The traveling show provided an opportunity for the USIA with the explicit co-operation of the International Council at the MoMA, to export a heroic notion of American identity to postwar Europe'.[113]

It is indeed curious that so much scholarship claims that 'The New American Painting' was either commissioned or sponsored by the USIA when the exhibition catalogue, in addition to press releases and other documents, clearly states the truth. Yet the falsehoods continued to be perpetuated. Errors regarding USIA sponsorship in the *Constructing American Identity* catalogue were repeated in exhibition reviews. Rasmussen drafted a letter to *The New York Times* outlining each specific error but did not send it. He did send a similar letter to the Whitney's director, David Ross, to make him aware of the poor scholarship and its damaging effect on MoMA.

Despite the government's resistance to abstract art in the 1940s and 1950s, the controversy subsided by the 1960s and Abstract Expressionism eventually became the academic, emblematic example of the American art style that had triumphed in the twentieth century. There does seem to be confusion over how it came to be pre-eminent. The lack of understanding of the US government's passive role in art exchanges during the 1950s led to the revisionist scholarship of the 1970s and 1980s that suggested that Abstract Expressionism's supposed triumph was based less on artistic merit than on a co-ordinated government/museum effort to promote American cultural hegemony. Any real attempt to find evidence of such co-ordination in the 1950s, when the revisionists claim it took place proves the contrary; all references to it were written after Cockroft's article. Victor Burgin, for example, confused private and government sponsorship of exhibitions in Europe, mistakenly inferring that a 'thaw' in official US policy led to an official decision to use Abstract Expressionism to promote 'freedom of expression', while in fact official efforts to promote modern art were only resumed well into the 1960s.[114] Burgin was probably alluding to what others, like Cockroft, had already wrongly identified as government-sponsored or government-organized initiatives, such as the International Program, that in reality were private.

That the eventual success of Abstract Expressionism triggered a shift in artistic hegemony from Paris to New York and that it occurred during a period when America was exporting American culture to Western Europe,

does suggest a political impulse for the movement's eventual triumph. Certainly this observation is worth raising, but completely to overlook æsthetics in favour of political ideology is perhaps an equally insular form of interpretation. Moreover, in examining the critical reception of 'The New American Painting' abroad, it is clear that it was in no way an immediate triumph. The fact that European museums requested 'The New American Painting' does not deny America's long-term, political commitment to cultural exchange during the Cold War, but it does refute the revisionists' argument that MoMA was the government's accomplice in its cultural Cold War. Indirectly, the government probably did benefit from cultural undertakings such as MoMA's International Program, since repeated mishaps by official agencies like the USIA were doing more harm than good to the effort to export America's free society image. Any successful cultural exchange promotes understanding and goodwill between countries and, in this sense, 'The New American Painting' may have unintentionally supported the American government's desire for a more popular image abroad during the Cold War. However, the government still perceived abstract art as a communist weapon in the later 1950s, so 'The New American Painting' did not present the image that the US was officially trying to promote.

While MoMA itself may have had no motivation to take part in cultural exchanges, other than perhaps to raise its prestige, it is possible that its programmes could have been appropriated and/or exploited by the US government for political ends. However, effective efforts to do this only took place in the 1960s, at which point Abstract Expressionism had become well-established as an academic movement of the 1940s and 1950s, in spite of overwhelming public and political opinion which denounced the movement during those decades as 'communistic' and inaccessible to a mass public.

Nevertheless, one might argue that the revisionist art historians appropriated the triumph of Abstract Expressionism and 'The New American Painting' even more vehemently than the government. What the artists who produced the paintings in question may actually have intended their work to represent or embody was marginalized by the revisionist ideological debates. Certainly, as Barbara Rose observed, the mingling of art and politics seems somehow 'out of context' in a relatively 'dispassionate and morally and politically neutral activity like art criticism'.[115] As Barnett Newman prophetically surmised in 1965, the year of another major Abstract Expressionism retrospective: 'The doctors of art history are not so much doctoring history as they are hoping that the patient will disappear.'[116]

Notes

Abbreviations

ICE: International Circulating Exhibitions

The Archives of American Art in Washington, D.C., abbreviated as AAA, has certain MoMA Archives material on microfilm. The first number in the sequence refers to the reel number and the second to the frame number.

1. George Kennon, excerpt from address given at a symposium sponsored by the International Council at MoMA, 12 May 1955.

2. International Council Press Release No. 2, '*The New American Painting*, Large Exhibition, Leaves for Year-Long Tour under Auspices of International Council at The Museum of Modern Art', 11 March 1958, The Museum of Modern Art Archives, NY: Dorothy C. Miller Papers I.14.G.

3. 'Paintings were lent by thirty-one private collectors, five galleries and museums, including The Museum of Modern Art, which lent seventeen from its own collections. Twelve of the artists have been featured in the series of American exhibitions presented regularly at MoMA under the direction of Dorothy Miller' (Press Release No. 45, 26 May 1959, The Museum of Modern Art Archives, NY: Dorothy C. Miller Papers I.14.G).

4. '"The New American Painting" is getting cheers from most younger painters, cries of outrage from many critics, nibbles from some collectors and a monumental amount of bafflement from the general public' ('American abstraction abroad', *Time*, 4 August 1958, p. 40).

5. The 1967 *exposés* revealed that the CIA funded a diverse cross-section of American cultural organizations including *Encounter* magazine, the National Student Association, the Congress for Cultural Freedom and even a Boston Symphony Orchestra tour to Paris. Thomas Braden defended his actions asking, 'Does anyone really think that congressmen would foster a foreign tour by an artist who has or has had left-wing connections?'. He explained the CIA's policy: 'Use legitimate, existing organizations; disguise the extent of American interest; protect the integrity of the organization by not requiring it to support every aspect of official American policy' (T. Braden, 'I'm glad the CIA is "immoral"', *The Saturday Evening Post*, 20 May 1967, pp. 10 + 14). See also Frances Stoner-Saunders, *Who Paid the Piper? The CIA and the Cultural Cold War*, London: Granta Books, 1999.

6. Max Kozloff, 'American painting during the Cold War' *Artforum*, Vol. 11, May 1973, pp. 43–54; Eva Cockroft, 'Abstract Expressionism, weapon of the Cold War', ibid., Vol. 12, June 1974, pp. 39–41; *Constructing American Identity*, exh.cat., Whitney Museum of American Art, New York 1991; Serge Guilbaut, *How New York Stole the Idea of Modern Art. Abstract Expressionism, Freedom, and the Cold War*, University of Chicago Press, 1983; *Reconstructing Modernism: Art in New York, Paris and Montreal*, Cambridge: MIT Press, 1990; 'The new adventures of the avant-garde in America', October, 15, 1980, pp. 61–78.

7. J. Strand, 'Do you remember the Fifties?', *Art International*, 4 1988, p. 10.

8. Cockroft, 'Abstract Expressionism', 1974, p. 39. Retired International Program director Waldo Rasmussen countered: 'The …disagreements that I have with the Cockroft article is that it acts as if European intellectuals were dumb, that they would take this propaganda and swallow it whole. And, secondly, I think it's demeaning to the artists [to claim] that the art has no content, hence it's palatable and it suggests American freedom in some vague way, and that the artists themselves would permit themselves to be used in that way' (conversation with Rasmussen, 6 January 1992).

9. Unpublished letter to David Ross, 15 July 1991, Museum of Modern Art, International Program: Waldo Rasmussen files, 'The New American Painting' file.

10. By 1953 McCarthy was at the peak of his power as head of the Senate Permanent Subcommittee on Investigations. By late 1954, however, his influence was on the wane and he was soon to be condemned by his fellow Senators (Donald Drew Egbert, *Socialism and American Art*, Princeton University Press, 1967, p. 132).

11. Other Congressional speeches by Dondero include: 'Communist art in government hospitals', 11 March 1949; 'Communists maneuver to control art in the United States', 25 March 1949; 'Communism in the heart of American art – what to do about it', 17 May 1949 and 'Communism under the guise of cultural freedom' 14 June 1956, Museum of Modern Art Archives, NY: Alfred H. Barr, Jr. Papers [AAA: 3156;995–1011].

12. See Jane de Hart Matthews, 'Art and politics in Cold War America', *American Historical Review*, Vol. 81, October 1976, pp. 762–87.

13. Emily Genauer, 'Still life with red herring', *Harper's Magazine*, 199:1192, September 1949, pp. 88–91. Dondero claimed it was the artist's responsibility to prove himself a loyal American, should he decide to flirt with communist subversion by painting an 'abstract' or 'distorted' picture. Much to the chagrin of Genauer, Dondero told her that it was the duty of the art critic to police artists for possible communist subversion.

14. Genauer, 'Still life', 1949.

15. Dondero, 'Modern art shackled to Communism', Congressional speech, 16 August 1949 (Museum of Modern Art Archives, NY, Alfred H. Barr Jr. Papers [AAA: 3156;1004]).

16. Genauer noted: 'by Dondero's aesthetic standards [MoMA] must at the very least be a communist cell' ('Still life', 1949).

17. Alfred Barr, 'Is modern art communistic?' *New York Times Magazine*, 14 December 1952, pp. 22 + 28. See also Sarah Wilson, 'Art and Politics of the Left in France, 1935–1955', unpublished PhD thesis, Courtauld Institute of Art, University of London, 1991, p. 340 and Cecile Whiting, *Antifascism in American Art*, New Haven: Yale University Press, 1989.

18. Lenin quoted in Genauer, 'Still life', 1949.

19. 'Is modern art communistic?', 1952.

20. Kevin Mulcahy, 'Cultural diplomacy: foreign policy and the Exchange Programs', in Kevin Mulcahy & C. Richard Swan (eds), *Public Policy and the Arts*, Boulder: Westview Press, 1982, p. 273. See also Gary Larson, 'From WPA to NEA: fighting culture with culture' in Judith Balfe & Margaret Wyszominski (eds), *Art, Ideology and Politics*, New York: Praeger, 1985, pp. 293–314.

21. Mulcahy, 'Cultural diplomacy', 1982, p. 227.

22. Ibid., p. 282.

23. While Marshall Aid helped to stabilize Western Europe, especially the French and Italian governments, it also had an often overlooked, albeit profound impact on the cultural developments of European nations. Certain examples of American cultural imperialism were directly related to economic and political issues. Guilbaut argues that the United States used Hollywood films to disseminate positive images of American culture in Europe to win public support, and that its monopoly tactics nearly destroyed the French film industry (*How New York Stole the Idea of Modern Art*, 1983, pp. 133–7).

24. See William Hauptmann, 'The suppression of art in the McCarthy decade', *Artforum*, 12, October 1973, p. 50; de Hart Matthews, 'Art and politics', 1976; T. Littleton & Maltby Sykes, *Advancing American Art: Paintings, Politics and Cultural Confrontation at Mid Century*, exh.cat., University of Alabama Press, 1989; Greenberg, review of *Advancing American Art, The Nation*, 23 November 1946; Barr, 'Artistic freedom' (response to letter by William A. Parker in *College Art Journal*, 15, 1956 in Irving Sandler & A. Newman (eds), *Defining Modern Art: Selected Writings of Alfred H.Barr Jr.*, New York: Harry N. Abrams, 1986, p. 222).

25. After the war, President Truman transferred the international information functions of the wartime Office of War Information and Office of the Co-ordinator of Inter-American Affairs to the State Department, forming the Office of International Information and Cultural Affairs (OIC), later to be renamed the Office of International Information and Educational Exchange (see Mulcahy, 'Cultural diplomacy', 1982, pp. 274–82).

26. Ibid., p. 287.

27. USIA Fact Sheet, USIA, Washington DC.

28. In fact, 'they have almost always arisen as a response to international political crises' (Mulcahy, 'Cultural diplomacy', 1982, pp. 276–7). In other words, although a cultural agency outside the State Department, the USIA was directly involved in international politics.

29. Conversation with Porter McCray, 25 January 1992.

30. Portions of this policy were eventually published in an article by Leslie Portner (*Washington Post and Times Herald*, 6 March 1955). See also Hauptmann, 'The suppression of art', 1973 and Barr, 'Artistic freedom', 1956.

31. American Federation of Artists, 'A statement on artistic freedom', *College Art Journal*, 14, 1955, inside rear cover.

32. Barr, letter to William Ainsworth Parker of the American Council of Learned Societies, in ibid., 15, 1956.

33. See Hauptmann, 'The suppression of art', 1973; de Hart Matthews, 'Art and politics', 1976; 'Dondero, Dallas and defeatism', *Arts*, July 1956; 'Art for propaganda', *Dan Smoot Report*, Dallas, 2:11, 16 March 1956.

34. De Hart Matthews, 'Art and politics' 1976, p. 771.

35. Museum of Modern Art Archives, NY: Alfred H. Barr Jr. Papers [AAA: 3156; 710].

36. Wilson, 'Art and Politics of the Left in France', 1991, pp. 340–56.

37. Quoted in Larson, 'From WPA to NEA', 1985. Compare the British Council, which from 1945 to 1956 was equally intent upon winning the Cold War: 'We are engaged today in a life struggle between two conflicting ideologies. The "cold war" is in essence a battle for men's minds. The British Council is one of [England's] chief agencies for fighting it … There are few European countries in which one can say that the cold war is won' (Sir John Troutbeck quoted in Frances Donaldson, *The British Council: The First Fifty Years*, London: Jonathan Cape, 1984, p. 169).

38. Quoted in Egbert, *Socialism and American Art*, 1967, pp. 134–5. See also Hauptmann, 'The suppression of art', 1973.

39. Conversation with Darthea Speyer, 19 March 1992. Speyer was instrumental in promoting American art in Paris.

40. Conversation with Porter McCray, 25 January 1992. The International Program did contact the USIS in each city, to ask for its help in publicizing exhibitions locally, including 'The New American Painting'; in the Italian press McCray was misidentified several times as the head of the Milan USIS. On occasion, the USIS also helped to expedite customs clearance (conversation with Rasmussen, 6 January 1992). Letters to USIS employees addressing the specifics of 'The New American Painting' in each country can be found in both the The Museum of Modern Art Archives, NY and International Program files (from Darthea Speyer in Paris and Stefan Munsing in London).

41. See Clement Greenberg in *The Nation*, 12, February 1944 and Barr, 'The Museum of Modern Art's record on American artists', a 'Letter to the Editor', *Art News*, September 1957.

42. MoMA's early Abstract Expressionist acquisitions included Gorky's *Agony* (1947), Gorky's *Garden in Sochi* (1941), Motherwell's *Pancho Villa, Dead and Alive* (1943) and Pollock's *She Wolf* (1943); all purchased one year after they were painted. See Barr, 'The Museum of Modern Art's record', 1957.

43. Miller's contribution to and influence upon American art during her tenure at MoMA is inestimable. Miller organized group shows until 1963, thus playing a substantial editorial role in which artists would be shown at MoMA until her retirement as Senior Curator of Painting and Sculpture in 1969.

44. Sam Hunter, *The Museum of Modern Art: the History and the Collection*, New York: Harry N. Abrams, 1984, pp. 20–1.

45. Presumably Russel Lynes's 1973 history of the Museum (*Good Old Modern: An Intimate Portrait of The Museum of Modern Art*, Athenaeum, New York: 1973). While Lynes's story is lively, it is not always accurate. This is significant as Lynes is one of only four sources cited by Cockroft in 'Abstract Expressionism'.

46. 'I couldn't believe the slaps [Cockroft] took at Nelson … It was totally, totally concocted on her part. I don't know where she ever got on to that track. I don't know what her purpose was' (conversation with Porter McCray, 25 January 1992).

47. In 1941 Rockefeller became the head of the Office of the Co-ordinator of Inter-American Affairs. In 1944 he was appointed Assistant Secretary of State for Latin America, a post he held until 1953.

48. Conversation, 25 January 1992. Rasmussen remembered similarly: 'I was here during those years, and he [Rockefeller] didn't participate that much in determining exhibitions. The exhibitions were determined by the staff, and approved then by the Board of Trustees and the International Council, so however he viewed it really isn't à propos' (conversation, 6 January 1992).

49. Piri Halasz, 'Art criticism (and art history) in New York: the 1940s vs. the 1980s; Part II: the magazines', *Arts Magazine*, 57, March 1983, p. 67.

50. See *Life*, August 1949.

51. Pollock's first showing in France was not until 1952, at Studio Facchetti in Paris.

52. Conversation with Rasmussen, 6 January 1992.

53. In '14 Americans' (1946) four out of 14 artists were Abstract Expressionists; in '15 Americans' (1952) five out of 15 and in '12 Americans' (1956) six out of 12 artists were Abstract Expressionists. These shows provided a stamp of approval for American avant-garde art and many important works in MoMA's collection were acquired from them. (All six 'Americans' exhibitions were organized in the same way, providing the basic format for 'The New American Painting'.)

54. Conversation with Rasmussen, 6 January 1992. This was plainly stated in a memo dated 13 July 1956 to McCray (Museum of Modern Art Archives, NY: Dorothy C. Miller Papers, I.14.F). Eventually, Barr would write the introduction to *The New American Painting* catalogue.

55. Museum of Modern Art, Archives, NY. Reports and Pamphlets, box 10.

56. Ibid.

57. It is sometimes overlooked that, as an exchange programme, the International Program brought foreign exhibitions to the United States, such as 'Architecture of Japan' and 'Latin American Architecture Since 1945'.

58. 'The Council ... sponsors the International Program and other exchange activities of The Museum of Modern Art. Currently members represent twenty-five countries' (Rasmussen, unpublished letter to Ross, 15 July 1991).

59. 'There was always this miscomprehension about what the International Program was, and what the International Council was' (conversation with McCray, 25 January 1992). Based on the five-year proposal of international exhibitions, the International Program was launched with initial funding from the Rockefeller Brothers Fund. The International Council would fund the International Program through membership fees and donations, eliminating the need for grants from the Rockefeller Brothers Fund.

60. This exhibition of 56 paintings by nine painters and 18 works by three sculptors: Albright, Calder, Davis, Gorky, Graves, Hopper, Kane, Marin, Pollock, Roszak, Shahn and Smith, circulated in France, West Germany, Sweden, Finland and Norway. In most of these countries, it was the first exhibition of modern American art.

61. In Paris this was called '50 Ans d'Art aux Etats Unis', though it is often thought to be two separate exhibitions.

62. Among the painters and sculptors shown were Albright, Hopper, Shahn, Marin, Graves, Kane, Davis, Calder, Roszak and Smith; and in the very small Abstract Expressionism section were Pollock, Gorky, Motherwell, Rothko, Hartigan, Kline, Stamos, Still, Tomlin and Baziotes. Many of the same artists and paintings would be in 'The New American Painting'.

63. Only 20 out of 107 paintings (by 49 artists) were Abstract Expressionist works. For reviews, see 'American art at the Tate', *The Times*, London, 5 January 1956; 'Paris is critical of US exhibition', *The New York Times*, 4 April 1956; John Russell, 'Yankee doodles', *The Sunday Times*, London, 8 January 1956; J. Lusinchi, 'Les écoles étrangères (cinquante ans de peinture aux Etats-Unis)', *Cimaise*, 2, May 1955, pp. 8–10; Patrick Heron, 'The Americans at the Tate Gallery', *Arts*, 30, March 1956, pp. 15–17. Heron's article is a convenient source for excerpts from other London reviews.

64. Press release 9 July 1948 and untitled International Council document of April 1958 (Museum of Modern Art Archives, NY: International Council/International Program Exhibition records, US Representation at Biennales before 1952. *XXIV Biennale di Venezia*: series II. Box 2.1).

65. The United States chose to exhibit in the XXIV Biennale (1948), the first since 1942, since the Communists had been evicted from Italy's government, an indirect result of Marshall Aid.

66. Press release, 9 July 1948 (Museum of Modern Art Archives, NY: ICE: *XXIV Biennale di Venezia*: series II. Box 2.1). The US pavilion at the Biennale, erected in 1929 by Grand Central Galleries, was purchased in 1953 by MoMA and was the only privately owned pavilion.

67. Lynes (*Good Old Modern*, 1975, p. 385) and Cockroft ('Abstract Expressionism', 1974) both wrongly state that MoMA was the sole organizer of the Venice Biennale prior to 1965.

68. De Hart Matthews, 'Art and politics', 1976.

69. The selection of Abstract Expressionists was systematically deplored by many of the New York critics including Emily Genauer ('Americans at Venice', *Arts Digest*, 1 June 1958).

70. Shahn was one of the artists considered subversive by the government (Frances Pohl, 'An American in Venice: Ben Shahn and American foreign policy at the 1954 Venice Biennale', *Art History*, Vol. 4, March 1981, pp. 80–113.

71. 'Abstract Expressionism', 1974. McCray called Cockroft's article a 'pack of lies' and reiterated how upset he was by her insinuations: 'She doesn't know me. She had never spoken to me, or written to me or anything… She never came to any of us [at MoMA] whom she blamed for all of this … She kept on making these wild, untrue statements. She totally concocted stories that were wrong and put them down as fact in a supposedly reputable magazine. I'd like to talk to her once and see what she's all about … I, as you know, was not at the Museum [when the article was published], and I insisted that the Museum reply to that article, and there were various drafts written: Waldo [Rasmussen], Dick Oldenberg and so forth were submitted to me because I was quite annoyed with this total falsification of fact, and the Museum board decided not to answer it. This distressed me very much and does to this day. But, it led to all of this nonsense with the Whitney ['Constructing American Identity'], too … I'd like to see somebody someday take it [the confusion] to its true conclusion … [to] exonerate my own integrity and question her authority over any of the statements she made' (conversation, 25 January 1992).

72. He took a year's leave of absence in 1951 to work in the exhibitions section of the Marshall Plan in Paris (ibid.).

73. In 1958 alone, four large International Program exhibitions simultaneously toured Western Europe: 'Jackson Pollock, 1912–56', 'The New American Painting', US representation at the XXIX Venice Biennale and 'French Drawings from American Collections'.

74. Unpublished letter to Ross, 15 July 1991 (Museum of Modern Art International Program, NY: Waldo Rasmussen files).

75. 'Mr McCray said that there were no big international exhibitions and that the International Council wanted something which would make New York aware of what they are doing … ['The New American Painting'] provides a review of the whole movement which the Museum needs' (Monroe Wheeler memo to staff, 6 March 1957, Museum of Modern Art, Archives, NY: Dorothy C. Miller Papers, I.14.F).

76. Memo McCray to d'Harnoncourt, 11 June 1956 (Museum of Modern Art Archives, NY: Dorothy C. Miller Papers, I.14.F).

77. See also Yvonne Hagen, 'US paintings shown' *New York Herald Tribune*, Paris, 23 April 1958. Hagen mentions that Rüdlinger originally proposed 'The New American Painting' and believed a comprehensive avant-garde show of American art to be in order for the European public.

78. Conversation, 6 January 1992.

79. Dorothy Miller was quoted in *The New York Times*: 'They were specifically requested; named by name.' Rüdlinger's original list included Diebenkorn, Rivers and Tobey and the sculptors Ferber, Lassaw, Lipton, Roszak, Smith. The sculpture was omitted, 'principally due to an unusual number of scheduling conflicts with other institutions which are planning sculpture exhibitions this year both in this country and abroad' (letter McCray to Rüdlinger 15 February 1958. Museum of Modern Art, Archives, NY: Frank O'Hara Papers, 16).

80. Letter Rüdlinger to McCray 16 April 1957 (International Program, Museum of Modern Art, NY: Work Files, ICE-36–57). Rüdlinger was intent upon acquiring American art for the Kunsthalle: 'The American exhibition has been such a wonderful success that I can count upon a small collection of pictures for our museum' (letter Rüdlinger to Miller, 28 October 1958. Museum of Modern Art Archives, NY: Dorothy C. Miller Papers, I.14.B).

81. Letters Jean Cassou, Musée National d'Art Moderne Paris; Giron in Brussels and Enzo Pagani, Milan all express appreciation for MoMA's organization of the exhibition (Museum of Modern Art Archives, NY: ICE 36–57 (Brussels); Museum of Modern Art Archives, NY: Dorothy C. Miller Papers, I.14.D).

82. See '"The New American Painting" and Jackson Pollock open simultaneously at Kunsthalle Basel, April 19', IC press release No. 4 (Museum of Modern Art Archives, NY: Dorothy C. Miller Papers, I.14.G); '"The New American Painting", Large Exhibition, Leaves for Year-Long European Tour under Auspices of International Council at The Museum of Modern Art', IC press release No. 2 (Museum of Modern Art Archives, NY: Dorothy C. Miller Papers I.14.G); 'Tate Gallery to Present the Work of 17 Important US Painters in "The New American Painting"', *Art News Bulletin*, USIS, London (Museum of Modern Art Archives, NY: ICE-F-36–57: box 37.13).

83. 'This is the kind of show that will *have* to be organized eventually, and [MoMA] is certainly the

logical sponsor. And also it is time for a serious catalogue and explanation of the work of this group of painters' (letter, Sam Hunter [Associate Curator of Painting & Sculpture] 14 February 1956 International Program, Museum of Modern Art, NY: Work Files, ICE-36–57). See also letter from Hunter to Henry Clifford, Curator of Painting at the Philadelphia Museum of Art, dated May 1955 (International Program, Museum of Modern Art, NY: Work Files, ICE-36–55).

84. René d'Harnoncourt, Foreword, *The New American Painting*, exh.cat., Museum of Modern Art, NY, 1959, p. 5.

85. The preface continues: '[Rüdlinger's] special interest in advanced tendencies in American Painting and his knowledge of its leading figures was a particular incentive in the realization of our own exhibition' (McCray, *The New American Painting*, Basel edition 1958).

86. See letters from museums (in Munich, Venezuela, Frankfurt, Lima, Stockholm, Copenhagen, Cologne and Helsinki) requesting the exhibition which did not receive it (Museum of Modern Art Archives, NY: Dorothy C. Miller Papers, I.14.F).

87. The itinerary of 'The New American Painting' was: Basel, Kunsthalle, 19 April–26 May 1958; Milan, Galleria Civita d'Arte Moderna, 1–29 June 1958; Madrid, Museo Nacional de Arte Contemporaneo, 16 July–11 August 1958; Berlin, Hochschule für Bildende Kunst, 1 September–1 October 1958; Amsterdam, Stedelijk Museum, 17 October–24 November 1958; Brussels, Palais des Beaux-Arts, 6 December 1958–4 January 1959; Paris, Musée National d'Art Moderne, 16 January–15 February, 1959; London, Tate Gallery, 24 February–23 March 1959.

88. A memo (7 April 1959) describes Miller's insistence upon including a subtitle in the New York catalogue. The name 'The New American Painting' evolved from 'Americans 1947–1957' (5 November 1957) through 'Recent American Painting and Sculpture' to 'American Art of the Last Decade' (January 1958), and 'Abstract Expressionism in America' (13 February 1958). It was named 'The New American Painting' by 28 February 1958, intended as a simple format title for ICE shows, such as 'The New Spanish Painting and Sculpture' and 'The New Japanese Painting and Sculpture'.

89. The New York version was based on the London version (minutes of meeting of Co-ordination Committee, 29 October 1958. Museum of Modern Art Archives, NY: Dorothy C. Miller Papers, I.14.B).

90. Memo from Monroe Wheeler to Dorothy Miller 10 February 1959 (Museum of Modern Art Archives, NY: Dorothy C. Miller Papers, I.14.B). See also *The New American Painting*, Museum of Modern Art, NY, 1959, pp. 7–14.

91. The European covers featured Gottlieb's *Burst*.

92. Influential figures in the London art world like Lawrence Alloway and David Sylvester were enthusiastic; Alloway alone wrote three reviews. The major London papers all published reviews, as did the tabloids and smaller city papers, which were petty and cynical. These reviews are of interest, as they present the layman's impression of the exhibition. See also Herbert Read, 'Dialogue on modern US painting', *Art News*, 59, May 1960, p. 33.

93. For concise overviews of the European reaction, see Dore Ashton, 'Europe sees our art', *The New York Times*, 15 June 1958; Lynes, *Good Old Modern*, 1975, p. 388; Réné d'Harnoncourt, Foreword, *The New American Painting*, 1959, pp. 7–14; Kenneth Rexroth, '2 Americans seen abroad', *Art News*, 58, 1959, p. 30 (this article distressed MoMA, as it depicted an entirely negative European reception. The Museum sent a letter to *Art News* in response).

94. The show toured seven cities in 1958–9, coinciding with 'The New American Painting' in Paris and Basel.

95. See Annette Michelson, 'Paris', *Arts Magazine*, 33, June 1959, pp. 16–19 and Pierre Schneider, 'Paris' *Art News*, 58, May 1958, p. 46.

96. A. Rüdlinger, speech, n/d but probably April 1958 (Museum of Modern Art Archives, NY: ICE-F-36–57: box 36.6).

97. Switzerland, for example, had not suffered the devastations of the war, nor was it a recipient of Marshall Aid.

98. *The New American Painting*, 1959, p. 16.

99. Edouard Roditi, 'Peinture ou non-peinture, Américaine ou non-américaine', *Presence*, 7/8, (Geneva), 1958.

100. John Canaday, 'A critic's valedictory: the Americanization of modern art and other upheavals', *The New York Times*, 8 August 1976.

101. Genauer, 'Will "advanced" art serve U.S. abroad?', *Herald Tribune*, 16 March 1958. See also 'The avant-garde goes to Europe', ibid.

102. Kozloff, 'American painting', 1973.

103. Ibid. p. 43.

104. Ibid. p. 44.

105. Ibid. p. 49.

106. Rasmussen, unpublished draft letter to *Village Voice* (Museum of Modern Art International Program, NY: Waldo Rasmussen files).

107. Conversation 6 January 1992: 'I don't know [why it wasn't sent]. I think it was just a feeling of great caution. I think there had been a lot of turmoil at the time, and the Museum administration just didn't want to enter an argument about it.'

108. Perreault, 'MOMA's Sugar Daddy', *Village Voice*, 4 July 1974. Many other articles on United States cultural diplomacy also implicated MoMA, including Lasch and Matthews.

109. John Tagg, 'American power and American painting: the development of vanguard painting in the United States since 1945'; *Praxis*, 1: 2, 1976, p. 71.

110. *Pollock and After*, 1985, p. 100.

111. See *Constructing American Identity*, exh.cat., Whitney Museum of American Art, 1991; Hilton Kramer, '"Constructing American Identity": travesty, courtesy of the Whitney', *New York Observer* 22–9 July 1991; Kay Larson, 'The politics of power', *New York*, 22 July 1991, pp. 48–9; Roberta Smith, 'An exhibition about art exhibitions', *The New York Times*, 5 July 1991.

112. See *Constructing American Identity*, exh. cat., Whitney Museum of American Art, NY, 1991.

113. Eric Miles in ibid., p. 2.

114. Burgin argued that based on Kruschev's denunciation of Stalin, a 'Cold War "thaw" released a flood of modern American art upon the world in a series of U.S. Government and Industry sponsored exhibitions.' Not realizing that he was mistaking private, International Program initiatives for government sponsored initiatives, he continued, 'much of the work toured was the "abstract" art which had previously been considered politically subversive simply because it offended the philistinism of conservative politicians. Increasingly however, abstraction ... by virtue of the *difference* it established in opposition to Soviet Realism, [stood for] "freedom of expression"' ('Modernism in the *work* of art', *20th Century Studies*, 15/16, December 1976, p. 51).

115. 'Problems of criticism, IV: the politics of art Part 1', *Artforum*, 6, February 1966, p. 32.

116. 'The New York School Question', *Art News*, 64, September 1965, p. 55.

'Place'

Toby Treves

Situating 'Place'

In Eric Newton's opinion 'Place' was one of the silliest exhibitions he had ever seen.[1] Held over three weeks at the Institute of Contemporary Arts (ICA) during the autumn of 1959, it was the result of a collaboration between three young painters: Robyn Denny, Ralph Rumney and Richard Smith. Thirty-four paintings were produced for the exhibition, 11 each by Denny and Smith and 12 by Rumney. From the outset the artists agreed to follow rules of colour, style and size. On completion, the works, all of which were seven feet high, stood on the gallery floor to form a maze of paintings for the visitor to walk through. An accompanying leaflet written by the ICA's exhibitions organizer, Roger Coleman, offered insights into the artists' interests.

In this paper the history of the exhibition is considered through Raymond Williams's theory of incorporation.[2] Taking Gramsci's conception of hegemony as the dominant and effective social system in a society, Williams analyses cultural incorporation as a strategy by which the hegemony maintains its position of domination. He argues that the survival of the hegemony partly rests on its ability to manipulate practices and meanings from every stratum of cultural activity, both past and present, into affirmations of the system. The selected history is then disseminated through powerful channels of influence, such as educational institutions and becomes fully incorporated.

Inevitably, some practices and meanings exist outside the hegemony. These Williams divides into 'alternative': those which exist independently but do not challenge the hegemony, and 'oppositional': those which intentionally threaten the hegemony and resist incorporation. Williams subdivides these categories further into 'residual' and 'emergent'. Residual practices and meanings are drawn from the husks of a previous hegemony, while the

emergent are new practices and meanings born from limitless human creativity. The hegemony has to confront these practices and meanings if it is to maintain its relevance to society. It is particularly alert to developments in areas of special interest, such as high culture. In such cases it reaches out and incorporates those practices and meanings which are willingly drawn into the hegemony. Those which continue to oppose it are subject to attack.

In the following pages, the ICA is shown to operate as an agent within the hegemony's network of incorporation, specializing in the reeling in of emergent alternative practices and the elimination of emergent oppositional practices. Coleman and Lawrence Alloway, deputy director of the ICA co-ordinate these activities within the Institute. Denny and Smith are seen as emergent alternative practitioners, members of the British avant-garde, waiting to be incorporated. Rumney, a member of the counter-avant-garde, represents emergent oppositional practices and meanings.

The central conflict between the contributors to 'Place' revolved around the status of the art object and the function of art. That section of the British avant-garde represented by Denny and Smith and supported by Alloway and Coleman was committed to art as a physical commodity subject to continual reconfiguration. Though the work produced was partly responsive to the wider social and political climates, it was not encumbered with a sophisticated theorization of its role within these contexts. On the other hand, the overtly political character of Rumney's project put it at odds with the work of his 'Place' colleagues. His aim was the overthrow of the capitalist hegemony through his existence as an artist. The art object was a dispensable entity in this undertaking, and if it did materialize it was only as a by-product, not the culmination, of a greater enterprise.

The approach that I have summarized is justified by the primary source documentation and my interviews with the contributors. It is clear from these that the initiative for the project came originally from Rumney and that he intended to smuggle oppositional practices and meanings into the ICA. It is equally clear from the interviews and the final manifestation of 'Place' that Rumney's ideas were deliberately subverted to create an exhibition which conformed to a set of alternative emergent practices and meanings which had been promoted by several exhibitions at the ICA during the 1950s and were, by 1959, in the advanced stages of incorporation.

Theorizing 'Place'

The first existing record in the ICA Exhibitions Committee minutes relating to 'Place' dates from 27 August 1958, when Lawrence Alloway proposed 'a painting/environmental exhibition (including architectural students of the

Regents Street Polytechnic, ex. Royal College of Art students, etc.) to take the place of the 'Three Americans' if it fell through'.[3] On 15 January the following year, the committee '"revived" the suggestion of an "environmental" exhibition' and named Robyn Denny, William Green, Ralph Rumney and Richard Smith as participants. At the same meeting Roger Coleman was appointed director of the exhibition and was asked to write the catalogue.[4] The architectural element which had appeared in the initial proposal seems to have been dropped by this date and by mid-March so had William Green.[5] At this point the participants' discussions about the format of the exhibition were well advanced,[6] with 'a module system and colour code' decided on.[7] The records are then silent until the summer when the opening of the show was brought forward two months to mid-September to fill in for a postponed exhibition.[8] On 8 August it surfaced again as the dates of the run were finalized, the production cost of the 500 catalogues was approved and Richard Smith was thanked for the catalogue design. Importantly, in the same minutes it was recorded that an 'opener [is] needed for "Place" (possibly a sociologist or town planner)'.[9] Thereafter it drops out of the records. The only other remaining documents are three letters written by Rumney from Paris and Venice to Coleman, Denny and Smith in the late winter and spring of 1959, and two photographs of Rumney's prototype model for the exhibition (Fig. 6.1).

Ralph Rumney was an ambiguous figure in the art community who drifted in and out of various European avant-garde and counter-avant-garde movements. Although he had exhibited successfully in England since 1956 and was well known to the London avant-garde, he was considered by its members to be more a European intellectual loosely aligned to the Situationist International (SI) than a fully integrated member of the London art world. Born in 1934, the son of a vicar, Rumney had attended Halifax School of Art until 1952. Between 1952 and 1955 he had spent much time living in France and Italy, though he had visited London often enough to found *Other Voices*, a short-lived weekly art magazine. His first one-man show was held in Trieste in 1955, followed a year later by another at the Galleria Apollinaire, Milan. In 1956 the New Vision Centre Gallery, London, gave him his first solo show in Britain. That same year he left the Communist Party in protest against the Soviet suppression of the Hungarian insurrection. In 1957 he collaborated with Asger Jorn on a joint exhibition at the Galerie Taptöe, Brussels and 14 of his paintings, including *The Change* (Fig. 2.7), were displayed in 'Metavisual, Tachiste, Abstract' at the Redfern Gallery, London. He did not exhibit again until 'Place'.

By 1959 he was married to Pegeen Guggenheim, daughter of Peggy Guggenheim, and was considered by his English peers to be leading a sophisticated life in continental Europe. Denny describes him as having

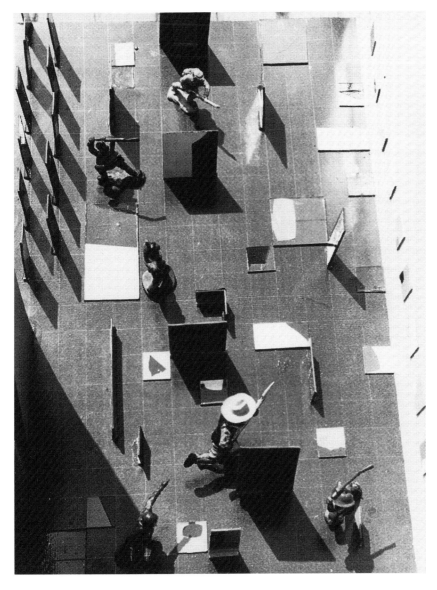

6.1 Ralph Rumney, model for 'Place', 1959

been an 'exotic outsider' and as 'a very precocious young artist', who 'did lots of interesting stuff and met lots of interesting people long before Dick [Smith] or I did'.[10] Coleman characterizes him as 'very much a kind of European. I always pictured him sitting with Sartre outside the café talking earnestly in that strange voice of his about mad things. He was much more a

real European intellectual, where we seemed more like media people in relation.'[11] Smith corroborates this perception of Rumney saying, 'Ralph had been around quite a bit and he was in touch with the Situationists or something like that, and gave lectures, and there was a sense of his modernism which was very Paris based.'[12] These assessments support Rumney's own view that he was seen in England as 'an offshore incident which occasionally blew in'.[13]

His relationship with the SI was as complex and contradictory as the group itself. The SI, founded in 1957 at Cosio d'Arroscia, Italy by among others Guy Debord, Asger Jorn and Rumney, was a tightly regulated confederation of anarchist art sects. Prominent among the formative groups were the Movement for an Imaginist Bauhaus, founded by Asger Jorn in 1953, two years after the dissolution of Cobra, with the Lettrist International, headed by Guy Debord. They had developed as extreme left offshoots of the international surrealist movement after André Breton's post-war denunciation of Communism, and his perceived betrayal of experimentalism in favour of a return to occultism and abstraction. By tracing the Marxist and surrealist heritage of the Situationists, Peter Wollen constructs them as post-Marxist/ post-Surrealists set on a political transformation of capitalism through ludic cultural activities.

The nature of these activities was an intensely divisive issue and by 1959 a schism had developed over the rôle of the art object in situationist practice. Debord argued for the eradication of the object, claiming that it was irrevocably mired in the commodity culture of capitalism; Jorn maintained that the object could function as a subversive force within capitalism and was thus valid; while Rumney, who had remained loyal to the SI's revolutionary doctrine despite having been expelled in 1958 for breaking one of its many rules,[14] relegated the object to an occasional by-product of an artistic life.[15] In a recent catalogue he was quoted as saying 'Je crois profondément qu'être un artiste est une façon de vivre. Le produit est un sous-produit, comme la merde est quelque chose qui arrive ou n'arrive pas à sortir de soi: elle peut être belle, pas belle, elle peut sentir bon ou mauvais ... Être un artiste est une façon d'être.'[16] The eradication of the art object, as suggested by Debord, or the relegation of it to a by-product, as Rumney proposed, were in direct conflict with the high value placed on the authentic artwork by the British avant-garde.

A central concern for Situationists was the reformation of the modern city. In his seminal essay 'Formula for a New City' written in 1953 and published in the first edition of *Internationale Situationniste* in June 1958, Gilles Ivain judged the contemporary city to be a banal, functionalist environment designed to suppress irrational, subconscious desires. For Ivain these cities were capitalism's most pernicious form of social control. In their place he

proposed playful cities with non-functionalist areas intended to awaken the subconscious of each inhabitant. Ivain's construction of play as a gateway to the subconscious was partly indebted to Johann Huizinga's *Homo Ludens*. Huizinga had observed that the essence of play, namely 'fun', seemed totally unrelated to any physical advantage bestowed on the participants by the act of playing. Taking material benefit as the goal of rationally motivated behaviour, Huizinga concluded that play was irrational. Its existence proved to him that humans 'must be more than merely rational beings'.[17] Ivain's new cities would nurture this neglected facet of human nature and so challenge the orthodoxy of functionalist capitalism.

Though Ivain prescribed zones, such as the sinister *quartier*, to arouse specific emotions, he did not provide a methodology for identifying those features in existing cities which could be recycled to construct these areas. Around 1957 Rumney founded the London Psychogeographical Society. As its founding and perhaps only member he began to develop techniques for recording the individual's subconscious response to the urban environment. Central to his research technique was the *dérive*, defined in *Internationale Situationniste* as 'a mode of experimental behaviour linked to the conditions of urban society: a technique of transient passage through varied ambiences'. In practice, a *dérive* was an unstructured drift through a city. It was an attempt to step out of normal rational behaviour and create a playful, subconscious interaction with the city. In some instances, the individual's responses were recorded. The data gathered was then to be submitted to sociologists and town planners to design the utopian cities Ivain had described.

During 1957 Rumney approached Lawrence Alloway with an idea for an exhibition called 'Hiss Chamber'.[18] As Rumney describes it, the exhibition would have consisted of a series of hexagonal chambers installed throughout the ICA's Dover Street premises. Each chamber was to have been a different size and to have had its own distinct environment, one of which, for example, would have emitted a hissing sound. Using a magnetic key participants would have entered and left a chamber through any one of the six different coloured doors constituting its sides. The path of each individual through the chambers was to be recorded and the collected data analysed for evidence of environmental preferences. The purpose of the exercise was, like the recorded *dérive*, to devise a methodology for assessing the individual's subconscious response to a particular environment. In the context of the Psychogeographical Society and 'Hiss Chamber' the significance of the ICA minute of 1959 stating that an 'opener [is] needed for "Place" (possibly a sociologist or town planner)' should be clear. 'Place' was directly linked with situationist strategies to transform modern life.

The connection between 'Place' and these concerns was made more apparent in Rumney's letters to Coleman, Denny and Smith.[19] Although only one was

dated, their content indicates the order in which they were written and their approximate dates. The first letter discussed broad conceptual ideas for the exhibition, the second suggested a specific layout and the third, dated 1 April 1959, seemed to refer back to the layout proposed in the second letter. Working on the premise that aims are likely to be set before strategy, the order suggested is logical. Regarding the dating, the first two letters, both addressed to Coleman, Denny and Smith from Paris, must postdate 15 January when Green was mentioned as a participant in the ICA minutes, and predate 21 March 1959 when Rumney said in the second letter that he would be leaving Paris for Venice. The third letter was addressed from Venice. The letters reveal that the exhibition was, like 'Hiss Chamber', intended to establish a methodology for recording subconscious responses to an environment.

The opening section of the first letter set a conceptual basis for the exhibition. In subsection three Rumney wrote, 'If we regard the project as to a certain extent symbol manipulation we may say that we are trying to represent certain symbols: the painted surface – the picture exhibition – the use of art.'[20] Symbol manipulation corresponded to the situationist strategy of *détournement* defined in *Internationale Situationniste* as:

Short for: détournement of pre-existing æsthetic elements. The integration of present or past artistic production into a superior construction of a milieu. In this sense there can be no situationist painting or music, but only a situationist use of these means. In a more primitive sense, détournement within the old cultural spheres is a mode of propaganda, a method which testifies to the wearing out and loss of importance of those spheres.[21]

How Rumney intended to *détourne* the 'painted surface – the picture exhibition – the use of art' and to what effect was developed in the course of the correspondence.

The questions in subsections four to 13 first addressed the manner in which publicly displayed culture was consumed by individuals, then the character of the ICA's audience and finally its members' perceptions of artists, exhibitions and themselves. It is evident from the remaining subsections that Rumney thought people were normally coerced by exhibitions into contemplating the art object as an æsthetic phenomenon before which they assumed a self-abasing passivity. In subsection sixteen he wrote, 'In a gallery there is usually no activity possible save that of looking at paintings. Can we involve the spectator in some sort of simple game so that he is only marginally aware of the pictures?'[22] And in subsection twenty he asked, 'Can we give the spectator a feeling of self-importance, or self-aggrandisement?'[23] He concluded the letter thus: 'If we can make an environment in which the spectator feels comfortable, can carry out some simple activity other than looking at pictures, and can yet at the same time be aware that he is in an environment made of pictures then we have succeeded in what we are trying to do.'[24]

Details of such an environment were given in the second letter where a format similar to 'Hiss Chamber' was suggested. Rumney proposed:

> ... to treat the wall space of the room broadly as we have agreed by hanging large paintings there in the most environmental way possible, and to treat the fmoor [sic] as a sort of crossword puzzle. That is to say that we should divide the floor into squares of a convenient size for one person to stand in. Some of these squares should then be blocked by pictures or written information or obstacles. The player would be required to find a route through this maze by which he would stand in every open space for not more than 15 seconds and he would never enter the same square twice. At the same time he would have to try to remember a large amount of information about his environment which would be tested by a short questionnaire that he would complete on leaving.[25]

Rumney's prototype model clarified this description (Fig. 6.1). In the model some canvases lay on the floor, some formed barricades or low-level obstacles and others hung on the wall. The canvases themselves were in various sizes and the imagery, while it always referred to a head, oscillated sharply from the close-up detail to the full head view. The complexity of the display made it a rich environment for a *dérive*. The use of toy figures was only intended to provide a sense of human scale. Through the device of a game, Rumney intended to *détourne* the traditional consumption of art by pushing the paintings into the visitor's peripheral vision[26] and making them 'something other than ART'.[27] In the process, the visitor would be transformed by this ludic environment from a spectator into a participant.

The inclusion of a questionnaire recalled the proposal in 'Hiss Chamber' to record the path of each individual and the occasional recording of a *dérive*. Both were intended to provide data on subconscious responses. In 'Place' Rumney went further, suggesting in the first letter that since 'questionnaire answers alone are almost valueless as they do not disclose subconscious motivations' they might consider 'a sort of psychoanalysis technique [sic] without couches which might work best in the form of a recorded group talking jag'. While the liberation of the spectator from passivity was congruent with Ivain's liberation of the individual from the joyless functionalism of capitalism through the creation of ludic cities, the gathering of data on subconscious responses to the environment was consistent with the aim of the *dérive* and 'Hiss Chamber' to provide information on how and from what these cities could have been constructed.

<p style="text-align:center">* * *</p>

Despite Rumney's situationist lineage for 'Place', it was Richard Hamilton and Victor Pasmore's 'an Exhibit', installed at the ICA in August 1957, which was cited by contemporary critics as its predecessor. 'an Exhibit' was closely

related to Hamilton's exhibition 'Growth and Form' held at the ICA in 1951. 'Growth and Form', which took its name from d'Arcy Wentworth Thompson's influential book, *On Growth and Form*, displayed photographs of micro-organisms with models of molecular structure. Thompson's thesis explored and developed physical and mathematical laws governing the relationship between the form of organisms and the forces of growth acting upon them. It was intended as a correction to the tastes of contemporary naturalists for theories of heredity and metaphysical debates on 'final causation'. For Hamilton, Thompson's ideas provided a scientific analogy for the physical creation of an artwork. This was made manifest in 'Growth and Form' where, in David Thistlewood's words, the viewer was drawn into 'an inner world of abstract images conforming to an evolutionary logic'.[28]

In 1953 Hamilton began teaching at King's College, University of Durham in Newcastle, with Victor Pasmore. There they developed a course called Basic Design, which was closely related to the evolutionary logic of organisms.[29] The premise of Basic Design was that once the first mark had been made, the next was applied in 'considered association'[30] with the first, the next in 'considered association' with the previous two and so on. Unlike Thompson's theories in which the development of organisms was determined by immutable laws, with Basic Design the development was subject to the varying temperament of the artist. Thus, in theory, however much the scientific analogy suggested otherwise, the element of chance and subjectivity in the artistic process was far greater than in Thompson's conception of the growth and form of organisms.

'an Exhibit' followed Basic Design's guiding principle of sequential growth. In the exhibition, large perspex panels with pieces of coloured paper attached to them were hung to form a quasi-maze, which the visitor was invited to negotiate. At the end of each day the panels were dismantled, and then reassembled the next morning by Hamilton and Pasmore. Having installed the first panel, the second was positioned in 'considered association' with the first, the third in relation to the first and second and so on until all the panels were used up. The pieces of paper were applied using the same method. On none of the eleven days during which 'an Exhibit' was installed at the ICA was the arrangement of elements repeated.

Alloway's catalogue for 'an Exhibit' made no direct reference to Basic Design. Instead his text discussed the exhibition in terms of a maze. Arguably, however, a maze may be read as a metaphor for the process of Basic Design; if the positioning of each panel apparently determined the options for the next, so in the maze each move was made in consideration of the previous moves and brought participants to their present positions from which only particular choices were available. In fact, photographs of 'an Exhibit' show that the panels did not create a clearly marked network of paths for visitors

to negotiate. Instead the translucent screens provided the individual with 'the opportunity to generate his own compositions'[31] simply by moving through the gallery. Theoretically, by their considered moves 'maze-bright'[32] players emulated the process of the Basic Design artist.

Although Alloway's catalogue text demonstrated that *Homo Ludens* had a readership within British art circles,[33] play theory was deployed without the sociological or political intent of Ivain or Rumney. The emphasis of 'an Exhibit', as with 'Growth and Form' and Basic Design, was on the process of artistic creation. Certainly visitors were invited to partake in that process within the confines of the gallery space, but there was no agenda to extend this freedom to the participant in the outside world. The gallery was in the catalogue's words 'a playground within which special rules operate'.[34] As its title suggested, 'an Exhibit' was made for such a playground; it did not seek a place in the normal world.

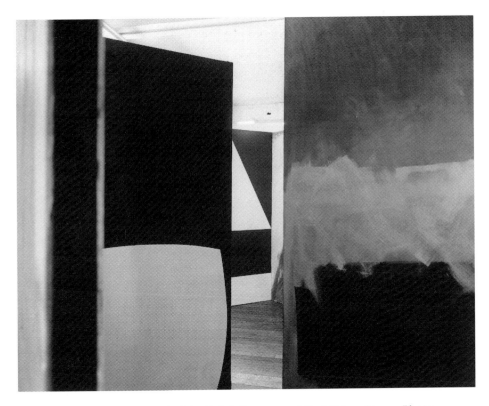

6.2 Installation of 'Place'. Left-right: Ralph Rumney, untitled; Robyn Denny *Place 7*, 1959; Robyn Denny, *Place 1*, 1959

Painting 'Place'

From the outset the artists had agreed on three rules. First, the 34 canvases were to be one of two sizes: seven by six feet and seven by four feet. The sizes were chosen to reflect a human dimension and for ease of handling. Second, only four colours were to be used, black and white, green and red. Third, the artists were to paint in their usual styles (Fig. 6.2). According to Coleman, the rules were devised to see how 'each painters [sic] approach to a similar problem differed'. Having set the rules, Denny, Rumney and Smith spent the summer of 1959 in their studios. A mildly competitive atmosphere prevailed but only rarely was Coleman required to arbitrate.[35] There was some concern that Rumney, who had arrived from Venice with pneumonia in late August, would not meet the deadline, but, with the help of Brian Young, he did.[36]

Denny and Smith, contemporaries at the RCA from 1954 to 1957, were united by a resistance to neo-Romanticism and social realism[37] and by an enthusiasm for the newly affluent urban society in which they lived.[38] For them, modern cities steeped in mass media and hi-tech commodities characterized the late 1950s, a period now seen as the dawn of the western economies' Golden Age.[39] By the end of 1957 Smith had written several articles on mass culture and its strategies for *ARK*.[40] In their humorous semiological dissection, the articles were indebted to Marshall McLuhan's *Mechanical Bride*, but whereas McLuhan's aim had been to awaken the consumer from the mental paralysis which he claimed the capitalist strategies of mass culture sought to impose, Smith remained uncritical of this culture. The publication in 1959 of Denny and Smith's joint project 'Ev'ry which way: a project for a film',[41] demonstrated their particular allegiance to a popular, predominantly American, urban culture.[42]

Though their picture titles often alluded to this culture, images from it were excluded from finished work. Both artists claimed their abstract paintings represented the distilled spirit of the 'intermittent stimuli'[43] of the modern city. The sheer variety of clashing tones and irregularity of overlapping marks in a work such as Smith's *No Place* corresponded metaphorically to 'this world whose periods of flux and stasis are not seasonal, and do not have any regular rhythm'.[44] The contrasting sense of time contained in the quickly applied brushstrokes and the trailing dribbles of paint added to this conception of the modern city, while the painting's title obliquely referred to popular culture.[45]

The diligence with which Smith avoided direct visual reference to specific objects or products was consistent with the balance he sought to maintain between his æsthetic attachment to the non-referential art of Sam Francis and Mark Rothko, and his interest in an urban environment inflected by mass culture.[46] In keeping with the rule on stylistic continuity, Smith's 'Place'

paintings shared characteristics with earlier works such as *Somewhere Over* (1958), particularly in their dimensions and their application of thin layers of marks to create 'hedges of colour'. Maggie Gilchrist, drawing attention to Smith's interest in magazine photography, has connected these sorts of images with the mass culture idiom of the blurred close-up.[47] In the context of his 'Place' paintings, the non-specific images combined with the centrifugal flow of brushmarks suggesting expansion beyond the canvas edge do acquire a visual character akin to the close-up.[48]

The hedges of colour, with their play between surface and illusional depth, invited the viewer to explore the various spatial levels of the paintings.[49] The restless movement between levels created a state of flux similar to that attributed to the modern city in 'Ev'ry which way'. It is significant that though the complementary colours of red and green, black and white specified by the rules seem to have been chosen without any referential intent, Smith connects them retrospectively with traffic lights.[50]

The triangle motif appeared in all of Smith's recorded 'Place' paintings. By consistently marking the horizontal middle of the canvas, it acted as a dividing agent between the upper and lower sections of the canvas. Given the intentionally human dimension of the canvases and the fact that they stood on the floor, this device served to draw the viewer more completely into the paintings. A photograph, reproduced in Coleman's *Architectural Design* article,[51] in which a deliberately blurred figure blends into the 'blurred' painting behind him, his dimensions echoed by those of the canvas, his proportions reflected in the waist-high division of the canvas by the triangle, made this explicit. Smith's 'Place' paintings gave viewers an opportunity to immerse themselves in the distilled spirit of capitalism's metropolis.

As Smith's partner in the 'Ev'ry which way', Denny clearly shared his enthusiasm for the modern city. He also shared his æsthetic interest in Rothko's work, which he had seen on a trip to Venice in 1958. While there he had also experienced Tintoretto's monumental cycle of biblical paintings in the Scuola di San Rocco. He recalls this as having been a revelatory encounter with:

a kind of art which was more than the sum of its parts; it filled your horizon, behind you, in front of you, it was on your left and on your right and one was involved in a drama. One was not just looking at an art work which was separated from you. It was that dramatic effect, the way it impinged upon all one's perceptions, which I found very interesting.[52]

This suggests that Denny had begun to formulate the concept of a total environment of painting prior to 'The New American Painting' exhibition at the Tate Gallery in 1959. Large scale works such as *Home from Home* and *Living-In* corroborate this. Their titles, as much as their scale, conveyed the idea of dramatic envelopment of the viewer.[53]

6.3 Robyn Denny, *Place 3*, 1959, 213.4 × 182.8 cm/84 × 72 in, oil on canvas, artist's collection

With the *Austin Reed Mural*, Denny managed to combine his interest in environment painting with his enthusiasm for the modern city. Measuring 195.5 by 302 cm, it was, with its bright colours and big bold letters exclaiming 'GGREAT [sic] BIG WIDE LONDON – LONDON BIGGEST!', an exuberant public proclamation of confidence in the metropolis. Sited in Austin Reed's premises on Regent's Street, it was clearly what Debord would have called an uncritical collusion with capitalism.[54]

Though 'The New American Painting' may only have reinforced Denny's interest in environment painting, it did introduce him to the hard edge or formal[55] work of Barnett Newman. For Denny, like many of his contemporaries, hard edge abstraction was an American art form to be emulated.[56] Its impact was evident in his 'Place' paintings (Fig. 6.3). In these there was a textural and formal progression from a scumbled Rothko-like irregularity, reminiscent of *Living-In*, to a flat, geometric æsthetic indebted to Newman. The large green section in *Place 1*, for example, displayed the same textured brushwork and slight formal irregularities as *Living-In*, while *Place 8* presented a much greater

clarity of form and smoothness of brushwork. In this respect there was a progression between idioms perceived to be American by Denny.

None of the works was as expansive as Smith's 'Place' paintings; those like *Place 2, 3, 4, 5* and *6* which shared Smith's energetic brushmarks were either confined by a frame of colour, as in *Place 1* and *2*, or lacked the formal dynamism to push them out beyond the canvas; those that had the formal dynamism, such as *Place 7* and *8* in which the tips of triangles were cut off by the upper edge of the canvas, were so smoothly painted and neatly geometric that they seemed to be static monoliths. In place of Smith's enveloping expansiveness, Denny's paintings used an absorbing formal magnetism similar to *Living-In* to draw the viewer into the pictorial space. The verticality of *Place 9* may seem anomalous given the preponderance of horizontal banding in the other paintings, but its door-like form complemented the threshold device common to the rest. With the paintings standing on the floor, the door and threshold motifs sought to confuse the distinction between real and pictorial space, and to erode the barrier between spectator and artwork.

Denny used colour to create a particularly restless relationship between his paintings. In *Place 7* and *8*, for example, the formal stability was disturbed by the reversal of colours. Likewise in *Place 1* and *2*, in which the green and black bands were exchanged. In other paintings colour changes were accompanied by subtle formal developments. *Place 5*, for instance, was another variation on *Place 1* and *2* except for the introduction of a fourth band along the top edge. The revisions and innovations between his canvases conspired to upset any regular rhythm which could have existed between them, and served to associate them metaphorically with his particular perception of the modern world. Like Smith's 'Place' paintings, Denny's works were a distillation of a metropolitan existence endorsed by the artist.

While Denny's and Smith's work was indebted to the American avant-garde and was stimulated by popular urban culture, Rumney's was perceived to be within a European cultural milieu. Coleman's article for the *Art News and Review* series 'Portrait of the Artist', written to coincide with Rumney's strong showing in 'Metavisual, Tachiste, Abstract' in 1957, categorized his work as belonging to 'that branch of the action painting l'art brut-tachist persuasion that calls itself post-action'. Eventually Coleman elected to use the term 'tachiste' because it 'is on the whole a better description of Rumney's activity, as it steers our attention to a European rather than trans-Atlantic orientation, quite apart from its less athletic orientation'.[57]

Noting a European 'professionalism' in Rumney as an artist,[58] Coleman observed of his work that it was so 'extraordinarily sophisticated' and so much like 'the popular conception of the tachist who treats his canvas as a do-it-yourself Rorschard [sic] test' that it seemed to contain a degree of

deliberate irony.[59] *The Change* (Fig. 2.7), which was displayed in 'Metavisual, Tachiste, Abstract', perhaps affirmed this analysis: though it was large-scale and painted on the floor,[60] its æsthetic allegiance was to the small patches of colour found in Tachisme rather than to the dribbles of paint associated with Jackson Pollock's Action Painting. The fact that the grid was added retrospectively to 'bring it [the painting] together'[61] did indeed reveal an element of finish and planning which was at odds with the privileging of spontaneity within Tachisme.

But such readings are partial. In 1956, before he left the Communist Party, Rumney wrote in the catalogue for his one-man show at the New Vision Centre Gallery: 'We look forward to the time when artists will no longer be bound by personal style. When, in anonymity, we shall be free to work without being forced to perpetually repeat and "develop" that which has already been achieved.' This wish to break away from a tradition of art, and indeed the market economy which the art system operates, points towards the appeal of the *tache* for Rumney. Fiona Gaskin has argued that in Britain the *tache* was considered to be without a tradition or dogma, and to be international. She claims that it offered a way out of the modernism of Matisse and Picasso without resorting to the insularity of Constructionism.[62] If this analysis is accepted then the title *The Change* may be read as a metaphor for the liberating iconoclasm of the *tache* within a tradition of modernism. But the construction of the *tache* as a self-affirming mark placed it within the avant-garde tradition which put high value on the creative personality, rather than Rumney's counter-avant-garde ideal of anonymous creation.

Gaskin suggests further that the multivalence of the *tache* was symptomatic of an age in which former certainties had been overturned but not replaced. Drawing on Rosalind Krauss' essay 'Grids, You Say', she cites the grid as a device which denies fixed meanings and indicates a spirit/matter dichotomy, and thus complements the mid-century social connotations she assigns to the *tache*.[63] In this context, the *tache* and the broken grid in *The Change* can be read as signs of disorientation. This interpretation is given a special resonance once the impact on the British Left of the Soviet repression of the Hungarian uprising in November 1956 is taken into account. Rumney recalls that after Hungary he was, in his own words, 'thrashing about in confusion because I couldn't stand the Communists'.[64] *The Change* may then be read both as a gambit to break with a tradition of modernism and as a sign of ideological crisis.

Between 1957 and 1959 there was a marked reduction in the public exhibition of Rumney's work.[65] Several factors may account for this, but, in this context, his involvement with the Situationists is the most significant.[66] Arguably Rumney's 'The Leaning Tower of Venice' cast an ironic eye over the apparent earnestness with which the Situationists theorized their position.

The evident humour of this *dérive*, likened by David Mellor to a 'kind of *Goon Show* version of a holiday snap-shot album',[67] might be read as a lampoon of ponderous situationist theory.[68] But humour was itself a situationist strategy; indeed the satirical article which appeared in *Internationale Situationniste* describing Rumney's activities in Venice was just as comically subversive as his record of the *dérive*.[69]

Nonetheless, though 'The Leaning Tower of Venice' need not be taken as evidence of Rumney's disengagement from the situationist ethos, the paintings that he submitted for 'Place' did severely test his situationist credentials. When he arrived in England he knew that his ideas for 'Place' had been overruled, and that it would no longer be a situationist enterprise. Yet he still produced his paintings for the exhibition.[70] Arguably Brian Young's involvement in the painting of the canvases was a rearguard action against the avant-garde cult of the creator, but Young's assistance was an expedient measure and does not exonerate Rumney's continued involvement from a Situationist's point of view. Rumney was caught between his commitment to his ideals and his need to make a living.

The paintings themselves were in flat bipolar colour, and depicted crisply delineated curved rectangular forms.[71] To Alloway and Alan Bowness the paintings were indebted to Ellsworth Kelly,[72] but Rumney repudiated this American source and cited instead the European cultural precedents of Enrico Baj's collage heads made during the 1950s, Jean Dubuffet's sack bodies and a cycladic head at the Louvre, as well as a modern table curved like a television.[73] The large central motif, with its neck-like protuberance reaching to the canvas edge was described as 'a colossal head' by Alloway.[74] It was presented either as whole and full-frontal, or cut in half by the canvas and as a profile. Yet the relationship with the spectator's body in Rumney's paintings was much more ambivalent than in the paintings of Smith and Denny; the brushstrokes betrayed no physical presence, the necks were too narrow to function as thresholds and the heads were not on a human dimension. Coleman, tying the paintings into a mass media æsthetic, described the forms as 'Cinemascope heads'.[75] But whereas the size of the Cinemascope screen served to involve the spectator more thoroughly in the action of the film, Rumney's equivalents for the screens were uniformly blank; their flat brushwork provided none of the drama of Smith's gestural strokes nor even Denny's flattest mark making. The emptiness of Rumney's screens pushed the viewer back to reading the shapes as flat heads, like shadows on a wall. As shadow referents they aspired to the insubstantial and peripheral.

The very limited motifs gave Rumney's 'Place' paintings a repetitive quality which further undermined the autonomous value of each work. There was no sense of serial progression between the paintings as with the stylistic developments in Denny's pieces, or sheer variety as with Smith's. Indeed, it

was their collective worth 'as bits of a big configuration, the parts of which seem to be slotting together to make a connected display', rather than their individual quality which Alloway commented on.[76] Yet, however much Rumney may have attempted to relegate his works to the status of background in the hope of salvaging his situationist ideals, the exhibition display and accompanying exegesis compromised them irrefutably.

<div align="center">* * *</div>

Once the paintings were completed they were transported to the ICA. Described in 1948 by Herbert Read, one of its founders, as 'an adult play-centre',[77] the Institute had been set up with the intention of encouraging cultural production of an interdisciplinary and experimental kind. Its independence from direct government funding made it unaccountable to the public or the state and thus, in theory at least, free to pursue its agenda unhampered by the interests of the hegemony. But while the funding structure allowed for ground-breaking exhibitions such as 'Growth and Form' and 'an Exhibit', it simultaneously imposed tight limitations on the Institute's budget which severely restricted the frequency of such loss-making shows.[78] In a pessimistic memo from around 1960, Read blamed shortage of money for the preponderance of solo exhibitions in the ICA's programme and cited this as an area in which it had failed to achieve its goal of experimentalism.[79] However partial this assessment may have been, it is notable that of the seven exhibitions which preceded 'Place' in 1959 only 'A Developing Process' could be said not to conform to traditional forms of display.

It is clear from the ICA records that the twin pressures of radicalism and finance caused tensions within the Management Committee. Alloway, Dorothy Morland's deputy since 1955, favoured radicalism.[80] He had spread his critical patronage of art movements widely during the 1950s, but by 1959 his æsthetic allegiance was firmly attached to the environment painting of the American avant-garde. His interest in an æsthetic which immersed the spectator in the painting was consistent with his policy of nurturing a more inclusive form of British avant-garde art, one which did not rely on 'a code of aesthetics associated with minorities with pastoral and upper class ideas'.[81] This policy was also manifest in the support he gave to artists who drew on a broad range of cultural interests, in particular mass culture.

Alloway delegated responsibility for 'Place' to Coleman.[82] Coleman shared Alloway's interest in the broad front of culture, and as editor of *ARK* from autumn 1956 to summer 1957 had published many articles on it. However much both Alloway and Coleman wanted to modernize British cultural life, it is evident that neither saw himself as a political revolutionary set on the overthrow of capitalism. Indeed their interest in American culture, its avant-

garde art, its mass media and modern cities showed a positive appreciation for the products of capitalism. Under their direction the ICA, which in theory could still have patronized emergent oppositional practices, was inclined to act as an incorporating agent drawing in emergent alternative practices. Their interests were introduced into 'Place' by Coleman who decided on the final layout and wrote the catalogue. Indeed, in Alloway's words, he 'masterminded and compered' the exhibition.[83]

Reading 'Place'

When visitors entered 'Place' they encountered '24 canvases … fixed back-to-back to make 12 double-sided pictures which were arranged on the gallery floor at 45° to the walls and at 90° to each other, and in addition 10 paintings (Smith 3, Denny 3, Rumney 4) [which] were fixed to the end walls and each other to project into the gallery. This gave four directions in which the pictures faced, three of which were taken, one by each painter, with the fourth side shared.'[84] The three large arrows in Smith's plan indicated the direction of each artist's vista; the small arrow marked the entrance to the room (the crenellated side represented the gallery windows) (Fig. 6.4).

From Coleman's article it was possible to identify where almost all the paintings stood. The three photographs which accompanied his text showed how the vista system functioned. The first photograph was taken along a Smith vista, with parts of three Smith paintings facing the viewer and a Denny painting standing at an oblique angle. The second showed a Rumney vista, with two Rumneys facing the viewer and four Dennys seen side-on. The last photograph was of a shared vista, with a Rumney in the left foreground, a Smith in the right foreground and, between these two, in the background, a Denny on the left and a small fragment of a Smith on the right. This arrangement created a cramped, shadowy environment radically different to traditional displays.[85] The seven foot high, unframed panels, which on Smith's plan looked like the dispersed linear elements of a grid, formed in the gallery a maze for the visitor to negotiate. In this respect 'Place' was reminiscent of 'an Exhibit'. But there were important material and conceptual differences between them. Firstly, whereas the elements of 'an Exhibit' were reassembled differently each day by Hamilton and Pasmore according to the principles of Basic Design, in 'Place' the paintings were always remounted according to exactly the same pattern.[86] Secondly, while the translucent perspex panels of 'an Exhibit' were abstract elements which allowed viewers to create their own compositions, the painted canvases of 'Place' presented them with ready-made if ambiguous

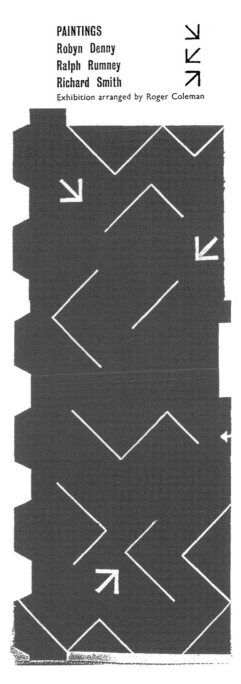

6.4 Richard Smith, ground-plan of 'Place', 1959

compositions. In short, Basic Design was not the informing principle of 'Place'.

<center>* * *</center>

Instead of receiving questionnaires designed to gauge their response to this environment, visitors were given Coleman's *Guide to Place* instructing them how to understand and consume the exhibition.

In his first letter Rumney had suggested that the title of the show 'should have good reassurance value, that is not to make the spectator feel there is something he doesn't understand. At the same time he should feel clever to understand it.'[87] In the context of a gallery, the everyday term 'place' provided a sense of familiarity which satisfied Rumney's requirement of 'reassurance value' and indicated that the paintings formed an entity which was other than a collection of independent works. The title invited questions about the character and function of this environment. In his catalogue Coleman attempted to answer these questions by specifying three contextual areas which he claimed were of interest to the artists: 'American painting and space', 'the mass media', and 'the game environment'.[88] He posited an 'exclusively English' interest in spectator participation as the overarching theme of the exhibition.[89]

The American art to which Coleman referred was the big canvases of Pollock, Rothko, Newman and Clifford Still; Rumney's European orientation was not mentioned. Coleman observed that, through their large size and flat surfaces, these American paintings enveloped the spectator. It was this aspect of American painting which he claimed Smith, Denny and Rumney sought to emulate as part of their peculiarly English project to heighten spectator participation. But while the importance of bodily envelopment was corroborated by Smith's and Denny's paintings, it was confused by the ambivalence towards the body in Rumney's works. Coleman furthered his positioning of the 'Place' paintings within an English conception of an American æsthetic by citing the mass media as an important and peculiarly English source for the exhibition's focus on spectator participation.[90] His claim that for the artists the mass media was not 'a source of imagery ... but a source of ideas that act as stimuli and as orientation in a cultural continuum'[91] held for Denny and Smith, as we have seen, but not for Rumney. There had been a notable absence of mass media references in his correspondence or in the sources he cited for his 'Place' paintings.[92] By flagging American fine art, the spectator's body and the mass media, Coleman steered the visitor towards the interests of Denny and Smith and towards an avant-garde æsthetic aspiring to the physically and culturally inclusive.

Interest in the final contextual area, the 'game environment', was especially attributed to Denny and Rumney, and was given as further evidence of a commitment to spectator participation. Without suggesting a particular game for 'Place', Coleman specified two levels of game participation: the first was visual and invited the viewer to think of 'the painter's gestures, marks, etc...[as] moves within a strategy which in turn elicits a "strategy" from the spectator';[93] the second was physical and included actual manipulation of works (for which there was no provision in 'Place') and maze environments 'in which the spectator in finding his way through the maze is "playing" against the artist'.[94] For this last possibility he cited 'Rumney's experiments with mazes' as an example. In doing so, Coleman revealed a fundamental misunderstanding of Rumney's project. It was a central aim of a proposal such as 'Hiss Chamber' that the artist should be hidden from the participant. The exhibition was to have been a sociological experiment concerning the individual's interaction with a particular environment, with a wider socio-political purpose. In fact a better comparison would have been Alloway's challenge to the 'maze-bright' visitor in 'an Exhibit',[95] but in that instance the visitor was asked to *complete* the play of the artists, not to compete against them.[96] In both of Coleman's types of play the paintings acted as conduits for an antagonistic game between artist and visitor. Such a game did not make individuals 'only marginally aware of the pictures', but instead put them at the centre of their attention. Quite apart from the fact that there was no questionnaire and indeed no clear game to be played in 'Place', this reinstatement of the artwork reveals a fundamental difference between Rumney's proposals for an investigative, counter-avant-garde exhibition and Coleman's recuperation of 'Place' as an avant-garde exhibition in which the artist and the artwork are pre-eminent.

In his follow-up article, 'The content of environment', Coleman linked the artists' perception of the mass media with their perceptions of the city and claimed that their pluralist observation of the urban environment had been of particular importance in the setting of the exhibition's rules, though he did not specify in what way. According to Coleman, the artists saw the mass media environment and the city as 'environment[s] qualified by symbols'.[97] Unlike the architect's urban Utopia characterized by 'utilitarian function, pictorial concepts of town planning, proportion and so on'[98] their city was a tangle of communications, 'a palimpsest of all kinds of things'.[99] For Coleman this distinction between the architect's vision of the city and the artists' perception of it was analogous to the difference between 'an Exhibit' and 'Place'. He claimed that 'an Exhibit', because of its almost blank perspex elements, 'came very near the spatial experience of modern architecture',[100] by which he meant that it was virtually a purely formal articulation of space. He considered 'Place', on the other hand, because it was made of paintings

and 'not merely painted screens', to be 'an environment qualified by symbols' and so one with 'content as well as form'.[101]

In this context, the title 'Place' acquires urban connotations; the *Guide to Place* may be linked to city guides with their historical background information, maps and advice on how to negotiate a particular city. Smith's plan, with its dispersed linear elements, may be read as the antithesis to the uniform grid plan of modernism's utopian cities, while the cramped, rigid layout of the actual exhibition, with its narrow pathways and jumble of panels can be seen as the physical representation of the multivalent cityscape. If 'Place' is considered as a representation of a particular sort of city through paintings, then the vistas might be said to form the avenues of that city. But for Rumney the vistas were anathema. In his first letter he had written 'The question of viewpoints seems to me superfluous, the bod [sic] should see the picture on the margins of his perception all the time without ever being forced to look directly at them unless he so desires.'[102] The truly irregular design proposed in the prototype model confirmed his resistance to the idea.

On examination it is clear that the vista system effectively undermined his hopes of 'Place' being a site for the spectator to 'carry out some simple activity other than looking at pictures and yet at the same time be aware that he is in an environment made of pictures'. Alloway's assessment of Smith's vista as 'a kingdom the size of a one-man show'[103] points towards the implications of the system. Although none of the paintings was labelled, Smith's plan showed the viewer which vistas belonged to which artist (Fig. 6.4). These vistas gave a momentum and unity to the paintings along them allowing, in Alloway's judgement, Smith's expansive works to 'snowball together', Denny's serial paintings to become even more clearly 'a parade in time of what can happen to forms', and Rumney's repetitive images to appear like 'bits of a big configuration, the parts of which seem to be slotting together to make a connected display'.[104]

Thus, while the rules of colour and dimension were intended to unite all the 'Place' paintings into a coherent environment, the vistas served to divide them into groupings based on individual artists and so invited a more conventional consumption of the exhibition as a three-man show. This was consistent with Coleman's advice to the spectator that, 'Participation is capable on different levels: A, the individual painting, B, the work of one of the artists, C, the work of all three artists together (black and white view) and D, random samplings from the exhibition as whole. PLACE can be looked at, through, over, between, in or out.' For Rumney the *laissez-faire* consumption of the exhibition sanctioned by the vista system reduced it to a gimmick,[105] but for Coleman it installed the artist and artwork at the centre of the viewer's gaze.

Coleman's explanation and layout thus served to marginalize Rumney's situationist intentions and to make 'Place' a manifestation of an avant-garde æsthetic which claimed to draw on the full length of the 'long front of culture' and to incorporate into it the viewer's body and his metropolitan habitat. In effect, Rumney's conception of an exhibition with a sociological, anti-art intent, was *détourné* as 'Place' was incorporated into a campaign to create a British avant-garde abstract art which could draw on an American high art æsthetic as well as claim to be oriented towards the spectator.

* * *

In his article on 'Place' Alloway accused Rumney of trying to claim the exhibition as 'a product of Situationism, Paris' only living avant-garde'. Arguing that because 'Debord, the Dr. Mabuse of the group, has, in fact, no use for painting' and that therefore the rest of the Situationists had none either, he charged Rumney with 'attempting to *invent* Situationist painting', and commented that 'it is significant that the only way he is able to do this is by sharing the influences and interests of his collaborators (mass media, spectator participation, U.S. art)'. He concluded that 'to claim, as Rumney has done, that the exhibition is a result of Situationism is an inversion of the facts'. As a reconciliatory gesture he attributed to Situationism 'interests [which] run parallel to the current activity that has culminated in "Place"' and suggested that 'it is all part of the pleasure-and-traps-of-the-spectator syndrome, at present so characteristic of British aesthetics'.[106]

However misinformed Alloway's understanding of the Situationists' complex relationship with the art object, and however partial his assessment of Rumney's 'influences and interests', his main point that 'Place' in actuality was not a situationist exhibition is undeniable. In its structure it was part of a series of radical displays at the ICA, including 'Growth and Form' and 'an Exhibit', which literally transformed the white cube, modernism's austere cultural chapel, into an informal cultural arena where the distinction between the space allocated to the spectator and that designated for the art object was deliberately confused. The deregulation of the gallery space was complemented in 'Place' by an 'aesthetic of intimacy, of presenting the work as a hot sample of the spectator's daily environment, and not as a special object of meditation'.[107] References to the mass media, the city and the spectator's body were a central part of this formulation of the work. In this light, 'Place' might appear carnivalesque in its reversal of traditions of display and of spectator/painting relations, but the innovations of *Place* were within an established game of art in which the object was paramount. There was no attempt to relegate the artwork to another element within a sociological experiment. Instead the vista system served to maintain the authority of the

object and the catalogue allowed the viewer to read the exhibition as a collection of objects.

But however accurate Alloway's assessment of the final form of 'Place', Rumney's initial proposals had been informed by the strategies and ethos of the Situationists. In the end these oppositional practices and meanings had been blocked in a textbook example of incorporation.

Notes

Abbreviations

AN&R: *Art News & Review*
TGA: Tate Gallery Archive

1. Eric Newton, '"Peace": excuses for the three painters', *The Guardian*, 26 September 1959 (TGA).

2. See 'Base and superstructure in Marxist cultural theory' in *Problems in Materialism and Culture* Verso, London, 1980, pp. 31–49.

3. ICA Exhibitions Committee minutes, 27 August 1958 (TGA).

4. Ibid., 15 January 1959.

5. Although Green remembers 'Place' he does not recall having been approached to take part. It seems likely, therefore, that the committee decided not to invite him. Coleman has suggested that Green's Action Paintings, which involved scorching the canvas and cycling over it, were not suitable for 'Place'. He describes Green's work as having been too much 'a record of his actions literally' to be appropriate for an environmental exhibition. This may well be the reason why he was dropped (interview with Coleman, 23 April 1997; telephone conversation with Green, 3 June 1997).

6. The average lead time for ICA exhibitions was six to eight months.

7. ICA, Exhibitions Committee minutes 17 March 1959 (TGA).

8. Ibid., 8 July 1959.

9. Ibid., 8 August 1959. Rather than 'a sociologist or a townplanner', Stefan Munsing, the US cultural attaché and close friend of Alloway, opened the exhibition, though we have no record of what he said. In retrospect the substitution of Munsing provides a parallel to the fate of Rumney's initial proposal.

10. Recorded interview with Denny, 22 April 1997.

11. Recorded interview with Coleman, 23 April 1997.

12. Recorded interview with Smith, 24 April 1997.

13. Recorded interview with Rumney, 13 May 1997.

14. He failed to submit 'The Leaning Tower of Venice' on time ('The Leaning Tower of Venice', *ARK*, 24, 1959; *ARK*, 25, 1960; *ARK*, 26, 1960, all unpaginated).

15. See Peter Wollen, 'Bitter victory: the Situationist International' in Iwona Blazwick (ed.), *An Endless Adventure…an Endless Passion…an Endless Banquet: a Situationist Scrapbook*, exh.cat., ICA, London, 1989, pp. 9–16.

16. *Aimer à Outrance*, exh. cat., gallery unknown, Manosque, 1994.

17. J. Huizinga, *Homo Ludens: a Study of the Play Element in Culture*, London: Routledge & Kegan Paul, 1949, p. 4.

18. There is no documentary record of 'Hiss Chamber' and probably the only person who could have corroborated Rumney's account is the late Lawrence Alloway. The title was a punning reference to the American spy scandal of the late 1940s and early 1950s in which Alger Hiss, a State Department employee, had been accused by Whittaker Chambers, a senior editor of *Time* and an ex-communist, of having been part of a pre-war communist cell within the American civil service. Hiss was convicted of perjury in 1950, though his guilt remained a subject of

considerable doubt. According to Rumney, the project was shelved because the state of the art technology it required was too expensive for the ICA and funding was not forthcoming from other sources. Rumney claims that the Movement for an Imaginist Bauhaus had submitted similar proposals to the Milan Triennale and the Stedelijk Museum in 1956, again without success, but it is difficult to establish the exact details of these proposals (interview, 13 May 1997).

19. All Robyn Denny Archive.

20. First letter, p. 1.

21. 'Definitions', *Internationale Situationniste* 1, June 1958 (Blazwick, *An Endless Adventure*, 1989, p. 22).

22. First letter, p. 2.

23. Ibid.

24. Ibid., p. 5.

25. Second letter, p. 1.

26. Rumney suggests the individual 'should see picture on the margins of his perception all the time without ever being forced to look directly at them unless he so desires' (first letter, p. 5).

27. Second letter, p. 1.

28. David Thistlewood, 'The Independent Group and art education in Britain 1950–1965' in David Robbins (ed), *The Independent Group: Post-war Britain and the Aesthetics of Plenty*, Cambridge Mass. & London: MIT Press, 1990, p. 215.

29. Ibid., pp. 214–5.

30. Ibid., p. 215.

31. Richard Hamilton quoted in Graham Whitham, 'Exhibitions' ibid., p. 160.

32. Alloway's parting challenge to the spectator in his catalogue for 'an Exhibit' was 'are you-maze-bright or maze-dim?' (*an Exhibit* exh.cat. ICA, London, 1957, unpaginated folder).

33. Parts of his text simply paraphrased passages from *Homo Ludens*. Compare for example the assertion in the catalogue text that 'The gallery resembles a tennis court or a hopscotch grid, a playground within which special rules operate' (*an Exhibit*, 1957), with *Homo Ludens*: 'The arena, the card table, the magic circle, the temple, the stage, the screen, the tennis court, the court of justice, etc., are all in form and function play-grounds, i.e. forbidden spots, isolated, hedged round, hallowed, within which special rules obtain' (Huizinga, *Homo Ludens*, 1949, p. 10).

34. *an Exhibit*, 1957.

35. On a visit to Smith's studio, Denny found him using pink. Coleman was summoned and the matter was resolved. It is unclear in whose favour the dispute was settled – Smith thinks he did not give in, Denny thinks he did, Coleman does not recall and no-one, including Rumney, can remember if Rumney was there (interviews with Denny, Coleman, Smith, Rumney, 22, 23, 24 April 1997, 13 May 1997). One press report mentions pink but this may not be reliable since in the same review blue is also referred to, which nobody else remembers having been used ('Colour maze', *Yorkshire Post*, 24 September 1959, TGA).

36. 'I painted them in Belsize Park in about three weeks, but Brian Young helped …. He was doing … you know you just had to paint the flat surfaces and I did the edges as it were. I drew it. I was in hospital for quite a bit of the time because I had pneumonia, and what do you do?' (interview with Rumney, 13 May 1997).

37. See David Mellor, *The Sixties Art Scene in London*, London: Phaidon with the Barbican Art Gallery, 1993, pp. 226 and 234.

38. Denny's antipathy to the rural æsthetic of British modernism was typified by his description of Ben Nicholson's 'fuddy duddy landscape ideas' (unpublished interview with Irving Sandler). See Sally Bulgin, 'Situation and New Generation: a Study of Non-Figurative Art in Britain during the 1960s', unpublished PhD thesis, Courtauld Institute of Art, University of London, 1991, p. 133). Coleman recalls thinking how 'dreary and earnest' the 'kitchen sink' paintings of the Beaux Arts Quartet were: 'A bit like one imagined Poland to be at the time' (interview, 23 April 1997).

39. See Eric Hobsbawm, *The Age of Extremes: The Short Twentieth Century*, London: Michael Joseph, 1994.

40. See 'Sitting in the middle of today' and 'Man and he-man', *ARK*, 19, 1957; *ARK*, 20, 1957.

41. In this montage produced by Denny and Smith for John Schlesinger as a proposal for a film about the city and art, they identified the inhabitants of their urban world; almost all were fantasy figures drawn from film, pop music, sport, and cartoons, and all were presented in character and so at play. The accompanying text stressed their mythical nature: 'The heroes, whose image may be in professional hands, are always due to change. Inclusion may depend on silhouette, symptoms or situation – all qualities tending to mutate, but though the figures are expendable their myth-quality is highly charged, pro temps' ('Ev'ry which way: a project for a film', *ARK*, 24, 1959, unpaginated).

42. The difficulties of long-distance travel and currency restrictions meant that only a few of those British artists who declared their admiration for the United States had actually been there. Their contact with it was mainly through films, music, literature (magazines as well as books) and the stories they heard. This consumption, though enthusiastic, was not without irony. William Green's *Elvis* (1958–9) cast a knowing eye over one of the best known American exports of the late 1950s. Green took a negative of a publicity photograph of Presley performing and made a photostatic print of it. The resulting reversed black and white image has been described by Mellor as one in a series of works by Green on famous people which 'uncover the heart of darkness embedded deep in their fame' (*The Sixties*, 1993, p. 19).

43. 'Ev'ry which way', 1959.

44. Ibid.

45. The title refers to the George Gershwin song 'I can't get started with you' containing the lyric 'My home is a show place, but I can't get no place with you' (Smith, telephone conversation, 4 June 1997).

46. Smith recalls being 'bowled off my feet by that yellowy Rothko' in 'The New American Painting', Tate Gallery, London, January 1959 (Maggie Gilchrist, 'Richard Smith: paintings 1956–62', unpublished MA thesis, Courtauld Institute of Art, University of London, 1978, p. 7). Rothko had also been shown in 'Modern Art in the United States' (Tate Gallery, 1956) and 'Some Paintings from the E. J. Power Collection' (ICA, 1958).

47. 'Richard Smith', 1978, p. 13.

48. The whereabouts of Smith's 'Place' paintings is unknown. The only reproductions are two black and white plates in *Richard Smith: Paintings 1958–1966*, exh.cat., Whitechapel Art Gallery, London, 1966 and the photographs of 'Place' in Coleman, 'The content of environment', *Architectural Design* 29: 12, December 1959, pp. 517–8 and Alloway, 'Making a scene', *AN&R*, 11: 18, 26 September 1959. In total only three of his eleven paintings for 'Place' have been recorded, with fragments of another three visible in the exhibition photographs.

49. Smith had used the term 'hedges of colour' to emphasize this quality in his work: 'I tend to think of colour ripening, or colour shimmering, and I think of hedges of colour because there is a density in my colour like the density of a hedge. You can see the colour but it's still a solid wall, though you can penetrate it and see the different parts of the hedge on various levels' (*Richard Smith: Paintings 1958–1966*, 1966).

50. Smith interview, 24 April 1997.

51. 'The content of environment', 1959.

52. Interview with Denny, 22 April 1997; see also Robert Kudielka, *Robyn Denny*, exh.cat., Tate Gallery, 1973, p. 27.

53. In a publicity photograph Denny deliberately crouched in front of *Living-In* to convey the idea of the spectator's envelopment by the painting: 'There's one picture of Living-In with me sitting right in front of it where I was sort of saying "look, I'm going to be very close to this picture, sort of surrounded by it"' (Denny interview, 22 April 1997; see Kudielka, *Robyn Denny*, 1973, p. 25).

54. The *Austin Reed Mural*, commissioned by Austin Reed, was completed in May 1959. The mural consisted of a hardboard support which Denny had collaged with posters and then painted over (Mellor, *The Sixties*, 1993 and illustration, pp. 44–5).

55. Alloway coined the term 'hard edge' in the wake of 'The New American Painting' to distinguish between pre-war geometric painting with its latent utopianism and the new American geometric art which he felt was concerned with spectator participation through optical effects and scale. Denny preferred the term 'formal' since it marked a continuity with his interests as an 'informal' painter in colour, space and form (Bulgin, *Situation and New Generation*, 1991, p. 199).

56. In an unpublished interview with Irving Sandler Denny recalled that seeing Newman's work 'was quite an experience … he was so different from our image of gestural and informal [which is] what we thought New York was' (ibid., p. 133).

57. Roger Coleman, 'Portrait of the Artist – Ralph Rumney', *AN&R*, 9: 11, 22 June 1957, p. 3.

58. He attributed this to Rumney's links with Cobra, the Movimento Nucleare, Asger Jorn, Karel Appel and Enrico Baj (ibid.).

59. Coleman, referring to a splotchy self-portrait which accompanied the article as 'a snide acknowledgement of the artist's inability to be objective', implied that the claims for Tachisme as a form of unstructured and authentic expression were being questioned by Rumney (ibid.).

60. At five feet by six feet, six inches it was about double the size of any painting he had produced up to 1957. Though he painted *The Change* on the floor this was out of expediency; the floor was the only space available in his flat (interview, 13 May 1997).

61. Of *The Change* Rumney says, 'I started making marks on the thing, and I went on with that until I thought that's enough marks, and the thing had an absence of structure, so then I got some black and a palette knife and I think brought it together' (ibid.).

62. See Chapter 2, 'British Tachisme in the post-war period' in this volume.

63. Ibid.

64. Interview, 13 May 1997.

65. Having been in six exhibitions in 1956–7 his work seems to have appeared in only one exhibition of any significance between 1957 and 1959, namely 'British Abstract Painting', Auckland City Art Gallery, New Zealand, 1958 (see 'Selected Chronology', *Ralph Rumney. Constats: 1950 –1988*, exh.cat., England and Co., London, 1989, p. 11).

66. Among these factors may have been the beginnings of his relationship with his first wife Pegeen Guggenheim.

67. *The Sixties*, 1993, p. 59.

68. Comparison of 'The Leaning Tower of Venice' with Ivain's 'Formula for a new city' might support this reading. Rumney's text apparently satirizes Ivain's. For instance, while Ivain suggested the construction of a 'Sinister Quarter' designed to symbolize the 'malefic forces of life', when this quarter is entered by 'A' in 'The Leaning Tower of Venice' it is much the same as everywhere else. The comic contrast between the two is also evident in the dramatic, aphoristic style of Ivain's visionary text, e.g. 'You'll never see the hacienda. It doesn't exist' (Camilla Gray, *The Incomplete Work of the Situationist International*, London: Free Fall Publications, 1974, pp. 17–20) and Rumney's banal commentary, e.g. 'Note A's interest and participation in children's games, also his hostility to cats and pigeons' ('The Leaning Tower of Venice', *ARK*, 24, 1958).

69. The humour in situationist texts like 'Formula for a New City' is simply drier than Rumney's; Ivain's witty suggestions for and descriptions of quarters illustrates the straight-faced humour within the text: 'Gothic-Romantic Quarter – The Happy Quarter, the most densely inhabited – The Noble and Tragic Quarter (for good boys) – The Historic Quarter (museum, schools, etc.) – The Useful Quarter (hospital, tool depots, etc.) – The Sinister Quarter, etc'. He describes the Sinister Quarter as somewhere which would be 'difficult to get into, and unpleasant once one succeeded (piercing whistles, alarm bells, sirens wailing intermittently, hideous sculptures, automatic mobiles with motors called Auto-Mobiles), as ill-lit at night as it glared bitterly during the day' (Gray, *The Incomplete Work*, 1974, p. 20). The article which appeared in *Internationale Situationniste* describing Rumney's activities in Venice was written in the style of a missing persons report. He was cast as an intrepid explorer who had disappeared in 'la jungle vénitienne'. The text was accompanied by two mug-shots of Rumney. ('Venise a Vaincu Ralph Rumney', *Internationale Situationniste* 1, June 1958, p. 28).

70. He later said that he should have withdrawn at that point (interview, 13 May 1997).

71. As with Smith's paintings the records are poor, but from Alloway's 'Making a Scene', 1959, it seems that they did not deviate in form or execution from those seen in the black and white photographs reproduced in Coleman's 'The content of environment', 1959.

72. Rumney recounts that Alloway said on seeing the paintings, 'Ah! You've been seeing some Ellsworth Kelly'. He claims never to have seen Kelly's work at this time (interview, 16 May 1997). Bowness made the same connection in his review of the exhibition (Alan Bowness, 'Smith, Denny, and Rumney in Place', *Arts* 34: 3, New York, December 1959, p. 20).

73. Unpublished transcript of interview, England and Co., July 1992.

74. 'Making a scene', 1959.

75. Roger Coleman, *Guide to Place*, exh.cat., ICA, 1959.

76. 'Making a scene', 1959.

77. *40 years of Modern Art, 1907–1947: a Selection from British Collections*, exh.cat., ICA, 1948, unpaginated.

78. As is clear from the Management Committee minutes, the ICA was dogged by financial worries throughout the 1950s and by May 1958 the situation was so dire that the Director, Dorothy Morland, suggested the closure of the gallery to save money (Management Committee Minutes, 22 May 1958, TGA). In a minute dated 4 June 1958 Morland explains to Read that theme exhibitions 'were expensive to organize and had to be sponsored, and sponsors were not easy to find'. 'an Exhibit,' which lost £26.18s.3d., was the biggest loss maker of 1957. For a full account of the ICA up to 1956 see Margaret Garlake, *New Art, New World: British Art in Postwar Society*, New Haven & London: Yale University Press, 1998, pp. 17–22.

79. 'Memo on ICA Policy from Sir Herbert Read', ICA *c*.1960 (TGA).

80. A constant issue in the minutes is the length of exhibition runs; Alloway consistently resisted pressure to lengthen runs as a measure to cut costs.

81. 'The arts and the mass media', *Architectural Design*, 28: 2, February 1958, pp. 84–5. See also Robbins, *The Independent Group*, 1990, p. 166.

82. Born in 1930, Coleman had attended Leicester Art College before entering the RCA in 1953. He was attracted to a wide range of abstract work including that of Denny and Smith, giving them his critical support in 'Two Painters', *ARK*, 20, 1957. Dorothy Morland praised his interest in 'all aspects of art' while recommending his elevation to the ICA Exhibitions Committee (Management Committee Minutes, 30 January 1957, TGA).

83. 'Making a scene', 1959.

84. Coleman, 'The content of environment', 1959.

85. Alloway compared the unconventional display with the normal hanging style found in London which he described as 'stale and habit-bound, almost completely dependent on size balances, centering, and colour contrasts' ('Making a scene', 1959).

86. Coleman and Denny both recall regularly disassembling and re-installing the paintings during the exhibition's run at the ICA (interview with Coleman, 23 April 1997; interview with Denny, 22 April 1997).

87. First letter, p. 2.

88. Coleman, *Guide to Place*, 1959.

89. Alloway supported this assessment of spectator participation: 'Coleman points out (and I would confirm this) that the interest of Denny, Rumney, and Smith in spectator participation – and in the mass media – is specifically British' ('Making a scene', 1959).

90. The mass media section of *Guide to Place* begins 'A significant development in post war art in this country (it appears to be exclusively English) is the acceptance on the part of some of the younger artists of the mass media as a legitimate body of reference.'

91. Ibid.

92. Nowhere in Rumney's letters was the mass media mentioned as an interest. There was no mention of it in the 20 questions Rumney asked his colleagues in his first letter or in the 34 questions he submitted for the audience questionnaire.

93. *Guide to Place*, 1959.

94. Ibid.

95. Alloway cited the 'play part of "an Exhibit"' as a precedent for 'Place' in his review of the exhibition ('Making a scene', 1959).

96. 'The meaning of "an Exhibit" is now dependent on the decisions of visitors, just as, at an earlier stage, it was dependent on the artists who were the players. It is a game, a maze, a ceremony completed by the participation of the visitors' (Alloway, *an Exhibit* 1957).

97. Coleman, 'The content of environment', 1959.

98. Ibid.

99. Recorded interview with Coleman, 23 April 1997.

100. Coleman, 'The content of environment', 1959.

101. Ibid.

102. First letter, p. 5.

103. 'Making a scene', 1959.

104. Ibid.

105. In the third letter he wrote 'If we allow "the spectator to participate in the paintings as he chooses" we are not doing anything that is not done in every exhibition all the time. It is always possible to participate as one chooses in paintings and I feel that if we limit ourselves to hanging up pictures in a more or less gimmicky way with more or less success we are entirely begging the question.'

106. 'Making a scene', 1959.

107. Ibid.

108. Ibid.

Bibliography

Abell, W., 'A symposium: the state of American art', *Magazine of Art*, 42: 3, March 1949.

Alley, R., *British Painting since 1945*, Tate Gallery, London, 1966.

Alloway, L., *Nine Abstract Artists* , Tiranti, London, 1954.

—— *An Exhibit*, exh.cat., Institute of Contemporary Arts, London, 1957.

—— 'Movimento Nucleare d'Italia', *Art News & Review*, 9: 1, 2 February 1957.

—— 'Background to Action' 1–6, *Art News & Review*, 9: 19, 12 October 1957; 20, 26 October 1957; 21, 9 November 1957; 23, 7 December 1957; 25, 4 January 1958; 26, 18 January 1958.

—— 'The arts and the mass media', *Architectural Design*, 28: 2, February 1958.

—— 'Paintings from the Big Country', *Art News & Review*, 11: 4, 14 March 1959.

—— 'Sic, sic, sic', *Art News & Review*, 11: 6, 11 April 1959.

—— 'The New American Painting', *Art International*, 3, 1959.

—— 'Making a scene', *Art News & Review* 11: 18, 26 September 1959.

Appleyard, B., *The Pleasures of Peace: Art and Imagination in Post-war Britain*, Faber & Faber, London, 1989.

Arthur Tooth & Sons Ltd, *Hommage à Nicolas de Staël*, exh.cat, 1956.

—— *Critic's Choice*, exh.cat., 1957.

—— *The Exploration of Paint*, exh.cat., 1958.

Arts Council of Great Britain, London, *Young Painters of the Ecole de Paris*, exh.cat., 1951.

—— *New Trends in Painting*, exh.cat., 1956.

—— *Abstract Impressionism*, exh.cat., 1958.

—— *Sculpture from the Arts Council Collection*, exh.cat., 1965.

—— *Eleven Sculptors, One Decade*, exh.cat.,1972.

—— *Roger Hilton: Paintings and Drawings 1931–1973*, exh.cat., 1974.

—— *Terry Frost, Paintings, Drawings and Collages*, exh.cat., 1976.

—— *Hubert Dalwood, Sculptures and Reliefs*, exh.cat., 1979.

—— *Annual Reports 1952–68*.

—— *Bibliography of Arts Council Exhibition Catalogues 1942–1980*, 1982.

—— *Three-Year Plan 1988/89–1990/91*, 1988.

Ashton, D., *The New York School: a Cultural Reckoning*, Viking, New York, 1973.

Avray Wilson, F., *Art as Understanding*, Routledge & Kegan Paul, London, 1963.

Ayer, A. J., *Language, Truth and Logic* (1936; 1946) Penguin, London, 1990.

Ayrton, M., 'The heritage of British painting' I–IV *The Studio*, 132: Nos. 641, 642, 643, 644 August–November 1946.

Banham, M. & Hillier, B., (eds), *A Tonic to the Nation: the Festival of Britain 1951*, Thames & Hudson, London, 1976.

Barbican Art Gallery, London, *Patrick Heron*, exh.cat., 1985.

Barker, O., 'Art from France in Britain c.1948–1959: influence and reception', unpublished MA thesis, Courtauld Institute of Art, University of London, 1993.

Baro, G., 'British painting: the post-war generation', *Studio Int.* 174:893, October 1967.

Barr, A. H., 'Artistic freedom' in Sandler, I., & Newman, A. (eds), *Defining Modern Art: Selected Writings of Alfred H. Barr Jr*, Harry N. Abrams, New York, 1986.

—— 'Is modern art communistic?', *New York Times Magazine*, 14 December 1952.

—— 'The Museum of Modern Art's record on American artists' in Sandler, I., & Newman, A. (eds), *Defining Modern Art: Selected Writings of Alfred H. Barr Jr*, Harry N. Abrams, New York, 1986.

—— Introduction: *The New American Painting as Shown in Eight European Countries 1958–1959*, exh.cat, Museum of Modern Art, New York, 1959.

Barrett, W., *Irrational Man*, (Doubleday, New York, 1958) Greenwood Press, Connecticut, 1977.

Berger, J., *Permanent Red*, Methuen, London, 1960.

—— 'The historical function of the museum' in *The Moment of Cubism and Other Essays*, Weidenfeld & Nicolson, London, 1969.

Berthoud, R., *The Life of Henry Moore*, Faber & Faber, London, 1987.

Binmore, K., *Essays on the Foundations of Game Theory*, Cambridge, Mass. & Oxford, 1990.

Blaswick, I. (ed.), *An Endless Adventure...an Endless Passion... an Endless Banquet: a Situationist Scrapbook*, exh.cat, Institute of Contemporary Arts, London, 1989.

Bonython Gallery, *Patrick Heron*, exh.cat., 1973.

Borzello, F., *Civilising Caliban: the Misuse of Art 1875–1980*, Routledge & Kegan Paul, London, 1987.

Bowness, A. (ed.), *William Scott: Paintings*, Lund Humphries, London, 1964.

—— *Alan Davie*, Lund Humphries, London, 1967.

—— *William Scott: Paintings, Drawings and Gouaches 1938–71*, exh.cat., Tate Gallery, London, 1972.

—— *Victor Pasmore with a Catalogue Raisonné of the Paintings, Constructions and Graphics 1926–76*, Thames & Hudson, London, 1980.

—— 'The American invasion & the British response', *Studio Int.*, 173: 890, June 1967.

Braden, T. W., 'I'm glad the CIA is immoral', *The Saturday Evening Post*, 20 May 1967.

Brisley, S., 'No, it is not on', *Studio Int.*, 183: 942, March 1972.

Brookshire, J., *Clement Attlee*, Manchester University Press, Manchester & New York, 1995.

Buettner, S., *American Art Theory 1945–70*, UMI Research, Michigan, 1981.

Bulgin, S., 'Situation & New Generation: a Study of Non-Figurative Art in Britain during the 1960s' unpublished PhD thesis, Courtauld Institute of Art, University of London, 1991.

Bumpus, J., 'The Contemporary Art Society: a significant contribution', *The Contemporary Art Society 1910–1985*, The Herbert Press, London, 1985.

Burgin, V., 'Modernism in the work of art', *20th Century Studies*, 15–16, December 1976.

Butler, R., *Creative Development*, Routledge & Kegan Paul, London, 1962.

Button, V., 'The concept of British "neo-romanticism" in art criticism and texts of the 1940s' unpublished MA thesis, Courtauld Institute of Art, University of London, 1984.

Calvocoressi, R., *Reg Butler*, exh.cat., Tate Gallery, London, 1983.

Cannon-Brookes, P. (ed.), *The British Neo-Romantics 1953–50*, exh.cat., National Museum of Wales, Cardiff, 1983.

Cavaliere, B. & Hobbs, R. C., 'Against a newer Laocoon', *Arts Magazine*, 51: 8, April 1977.

Centre Georges Pompidou, Paris, *Paris–New York*, exh.cat., 1977.

—— *Paris–Paris 1937–57*, exh.cat., 1981.

—— *Les Années 50*, exh.cat., 1988.

Centre National des Arts Plastiques, Paris, *Charles Estienne et l'art à Paris 1946–1966*, exh.cat., 1984.

Cherry, D. & Steyn, J., 'The moment of realism: 1952–1956', *Artscribe*, 35, June 1982.

Chipp, H. B., *Theories of Modern Art* , University of California Press, Berkeley, 1968.

City Art Gallery, Wakefield, *Patrick Heron*, exh.cat., 1952.

—— *Alan Davie*, exh.cat., 1958.

Clark, K., *The Other Half: a Self-Portrait*, John Murray, London, 1977.

Cockroft, E., 'Abstract Expressionism, weapon of the Cold War', *Artforum*, 13, June 1974.

—— 'Mexico, MoMA and cultural imperialism', *Art Workers News*, March 1981.

Coleman, R., 'Portrait of the artist – Ralph Rumney', *Art News & Review*, 9: 11, 22 June 1957.

—— 'The content of environment', *Architectural Design*, 29: 12, December 1959.

—— *Guide to Place*, exh.cat., Institute of Contemporary Arts, London, 1959.

Compton, M., 'The Gregory Fellowships', *The Leeds Art Calendar*, 9: 30, summer 1955.

Compton, S. (ed.), *British Art in the 20th Century: the Modern Movement*, exh.cat., Royal Academy of Arts, London, 1987.

Contemporary Art Society, *Annual Reports 1958–70*.

—— *17 Collectors: an Exhibition of Paintings and Sculpture from the Private Collections of Members of the Executive Committee of the Contemporary Art Society*, exh.cat., London, 1952.

Cooke, L., 'The sculpture of Philip King, 1960–72' unpublished MA thesis, Courtauld Institute of Art, University of London, 1978.

Coplans, J., 'Portrait of the artist: Denis Bowen', *Art News & Review*, 10: 11, 21 June 1958.

Cox, A., *Art as Politics: the Abstract Expressionist Avant-Garde and Society*, UMI Research, Ann Arbor, Michigan, 1982.

Crawford, R. et al., 'Symposium: is the French avant-garde over-rated?', *Art Digest*, 15 September 1953.

Cumberlege, G., *The Arts Enquiry: the Visual Arts, a Report Sponsored by the Dartington Hall Trustees*, Oxford University Press, London, New York, Toronto, 1946.

Cummings, M. C. & Katz, R. S., *The Patron State: Government and the Arts in Europe, North America and Japan*, Oxford University Press, New York & Oxford, 1987.

Davis, S., 'Foreword: New York', *Arts Yearbook*, 3, 1959.

Dempsey, M., 'The critics', *Art & Artists*, 3:10, January 1969.

Denny, R. & Smith, R., 'Ev'ry which way: a project for a film', *ARK*, 24, 1959.

Diaper, H., 'The new spirit' in *The New Spirit, Patrons, Artists and the University of Leeds in the Twentieth Century*, exh.cat., University Gallery, University of Leeds, 1986.

—— 'The Gregory Fellowships' in Read, B. & Thistlewood, D. (eds), *Herbert Read: a British Vision of World Art*, exh.cat., Leeds City Art Galleries with the Henry Moore Foundation & Lund Humphries, 1993.

—— 'The University of Leeds art collection and gallery: a short history' in *The University of Leeds Art Collection and Gallery: a Short History*, exh.cat., University Gallery, University of Leeds, 1995.

—— 'Documents. The progress of art in America'; 'The arts as our ambassador', *Art Digest*, 15 November 1953.

Dodd, K., 'Artist Placement Group 1966–76', unpublished MA thesis, Courtauld Institute of Art, University of London, 1992.

Drian Gallery, *Denis Bowen*, exh.cat., London, 1961.

Drouin, R., 'Tachisme is only a word', *Architectural Design* 26: 8, 1956.

Dubuffet, J. et al., 'Symposium: is the American avant-garde over-rated?' *Art Digest*, 15 October 1953.

Duncan, C. & Wallach, A., 'The universal survey museum', *Art History*, 3: 4, 1980.

Duncan, S., 'Tension and vitality: figurative sculpture of the Fifties', *Artscribe* 35, 1982.

Egbert, D. D., *Socialism and American Art*, Princeton University Press, 1967.

England & Co., *Ralph Rumney. Constats: 1950–1988*, exh. cat., London, 1989.

Fineberg, J., *Art since 1940: Strategies of Being*, Laurence King, London, 1995.

Foster, S. C., *The Critics of Abstract Expressionism*, UMI Research, Ann Arbor, Michigan, 1980.

Frascina, F. (ed.), *Pollock and After: the Critical Debate*, Harper & Row, New York, 1985.

—— & Harrison, C. (eds), *Modern Art and Modernism: a Critical Anthology*, Harper & Row, London, with the Open University 1982.

—— 'French art and the postwar crisis', *Arts Yearbook*, 3, 1959.

Fuller, P. , 'The visual arts' in Ford, B. (ed.), *The Cambridge Guide to the Arts in Britain*, Vol. 9: *Since the Second World War*, Cambridge University Press, 1988.

Gainsborough, R., 'Portrait of the artist: Ralph Rumney', *Art News & Review* 9: 11, 22 June 1957.

Galeries Nationales du Grand Palais, Paris, *Nicolas de Staël*, exh.cat., 1981.

Gardener Centre, University of Sussex, *William Gear, Paintings 1964–71*, exh.cat., 1971.

Garlake, M., *New Art, New World: British Art in Postwar Society*, Yale University Press, New Haven & London, 1998.

—— 'Ralph Rumney; David Tremlett', *Art Monthly*, 125, April 1989.

—— '"A war of taste": the LCC as art patron 1948–1965' *The London Journal*, 18: 1, 1993.

—— 'The Relationship between Institutional Patronage and Abstract Art in Britain *c.*1945–56', unpublished PhD thesis, Courtauld Institute of Art, University of London, 1987.

Gaskin, F., 'Aspects of British Tachisme, 1946–1957', unpublished MA thesis, Courtauld Institute of Art, University of London, 1996.

Genauer, E., 'Still life with red herring', *Harper's Magazine* 199: 1192, September 1949.

—— 'Americans at Venice', *Arts Digest*, 1 June 1958.

Getlein, F., 'Schmeerkunst & politics', *New Republic*, 9 February 1959.

Gilchrist, M., 'Richard Smith: paintings 1956–1962', unpublished MA thesis, Courtauld Institute of Art, University of London, 1978.

Gimpel Fils, London, *William Gear*, exh.cats., 1948, 1951, 1953.

—— *Alan Davie*, exh.cats., 1950, 1952, 1954.

—— *Roger Hilton*, exh.cats., 1954, 1956.

—— *Pierre Soulages*, exh.cat., 1955.
—— *Sam Francis*, exh.cat., 1957.
—— *William Gear Retrospective*, exh.cat., 1961.
Gindertael, R. V., 'Peintres britanniques d'aujourd'hui', *Art d'Aujourd'hui*, 4: 2, March 1953.
Glazebrook, M., 'The Whitechapel's future', *Studio Int.*, 177: 908, February 1969.
Goldwater, R., 'Reflections on the New York School', *Quadrum*, 8, 1960.
Golub, L., 'A critique of Abstract Expressionism' *College Art Journal*, 14: 2, 1955.
Gooding, M., *John Hoyland*, John Taylor with Lund Humphries, London, 1990.
—— *Patrick Heron*, Phaidon, London, 1994.
Gray, C., *The Incomplete Work of the Situationist International*, Free Fall Publications, London, 1974.
Green, M., Wilding, M. with Hoggart, R., *Cultural Policy in Great Britain*, UNESCO Studies and Documents on Cultural Policies, 7, 1970.
Greenberg, C., 'Anthony Caro', *Studio Int.*, 174: 892, September 1967.
Griffiths, H., 'Bath Academy of Art, Corsham Court, Wiltshire 1946–1955' unpublished MA thesis, Courtauld Institute of Art, University of London, 1979.
Guilbaut, S. (trans. Goldhammer, A.), *How New York Stole the Idea of Modern Art: Abstract Expressionism, Freedom and the Cold War*, University of Chicago Press, 1983.
—— (ed.), *Reconstructing Modernism: Art in New York, Paris and Montreal*, MIT Press, Cambridge, Mass, 1990.
—— 'The new adventures of the avant-garde in America', *October*, 15, 1980.
Halasz, P. , 'Art Criticism (& art history) in New York: the 1940s vs the 1980s; Parts 1–111: the newspapers, the magazines, Clement Greenberg', *Arts Magazine*, 57, February, March, April 1983.
Hanover Gallery, London, *Hans Hartung*, exh.cat., 1949.
—— *William Scott* , exh.cats., 1954, 1956.
—— *William Scott: 20 Gouaches, 1952*, exh.cat., 1962.
Harris, J. S., *Government Patronage of the Arts in Great Britain*, University of Chicago Press, Chicago & London, 1970.
Harrison, C., 'Sculpture's recent past' in *A Quiet Revolution in British Sculpture*, exh.cat, Museum of Contemporary Art, Chicago, 1987.
Hart Matthews, J. de, 'Art & Politics in Cold War America', *American Historical Review*, 81, October 1976.
Hauptmann, W., 'The suppression of art in the McCarthy decade', *Artforum*, 12, October 1973.
Hellman, G. T., 'Profile of a museum', *Art in America*, 52: 1, 1964.
Herbert, J. D., *The Political Origins of Abstract Expressionist Art Criticism*, Leland Stanford Junior University, Stanford, California, 1985.
Heron, P. , *The Changing Forms of Art*, Routledge & Kegan Paul, London, 1955.
—— 'At the Mayor Gallery', *The New Statesman & Nation*, 34: 866, 11 October 1947.
—— 'The School of London', *The New Statesman & Nation*, 37: 944, 9 April 1949.
—— 'The power of Paris', *The New Statesman & Nation*, 44: 1115, 19 July 1952.
—— 'Turner resurgent', *The New Statesman & Nation*, 45: 1146, 21 February 1953.
—— 'The Americans at the Tate Gallery', *Arts*, 30, March 1956.
—— 'The ascendancy of London in the Sixties', *Studio Int.*, 172: 884, December 1966.
—— *Space in Colour*, exh.cat., Hanover Gallery, London, 1953.
Herrigel, E., *Zen in the Art of Archery*, London, 1953.
Hess, T., 'Is abstraction un-American?' *Art News*, 49: 10, February 1951.

Hewison, R., *In Anger: Culture in the Cold War 1945–60*, Weidenfeld & Nicolson, London, 1981.
—— *Too Much: Art and Society in the Sixties 1960–75*, Methuen, London, 1986.
—— *Culture and Consensus: England, Art and Politics since 1940*, Methuen, London, 1995.
HMSO, *A Policy for the Arts: the First Steps*, Cmnd. 2601, 1965.
Huddersfield Art Gallery, *Denis Bowen: Second Retrospective Exhibition*, exh.cat., 1989.
Huizinga, J., *Homo Ludens: a Study of the Play Element in Culture*, Routledge & Kegan Paul, London, 1949.
Humphreys, C., *Buddhism*, (Pelican, Harmondsworth, 1951), London, 1990.
Hunter, S., *Jackson Pollock, 1912–1956*, exh.cat., Museum of Modern Art, New York 1956.
Hutchison, R., *The Politics of the Arts Council*, Sinclair Browne, London, 1982.
Institute of Contemporary Arts, London, *40 Years of Modern Art 1907–1947: a Selection from British Collections*, exh.cat., 1948.
—— *London–Paris: New Trends in Painting and Sculpture*, exh.cat.,1950.
—— *Opposing Forces*, exh.cat., 1953.
—— *Jean Dubuffet*, exh.cat., 1955.
—— *Mark Tobey*, exh.cat., 1955.
—— *Mathieu*, exh.cat., 1956.
—— *Statements: a Review of British Abstract Art in 1956*, exh.cat., 1957.
—— *The Gregory Fellowships*, exh.cat., 1958.
—— *A Selected Exhibition from the Collection of the Late E. C. Gregory*, exh.cat., 1959.
—— *The Developing Process*, exh.cat., 1959.
—— *Matter Painting*, exh.cat., 1960.
James, P. , 'Patronage for painters: 60 paintings for '51', *The Studio*, 142: 701, August 1951.
Jung, C. G., 'The archetypes and the collective unconscious' in Read, H. et al. (eds), *The Collected Works of C. G. Jung*, 9:1, Routledge & Kegan Paul, London & New York, 1959.
Kelly, O., *Community Art and the State: Storming the Citadel*, Commedia, London, 1984.
Kharibian, L., 'Un art autre où il s'agit de nouveaux dévidages du réel, Michel Tapié, 1952' unpublished BA project, Courtauld Institute of Art, University of London, 1984.
Knowles, E. (ed.), *Terry Frost*, Ashgate Publishing, Aldershot, 1994.
Kozloff, M., 'The critical reception of Abstract Expressionism', *Arts Magazine*, 40, December 1965.
—— 'American painting during the Cold War', *Artforum*, 11, May 1973.
—— Introduction, *Twenty-five Years of American Painting*, exh.cat., Des Moines Art Centre, Iowa, 1973.
Kramer, H., 'Art & life in Paris and New York', *Arts Yearbook*, 3, 1959.
Krauss, R., 'Grids you say' in *Grids: Format and Image in 20th Century Art*, exh.cat., Pace Gallery, New York & the Akron Art Institute, Chicago, 1979.
Kudielka, R., *Robyn Denny*, exh.cat., Tate Gallery, London, 1973.
Labour Party, *Let Us Face the Future*, April 1945.
—— *The Arts and the People: Labour's Policy Towards the Arts*, October 1977.
Larson, G. O., 'From WPA to NEA: fighting culture with culture' in Balfe, J. H. & Wyszominski, M. J. (eds), *Art, Ideology and Politics*, Praeger, New York, 1985.
Lasch, C., 'The cultural Cold War: a short history of the Congress for Cultural Freedom'

in Bernstein, B. J. (ed.), *Towards a New Past: Dissenting Essays in American History*, Pantheon, New York, 1968.

Leavitt-Bourne, M., 'Some aspects of commercial patronage 1950–1959: four London galleries' unpublished MA thesis, Courtauld Institute of Art, University of London, 1990.

Leeds City Art Galleries, *Gregory Memorial Exhibition*, exh.cat., 1960.

Leicester Galleries, London, *In Paris Now*, exh.cat., 1950.

—— *William Scott* , exh.cat., 1951.

Lewis, A., 'British avant-garde painting 1945–56', Parts I, II, III, *Artscribe*, 34–6, March, June, August 1982.

—— *Roger Hilton: the Early Years 1911–1955*, exh.cat., Leicester Polytechnic Gallery, 1984.

—— 'American art and its influence on British painting *c*.1945–65' unpublished MA thesis, Courtauld Institute of Art, University of London, 1975.

Lippard, L. R., *Pop Art*, Thames & Hudson, London, 1970.

Littleton, T. & Maltby, S., *Advancing American Art: Paintings, Politics and Cultural Confrontation at Mid Century*, exh.cat., University of Alabama Press, 1989.

Lledó, E., 'Post-war Abstractions: the Paradox of Nicolas de Staël' unpublished PhD thesis, Courtauld Institute of Art, University of London, 1995.

Lucie-Smith, E., *Sculpture Since 1945*, Phaidon, London, 1987.

—— 'An interview with Clement Greenberg', *Studio Int.*, 175: 896, January 1968.

Lynes, R., *Good Old Modern: an Intimate Portrait of the Museum of Modern Art*, Atheneum, New York, 1973.

Lynton, N., *Kenneth Armitage*, Methuen, London, 1962.

Macnamara, A., 'Between flux and certitude: the grid in avant-garde utopian thought', *Art History*, 15: 1, March 1992.

Mankin, L., 'Government patronage: an historical overview' in Mulcahy, K. & Swaim, C. R. (eds), *Public Policy and the Arts*, Westview Press, Boulder, Colorado, 1982.

Manosque, France, *Aimer à Outrance*, exh.cat., 1997.

Marlow, T., 'The marketing and impact of New Generation sculpture', unpublished MA thesis, Courtauld Institute of Art, University of London, 1988.

Marshall McLuhan, H., *The Mechanical Bride: Folklore of Industrial Man*, (New York 1951) Boston, 1970.

Mathieu, G., *De la révolte à la renaissance: au-delà du Tachisme*, (1963) Gallimard, Paris, *c*.1972.

Matthiesen Gallery, London, *Nicolas de Staël*, exh.cat., 1952.

Medley, R., *Drawn from the Life: a Memoir*, Faber & Faber, London, 1983.

Mellor, D. (ed.), *A Paradise Lost: the Neo-Romantic Imagination in Britain 1935–55*, exh.cat., Lund Humphries with the Barbican Art Gallery, London, 1987.

—— *The Sixties Art Scene in London*, Phaidon with the Barbican Art Gallery, London, 1993.

—— 'Existentialism in post-war British art' in Morris, F. (ed.), *Paris Post War: Art and Existentialism 1945–55*, exh.cat., Tate Gallery, London, 1993.

Melville, R., 'Action painting: New York, Paris, London', *ARK*, 18, 1956.

Merleau-Ponty, M., 'Cézanne's doubt', *Partisan Review*, 13: 4, September–October 1946.

Miller, D., *14 Americans*, exh.cat., Museum of Modern Art, New York, 1946.

—— *15 Americans*, exh.cat., Museum of Modern Art, New York, 1952.

—— *12 Americans*, exh.cat., Simon & Schuster for the Museum of Modern Art, New York, 1956.

Morris, F. (ed.), *Paris Post War: Art and Existentialism 1945–55*, exh.cat., Tate Gallery, London, 1993.

Motherwell, R., 'What abstract art means to me', *Bulletin*, 18: 3, Museum of Modern Art, New York, 1951.

Mulcahy, K., 'Cultural diplomacy: foreign policy and the exchange programs' in Mulcahy, K. & Swaim, C. R. (eds), *Public Policy and the Arts*, Westview Press, Boulder, Colorado, 1982.

Musgrave, E., Editorial, *The Leeds Art Calendar*, 9: 31, 1955; 10: 37, 1957.

Nairne, S. & Serota, N. (eds), *British Sculpture in the Twentieth Century*, Whitechapel Art Gallery, London, 1981.

Newman, B., 'The New York School question', *Art News*, 64, September 1965.

New Vision Centre Gallery, London, *Ralph Rumney*, exh.cat., 1956.

—— *Denis Bowen*, exh.cats, 1956, 1957.

Neumann, J. von, & Morgenstern, O., *Theory of Games and Economic Behavior*, Princeton, New York, 1953.

O'Hana Gallery, London, *Dimensions: British Abstract Art 1948–1957*, exh.cat., 1957.

O'Hara, F., *Art Chronicles*, Braziller, New York, 1978.

Osborne, A. (ed.), *Patron: Industry Supports the Arts*, The Connoisseur Ltd, London, 1966.

Parsons Gallery, London, *Aspects of Contemporary French Painting*, exh.cat., 1954.

—— *Aspects of Contemporary English Painting*, exh.cat., 1956.

Pearson, N., *The State and the Visual Arts: a Discussion of State Intervention in the Visual Arts in Britain, 1760–1981*, The Open University, Milton Keynes, 1982.

Perrault, J., 'MoMAS's sugar daddy', *Village Voice*, 4, July 1974.

Pimlott, B., *Harold Wilson*, HarperCollins, London, 1992.

Poggioli, R., *The Theory of the Avant-Garde* trans. Fitzgerald, G. (1962), Harvard University Press, Cambridge Mass. & London, 1968.

Pohl, F., 'An American in Venice: Ben Shahn and American foreign policy at the 1954 Venice Biennale', *Art History*, 4: 1, March 1981.

Pollock, G. & Orton, F., 'Avant Gardes and partisans reviewed' in Frascina, F. (ed.), *Pollock and After: the Critical Debate*, Harper & Row, New York, 1985.

Porter, F., 'Art', *The Nation*, 3 October 1959.

Ray, P. C., *The Surrealist Movement in England*, Cornell University Press, New York, 1971.

Read, B., & Thistlewood, D. (eds), *Herbert Read: a British Vision of World Art*, exh.cat., Leeds City Art Galleries with the Henry Moore Foundation & Lund Humphries, 1993.

Read, H., *Education Through Art*, Faber & Faber, London, 1943.

—— *Existentialism, Marxism and Anarchy*, Freedom Press, London, 1949.

—— *Icon and Idea: the Function of Art in the Development of Human Consciousness*, Faber & Faber, London, 1955.

—— *Henry Moore: a Study of his Life and Work*, Thames & Hudson, London, 1965.

—— 'New aspects of British sculpture', *XXVI Biennale di Venezia*, exh.cat., British Council, 1952.

—— & Arnason, H. H., 'Dialogue on modern US painting', *Art News*, 59, May 1960.

Redfern Gallery, London, *Patrick Heron*, exh.cat., 1948.

—— *Metavisual, Tachiste, Abstract*, exh.cat., 1957.

—— *William Gear: an Exhibition of Paintings, 1955–56*, exh.cat., 1992.

Ridley, P. , 'The concept of the gesture in Abstract Expressionism' unpublished MA thesis, Courtauld Institute of Art, University of London, 1974.

Robbins, D. (ed.), *The Independent Group: Post War Britain and the Aesthetics of Plenty*, MIT Press, Cambridge, Mass & London, 1990.

Roberts, J., 'Japanese influence on the Ecole de Paris' unpublished BA project, Courtauld Institute of Art, University of London, 1988.

Robertson, B., 'David Bomberg', *The Studio*, 131: 634, January 1946.

—— 'The younger British artists', *The Studio*, 131: 636 ,March 1946.

—— 'Whitechapel's interim', *Art & Artists*, 3: 3, June 1968.

—— 'Recent British painting' in Scheepmaker, H. (ed.), *Adventure in Art: an International Group of Art Collections in Industrial Environments*, Harry N. Abrams, New York, 1971.

—— 'The Sixties' in *Twenty Five Years: Three Decades of Contemporary Art*, exh.cat., Annely Juda Fine Art/Juda Rowan Gallery, 1985.

—— with Russell, J. & Snowdon, *Private View*, Thomas Nelson & Sons Ltd, London, 1965.

Roditi, E., 'Peinture ou non-peinture, américaine ou non-américaine', *Présence* No. 7/8, Geneva, 1958.

Roob, R., 'Alfred H.Barr, Jr: a bibliography of published writings' in Sandler, I. & Newman, A. (eds), *Defining Modern Art: Selected Writings of Alfred H.Barr Jr*, Harry N. Abrams, New York, 1986.

Rose, B., 'Problems of criticism IV: the politics of art, Part 1', *Artforum*, 6, February 1966.

Rosenberg, H., 'Introduction to six American artists', *Possibilities*, 1, winter 1947–8.

—— 'The American action painters', *Art News*, 51: 8, December 1952.

Roskill, M., 'The promise of British sculpture', *The Listener*, 76: 1947, 21 July 1966.

Ross, A. (ed.), *Keith Vaughan: Journals 1939–1977*, John Murray, London, 1989.

Roth, M., 'The æsthetics of indifference', *Artforum*, 16, November 1977.

Rothenstein, J., *Modern English Painters* I (1952) & II (1956), Macdonald & Jane's, London, 1976; III, Macdonald & Jane's, London, 1974.

Royal Academy of Arts, London, *L'Ecole de Paris 1900–1950*, exh.cat., 1951.

Rumney, R., 'The leaning tower of Venice', *ARK*, 24, 1959; 25, 1960; 26, 1960.

—— 'Ralph Rumney', *Transcript*, 1: 2, 1995.

Sandilands, G. S., 'London County Council as art patron: 1', *The Studio*, 159: 801, January 1960.

Sandler, I., *The Triumph of American Painting*, Praeger, New York, 1970.

Sartre, J. P. , *Existentialism and Humanism* (1946), trans. P. Mairet 1948, London 1978.

Sausmarez, M. de, 'Bryan Robertson's achievement at the Whitechapel', *Studio Int.*, 177: 908, February 1969.

Seago, A., *Burning the Box of Beautiful Things: the Development of a Postmodern Sensibility*, Oxford University Press, 1995.

Seitz, W., *Abstract Expressionist Painting in America*, Harvard University Press, Cambridge, Mass, 1983.

Shackleton, P. , 'New activists, new art and the Arts Council 1968–74' unpublished MA thesis, Courtauld Institute of Art, University of London, 1993.

Shapiro, D. & C., 'Abstract Expressionism: the politics of apolitical painting' in Frascina, F. (ed.), *Pollock and After: the Critical Debate*, Harper & Row, New York, 1985.

Shone, R., *The Century of Change: British Painting since 1900*, Phaidon, Oxford, 1977.

Sinclair, A., *Arts and Cultures: the History of the 50 Years of the Arts Council of Great Britain*, Sinclair-Stevenson, London, 1995.

Smith, R., 'Ideograms', *ARK*, 16, 1956.

Spacex Gallery, Exeter, *William Gear: Paintings into Landscape, Paintings and Drawings 1976*, exh.cat., 1982.

Spalding, F., *British Art since 1900*, Thames & Hudson, London, 1986.

Spender, S., *The Thirties and After: Poetry, Politics, People (1933–75)*, Fontana, London, 1978.

Steele, T., *Alfred Orage and the Leeds Art Club 1893–1923*, Scolar Press, Aldershot, 1990.

Steyn, J., 'The complexities of assimilation in the 1906 Whitechapel Art Gallery exhibition "Jewish Art & Antiquities"', *The Oxford Art Journal*, 13: 2, 1990.

Still, C., 'An open letter to an art critic', *Artforum*, 11, December 1969.

Stitch, S., *Made in USA: an Americanization of Modern Art, the 50s and 60s*, exh.cat., University Art Museum, University of California at Berkeley, University of California Press, 1987.

Stonor Saunders, F., *Who Paid the Piper? The CIA and the Cultural Cold War*, Granta Books, London, 1999.

Strand, J., 'Do you remember the Fifties?', *Art International*, 4, 1988.

Sutherland, G., 'Thoughts on painting', *The Listener*, 46: 1175, 6 September 1951.

Suzuki, D. T., *Essays in Zen Buddhism*, (1950), London, 1980.

Sylvester, D., 'The auguries of experience', *The Tiger's Eye*, 1: 6, 15 December 1948.

—— 'Round the London art galleries', *The Listener*, 47: 1202, 13 March 1952.

—— 'Round the London art galleries', *The Listener*, 50: 1282, 24 September 1953.

Tagg, J., 'American power and American painting: the development of vanguard painting in the United States since 1945', *Praxis*, 1: 2, 1976.

Tapié, M., *Un art autre*, Gabriel-Giraud, Paris, 1952.

Tate Gallery, London, *Paul Klee 1879–1940*, exh.cat., 1945.

—— *Braque and Rouault*, exh.cat., 1946.

—— *Modern Art in the United States: a Selection from the Museum of Modern Art New York*, exh.cat., 1956.

—— *Review 1953–63*, London, 1964.

—— *Annual Reports 1952–69*.

Taylor, B., *Art for the Nation: Exhibitions and the London Public 1747–2001*, Manchester University Press, 1999.

Taylor, J. C., 'The art museum in the United States' in Lee, S. E. (ed.), *On Understanding Art Museums*, Prentice Hall, Englewood Cliffs, New Jersey, 1975.

T. D. M., 'The United States government and abstract art', *Museum of Modern Art Bulletin*, 5: 3, April 1936.

Thistlewood, D., *Herbert Read, Formlessness and Form: an Introduction to his Aesthetics*, Routledge & Kegan Paul, London, Boston, Melbourne, Henley, 1984.

—— 'The MoMA and the ICA: a common philosophy of modern art', *British Journal of Aesthetics*, 29: 4, 1989.

—— 'The Independent Group and art education in Britain 1950–65' in Robbins, D. (ed.), *The Independent Group: Post War Britain and the Aesthetics of Plenty*, MIT Press, Cambridge, Mass & London, 1990.

Thompson, D., *Robyn Denny*, Penguin, London, 1971.

—— 'Post War Sculpture in Britain' in *Sculpture from the Arts Council Collection*, exh.cat., Arts Council of Great Britain, 1965.

Tilston, R., 'Aspects of abstract painting in England 1947–1956' unpublished MA thesis, Courtauld Institute of Art, University of London, 1977.

Tuchman, M., *New York School: the First Generation*, exh.cat., Los Angeles County Museum of Art, 1965.

Tucker, M. (ed.), *Alan Davie: the Quest for the Miraculous*, exh.cat., University of Brighton Gallery with Lund Humphries & Barbican Art Gallery, London, 1993.

Tucker, W., 'An essay on sculpture', *Studio Int.*, 177: 907, January 1969.

University of Lancaster, *The Irene Manton Bequest, an Interim Catalogue of Work from the Irene Manton Bequest in Lancaster University's Collection*, exh.cat., 1993.

University Gallery, University of Leeds, *Gregory Fellows Exhibition*, exh.cat., 1964.

—— *The New Spirit: Patrons, Artists and the University of Leeds in the Twentieth Century*, exh.cat., 1986.

—— *Michael Sadler*, exh.cat., 1989.

—— *Eric Taylor: a Retrospective*, exh.cat., 1994.

—— *The University of Leeds Art Collection and Gallery: a Short History*, exh.cat., 1995.

—— 'Venise a vaincu Ralph Rumney', *Internationale Situationniste*, 1, June 1958.

Vergo, P. , 'The reticent object' in Vergo, P. (ed.), *The New Museology*, Reaktion Books, London, 1989.

Wakefield Art Gallery, *Alan Davie*, exh.cat., 1958.

Warnock, M., *Existentialism*, Oxford University Press, (1970) 1977.

Whitechapel Art Gallery, London, *William Scott: Painter's Progress*, exh.cat., 1950.

—— *20th Century Form: Painting, Sculpture and Architecture*, exh.cat., 1953.

—— *Michael Ayrton*, exh.cat., 1955.

—— *Nicolas de Staël (1914–55)*, exh.cat., 1956.

—— *Piet Mondrian*, exh.cat., 1956.

—— *Alan Davie*, exh.cat., 1958.

—— *Kenneth Armitage*, exh.cat., 1959.

—— *Keith Vaughan*, exh.cat., 1962.

—— *New Generation: 1964*, exh.cat., 1964.

—— *New Generation: 1965*, exh.cat., 1965.

—— *Richard Smith: Paintings 1958–1966*, exh.cat., 1966.

—— *British Sculpture and Painting from the Collection of the Leicestershire Education Authority*, exh.cat., 1967.

—— *Philip King 1960–8*, exh.cat., 1968.

—— *New Generation 1968: Interim*, exh.cat., 1968.

Whiteley, N., *Pop Design: from Modernism to Mod*, Design Council, London, 1987.

Whiting, C., *Antifascism in American Art*, Yale University Press, New Haven, 1989.

Whitney Museum of American Art, New York, *Constructing American Identity*, exh.cat., 1991.

Whittet, G. S., 'London commentary', *The Studio*, 157: 794, May 1959.

Wilenski, R. H., *Modern French Painters*, (1940) Faber & Faber, London, 1963.

Williams, R., 'Base and superstructure in Marxist cultural theory' in *Problems in Materialism and Culture*, Verso, London, 1980.

Wilson, S., 'Informal painting in France 1939–49' unpublished MA thesis, Courtauld Institute of Art, University of London 1979.

—— 'Art and Politics of the Left in France, 1935–1955' unpublished PhD thesis, Courtauld Institute of Art, University of London, 1991.

Winer, H., 'The Whitechapel Gallery', *East End Papers*, 12: 1, summer 1969.

Witham, G., 'Exhibitions' in Robbins, D. (ed.), *The Independent Group: Post War Britain and the Aesthetics of Plenty*, MIT Press, Cambridge, Mass & London, 1990.

Witts, R., *Artist Unknown: an Alternative History of the Arts Council*, Little Brown & Co., London, 1998.

Wolff, J., *The Social Production of Art*, Macmillan, London, 1981.

Wright, P. , 'The quality of visitors' experiences in art museums' in Vergo, P. (ed.), *The New Museology*, Reaktion Books, London, 1989.

Wu, Chin-Tao, 'Embracing the enterprise culture: art institutions since the 1980s', *New Left Review*, 230, July/August 1998.

Yoemans, R., 'The Foundation Course of Victor Pasmore and Richard Hamilton 1954–1966' unpublished PhD thesis, Institute of Education, University of London, 1987.

Yorke, M., *The Spirit of Place: Nine neo-Romantic Artists and Their Times*, Constable, London, 1988.

Index